DARE TO KNOW

PRINTS AND DRAWINGS IN THE AGE OF ENLIGHTENMENT

Edited by Edouard Kopp, Elizabeth M. Rudy, and Kristel Smentek

With contributions by J. Cabelle Ahn, Elizabeth Saari Browne, Rachel Burke, Alvin L. Clark, Jr., Anne Driesse, Paul Friedland, Thea Goldring, Margaret Morgan Grasselli, Ashley Hannebrink, Joachim Homann, Kéla Jackson, Penley Knipe, Edouard Kopp, Ewa Lajer-Burcharth, Heather N. Linton, Austėja Mackelaitė, Tamar Mayer, Elizabeth Kathleen Mitchell, Elizabeth M. Rudy, Brandon O. Scott, Kristel Smentek, Phoebe Springstubb, Gabriella Szalay, and Christina Taylor

Harvard Art Museums
Cambridge, Mass.
Distributed by Yale University Press
New Haven and London

The eighteenth century saw dramatic growth in the circulation of works on paper, ushering in an era of information sharing that rivals our own digital age. Still, even as we grapple today with the downsides of living in a world in which content can be created and disseminated with ease, many of us tend to think of the Enlightenment as a wholly progressive, eminently rational movement, one in which the scientific method was glorified and the democratic philosophies of revolutionaries prevailed. *Dare to Know* complicates this history, revealing how the depiction of new ideas and new discoveries, from the microscopic to the cosmic, could likewise be inscribed with old prejudices—issues that continue to resonate in our time of misinformation and online aggression.

Lucky for us, though, there is equally as much delight and intrigue to be found in the graphic arts of the era. Presented in this volume are twenty-six essays—one for each letter of the alphabet—and eleven object-specific spotlights whose impressive range demonstrates how, like the glut of information that is for us only a keystroke away, prints and drawings touched every aspect of eighteenth-century life, from A(ntiquities) to Z(ealotry). Opening up the study of these works to synchronous investigations in the realms of the natural sciences, technology, justice, religion, economics, sexual health, and others, this multidisciplinary approach brings an ocean of literature to bear on the art historical record, providing much-needed nuance for a field that has long employed a definition of the Enlightenment that is too easy, too comfortable. The project also called for a range of voices. The two dozen contributors to this volume bring diverse research interests and expertise, embodying the kind of wide-ranging academic curiosity for which the period under study is so often praised.

At the helm are Elizabeth M. Rudy, the Carl A. Weyerhaeuser Curator of Prints at the Harvard Art Museums; Kristel Smentek, associate professor of art history at the Massachusetts Institute of Technology; and Edouard Kopp, the John R. Eckel, Jr., Foundation Chief Curator at the Menil Drawing Institute in Houston. Their cross-institutional collaboration over the course of many years—including through a pandemic that presented numerous logistical challenges, not least a moratorium on meeting in person or with objects—is a testament to their generosity of spirit, tenacity, and scholarly commitment. It is also a demonstration of the best of what the Internet has to offer: a bridge between physically distant individuals willing to learn from one another and to work together toward a common goal.

Such bridges are what allow exhibitions like the one this volume accompanies to come together. Building on a project conceived during Kopp's tenure as the Maida and George Abrams Curator of Drawings at the Harvard Art Museums, Rudy and Smentek have curated a show that unites roughly 150 works from our own collections and lending institutions in the first large-scale exhibition devoted at once to both the prints and drawings of the Enlightenment. As a home for this ambitious and singular

exhibition, which positions drawings and prints as technical and aesthetic companions whose contributions to the so-called Age of Reason cannot be disentangled, the Harvard Art Museums are unmatched: our renowned collections of works in these media form the backbone of our mission as a teaching institution.

What's more, the multidisciplinary study at the heart of this catalogue is able to come alive within the context of a major research university, creating unexpected cross-currents of investigation and engagement. Not only will William Pether's mezzotint of *A Philosopher Giving a Lecture on the Orrery*, for instance, be displayed alongside an actual example of the apparatus from Harvard's Collection of Historical Scientific Instruments, but the central theme of the work—intellectual discovery—is reenacted in thrilling ways every day at the museums. On any given day while *Dare to Know* is on view, a professor from Harvard Medical School might bring a class to view a print depicting the human muscular system; a Harvard Divinity student may find something to ponder in works that suggest a tension between faith and doubt, the secular and the sacred; a geologist can marvel at the research of her eighteenth-century predecessors; or a budding artist might try his hand at the aquatint technique in the Materials Lab.

We would not be able to foster these moments of discovery without the help of our supporters. This project is made possible in part by an award from the National Endowment for the Arts. Support for the exhibition is provided by the Melvin R. Seiden and Janine Luke Fund for Publications and Exhibitions, the Robert M. Light Print Department Fund, the Stanley H. Durwood Foundation Support Fund, the Catalogues and Exhibitions Fund for Pre-Twentieth Century Art of the Fogg Museum, and the Gladys Krieble Delmas Foundation. The catalogue was made possible by the Andrew W. Mellon Publication Funds, including the Henry P. McIlhenny Fund. Related programming is supported by the M. Victor Leventritt Lecture Series Endowment Fund.

Taking its name from an Enlightenment motto made famous by Immanuel Kant, this project exposes how the recent politization of what it means to "do your own research" is, in fact, nothing new. The prints and drawings offered for exploration on the following pages served as intermediaries in an exchange of ideas whose biases and gaps in understanding are still being debated. Indeed, some of the information in this volume will no doubt eventually become outdated; that is the work of continuous learning. As important as it is to dare to know the full story, it is also crucial to recognize that the story is not yet nor ever will be final.

Martha Tedeschi
Elizabeth and John Moors Cabot Director
Harvard Art Museums

ACKNOWLEDGMENTS

Dare to Know was developed over many years in collaboration with scores of contributors, whose generosity and support ensured that this publication and the related exhibition would come to fruition. We thank profusely the stellar scholars who persevered through the logistical challenges of the last two years to contribute thoughtful, original scholarship to this book: J. Cabelle Ahn, Elizabeth Saari Browne, Rachel Burke, Alvin L. Clark, Jr., Anne Driesse, Paul Friedland, Thea Goldring, Margaret Morgan Grasselli, Ashley Hannebrink, Joachim Homann, Kéla Jackson, Penley Knipe, Ewa Lajer-Burcharth, Heather N. Linton, Austėja Mackelaitė, Tamar Mayer, Elizabeth Kathleen Mitchell, Brandon O. Scott, Phoebe Springstubb, Gabriella Szalay, and Christina Taylor.

Numerous colleagues from institutions across the United States and in London and France met with us over the course of our research—some repeatedly—to suggest remarkable works from their respective collections to include in our selection and to exchange ideas about the age of Enlightenment. We are grateful to the following individuals for their time, enthusiasm, and thoughtfulness in helping us shape this study, and we cannot thank them enough for their continued support during the pandemic, without which this publication would be frozen in a state of suspended animation: Lena Newman (Avery Library, Columbia University); Laura Linard, Melissa Ann Murphy, Heather Oswald, and Christine Riggle (Special Collections, Baker Library, Harvard Business School); Morgan Dowty (Baltimore Museum of Art); Sylvie Aubenas, Sophie Baillat, Jean-Marc Chatelain, Pauline Chougnet, Nathalie Coilly, Laurence Engel, Corinne Le Bitouzé, Rémi Mathis, Delphine Minotti, Jocelyn Monchamp, Brigitte Robin-Loiseau, and Vanessa Selbach (Bibliothèque nationale de France); John Buchtel, Leah Rosovsky, and Lily Sterling (Boston Athenaeum); Danielle Castronovo, Diane Rielinger, Chris Robson, Amy Van Epps, and Judith Warnement (Botany Libraries, Harvard University); Esther Bell and Anne Leonard (Clark Art Institute); Sara Frankel, Peter Galison, Jean-François Gauvin, and Sara Schechner (Collection of Historical Scientific Instruments, Harvard University); Caitlin Condell, John Davis, Mir Finkelman, Steve Langehough, Antonia Moser, Caroline O'Connell, and Yao-Fen You (Cooper Hewitt, Smithsonian Design Museum); Dominic Hall, Elaine Martin, and Jessica B. Murphy (Countway Library, Harvard Medical School); Constance Rinaldo and Robert Young (Ernst Mayr Library, Harvard University); Joanne Bloom, András Riedlmayer, and Shalimar Fojas White (Fine Arts Library, Harvard University); Claudia Covert and Margot Nishimura (Fleet Library, Rhode Island School of Design); Emily Beeny, Julian Brooks, Jennifer Garpner, Stephen Heer, Kevin Marshall, Timothy Potts, Betsy Severance, Michelle Sullivan, and Nancy Turner (J. Paul Getty Museum); Karen Beck, Jocelyn Kennedy, and Lesley Schoenfeld (Harvard Law School Library); Tom Lingner and Robert Zinck (Harvard Library Imaging Services); David Weimer (Harvard Map Collection); Paul L. Jackson (Hellenic

and Roman Library, University of London); Alvin L. Clark, Jr. (Jeffrey E. Horvitz Collection); Peter Accardo, Anne-Marie Eze, Tom Hyry, Laura Larkin, Hope Mayo, Carie McGinnis, John Overholt, and Susan Pyzynski (Houghton Library, Harvard University); Cynthia Roman (Lewis Walpole Library, Yale University); Brianne Chapelle (Menil Drawing Institute); Emily Foss, Clara Goldman, Max Hollein, Connie McPhee, Nadine Orenstein, Allison Rudnick, Perrin Stein, and Elizabeth Zanis (Metropolitan Museum of Art); Chris Bourg, Mattie Clear, Jana L. Dambrogio, Emilie Hardman, Terra Huber, Ayako Letizia, and Nora Murphy (Department of Distinctive Collections, MIT Libraries); Deborah Douglas, Kurt C. Hasselbalch, and Ariel Weinberg (MIT Museum); John Alexander, Colin Bailey, Austėja Mackelaitė, John Marciari, and Jennifer Tonkovich (Morgan Library & Museum); Anne Bouillé, Krystel Gualde, and Bertrand Guillet (Musée d'histoire de Nantes); Laurence des Cars, Jean-Luc Martinez, Fanny Meurisse, Xavier Salmon, Juliette Trey, and Christel Winling (Musée du Louvre); Solenne Coutagne and Amandine Postec (Muséum national d'Histoire naturelle); Cliff Ackley, Helen Burnham, Janet Moore, Patrick Murphy, Edward Saywell, Stephanie Stepanek, Jennifer Swope, Matthew Teitelbaum, and Ben Weiss (Museum of Fine Arts, Boston); Jonathan Bober, Kaywin Feldman, Michelle Fondas, Rena Hoisington, Greg Jecmen, Shelley R. Langdale, and Lisa MacDougall (National Gallery of Art, Washington, D.C.); David G. Christie, Hope Cullinan, Margaret Glover, Anthony W. Marx, Deborah Straussman, Madeleine Viljoen, and Theodore Walther (New York Public Library); Patricia Capone, Viva Fisher, Castle McLaughlin, Jane Pickering, and Katherine Satriano (Peabody Museum of Archaeology & Ethnology, Harvard University); John Ittmann, Jillian Kruse, Louis Marchesano, Lisa Morra, Eileen Owens, Timothy Rub, and Irene Taurins (Philadelphia Museum of Art); James McCabe (Rice University); Catherine Badot-Costello, Debra Cuoco, Debora Mayer, Erin Murphy, and Christopher Sokolowski (Weissman Preservation Center, Harvard University); Charles Berlin, Ardys Kozbial, and Vardit Samuels (Widener Library, Harvard University); Megan Czekaj, Martina Droth, Matthew Hargraves, Charlotte Lefland, Courtney Skipton Long, Courtney J. Martin, Chitra Ramalingam, and Scott Wilcox (Yale Center for British Art); and Lynne Addison, Suzanne Boorsch, Suzanne Greenawalt, Elisabeth Hodermarsky, Frauke Josenhans, Ashley Kane, Isabelle Sagraves, Freyda Spira, Elissa Watters, and Stephanie Wiles (Yale University Art Gallery).

Several scholars contributed critical research and support for *Dare to Know*, many of whom also authored essays in this book. We are grateful to graduate student researchers J. Cabelle Ahn, Thea Goldring, Sarah Lund, and Brandon O. Scott for their creative and tenacious work, which benefited myriad aspects of this project. We are indebted to postdoctoral researchers Austėja Mackelaitė, Galina Mardilovich, Gabriella Szalay, Amy Torbert, and Ilka Voermann for their focused research on

specific objects and topics, which allowed us to incorporate themes outside our primary areas of expertise. We are also grateful to the numerous scholars who provided critical feedback on our work, especially Hélène Bilis, Joseph Connors, Robert Darnton, Rena Hoisington, Erika Naginski, Christopher Parsons, Jeffrey Ravel, Keidrick Roy, James Schmidt, Stacey Sloboda, Perrin Stein, Susan Wager, Reva Wolf, and Henri Zerner. In addition to the scholars who are thanked individually throughout this book for their discerning input on specific topics, we would like to acknowledge the considerable support of Marjorie Cohn and John Shovlin, whose continuous feedback was integral to the evolution of this project, and who very generously reviewed early drafts of many of the essays in this book. A. Cassandra Albinson, the Margaret S. Winthrop Curator of European Art and head of the Division of European and American Art at the Harvard Art Museums, helped further shape the manuscript; we thank her for her guidance both as an insightful reviewer and as an important advocate for this project throughout its development.

We are deeply grateful to Jeffrey E. Horvitz and J. William Middendorf for lending extraordinary works from their respective collections to our exhibition, each enriching our presentation in a unique way. The warmth and kindness with which they, along with Carol Horvitz and Frances Middendorf, greeted us on our visits both inspired and guided our journey throughout this undertaking. Thank you also to the late Richard Balzer and his wife Patricia Bellinger, whose generosity was vital to the early development of the exhibition. The time and humor with which Dick shared his considerable collection helped shape our approach to the ephemera we encountered in our research and reminded us to take moments to delight in our scholarly pursuit and to find joy in our discoveries. Additional thanks are given to Ivan E. Phillips for his hospitality and to David and Julie Tobey and John Davidson for their ongoing friendship and partnership throughout this project and many others.

The members of the museums' collection committees for drawings and prints have been unanimously supportive of and excited about this project over its evolution. We wish to thank the following individuals, whose feedback and encouragement were crucial to the project's success: George S. Abrams, Morton C. Abromson, Kate de Rothschild Agius, Regina D. Champion, Marjorie Benedict Cohn, Lindsay Leard Coolidge, John B. Davidson, Phyllis Caroline Hattis, David M. Leventhal, Elizabeth Llewellyn, Suzanne F. McCullagh, Joan L. Nissman, Christopher C. North, Jo-Ann Edinburg Pinkowitz, Emily Rauh Pulitzer, James M. Rabb, William Walker Robinson, Alan E. Salz, Peter F. Soriano, David M. Tobey, Julie Tobey, Barbara Ketcham Wheaton, George H. White, and Scott R. Wilson.

Dare to Know was only possible due to the unwavering support of Martha Tedeschi, the Elizabeth and John Moors Cabot Director of the Harvard Art Museums, whose enthusiasm for our vision over many years was both essential and uplifting. We are also grateful for the imaginative guidance of Soyoung Lee, the museums' Landon and Lavinia Clay Chief Curator, who ensured that the exhibition would reach its fullest ambition and scope.

Numerous other colleagues from departments across the museums helped make this project a reality. We are grateful to: Heather Linton for her patient and stalwart stewardship of this publication as well as every facet of the exhibition;

Heather's predecessor, Tara Murphy, for her contributions during the early development of the show; Francine Flynn for shepherding all loans to the exhibition with assiduous care; Elie Glyn for his thoughtful and stunning design of the exhibition; Micah Buis and Sarah Kuschner for their wise advice, inordinate patience, and beautiful editing of this book; Zak Jensen, Angela Lorenzo, and Adam Sherkanowski, the talented creative team behind the book's design; Adam Baker, Angela Chang, Anne Driesse, Charlotte Karney, Penley Knipe, Yi Bin Liang, and Christina Taylor for their generous help securing loans and tremendous care in preparing objects in the museums' collections for exhibition; Britt Bowen, Katya Kallsen, Mary Kocol, and Katie Kujala, who photographed objects in the museums' collections for the catalogue and while on view; Ana Barros, Jeanne Burke, Tayana Fincher, Camran Mani, Laura Muir, David Odo, Molly Ryan, and Jen Thum for helping us think creatively about how to make our work relevant and relatable to contemporary audiences; Jennifer Aubin, Krystle Brown, John Connolly, and Tara Metal for reaching those audiences with stories of the exhibition and related events; Mary Lister and her tireless team in the Art Study Center, who made it possible for us to preview this exhibition to different constituents over the years and whose support helped finalize the selection of works for the exhibition; Tisha Stima for her keen, unflagging work on grant applications; Elizabeth Cartland, Melanie Sheffield, and Bridget Thompson for their dedicated efforts to raise critical financial support for this project; Michael Ricca, who secured contracts for contributors to this book and the exhibition; Brette Farrelly, Sergey Gleykin, Nancy Laird, Evelyne Reyes, Stephanie Schilling, Marsy Sumner, and Juliana Wong, who guided all financial components of the undertaking; Jane Braun for her superlative project management every step of the way; Jane's predecessor, Dana Greenidge, for her key involvement in the project's early stages; Erica Lawton for her invaluable help with programming, image ordering, and payment processing, among other tasks; Clara Guzman and Sam Nehila for their administrative support; Casey Kane Monahan and Miriam Stewart for cataloguing and shepherding many new acquisitions into the collection for this project; and all the members of the Division of European and American Art, past and present, for their consistent encouragement and inspiration from day one.

Lastly, we would like to acknowledge our families, whose love, patience, and support made all the difference.

Edouard Kopp
John R. Eckel, Jr., Foundation Chief Curator
Menil Drawing Institute

Elizabeth M. Rudy
Carl A. Weyerhaeuser Curator of Prints
Harvard Art Museums

Kristel Smentek
Associate Professor of Art History
Massachusetts Institute of Technology

J. Cabelle Ahn is a Ph.D. candidate in the Department of History of Art and Architecture at Harvard University.

Elizabeth Saari Browne completed her Ph.D. in the History, Theory, and Criticism of Art and Architecture program in the Department of Architecture at the Massachusetts Institute of Technology in 2021.

Rachel Burke is a Ph.D. student in the Department of History of Art and Architecture at Harvard University.

Alvin L. Clark, Jr., is Curator of the Horvitz Collection and the Jeffrey E. Horvitz Research Curator, emeritus, at the Harvard Art Museums.

Anne Driesse served as Senior Conservator of Works on Paper in the Straus Center for Conservation and Technical Studies at the Harvard Art Museums; she retired in 2020 and now works in private practice.

Paul Friedland is Professor of History at Cornell University.

Thea Goldring is a Ph.D. candidate in the Department of History of Art and Architecture at Harvard University.

Margaret Morgan Grasselli is a Visiting Senior Scholar for Drawings at the Harvard Art Museums and Visiting Lecturer in the Department of History of Art and Architecture at Harvard University.

Ashley Hannebrink is a Ph.D. candidate in the Department of History of Art and Architecture at Harvard University.

Joachim Homann is the Maida and George Abrams Curator of Drawings at the Harvard Art Museums.

Kéla Jackson is a Ph.D. student in the Department of History of Art and Architecture at Harvard University.

Penley Knipe is the Philip and Lynn Straus Senior Conservator of Works on Paper and Head of the Paper Lab in the Straus Center for Conservation and Technical Studies at the Harvard Art Museums.

Edouard Kopp is the John R. Eckel, Jr., Foundation Chief Curator at the Menil Drawing Institute; he served as the Maida and George Abrams Curator of Drawings at the Harvard Art Museums from 2015 to 2018.

Ewa Lajer-Burcharth is the William Dorr Boardman Professor of Fine Arts in the Department of History of Art and Architecture at Harvard University.

Heather N. Linton is the Curatorial Assistant for Special Exhibitions and Publications in the Division of European and American Art at the Harvard Art Museums.

Austėja Mackelaitė is the Annette and Oscar de la Renta Assistant Curator of Drawings and Prints at the Morgan Library & Museum.

Tamar Mayer is Assistant Professor at Tel Aviv University and Chief Curator of the Genia Schreiber University Art Gallery.

Elizabeth Kathleen Mitchell is the Burton and Deedee McMurtry Curator and interim co-director of the Cantor Arts Center at Stanford University.

Elizabeth M. Rudy is the Carl A. Weyerhaeuser Curator of Prints at the Harvard Art Museums.

Brandon O. Scott is a Ph.D. candidate in the History, Theory, and Criticism of Art and Architecture program in the Department of Architecture at the Massachusetts Institute of Technology.

Kristel Smentek is Associate Professor of Art History in the History, Theory, and Criticism of Art and Architecture program in the Department of Architecture at the Massachusetts Institute of Technology.

Phoebe Springstubb is a Ph.D. candidate in the History, Theory, and Criticism of Art and Architecture program in the Department of Architecture at the Massachusetts Institute of Technology.

Gabriella Szalay is a Ph.D. candidate at the Georg-August-Universität Göttingen; she served as the 2018–20 Renke B. and Pamela M. Thye Curatorial Fellow in the Busch-Reisinger Museum.

Christina Taylor is Associate Paper Conservator in the Straus Center for Conservation and Technical Studies at the Harvard Art Museums.

Anonymous

Arnold Arboretum Library, Harvard University

Baker Library, Harvard Business School

Bibliothèque nationale de France

Boston Athenaeum

Boston Medical Library

Château des ducs de Bretagne, Musée d'histoire de Nantes

Collection of Historical Scientific Instruments, Harvard University

Cooper Hewitt, Smithsonian Design Museum, New York

Distinctive Collections, MIT Libraries

Ernst Mayr Library of the Museum of Comparative Zoology, Harvard University

Fine Arts Library, Harvard University

Fleet Library, Rhode Island School of Design

Francis A. Countway Library of Medicine, Harvard Medical School

Harvard Law School Library

Harvard Map Collection

The Horvitz Collection

Houghton Library, Harvard University

J. Paul Getty Museum, Los Angeles

The Metropolitan Museum of Art, New York

Hon. William Middendorf

The Morgan Library & Museum, New York

Musée du Louvre, Paris

Museum of Fine Arts, Boston

National Gallery of Art, Washington, D.C.

New York Public Library

Peabody Museum of Archaeology & Ethnology, Harvard University

Philadelphia Museum of Art

Widener Library, Harvard University

Yale Center for British Art

Yale University Art Gallery

INTRODUCTION

Edouard Kopp,
Elizabeth M. Rudy,
and Kristel Smentek

What was Enlightenment? A philosophical movement? A singular project? A constellation of practices? Was it a secular era? An age of reason? Of skepticism? Or an age of feeling? Of progress? Was it an era of conquest and colonization, or of contest against empire? Of expanding global consciousness? Was it a revolution of the mind? Was there one Enlightenment or was it plural? When did it start? Has it ended?

Debates, sometimes heated, over what Enlightenment was and what it means have continued since at least 1783, when the query "Was ist Aufklärung?" (What is Enlightenment?) was published in the *Berlinische Monatsschrift*, prompting responses by philosophers Moses Mendelssohn and Immanuel Kant, among others.[1] Reaching back to ancient Roman writer Horace and to the German Society for the Friends of Truth, who adopted Horace's words as their motto in 1736, Kant began his famous answer to the question, published in 1784, with the injunction *Sapere aude!* (Dare to know!), which he translated as "have [the] courage to use your own reason."[2] Today, in an era marked by assaults on truth and democracy and by ongoing structural racism, these debates have taken on renewed vigor in newspaper columns, social media outlets, and college seminars. Whether the European Enlightenment is celebrated, deplored, or cautiously engaged with, disputes over its legacies persist because conceptions of the Enlightenment are intimately bound up with the ideals and failures of western modernity. Historian and philosopher Michel Foucault wrote that the question to which Mendelssohn and Kant responded really asked, "What just happened to us?"[3] In 2022, many of us find ourselves wondering the same thing, and we often look to the Enlightenment, variously defined, for answers.

This book and the related exhibition extend contemporary debates on the historical Enlightenment, which we locate roughly from 1720 to 1800, by focusing on the graphic arts as active agents in the propagation of its ideas and the construction of its blind spots. Our goal is not to settle on any one definition of the Enlightenment, but rather to bring into view the ways in which drawings and prints shaped and communicated the debates of the moment. We take the position that there was not one Enlightenment but many, and that visual media were critical to its varied ambitions and manifestations in diverse locales. As in every era, including our own, images were not mere documents of eighteenth-century thought and practice; they were constitutive of it. Our approach has benefited from the early exemplar of Barbara Maria Stafford's work in particular.[4] It differs from, but also builds upon, a number of past exhibition catalogues on the Enlightenment, which have tended to consider prints and drawings largely as mirrors of the age.[5] We give the agency of these media due consideration as well.

Drawn and printed images not only reflected but also effected aesthetic, social, political, and scientific change. They possessed an immediacy that texts did not, an ability to vividly depict new discoveries about the physical world and to persuade people of new opinions and tastes. Works on paper were less costly and far more mobile than visual images in other media, and they offered multiple possibilities for experimentation, not only in technique but also in format and scale. Drawing as a medium was both nimble and remarkably effective in its ability to make new things visible and familiar things visible in new ways. As multiples, prints circulated the same visual information to widely dispersed viewers, vastly expanding access to

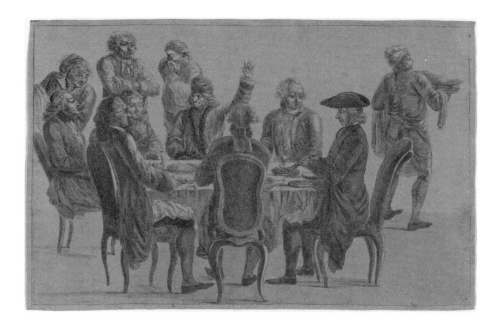

Fig. 1
Unidentified artist, after Jean
Huber (1721–1786), *The Philosophers'
Meal*, after 1772. Etching with gray
wash on blue wove paper, sheet:
21.2 × 31.7 cm. National Gallery of
Art, Washington, D.C., Rosenwald
Collection, 1980, 1980.45.846.

new knowledge, consolidating facts as well as prejudices, and forming a public out of
heterogeneous and anonymous audiences.[6]

This public was not passive, and its responses to visual images were not always
predictable. Viewers across Europe and in its colonies were active consumers of works
on paper, turning the sequential pages of illustrated books, unfolding large, multi-
plate engravings, lifting the flaps attached to prints, and annotating drawings and
etchings. Through this consumption, self-aware viewers negotiated the social and
cultural changes we now identify with the Enlightenment. In *The Philosophers' Meal*
(Fig. 1), an anonymous etching after Swiss artist and caricaturist Jean Huber, viewers
would have immediately recognized the man seated at center with his hand raised as
the French writer Voltaire, whose likeness was depicted in a number of prints already
in circulation. The eighteenth century was the age in which celebrity was invented,
and print publishers and artists like Huber, an intimate of Voltaire's, responded to
public curiosity about the private lives of the famous.[7] In this case, Huber's scene
stages an imaginary dinner at the Château de Ferney, near Geneva, where Voltaire
lived in quasi-exile and was visited by the great and the grand. The print exists in
several impressions, some of which viewers annotated in pen and ink with the names
of the sitters around the table. They include the writer Denis Diderot, who never vis-
ited Ferney, but whose identification by viewers, along with those of other prominent
eighteenth-century thinkers, evokes a self-awareness, in both artist and consumer, of
the intellectual ferment of the era, as well as a personal connection to it.

Prints such as Johann Esaias Nilson's *Neues Caffehaus* (The New Coffeehouse;
Fig. 2) playfully evoke one of the new institutions of eighteenth-century social life,
where imbibing imported coffee provided the context for conversation, sometimes
across social divides, and the exchange of news and rumor. That the coffeehouse is a
place to advance one's knowledge is suggested by the young man seated at right, book
in hand. At the same time, the admonishing woman at left and the print's caption

Edouard Kopp, Elizabeth M. Rudy, and Kristel Smentek

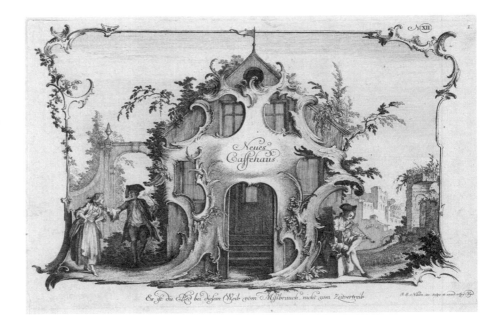

allude to anxieties about the coffeehouse as a potentially divisive space and a site of improper behavior (*Missbrauch*). This print and others like it also assert, both to contemporaries and to posterity, that the Enlightenment was largely a white male affair.

As recent scholars have shown, representations like *The Philosophers' Meal* and *Neues Caffehaus* occlude the diversity of actors—from Tahitian star navigators and Indian astronomers, to women scientists and anonymous artisans, to free and enslaved people of color—who shaped the discourses and practices of the European Enlightenment. This catalogue's structure deliberately emulates the polyvocality of the era and its debates, then and now. Twenty-six essays, each corresponding to a letter of the alphabet, explore themes that engage the Enlightenment's complexities and contradictions. This book does not address all the debates of the era, but it strives with its structure to highlight the disparate and often incongruous aspects of the period, with a particular focus on scientific investigation, religious belief, empathy, colonialism, the study of ancient civilizations worldwide, and political revolution.

Our principal model for the book is one of the most familiar illustrated publications of the Enlightenment, Diderot and Jean le Rond d'Alembert's twenty-eight volume *Encyclopédie, ou, Dictionnaire raisonné des sciences, des arts et des métiers* (Encyclopedia; or, Analytical Dictionary of the Sciences, Arts, and Trades; 1751–72).[8] Like the *Encyclopédie*, our book is premised on the conviction that the advancement of knowledge depends on collaboration and that a multiplicity of perspectives propels productive debate. The *Encyclopédie*, too, was organized alphabetically, a novelty in the eighteenth century that dispensed with the thematic organization of earlier encyclopedias, placing equal value on each entry and encouraging the active participation of readers.[9] As with this volume, multiple authors, representing a variety of expertise and diversity of opinion, were invited to contribute entries. And as with the *Encyclopédie*, our texts are linked to each other by cross-references that we hope will

lead, as they provocatively do in Diderot and d'Alembert's publication, to unexpected conjunctions and diverging points of view on the Enlightenment and the role of images in it, while also facilitating a less scripted trajectory through the book. (Look for this icon ◉ and the accompanying cross-references in the margins.) Diderot and d'Alembert initially planned six hundred printed illustrations for their publication; that number ballooned to roughly three thousand housed in eleven folio volumes as they realized the full significance of images to their enterprise and, more broadly, to the mediation of the Enlightenment and the complex futures it would help usher in.

1. James Schmidt, ed., *What Is Enlightenment? Eighteenth-Century Answers and Twentieth-Century Questions* (Berkeley: University of California Press, 1996). For some of the contours of recent debates on the Enlightenment, see Daniel Carey and Lynn M. Festa, eds., *Postcolonial Enlightenment: Eighteenth-Century Colonialism and Postcolonial Theory* (Oxford: Oxford University Press, 2009); Sebastian Conrad, "Enlightenment in Global History: A Historiographical Critique," *American Historical Review* 117 (4) (2012): 999–1027; Dan Edelstein, *The Enlightenment: A Genealogy* (Chicago: University of Chicago Press, 2010); Jonathan Israel's trilogy, *Radical Enlightenment: Philosophy and the Making of Modernity, 1650-1750* (Oxford: Oxford University Press, 2001), *Enlightenment Contested: Philosophy, Modernity, and the Emancipation of Man, 1670-1752* (Oxford: Oxford University Press, 2006), and *Democratic Enlightenment: Philosophy, Revolution, and Human Rights, 1750-1790* (Oxford: Oxford University Press, 2011); Margaret Jacob, *The Secular Enlightenment* (Princeton, N.J.: Princeton University Press, 2019); Antoine Lilti, *L'héritage des Lumières. Ambivalences de la modernité* (Seuil: Gallimard, 2019); Genevieve Lloyd, *Enlightenment Shadows* (Oxford: Oxford University Press, 2013); Sankar Muthu, *Enlightenment against Empire* (Princeton, N.J.: Princeton University Press, 2003); Jonathan Sheehan, "Enlightenment, Religion, and the Enigma of Secularization: A Review Essay," *American Historical Review* 108 (4) (2003): 1061–80; Clifford Siskin and William Warner, eds., *This Is Enlightenment* (Chicago: University of Chicago Press, 2010); and Charles W.J. Withers, *Placing the Enlightenment: Thinking Geographically about the Age of Reason* (Chicago: University of Chicago Press, 2007).

2. Immanuel Kant, "An Answer to the Question: What is Enlightenment (1784)?" in Schmidt, *What Is Enlightenment?*, 58. See also Clifford Siskin and William Warner, "This Is Enlightenment: An Invitation in the Form of an Argument," in Siskin and Warner, *This Is Enlightenment*, 2–3.

3. Michel Foucault, "For an Ethics of Discomfort," in *The Politics of Truth*, ed. Sylvère Lotringer, trans. Lysa Hochroth and Catherine Porter (Los Angeles: Semiotext(e), 2007), 121; and Siskin and Warner, "This Is Enlightenment," 3.

4. Barbara Maria Stafford, *Artful Science: Enlightenment Entertainment and the Eclipse of Visual Education* (Cambridge, Mass.: MIT Press, 1994); and Barbara Maria Stafford, *Body Criticism: Imaging the Unseen in Enlightenment Art and Medicine* (Cambridge, Mass.: MIT Press, 1991).

5. Herbert Beck, Peter C. Bol, and Maraike Bückling, eds., *Mehr Licht. Europa um 1770. Die bildende Kunst der Aufklärung* (Munich: Klinkhardt & Biermann, 1999); Yann Fauchois, Thierry Grillet, and Tzvetan Todorov, *Lumières! Un héritage pour demain* (Paris: Bibliothèque nationale de France, 2006); and Lu Zhangshen, ed., *The Art of the Enlightenment* (Beijing: National Museum of China; Berlin: Staatliche Museen zu Berlin; Dresden: Staatliche Kunstsammlungen Dresden; Munich: Bayerische Staatsgemäldesammlungen München, 2011).

6. Bruno Latour, "Drawing Things Together," in *Representation in Scientific Practice*, ed. Michael Lynch and Steve Woolgar (Cambridge, Mass.: MIT Press, 1990), 19–68; and Lilti, *L'héritage des Lumières*, 184–85.

Edouard Kopp, Elizabeth M. Rudy, and Kristel Smentek

7. Antoine Lilti, *The Invention of Celebrity*, trans. Lynn Jeffress (Cambridge: Polity, 2015), 14–23; and Nicholas Cronk, "Voltaire et la *Sainte Cène* de Huber: Parodie et posture," in *Philosophie des lumières et valeurs chrétiennes: Hommage à Marie-Hélène Cotoni*, ed. Christiane Mervaud and Jean-Marie Seillan (Paris: L'Harmattan, 2008), 23–34. See also Heather McPherson, *Art & Celebrity in the Age of Reynolds and Siddons* (University Park: Pennsylvania State University Press, 2017).

8. We are equally inspired by the format of the catalogue *1740, un abrégé du monde: Savoirs et collections autour de Dezallier d'Argenville*, ed. Anne Lafont (Lyon: Fage, 2012), which accompanied an exhibition of the same name at the Institut national d'histoire de l'art in Paris and which similarly featured twenty-six alphabetically ordered thematic essays by a range of authors.

9. Daniel Rosenberg, "An Eighteenth-Century Time Machine: The *Encyclopédie* of Denis Diderot," in *Postmodernism and the Enlightenment: New Perspectives in Eighteenth-Century French Intellectual History*, ed. Daniel Gordon (New York: Routledge, 2001), 45–66.

Jacob Christian Schäffer
Second Sample, First Trial with Pine Cones

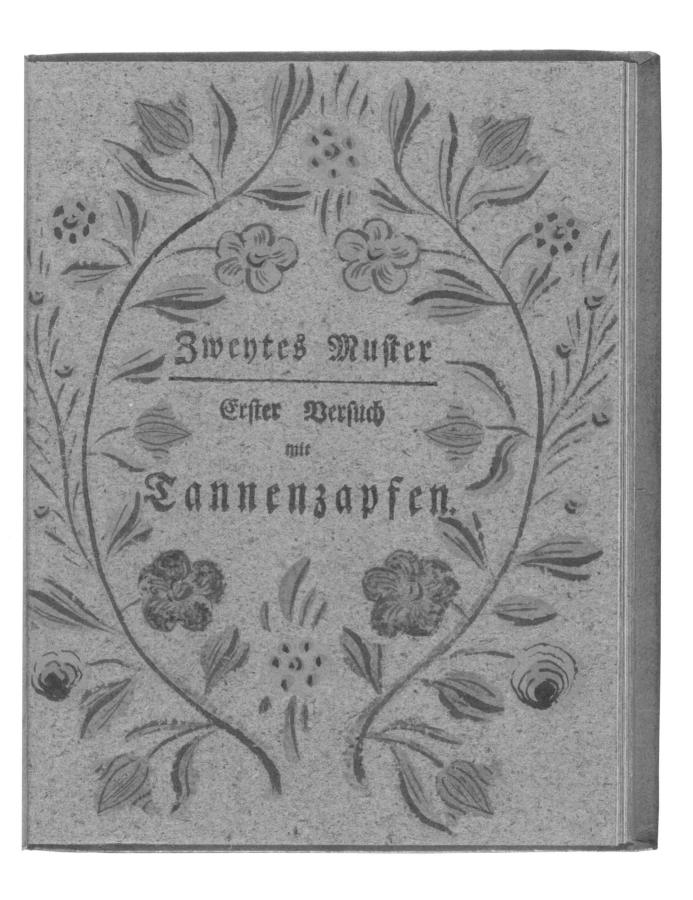

The Enlightenment witnessed a profound interest in the material properties of paper, as evidenced by the efforts of men of learning across Europe to find alternate means for its production. Paper in the region had traditionally been made from fermented linen rags, which in turn were woven with thread spun from the stalks of flax plants. While this method yielded brilliant results, it led to a dependence on linen supplies, which could easily become scarce, as in times of war, when linen was needed for burying the dead.

To combat what he feared to be a growing shortage of fine white writing paper in the wake of the Seven Years' War (1756–63), Regensburg pastor Jacob Christian Schäffer conducted more than seventy experiments on over fifty different substances starting in 1764. While Schäffer mostly experimented on materials sourced from plants, he also tested theories like that of his French correspondent, René Antoine Ferchault de Réaumur, who claimed that paper could be made from wasp nests.[1]

In each case, Schäffer preserved the results of his experiments, publishing them between 1765 and 1767 in a series of six books titled *Versuche und Muster ohne alle Lumpen [. . .] Papier zu machen* (Trials and Samples [. . .] for Making Paper without Rags).[2] The example seen here, made from a pulp of macerated pine cones, demonstrates the wide range of colors, weights, and grades achieved by Schäffer, who argued that this particular sample was well suited to the contemporary craze for wallpaper and sought to convince papermakers to try their hand at such materials. But fearing that the quality of their product would suffer, papermakers continued to use linen rags until the 1840s, when paper made from wood pulp entered large-scale commercial production.

Jacob Christian Schäffer (1718–1790), *Second Sample, First Trial with Pine Cones*, from *Versuche und Muster ohne alle Lumpen [. . .] Papier zu machen* (Trials and Samples [. . .] for Making Paper without Rags), by Jacob Christian Schäffer (Regensburg: 1765–67). Pinecone paper sample with hand-coloring, sheet: 18.8 × 15.7 cm. Houghton Library, Harvard University, Bequest of Philip Hofer, 1984, GEN Typ 720.65.773.

1. For more on the wider context in which these experiments were conducted, see Dard Hunter, *Papermaking: The History and Technique of an Ancient Craft* (New York: Dover Publications, 1978), esp. 309–40.

2. The full German title of the first volume is *Versuche und Muster ohne alle Lumpen oder doch mit einem geringen Zusatze derselben Papier zu machen* (Regensburg: 1765).

Gabriella Szalay

ANTIQUITIES

Kristel Smentek

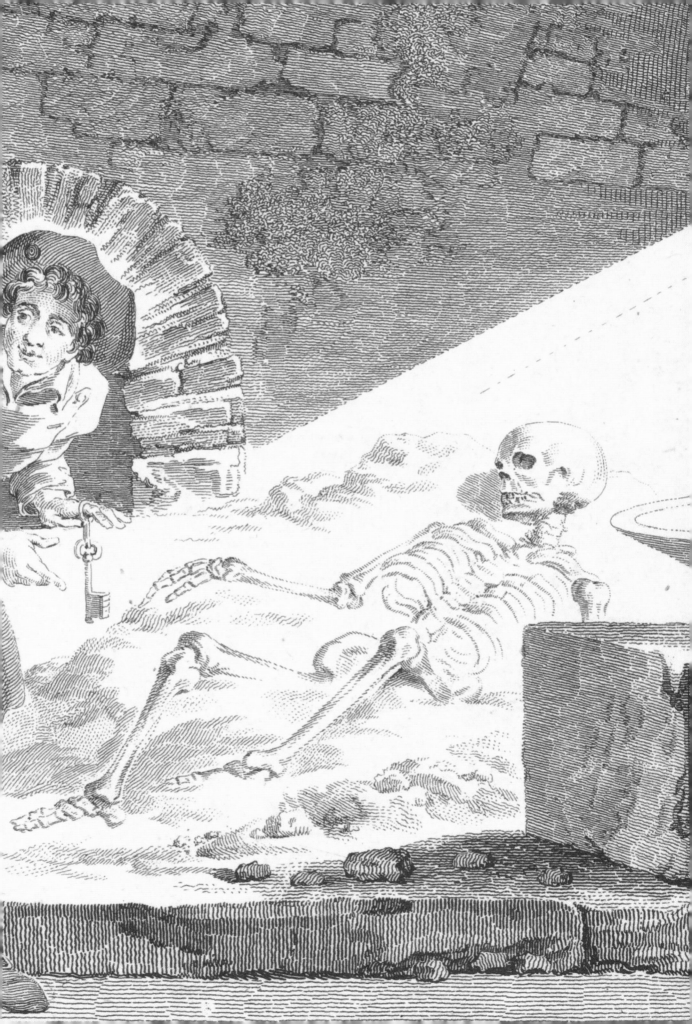

The ancient past loomed over the Enlightenment. While Greco-Roman art and history had long been held up as ideals to aspire to, for some eighteenth-century thinkers, this primacy was challenged, if not surpassed, by modern scientific and artistic advances. For others, the moral and aesthetic models of Greece and Rome took on renewed significance, becoming the primary means to navigate the social and technological transformations of modern life and to counter its perceived ills.

The presence of the ancient past in eighteenth-century debates was magnified by increasing access to its material remains. For elite European men embarking on continental tours and the women who sometimes accompanied them, visiting ancient sites and viewing excavated antiquities were essential activities. Such firsthand encounters with monuments and objects also inspired antiquarians and ambitious artists. Some pushed farther than Italy, the destination of choice for Grand Tourists and artists alike, to the perceived edges of Europe and into the Ottoman Empire, and deepened the knowledge of Greek and Roman art and architecture back home by publishing their findings. At the same time, conquest, missionary activity, and trade increased exposure to the art and architecture of other parts of the globe; the publications that resulted expanded contemporary European geographical and historical consciousness to include the antiquities of Egypt, China, and India.

These alternate material histories challenged eighteenth-century constructions of the Greco-Roman past, which more often than not was the standard against which unfamiliar cultural productions and the peoples who produced them were judge ●.[1] Europeans also shifted their attention toward local, non-classical material cultures, likewise described as antiquities, such as Druidic monuments in Britain and Islamic art in Spain.

VENUS

The often lavishly illustrated accounts of antiquities published in the eighteenth century indelibly shaped understandings of distant pasts, for they not only documented ancient material remains but interpreted them. Some thinkers subtly registered the temporal distance between the ancient world and the present, a tension between imitability and historicity articulated most eloquently by German antiquarian Johann Joachim Winckelmann.[2] Winckelmann famously equated the "noble simplicity and quiet greatness" of Greek art (which he did much to distinguish from and elevate above Roman art) with political freedom, advising his readers that "the only way for us to become great, and, if indeed it is possible, inimitable, is through the imitation of the ancients . . . especially of the Greeks."[3] In so doing, he also reinforced an aesthetics of form, a Greek ideal, with profound implications for emergent constructs of race.[4] Yet Winckelmann also recognized the historical gulf between past and present. Greek antiquity was, in his evocative analogy, like the shadowy outline of a lover on a departing ship grasped after by his beloved on shore. It was a past forever receding from view.[5]

A compelling example of an artist's study of antiquities is the sketchbook by Englishman John Flaxman now in the Yale Center for British Art.[6] Flaxman was already an established sculptor when he and his wife Ann ("Nancy") arrived in Rome, where they stayed from 1787 to 1794. The couple's voyage was both a Grand Tour and an opportunity for Flaxman to expand his study of ancient art and to attract commissions from other foreign visitors. Beginning in 1775, a dozen years before his arrival

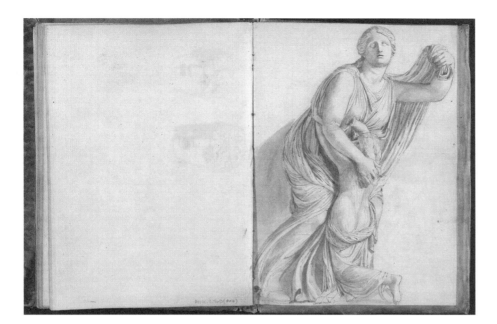

Fig. 1
John Flaxman (1755–1826), *Niobe and Her Youngest Daughter*, from *Italian Sketchbook*, 1787. Graphite, pen and black ink, and gray wash in bound sketchbook, sheet: 21.9 × 15.2 cm; spine: 22.9 cm. Yale Center for British Art, New Haven, Conn., Paul Mellon Collection, B1975.3.468.

in Italy, Flaxman had supplied classicizing designs to Josiah Wedgwood for ceramic wares that emulated Greek and Roman forms. These highly successful objects catered to the taste for Greco-Roman antiquities in late eighteenth-century England and simultaneously demonstrated English technological innovation in the field of ceramics. Though he had access to small antiquities in the British Museum, Flaxman's designs for Wedgwood were largely inspired by his studies of printed images of antiquities, notably of the Greek vases amassed by the British ambassador to Naples, Sir William Hamilton, and published in a spectacular four-volume edition of hand-colored engravings from 1767 to 1776.[7]

Misled by printed representations, Flaxman was initially disappointed by Rome and its ancient monuments, which seemed small in comparison to the grandeur Giovanni Battista Piranesi's engravings of the city's ruins had primed him to expect (see p. 103).[8] One of six extant journals and sketchbooks Flaxman filled in Italy, the Yale sketchbook records the reality of his firsthand experience of ancient and Renaissance works of art in Florence and Rome. Flaxman drew mainly on the rectos of the eighty-one folios in the parchment-bound volume and worked with the book upside down, so that the flap attached to the intended front cover could be used to hold down the previous pages as he drew. Some of the sheets are light graphite sketches. Others demonstrate Flaxman's awareness of the parts of ancient sculptures that had been restored; he frequently omitted them from his drawings, preferring instead to focus on the original remains.[9] Still others, such as his drawing of the famous sculpture *Niobe and Her Youngest Daughter*, presumed at the time to be Greek, are fully worked-up studies rendered in graphite, pen and ink, and wash, a treatment that accords both with the sculpture's significance and its importance in Flaxman's own oeuvre (Fig. 1). The Niobe was the model for the distraught mother in Flaxman's *Fury of Athamas* (1790–94), a life-size marble group commissioned from him in Rome by Frederick Augustus Hervey, 4th Earl of Bristol, for his house at

Kristel Smentek

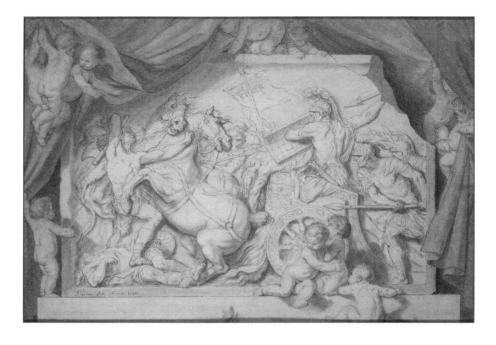

Ickworth in Suffolk, England.[10] Flaxman's reference to the Niobe was thematically apt; both the ancient sculpture and the artist's modern one foreground the anguish of mothers faced with the murder of their children. It was also an aesthetic claim. *Niobe and Her Youngest Daughter* had been celebrated for its beauty and expressive restraint since its discovery with several other related sculptures in Rome in 1583.[11] Winckelmann, for example, had singled out the Niobe as exemplifying the high style in Greek art, a style he described as austere and pure and in which, as in the case of the Niobe, extreme suffering was sublimated into ideal form. For Flaxman, who, like Winckelmann, did not focus on the violence of the Niobe story, the figures were of the "sublimest character and expression," "noble," and without "affectation of style."[12]

Flaxman sought direct contact with antiquity in Italy, but his experiences there were also mediated by copies. The sculptor encountered the Niobe when he visited Florence in 1787, where it was on display in the Uffizi. Intriguingly, however, his study of the mother and daughter is situated among his Roman drawings in the sketchbook. This placement suggests that he copied a plaster cast of the figure in Rome, as do the drawing's strong tonal contrasts, which, as Eckart Marchand has pointed out, are typical of a study after a plaster.[13] The sharp edges and profiles of plasters, much like the linearity of the prints of antiquities Flaxman studied, contributed to the austere outline drawings he would produce to illustrate classical texts by Homer and Aeschylus.[14] These spare images, rendered in contour only, would establish Flaxman's pan-European reputation.

The continuing relevance of Greco-Roman antiquity and a simultaneously more playful relationship to it are evident in Augustin Pajou's large, finished drawing representing Diomedes assailed by the Trojans (Fig. 2). Executed in a striking combination of black ink, black chalk, and gray and red wash and approaching the dimensions of a painting in scale, the imposing sheet was one of two exhibited by

the artist in his first Salon exhibition in 1759 👁. He signed it prominently at bottom PUBLIC
left: *Pajou fecit Romae 1756* (Made by Pajou in Rome, 1756). Both the signature and the
content of the drawing highlighted the artist's recent sojourn at the French Academy
in Rome (1752–56). Like Flaxman, Pajou was a sculptor, but he traveled to Rome at a
much younger age to complete his state-sponsored artistic training by copying
approved ancient and modern works.[15] In 1759, three years after his return to Paris,
Pajou was formally accepted into the French Royal Academy of Painting and
Sculpture as a member (rather than as a student) and was at the beginning of his
highly successful career (see p. 163).

Pajou's drawing fuses ancient and modern artistic models: he cleverly inte-
grated a battle scene on a fictional antique bas-relief rendered in pen and ink with a
theatrical curtain and scrambling putti in red chalk and wash. The Diomedes com-
position also contrasted with the more severe and monochromatic drawing Pajou
exhibited it with in 1759, *Pyrrhus in the House of Glaucias*.[16] In the latter, Pajou depicted
an episode from Plutarch's *Lives*, a series of biographies of famous men probably dating
from the early second century CE. Diomedes was a hero of the *Iliad*, but the scene
shown here—in which he is portrayed fighting, with the dead body of his equerry
slumped on the chariot beside him—is nowhere to be found in Homer's epic poem.
What is more, Diomedes, a Greek king, battles under a standard with the letters of
the Roman republic, SPQR—an inclusion suggestive of the studies of Roman antiqui-
ties on which Pajou based the details of the bas-relief.[17] Meanwhile, the putti and the
drapery they energetically push back to reveal the timeworn sculpture recall paintings
and decorative ensembles by sixteenth- and seventeenth-century Italian artists. As the
battle rages on, the putti inject a note of humor: while some, like the standing putto at
lower left, admire the antique carving, others irreverently climb on it, and one, to the
right of center at bottom, shrinks away from a salamander that climbs onto the base of
the relief. Like the living putti, the creature casts a shadow as it moves.

Pajou's decision to exhibit drawings in the Salon is indicative of the era's new
appreciation of drawings as autonomous works in their own right, rather than simply
as working tools, and as a medium that offered artists greater freedom of invention
than painting or sculpture 👁. Here, Pajou's staging of the imagined Diomedes relief DRAWING, IMAGINATION
signals an investment in the heroic virtue and the moral and aesthetic exemplarity of
Greco-Roman antiquity, qualities echoed in the severity of the drawing he exhibited
along with it. At the same time, the Diomedes drawing may also register the tempo-
ral distance between the Greek and Roman past and Pajou's mid-eighteenth-century
present.[18] In contrast to the lively putti, the swirling drapery, and the advancing
salamander, the conspicuously damaged relief appears frozen in time.

Attachments to the Greco-Roman past were intensified by the systematic
excavations of the Roman cities of Herculaneum and Pompeii on the bay of Naples,
which began in 1738 and 1748, respectively. Discoveries at these sites, which had been
buried in 79 CE by the eruption of Mount Vesuvius 👁, revealed not only individual LAVA
sculptures and coins but also domestic interiors and objects of daily life in antiquity.
The open-air site of Pompeii (identified as such by an inscription discovered in 1761)
in particular became an obligatory destination for artists and Grand Tourists.[19] These
included French painter Jean-Honoré Fragonard and his patron Pierre-Jacques-

Kristel Smentek

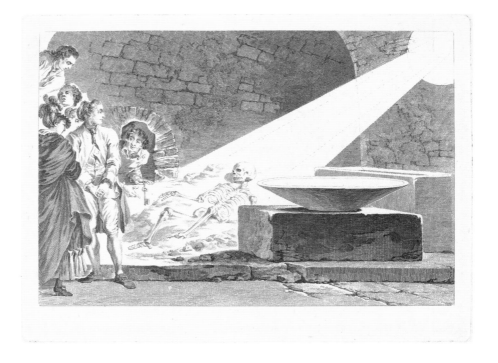

Onésyme Bergeret de Grancourt, who visited Pompeii with their companions, Jeanne
Vignier and miniature painter Marie-Anne Fragonard, in May 1774. In a drawing
subsequently engraved for publication by Claude-Mathieu Fessard, Fragonard
recorded a particularly emotive moment during the group's visit: the sighting of a
human skeleton in the basement of a Pompeiian residence, now named the House of
Joseph II after the Holy Roman Emperor who visited it in 1768 (Fig. 3).[20] In the
etched proof impression of the print seen here, the discovery is dramatized by the
shaft of bright light entering the subterranean chamber, by the guide, key in hand,
who gestures toward the human remains, and by the stunned expressions of the
visitors brought face to face with the human cost of the natural disaster. Bergeret
described the episode in his travel journal, concluding his account by noting that the
encounter left his party "in stupefaction at the realization that this happened 1700
years ago."[21] At the same time, the theatricality of the guide in the print is suggestive
of the ways in which "discoveries" were orchestrated for visitors to the site. Joseph II,
for example, suspected that parts of his visit had been staged specifically for him.[22]

Fessard's print after Fragonard's drawing was published in the first volume of
the Abbé de Saint-Non's four-volume illustrated work *Voyage pittoresque, ou descrip-
tion des royaumes de Naples et de Sicile* (Picturesque Journey; or, Description of the
Kingdoms of Naples and Sicily; 1781–86), without the protagonists identified.[23] Like
other publications in the genre of the *Voyage pittoresque*, Saint-Non's book included
maps, landscapes views, and more precise renderings (and occasional reconstruc-
tions) of monuments and artifacts accompanied by extensive explanatory texts (see
p. 136). Fessard's print is somewhat unusual in the context of Saint-Non's publication,
as it highlights the human drama of Vesuvius's catastrophic eruption. The image
simultaneously established the iconography for further representations of Pompeii

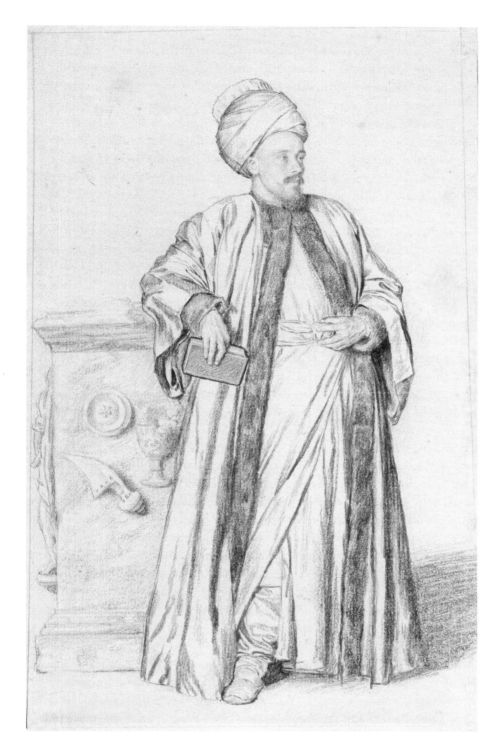

Fig. 4
Jean-Étienne Liotard (1702–1789), *Portrait de l'archéologue et théologien Richard Pococke* (Portrait of Archaeologist and Theologian Richard Pococke), 1740. Red and black chalk, 21 × 13 cm. Musée du Louvre, Paris, Département des Arts graphiques, RF 1379.

and influenced the staging of subsequent visits, including into our own day, where plaster cast bodies of the dead, first produced in the 1860s, are a sobering feature of the site.[24]

Kristel Smentek

Other eighteenth-century artists and travelers ventured further afield in their quest to experience and to study the material remains of the ancient world firsthand. Geneva-born artist Jean-Étienne Liotard recorded one such traveler, Anglo-Irish antiquarian and cleric Richard Pococke, in a remarkable drawing made in 1740, when the two men met in Constantinople (present-day Istanbul) (Fig. 4). The portrait shows Pococke near the end of his highly unusual Grand Tour, dressed in the clothing he wore while traveling in Ottoman lands in search of antiquities and to visit biblical sites in Egypt, the Holy Land, Lebanon, Syria, the Greek Islands, Turkey, mainland Greece, and Cyprus 👁. In Liotard's study, which was preparatory for a full-length painting now in the Musée d'art et d'histoire in Geneva, Pococke leans on what appears to be a Roman pedestal ornamented with the instruments of sacrifice: a knife, paten, and bowl. A bas-relief is just visible on its lateral side.[25] In his hands, Pococke holds a leather-bound book or possibly a notebook, which may allude to drawings he made of the antiquities he saw and subsequently published in a two-volume illustrated account titled *A Description of the East and Some Other Countries* (1743–45).[26] Liberally illustrated with images of artifacts, architectural drawings, maps, and plans and subsequently translated into German, French, and Dutch, Pococke's book was especially praised for its detailed accounts of Egyptian antiquities and its accurate line drawings of ancient monuments in Athens, which was then in Ottoman hands and largely inaccessible to Europeans.[27]

Pococke's *A Description of the East* anticipated numerous subsequent illustrated publications of antiquities and ancient monuments. In 1782, peripatetic French painter and draftsman Louis-François Cassas traveled to the Istrian and Dalmatian coasts on the Adriatic Sea to record ancient monuments in the former Roman province of Dalmatia. Considered by many in the eighteenth century to be on the eastern frontier of civilized Europe, the Istrian and Dalmatian coasts were not standard Grand Tour destinations. Cassas's many drawings of the area's late Roman remains, including his superbly evocative depiction on blue paper of two temples and a palace in Spalato (modern-day Split, Croatia), were initially commissioned by Austrian authorities in Trieste to publicize Roman monuments in their territories (Fig. 5). The drawings were not published, however, until nearly twenty years later, when they were engraved under the direction of François Denis Née for publication in Joseph Lavallée's *Voyage pittoresque et historique de l'Istrie et Dalmatie, rédigé d'après l'itinéraire de L.F. Cassas* (Picturesque and Historic Journey to Istria and Dalmatia, Based on the Itinerary of L.F. Cassas), issued in 1802.[28]

Notable for its high-quality plates, including many multiple-plate foldout views, the book also highlights the ethnographic dimensions of such antiquarian projects as well as the national rivalries and imperial claims that sometimes undergirded them.[29] The sites Cassas recorded were in Austrian or Venetian hands when he visited them. By 1802, however, the French had defeated the Venetians and ceded its Istrian and Dalmatian territories to Austria. In the book's text, France and Austria are positioned as the civilized caretakers of the antiquities depicted in its plates. France's perennial enemy, England, is vilified in the form of an attack on English architect Robert Adam, who had traveled to Spalato well before Cassas, and on Adam's publication of drawings of the city's Roman ruins in 1757. Meanwhile, the

Fig. 5
Louis-François Cassas (1756–1827),
*Two Temples and a Palace in Spalato,
Dalmatia*. Black ink with brush and
gray wash, heightened with white
gouache, 28.5 × 40.1 cm. The Horvitz
Collection, Wilmington, Del.,
D-F-541.

figures in eastern dress that people Cassas's drawings are linked to previous Ottoman
and Venetian empires in the region. Mobilizing orientalist tropes of lassitude and
barbarity, the figures are presented as evidence of indifference to the monuments and
as the cause of their current ruinous state.[30] Accordingly, the description of the print
after the drawing shown here emphasizes the partial demolition of one of the temples
by locals to build an official's palace.[31]

 National interests also motivated the publication of *Antigüedades árabes de
España* (Arab Antiquities of Spain), first published in 1787 by the Royal Academy of
Fine Arts of San Fernando in Madrid. A more complete edition followed in 1801.[32]
The publication's large engravings were based on images commissioned by the acad-
emy in 1762 from Diego Sánchez Sarabia, an artist active in Granada. His brief was to
document the architecture and decoration of the Alhambra, the hilltop palace of the
Nasrids of Granada (r. 1232–1492)—then, as now, the most recognizable monument
of Al-Andalus, or Muslim Iberia. The book also included prints by Tomás Francisco
Prieto after Sarabia's watercolors of two impressively large, tin-glazed earthenware
vessels, one being the so-called Gazelle Vase, produced in the mid-fourteenth century
for use at the Nasrid court.[33] Sarabia's representation and Prieto's print after it both
show the vase in a more ideal state of preservation than it was actually in (Fig. 6).[34]
The initial project was explicitly undertaken by the academy "to preserve and make
known our antiquities and monuments and particularly those most in danger of
disappearing with the passage of time"; the subsequent decision to engrave Sarabia's
images was motivated by the renown they would bring "to the Academy and to the
nation."[35] Before ascending to the Spanish throne in 1759, Charles III had been king
of Naples. There, he had severely restricted access to the excavations and findings
at Herculaneum and Pompeii and tightly controlled their publication. As Andrew

Kristel Smentek

Schulz has argued, he was well aware of how powerfully the material culture of antiquity could lend prestige in the present. In *Antigüedades árabes*, the Catholic kingdom not only publicly positioned itself as an enlightened, responsible steward of its cultural heritage, it reconceived that heritage to include Islamic monuments—now recast as antiquities found within the borders of Spain—circulating them in impressive, folio-sized prints and pressing them into the service of an emergent, territorially defined national cultural narrative.[36]

1. On these themes, see the essays in Charlotte Guichard and Stéphane van Damme, eds., *Les Antiquités dépaysées: Histoire globale de la culture antiquaire au siècle des Lumières* (Liverpool: Liverpool University Press, 2022).

2. Alex Potts, *Flesh and the Ideal: Winckelmann and the Origins of Art History* (New Haven, Conn.: Yale University Press, 1994), 23–27.

3. Johann Joachim Winckelmann, "Thoughts on the Imitation of Greek Works in Painting and the Art of Sculpture (1755–56)," in *Winckelmann on Art, Architecture, and Archaeology*, trans. with an introduction and notes by David Carter (Woodbridge, U.K.: Boydell & Brewer, 2013), 32, 42.

4. Eric Michaud, "Was die moderne Anthropologie und Ethnologie von Winckelmann lernten. Eine kritische Sichtung," in *Winckelmann: Moderne Antike*, by Elisabeth Décultot et al. (Munich: Hirmer, 2017), 115–25; and David Bindman, *Ape to Apollo: Aesthetics and the Idea of Race in the 18th Century* (Ithaca, N.Y.: Cornell University Press, 2002).

5. Johann Joachim Winckelmann, *History of the Art of Antiquity*, trans. Harry Francis Mallgrave (Los Angeles: Getty Research Institute, 2006), 351.

6. The sketchbook is digitized at https://collections.britishart.yale.edu/catalog/tms:53744.

7. Pierre-François d'Hancarville, *Collection of Etruscan, Greek and Roman Antiquities from the Cabinet of the Honorable William Hamilton*, 4 vols. (Naples: 1766–67). The publication was actually completed and issued between 1767 and 1776. Flaxman had also studied plaster casts of antiquities and the Greek vases sold by Hamilton to the British Museum in 1772.

8. Kenneth Garlick and Angus Macintyre, eds., *The Diary of Joseph Farington*, vol. 2 (New Haven, Conn.: Yale University Press, 1978), 444; and David Irwin, *John Flaxman, 1755–1826: Sculptor, Illustrator, Designer* (New York: Rizzoli, 1979), 44.

9. For a thorough analysis of the Yale sketchbook and its contents, see Eckart Marchand, "Flaxman: The Yale Sketchbook," in *John Flaxman and William Young Ottley in Italy*, Walpole Society 72, by Hugh Brigstocke, Eckart Marchand, and A. E. Wright (Leeds: Walpole Society, 2010), 119–58.

10. Irwin, *John Flaxman, 1755–1826*, 43, 57.

11. On the Niobe group, see Francis Haskell and Nicholas Penny, *Taste and the Antique: The Lure of Classical Sculpture, 1500–1800* (New Haven, Conn.: Yale University Press, 1981), 274–79.

12. Hugh Brigstocke, "Flaxman: The Fitzwilliam Journal," in Brigstocke, Marchand, and Wright, *John Flaxman and William Young Ottley in Italy*, 92.

13. Marchand, "Flaxman: The Yale Sketchbook," 124–25, 148; and Eckart Marchand, "Artist and Grand Tourist: John Flaxman's Italian Journals and Sketchbooks," in *Antiquity Multiplied: Rome as a European Sculpture Workshop (1770–1820)*, ed. Tomas Macsotay (New York: Routledge, 2017), 179–95.

14. Deanna Petherbridge, "Constructing the Language of Line," in *John Flaxman, 1755–1826: Master of the Purest Line*, ed. David Bindman (London: Sir John Soane's Museum, 2003), 7–13.

15. Like other young artists in the city, Pajou inscribed his name on at least one of the ancient monuments he visited. See Charlotte Guichard, *Graffitis: Inscrire son nom à Rome XVIe–XIXe siècle* (Paris: Seuil, 2014), 59, 102, color pl. 9.

16. The drawing is now in the Metropolitan Museum of Art (2014.439). My thanks to Delanie Linden for her research assistance.

17. Guillaume Faroult, Christophe Leribault, and Guilhem Scherf, eds., *L'antiquité rêvée: Innovations et résistances au XVIIIe siècle* (Paris: Gallimard and Musée du Louvre, 2010), cat. 17; James David Draper and Guilhem Scherf, *Augustin Pajou: Royal Sculptor, 1730–1809* (New York: Metropolitan Museum of Art, 1997), cat. 23; and James David Draper and Guilhem Scherf, "Augustin Pajou, dessinateur en Italie, 1752–1756," *Archives de l'Art français* 33 (1997): 32.

18. On these tensions between past and present, see Larry F. Norman, *The Shock of the Ancient: Literature and History in Early Modern France* (Chicago: University of Chicago Press, 2011); and Dan Edelstein, *The Enlightenment: A Genealogy* (Chicago: University of Chicago Press, 2010).

19. Eugene Dwyer, "Pompeii versus Herculaneum," in *Rediscovering the Ancient World on the Bay of Naples, 1710-1890*, ed. Carol C. Mattusch (Washington, D.C.: National Gallery of Art, 2013), 245-63.

20. Fragonard's drawing, in the same orientation as Fessard's print, is in the Musée des Tissus et des Arts Décoratifs, Lyon (429). See Pierre Rosenberg, *Fragonard* (New York: Metropolitan Museum of Art, 1988), cat. 189.

21. A. Tornézy, ed., *Bergeret et Fragonard: Journal inédit d'un voyage en Italie (1773-1774)* (Paris: May et Motteroz, 1895), 315, entry for May 6, 1774.

22. Dwyer, "Pompeii versus Herculaneum," 253-56.

23. Jean Claude Richard, Abbé de Saint-Non, *Voyage pittoresque, ou description des royaumes de Naples et de Sicile*, vol. 1 (Paris: 1781), facing p. 88. The full publication is digitized at https://digi.ub.uni-heidelberg.de/diglit/saintnon1781ga.

24. Dwyer, "Pompeii versus Herculaneum," 256-57, Fig. 8.

25. Anne de Herdt, *Dessins de Liotard suivi du catalogue de l'œuvre dessiné* (Paris: Réunion des musées nationaux; Geneva: Musée d'art et d'histoire, 1992), 76, cat. 33; and Marcel Roethlisberger and Renée Loche, *Liotard: Catalogue, sources et correspondence*, vol. 1 (Doornspijk: Davaco, 2008), 280-83.

26. Rachel Finnegan, *English Explorers in the East (1738-1745): The Travels of Thomas Shaw, Charles Perry and Richard Pococke* (Leiden: Brill, 2019), 81.

27. Ibid., 293-94.

28. For the history of the original commission, see Barbara Nassivera, "Louis-François Cassas: Il *Voyage pittoresque et historique de l'Istrie et de la Dalmatie*," *Atti et memorie della Società istriana di archeologia e storia patria* 47 (1999): 169-206. See also Uwe Westfehling, "Voyage en Istrie et en Dalmatie/Reise nach Istrien und Dalamtien," in *Louis-François Cassas, 1756-1827: Dessinateur—Voyageur im Banne der Sphinx*, ed. Annie Gilet and Uwe Westfehling (Mainz am Rhein: Philipp von Zabern, 1994), 66-83. The full publication is digitized at https://digi.ub.uni-heidelberg.de/diglit/lavallee1802.

29. David McCallam, "(Ac)claiming Illyria: Eighteenth-Century Istria and Dalmatia in Fortis, Cassas, and Lavallée," *Central Europe* 9 (2) (November 2011): 134-35.

30. Ibid.; Renzo Dubbini, *Geography of the Gaze: Urban and Rural Vision in Early Modern Europe*, trans. Lydia G. Cochrane (Chicago: University of Chicago Press, 2002), 102–6; and Erika Naginski, "The Imprimatur of Decadence: Robert Adam and the Imperial Palatine Tradition," in *Dalmatia and the Mediterranean: Portable Archaeology and the Poetics of Influence*, ed. Alina Payne (Leiden: Brill, 2014), 105–6.

31. Joseph Lavallée, *Voyage pittoresque et historique de l'Istrie et Dalmatie, rédigé d'après l'itinéraire de L.F. Cassas* (Paris: 1802), 163, description of plate 27: "Vue des deux temples et du palais du Podestat."

32. On the complex publication history of the *Antigüedades árabes*, see Delfín Rodríguez Ruiz, *La memoria frágil: José de Hermosilla y las Antigüedades árabes de España* (Madrid: Fundación Cultural COAM, 1992).

33. All of Sarabia's extant images are reproduced in Antonio Almagro Gorbea, ed., *El legado de al'Ándalus: Las antigüedades árabes en los dibujos de la Academia* (Madrid: Real Academia de Belles Arts and Fundación MAPFRE, 2015). See cat. 42 for his watercolor of the Gazelle Vase.

34. Andrew Schulz, "'The Porcelain of the Moors': The Alhambra Vases in Enlightenment Spain," *Hispanic Research Journal* 9 (5) (December 2008): 399, 410; and Delfín Rodríguez, "La fortuna e infortunios de los jarrones de la Alhambra en el siglo XVIII," in *Los jarrones de la Alhambra: Simología y poder*, by María del Mar Villafranca Jiménez et al. (Granada: Patronato de la Alhambra y Generalife, 2006), 97–122. On the Gazelle Vase, which is an impressive 134 centimeters tall and is now in the Museo de la Alhambra in Granada, see cat. 1 in the latter publication.

35. Schulz, "The Porcelain of the Moors," 411.

36. Ibid., 410–11; and Razan Francis, "Secrets of the Arts: Enlightenment Spain's Contested Islamic Craft Heritage," Ph.D. dissertation, MIT, 2014. I am grateful to Francis for sharing her research on the *Antigüedades árabes* with me.

Kristel Smentek

Benigno Bossi
after Ennemond Alexandre Petitot
Young Monk in a Grecian Costume

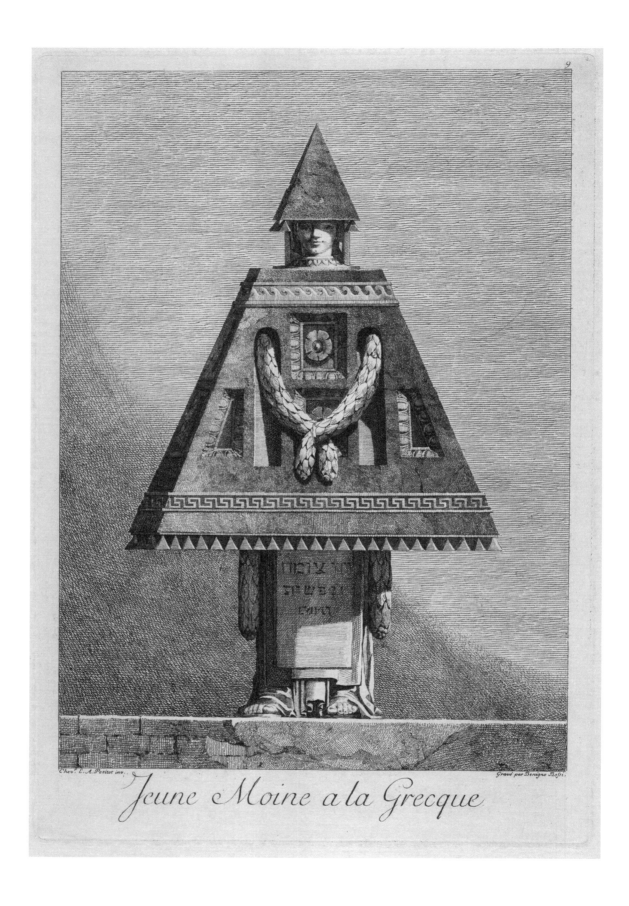

Jeune Moine a la Grecque

Jeune Moine à la Grecque (Young Monk in a Grecian Costume) is the penultimate print in *Mascarade à la Grecque* (Greek Masquerade)—an imaginative and witty series reflecting on the contemporary obsession with the *goût à la grecque* (Greek taste). The figure is monumental and refined, yet also comically misshapen. His upper body and head compose a pyramid, a fundamental form in ancient Egyptian architecture, which Ennemond Alexandre Petitot likely chose because it visually echoed the shape of the monk's habit.

Although pyramids were admired for their stereometric purity, Petitot transformed the shape into a decorative form by adding recesses, embellished with a rosette and egg-and-dart moldings, and running ornaments, such as a Greek meander and a wave scroll. Morphing architectural and human forms, the artist subverted the Vitruvian principle that architecture follows human proportion, instead contorting the human body to fit an architectural frame. Etched by Benigno Bossi, the print's surface vibrates and shimmers, with lines ranging from short, stipple-like marks that describe the texture of stone to delicate horizontal strokes of varying thickness, which create a rippling effect in the background.

Mysterious letters are gouged into the figure under the pyramid shape, the only instance of such an inscription in the series. Although the writing has been interpreted as pseudo-Hebrew or even pseudo-hieroglyphic, at least one word—צומח (vegetation)—is fully legible, suggesting that Petitot copied the Hebrew from an as yet unidentified source.[1]

Benigno Bossi (1727–1792), after Ennemond Alexandre Petitot (1727–1801), *Jeune Moine à la Grecque* (Young Monk in a Grecian Costume), Plate 9 from the series *Mascarade à la Grecque* (Greek Masquerade), 1771. Etching, plate: 27 × 18.8 cm. Harvard Art Museums/ Fogg Museum, Acquisition Fund for Prints, 2017.180.

1. My thanks to Avishai Bar-Asher, Hillel Ben Sasson, and Tamar Mayer for help deciphering the inscription.

Austėja Mackelaitė

BELIEVE

Kristel Smentek

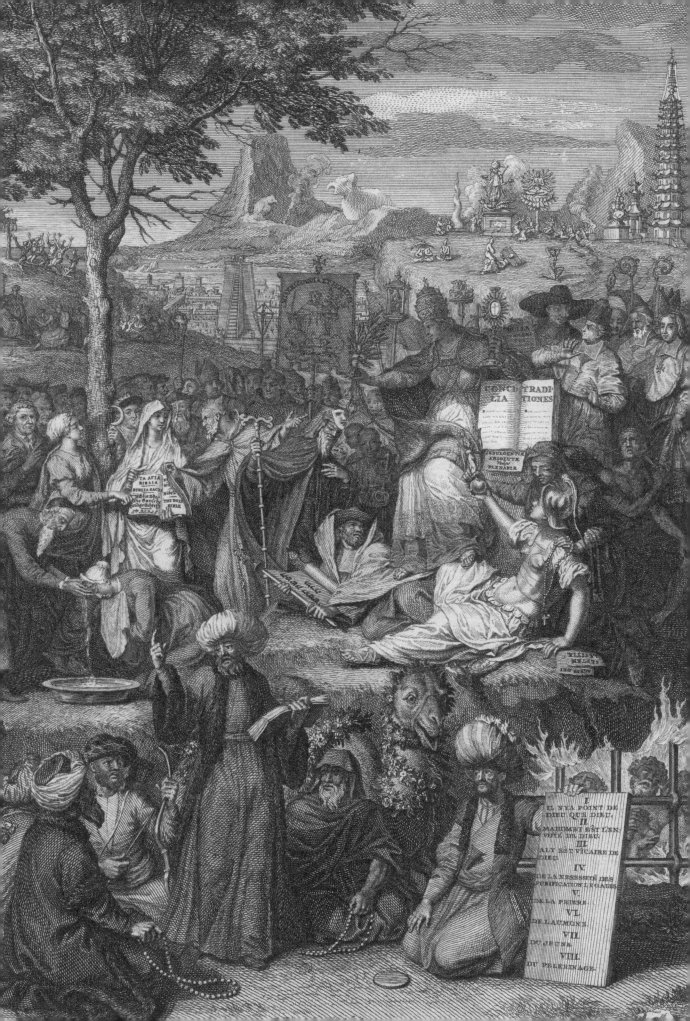

The Enlightenment has historically been interpreted as a philosophical movement hostile to religion. Such a view was essential to the scholarly positioning of the era as the origin of secular modernity. But just as the presumed equivalence of "modern" and "secular" has come under pressure, so too has the Enlightenment's supposed marginalization of religious belief. Recent studies of the period make evident the degree to which faith continued to structure daily life and thought for all but a few committed atheists. When the Enlightenment is understood, as it increasingly is, as a set of institutions and practices through which new ideas were created and propagated, the convergences between Enlightenment ideals and new religious cultures come into view.[1]

ZEALOTRY

As colonists and missionaries shared news of their travels, philosophers and theologians alike had to contend with the influx of information about the various belief systems to be found throughout the world; at the same time, the ferocity and zealotry of the previous century's wars of religion haunted all Europeans ⊙. Both were important factors in stimulating Enlightenment interest in the history of religion, the emergence of comparative religion as a field of inquiry, and the acceptance of doctrinal difference.[2] Images were critical to these enterprises. Religious institutions and reformers mobilized prints published in a variety of formats to bolster faith, publicize new initiatives, and promote a more tolerant understanding of belief, in which confessional variety was accepted and religious dogmatism (ideally) overcome.

The most celebrated eighteenth-century illustrated publication on the topic of religion was Bernard Picart and Jean Frederic Bernard's seven-volume *Cérémonies et coutumes religieuses de tous les peuples du monde* (Religious Ceremonies and Customs of All the Peoples of the World), first published in French in Amsterdam from 1723 to 1737 and widely translated, reprinted, and adapted thereafter.[3] The spectacular success of the publication was largely due to its images, the majority of which were designed and executed by Picart, to whom the publication was officially credited. Some 600 illustrations, distributed over more than 250 plates, made visible the plurality of the world's belief systems with an immediacy that the work's hundreds of pages of text could not. The plates also allowed for the visual comparison of those systems. Picart and Bernard set aside the standard division between Christians and infidels and instead placed on equal footing the rituals (such as marriage and funerary practices) of contemporary Judaism, Catholicism, Greek Orthodoxy, Protestantism, and Islam and of peoples in the Americas, India, Asia, and Africa.

The sweeping ambition of the book is announced in Picart's frontispiece, *Tableau of the Principal Religions of the World* (Fig. 1), which he designed in 1727 after the first edition was printed. In the foreground, 'Ali, the cousin and son-in-law of the Prophet Muhammad, discusses the precepts of Islam with his followers. Judaism and various Christian denominations are represented in the middle ground, and seen in the distance are the temples and gods of the "idolatrous" peoples of the Americas and Asia. Though they are hierarchically ordered, all of the world's religions then known by Europeans to exist are represented.

The frontispiece, like the book itself, is not devoid of polemics. Picart had converted from Catholicism to Protestantism, and Bernard was a Protestant refugee from France who settled in Amsterdam after Louis XIV revoked in 1685 the

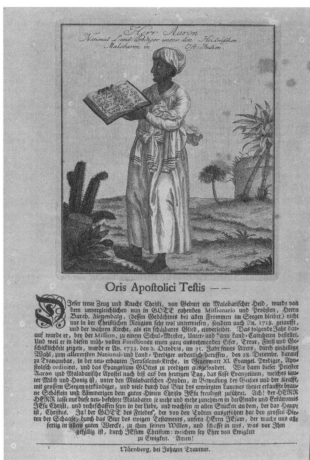

limited rights previously granted to Protestants in the kingdom. The print encapsulates the pair's anti-Catholicism: while the Protestant reformers at left are, despite their differences, peaceably grouped around the woman in white holding a Bible, at right an allegory of the Roman Catholic church—accompanied by a personification of superstition and belligerent members of various Catholic orders—tramples the Jewish rabbi at her feet. And yet, in the frontispiece as in the book, Protestantism and Catholicism are just two among the many religions of the world. In this sense, Picart and Bernard's volumes exemplify one of the most significant legacies of the Enlightenment: the discovery of religions, in the plural, and the understanding of religious rituals as social or cultural phenomena common to all humans.

Recognizing the beliefs of others did not, however, preclude the ambition to convert those of other faiths to one's own. Adherents of such powerful new religious movements as Pietism, a Lutheran reform movement, and Methodism, an Anglican reform movement, deployed printed images, such as the German broadside representing the Indian pastor Aaron (born Arumugam Pillai), to publicize their sects and to solicit financial support for missionary work (Fig. 2). Broadsides combined printed images and letterpress text and were frequently created in response to current events. This portrait of Aaron, executed by Johann Sebastian Müller around 1741–44 and

Fig. 1
Bernard Picart (1673–1733), *Tableau of the Principal Religions of the World*, frontispiece to *Cérémonies et coutumes religieuses de tous les peuples du monde* (Religious Ceremonies and Customs of All the Peoples of the World), vol. 1 (Amsterdam: 1739). Bound book, spine: 41 cm. Widener Library, Judaica Collection, Harvard University. (Detail on p. 29.)

Fig. 2
Johann Sebastian Müller (1715–c. 1792), *Herr Aaron* (Pastor Aaron), c. 1741–44. Etching with watercolor and letterpress, 27.9 × 21.6 cm. Fine Arts Library, Harvard University, Edwin Binney 3rd Collection of Orientalist Prints circa 15th–19th century, Special Collections, AKP287.246.

Kristel Smentek

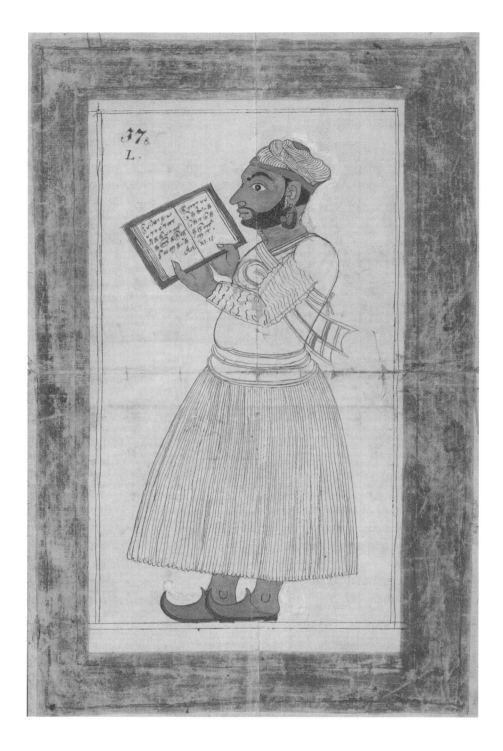

published by Johann Trautner in Nuremberg, was one of a number of prints that told
of the unprecedented ordination of an Indigenous Protestant pastor in 1733 at the
Pietist mission in Tranquebar (now Tharangambadi), a Danish-controlled trading
post on the Bay of Bengal.[4] In this engraving, interest in the peoples of the globe
merges with the conviction of the rightness of one's own faith.

Founded by order of Danish king Frederik IV, the Tranquebar mission was established in 1706 by Bartholomäus Ziegenbalg and Heinrich Plütschau, German pastors from the Pietist center of Halle. When news of Aaron's ordination reached the German city, a request for a true likeness of this most unusual of clergymen was sent to the mission in India. Aaron was Tamil, and unlike the other Tranquebar missionaries, who retained their dark European robes, he wore lightly colored dress. Almost all of the images of Aaron published in Europe—Müller's broadsheet included—were ultimately based on a painting on paper by an unidentified Indian artist that arrived in Halle in 1736 (Fig. 3). However, Müller's composition was modeled after an engraving that was in turn based on a modified drawing of the Indian portrait that conformed to European artistic standards. Pastor Conrad Daniel Kleinknecht commissioned the engraving from Augsburg printmaker Jacob Andreas Fridrich the Younger, who finished the work in 1741 or 1742. Kleinknecht then added a letterpress biography of and a poem about Aaron. Kleinknecht circulated the broadside with hopes of soliciting financial support for the young mission, a goal whose success far exceeded expectations.[5]

Indeed, Kleinknecht's print inspired Trautner to commission a version from Müller—proof that the Augsburg broadside stimulated widespread interest in Aaron and the Tranquebar mission. The Nuremberg print copies the format, title caption, and in this impression, hand-coloring of Kleinknecht's version. Müller amplified the exotic appeal of the initial image, however, by adding a landscape with cacti and palm trees. These additions were included in still other engravings of Aaron's likeness, including one by English printmaker George Vertue, issued in London after 1744 with the support of Selina, Countess of Huntingdon, a key figure in the Methodist movement. Aaron's ordination had become a kind of cause célèbre for what has been called the Protestant International, a group whose shared commitment to spreading the gospel across the globe and common opposition to Catholicism transcended their denominational differences.[6]

In all versions of his likeness, Aaron holds a printed Tamil Bible open to Acts 11:18, a passage about the conversion of gentiles. In the Indian painting, the inclusion of this book is an integral part of its message. Ziegenbalg, who had learned to read and speak Tamil, translated the New Testament and had it printed in 1714 on a press sent by the English Anglican organization the Society for Promoting Christian Knowledge. The printed Tamil Bible was a powerful symbol of the mission and an important part of its publicity campaign; a copy was sent, for example, from Tranquebar to Cotton Mather, a Puritan supporter of the mission living in colonial Boston.[7] Much more accessible than the Tamil Bible, however, was the frequently copied image of Aaron, who became a kind of eighteenth-century celebrity. A bust-length mezzotint portrait of the pastor by Augsburg printmaker August Scheller began to circulate after Aaron's death in 1745.[8]

A more enigmatic print, *The Tombs of the Jews*, engraved by Johann Rudolph Holzhalb in Zurich in 1755, demonstrates an expanding interest among eighteenth-century Europeans in ancient burial practices. It may also subtly allude to the rites of local Jews living in Switzerland. Holzhalb attached a smaller second print, or flap, to the lower third of his composition to present two versions of the scene.

When the flap is closed, the entrances to the caves in which the biblical Jews interred their dead are visible (Fig. 4); when it is lifted, the bodies inside are revealed, their presence foreshadowed by the wrapped corpse at the top of the engraving and the shape of the flap itself, which echoes the structures of the burial chambers underneath (Fig. 5). In the margins, skeletons posed as caryatids holding an hourglass and aspergillum evoke the Christian tradition of memento mori, pictorial reminders of the inevitability of death. An excerpt from Revelation 14:13 captions the print: "Blessed are the dead who die in the Lord; they rest from their labors!"[9]

Holzhalb based both the flap format and the content of his print on plates from German antiquarian Johann Nicolai's *Libri IV. de sepulchris Hebraeorum* (Book IV of the Tombs of the Hebrews), a book on ancient Jewish burial rites published in 1709. Holzhalb adapted elements of his landscape and the column and open tombs visible in the distance from separate illustrations in Nicolai's volume, and he copied the right chamber revealed by his flap from one of the earlier publication's two flap prints.[10] The procession at lower right and the tomb exposed at left in Holzhalb's engraving are either derived from other visual sources or based on descriptions in Nicolai's text. Originating in the Renaissance, flap prints commonly depicted Christian religious images, memento mori themes, or before-and-after scenes of natural disasters. Like these and the early eighteenth-century flap prints Holzhalb

Die Gräber der Juden

Aten, nach Beschaffenheit der Personen, unterschiedlich. Die Armen mußten mit einem Begräbniß in der Erde zufrieden seyn; und man hatte zu dem Ende hin aller Orten gemeine Begräbnisse, wie etwa unsere Kirchhöfe sind. Die Reichen aber bauten sich ansehnliche Grab-Gewölber, die sie gewöhnlich in die Felsen einhauen liessen, wohin denn ihre in leinene Tücher eingewickelte Leichname gebracht wurden. Diese Grab-Höhlen oder Grab-Gewölber befanden sich außer den Städten; denn weil die Todten verunreinigten, so wurde auch in den Städten (die Königlichen Familien ausgenommen, 1. Kön. Cap. II : 10. Cap. XI : 43.) niemand begraben. Es waren diese Grab-Gewölber, nach Beschaffenheit des Vermögens der Leute, öfters gar groß, so daß ganze Familien darein könnten gelegt werden; daher denn auch die bekannte Redensart gekommen ist: Zu seinen Vätern fahren, zu seinem Volke versammelt werden. Zuweilen liessen auch die Reichen auf einzele Grabstädte schöne Gedächtniß-Säulen aufrichten.

Mehrers wollen wir nicht melden; zumalen unser Absehen nicht dahin gehet, uns in einige Weitläuftigkeit einzulassen. Der Bibel-liebende Leser mag folgende Schrift-Oerter nachsehen, so wird er finden, daß dieses hier stehende Kupfer die unten angeführte Schriftörther, und die angeführte Schriftörther das Kupfer erklären.

1. B. Mos. XXIII. XXV : 8, x. XXXV : 19, 20.	2. Chron. XVI : 13, x. XXI : 20.
XLVII : 29, x. XLIX : 29. L : 13.	Jes. XXII : 15, x. LXV : 4.
Josua, XXIV : 30.	Jer. XXVI : 23.
2. Sam. II : 32.	Matth. VIII : 28. XXVII : 51, 52, 53, 60.
1. Kön. II : 34. XIII : 30, x.	Macc. XV : 46.
2. Kön. XIII : 20, x.	Joh. XIX : 39.

Figs. 4–6
Johann Rudolph Holzhalb (1730–1805), *The Tombs of the Jews*, 1755. Etching and engraving with letterpress and woodcut, plate: 29.6 × 20.3 cm; folded sheet: 39.6 × 25.4 cm. Harvard Art Museums/ Fogg Museum, Acquisition Fund for Prints, 2016.99.

emulated, his engraving invited physical manipulation, heightening the viewer's sensation of discovery.[11]

The circumstances surrounding the production of Holzhalb's flap print are unclear. The image is printed on one page of a folded full sheet; the second page contains a letterpress text with biblical references to Jewish burial rites (Fig. 6). This conjunction of text and image is suggestive of a broadside, but it may also indicate that *Tombs of the Jews* was intended for a larger publication. The only other known impression of the print is housed in one of two volumes of manuscript materials compiled by Zurich minister Johann Caspar Ulrich for a book that was never published.[12] The project was planned to supplement Ulrich's *Sammlung jüdischer Geschichten* (Collection of Jewish Histories; 1768), a five-hundred-page history of the Jews in Switzerland from the thirteenth century to 1762. For that book, Holzhalb prepared drawings and prints of the new local Jewish cemetery and the recently built synagogues in the towns of Endingen and Lengnau, the only Swiss municipalities in which Jews were allowed to live in the eighteenth century. These communities had been granted permission in 1750 to move their cemetery from a distant island leased from a German municipality to a plot on Swiss soil between

Kristel Smentek

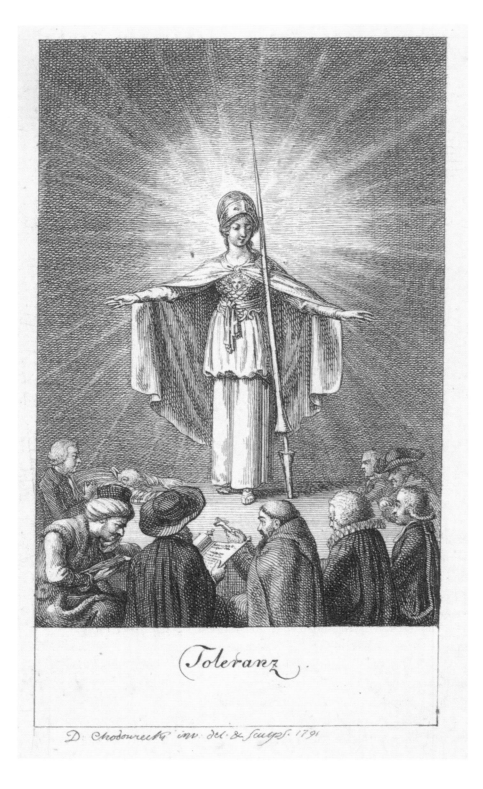

the two villages. The first burials occurred in 1752, and it is possible that Holzhalb's 1755 print of biblical Jewish rites obliquely references the contemporary practices of local Jews.

The caption to Holzhalb's engraving suggests yet another subtext. Ulrich was committed to documenting Jewish life, and he was unusually sympathetic to the injustices visited on European Jews in the past and on those living in eighteenth-century Switzerland.[13] At the same time, he actively sought, in accordance with his Pietist leanings, to convert the Jews he met—not by force, but through the gentler techniques of friendship and teaching. This missionary ambition adds resonance to the inscription, for it was on interpretations of the Book of Revelation that Pietists based their belief in the widespread conversion of Jews to Christianity at the end of times.

In the frontispiece to Ulrich's *Sammlung jüdischer Geschichten*, Jewish leaders offer a Torah scroll to a personification of friendship and gentleness, an emblem of the reasonableness by which religious enlighteners believed different confessions should be understood and by whose light they were to be accepted.[14] Though widely contested and imperfectly realized in practice, this principle of toleration was another of the Enlightenment's fundamental legacies.[15] It was also an ideal by which the Enlightenment represented itself to itself, as exemplified by Daniel Chodowiecki's almanac print *Tolerance*, published in 1792 (Fig. 7). Against a background of brilliant light, "enlightened wisdom"—in the form of Minerva, the Roman goddess of wisdom, who here also resembles Christian images of the Madonna of Mercy—"takes relations from all religions under her protection, Turks, Jews, Catholics, Lutherans, Calvinists, Quakers, Mennonites, Moravians, and the Chinese."[16] A figure representing the last lies prostrate at Minerva's feet, to the far left of the others. There are no idolators here, only believers of different faiths gathered together.

My warmest thanks to Jonathan Sheehan, Kaspar von Greyerz, Suzanne Karr Schmidt, Liza Oliver, Ari Gautier, Sarah Biäsch, and Ilka Voermann for their invaluable help in the development of this essay.

1. Jonathan Sheehan, "Enlightenment, Religion, and the Enigma of Secularization: A Review Essay," *American Historical Review* 108 (4) (2003): 1075–76.

2. Ibid.; Jonathan Sheehan, *The Enlightenment Bible: Translation, Scholarship, Culture* (Princeton, N.J.: Princeton University Press, 2005); David Sorkin, *The Religious Enlightenment: Protestants, Jews, and Catholics from London to Vienna* (Princeton, N.J.: Princeton University Press, 2008); Guy G. Stroumsa, *A New Science: The Discovery of Religion in the Age of Reason* (Cambridge, Mass.: Harvard University Press, 2010); and Carmen Bernard and Serge Gruzinski, *De l'idolâtrie: Une archéologie des sciences religieuses* (Paris: Seuil, 1988).

3. Key studies of this publication are Paola von Wyss-Giacosa, *Religionsbilder der frühen Aufklärung: Bernard Picarts Tafeln für die "Cérémonies et coutumes religieuses de tous les peuples du monde"* (Wabern: Benteli, 2006); Lynn Hunt, Margaret C. Jacob, and Wijnand Mijnhardt, eds., *Bernard Picart and the First Global Vision of Religion* (Los Angeles: Getty Research Institute, 2010); and Lynn Hunt, Margaret C. Jacob, and Wijnand Mijnhardt, *The Book That Changed Europe: Picart and Bernard's Religious Ceremonies of the World* (Cambridge, Mass.: Harvard University Press, 2010). In the last, see pp. 313–16 for a list of editions of *Cérémonies et coutumes*.

4. Müller's broadside is undated but must have been executed before he immigrated to London in 1744.

5. For a full discussion of the circumstances of the portrait and Kleinknecht's commission, see Daniel Cyranka and Andreas Wenzel, "'Das eigentliche Portrait des seligen Aarons'— Der indische Prediger Aaron (1698/99–1745) auf Bildern des 18. Jahrhunderts," *Pietismus und Neuzeit* 35 (2009): 148–203. Neither Müller's broadsheet nor the mezzotint portrait of Aaron discussed below are addressed in this article.

6. Edward E. Andrews, "Tranquebar: Charting the Protestant International in the British Atlantic and Beyond," *The William and Mary Quarterly* 74 (1) (2017): 3–34.

7. Ibid., 4.

8. Franckesche Stiftungen, Halle, Böttichersche Porträtsammlung, PP 173. On celebrity as a phenomenon of the Enlightenment, see Antoine Lilti, *The Invention of Celebrity, 1750–1850*, trans. Lynn Jeffress (Cambridge: Polity, 2017).

9. "Selig sind die Todte die im Herren Sterben: Sie ruhen von ihren Arbeiten! Offenb. Cap. 14: v. 13."

10. Johann Nicolai, *Libri IV. de sepulchris Hebraeorum: in quibus Variourum populaorum mores proponuntur, multa obscura loca enucleantur, usus approbantur & abusus rejiciuntur, genuina Hebraeorum sepulcrorum forma ostenditur, illorumque ritus in illis exhibentur et figuris aeneis illustrantur* (Leiden: Henricus Teering, 1709), plates facing 153 (column), 173 (tomb openings), 177 (flap print with tomb interior). Warmest thanks to Suzanne Karr Schmidt for bringing this book to my attention. Holzhalb copied the wrapped bodies from Johann Jakob Scheuchzer's biblical encyclopedia *Physica Sacra*, vol. 1 (Augsburg and Ulm: 1731–35), plate 114.

11. On flap prints, see Suzanne Karr Schmidt, *Interactive and Sculptural Printmaking in the Renaissance* (Boston: Brill, 2017); and her "Memento Mori: The Deadly Art of Interaction," in *Push Me, Pull You: Imaginative, Emotional, Physical, and Spatial Interaction in Late Medieval and Renaissance Art*, vol. 2, ed. Sarah Blick and Laura D. Gelfand (Leiden: Brill, 2011), 261–94.

12. Johann Caspar Ulrich, "Fortgesetzte und vermehrte Sammlung jüdischer Geschichten (1768)," Staatsarchiv Aargau, Aarau, Switzerland, NL.A-0173/0001-2. On this manuscript, see Uri Robert Kaufmann, "Eine zu publizierende geschichtliche Quelle aus dem 18. Jahrhundert," *Judaica* 42 (1) (1986): 17–21; and Florence Guggenheim-Grünberg, *Ulrich als Missionar im Surbtal. Ein Beitrag zur Judenmission in der Schweiz im 18. Jahrhundert*, Beiträge zur Geschichte und Volkskunde der Juden in der Schweiz 3 (Zurich: Verlag Jüdische Buch-Gemeinde, 1953), 6–21.

13. R. Po-chia Hsia, "Judaism and Protestantism," in *The Cambridge History of Judaism*, Vol. 7: *The Early Modern World, 1500–1815* (Cambridge: Cambridge University Press, 2017), 72; and Lothar Rothschild, *Johann Caspar Ulrich von Zürich und seine* Sammlung jüdischer Geschichten in der Schweiz. *Ein Beitrag zur Diskussion der Judenfrage in der Schweiz im 18. Jahrhundert* (Zurich: Gebr. Leemann, 1933).

14. Johann Caspar Ulrich, "Erklärung des Titul-Kupfers," in *Sammlung jüdischer Geschichten*, 2nd ed. (Zurich: 1770); and Elisheva Carlebach, *Divided Souls: Converts from Judaism in Germany, 1500–1750* (New Haven, Conn.: Yale University Press), 223. On reasonableness, see Sorkin, *Religious Enlightenment*, 11–14.

15. For an overview of eighteenth-century debates about tolerance, see Dorinda Outram, *The Enlightenment*, 4th ed. (Cambridge: Cambridge University Press, 2019), 126–31.

16. "Die aufgeklärte Weisheit nimmt alle Religionsverwandten, Turken, Juden, Catholiken, Lutheraner, Calvinisten, Quaker, Mennonisten, Herrnhuter und Chineser unter ihren Schutz." "Kurzer Erklärung der Monatskupfer," *Göttinger Taschen-Calender für das Jahrgang 1792* (Göttingen: Johann Christian Dietrich), 213. Chodowiecki's print, one of a series of six published in the almanac representing the major events of the previous decade (see the essay "Time" in this volume), likely references the Holy Roman Emperor Joseph II's Patent of Toleration (1781), which extended freedoms to non-Catholic Christians, and Edict of Tolerance (1782), which granted limited rights to Jews. The etching may also allude to Louis XVI's Edict of Versailles (1787), which granted civil but not political rights to non-Catholics in France.

Kristel Smentek

CRUELTY

Paul Friedland

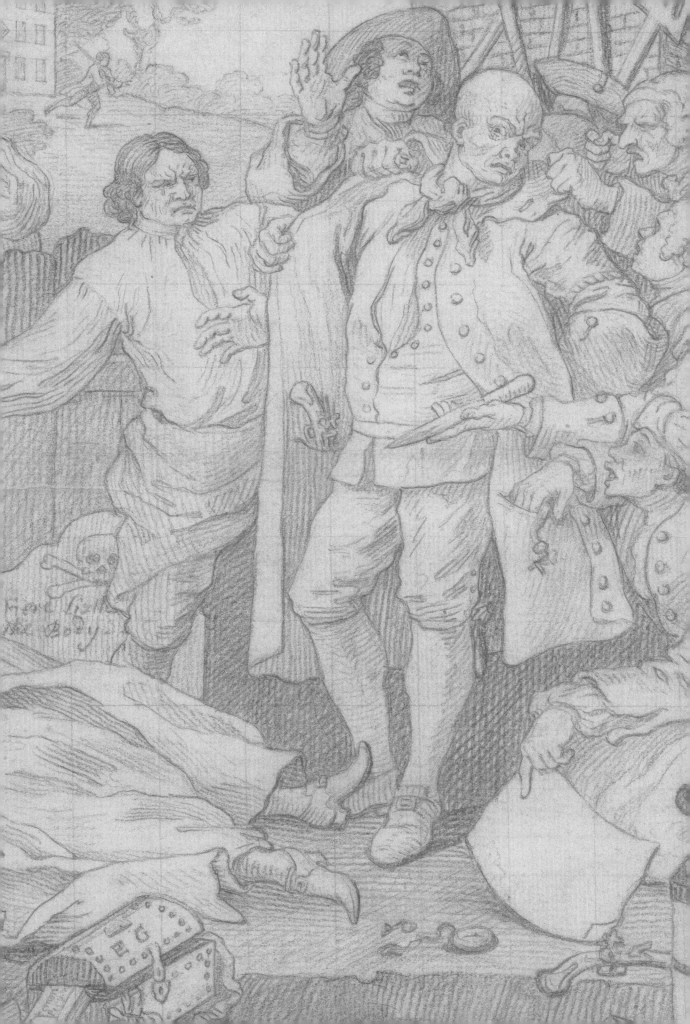

In 1760, Jacques Mauger, royal attorney for Caen, in northern France, recorded the details of a "memorable execution" in his unofficial diary of noteworthy events. A local murderer had been broken on the wheel, a particularly gruesome form of public execution that involved strapping condemned criminals to a large wheel, breaking their limbs with an iron bar, and leaving them to die over the ensuing hours or days. Mauger provided a minute-by-minute narrative of the execution, noting that the public square was "covered with an innumerable crowd" of spectators. Surprisingly, Mauger was not one of them. He explained in the diary, "I do not report this as an eyewitness: I have never been able to bring myself to watch a breaking on the wheel. My compassionate pity would not allow me to do it. But all these facts were reported to me that day by such a great number of people that I could not stop myself from including the account in this record."[1]

Many of the images in the Harvard exhibition were produced around the time that Mauger was writing and betray a similar ambivalence, a simultaneous fascination with and sensitivity toward spectacles of cruelty and suffering. Cultural attitudes were changing, and a range of emotions—from fascination and delight to horror and disgust—were associated with the sight of suffering. Artists who depicted such scenes walked a fine line, purporting to edify the viewer, or at least to elicit sympathy, while also catering to baser and more voyeuristic predilections. Perhaps no images accomplish these conflicting goals more successfully than those in William Hogarth's series on cruelty, which simultaneously seem to condemn the cruelty they portray and to take delight in it (Fig. 1).

Today, Mauger's discomfort at the sight of suffering might seem the natural response. As his diary shows, however, most people in eighteenth-century Europe loved attending public executions; those involving famous criminals could draw several hundred thousand spectators.[2] In André-Charles Cailleau's image of the execution of poisoner Antoine-François Desrues (Fig. 2), people crowd around the scaffold, desperate to see the action, while wealthier spectators overlook the scene from rented windows and balconies. (Note the well-dressed women and men at top left, watching the burning of Desrues's corpse.) Mauger's reluctance to attend executions in 1760 was therefore still unusual, evincing a sensitivity, or *sensibilité*, that was just starting to catch on among the more refined and educated set in France and Britain.

Discomfort at the sight of pain was not, in itself, new. As early as the 1580s, Michel de Montaigne wrote that he experienced "great, tender compassion with the sufferings of others." But rather than considering those feelings to be a positive quality, Montaigne regarded them as peculiar, something he could not control. He confessed that he shed tears "at any occasion at all" and that his sympathy extended not only to people but to animals, remarking that he was "weak to the point of not being able to watch a chicken being killed without displeasure."[3]

What Montaigne thought of as a peculiar weakness would come to be seen, by the end of the seventeenth century, as a laudable attribute of especially sensitive people. By the early eighteenth century, intellectuals on both sides of the English Channel were positing the idea that sympathy is innate to human beings, a reaction we cannot help feeling when confronted with the suffering of other people and

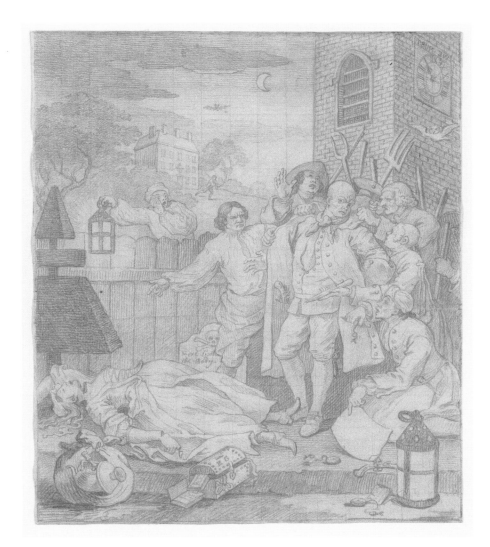

Fig. 1
William Hogarth (1697–1764),
*Third Stage of Cruelty (Cruelty in
Perfection)*, 1750. Red chalk, with
graphite, on paper; incised with
stylus and squared for transfer in
graphite; verso rubbed with red
chalk for transfer, 36 × 30.2 cm.
The Morgan Library & Museum,
New York, Purchased by Pierpont
Morgan (1837–1913) in 1909, III, 32d.
(Detail on p. 41.)

even animals. Writing in 1722, William Wollaston insisted that "there is something in human nature, resulting from our very make and constitution, which renders us obnoxious to the pains of others, causes us to sympathize with them, and almost comprehends us in their case. It is grievous to see or hear (and almost to hear of) any man, or even any animal whatever, in torment." What for Montaigne had been a peculiarity was for Wollaston a natural human instinct, the absence of which was "inhuman and unnatural."[4]

The musings of philosophers did not so much transform contemporary attitudes as they picked up on cultural trends before they became widespread. A real shift in public opinion did not take place (in France at least) until the execution of Robert-François Damiens in 1757, which marked a watershed in contemporary sensibilities. Damiens, who had attempted to stab Louis XV, was sentenced to the most horrible punishments that early modern justice could imagine: his body was mutilated over a period of several hours, after which he was quartered alive by horses. For the hundreds of thousands of people who flocked to Paris to see his

Paul Friedland

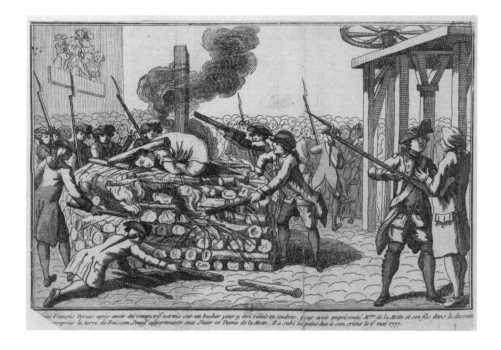

execution, filling every seat on the hastily erected viewing platforms and every
window within sight, Damiens's execution promised to be the greatest spectacle
of the century. Attendees even packed picnic lunches to eat while watching the
show, but the gruesome and protracted nature of the execution—exacerbated
by a botched quartering—left many feeling revolted. There would be an almost
instantaneous backlash and a kind of public soul-searching, prompting many to
ask: why *had* so many people shown up to watch another human being suffer a
gruesome death?

Interestingly, many contemporaries singled out the numerous women in
attendance. Playwright Charles Collé claimed that "none of the women who were
present . . . stepped away from the windows, whereas the majority of men could not
stand the spectacle and moved to the interior of the rooms, and many fainted."[5] A
decade later, Voltaire made it seem as if heartless women had made up the majority
of spectators: "I remember, being in Paris when Damiens was forced to undergo the
most elaborate and the most ghastly death one could imagine, that all the windows
that looked out on the square were rented at steep prices by women."[6] The callous-
ness of these women violated contemporary preconceptions about women's natural
sensitivity, making their behavior not only inhuman but unbecoming of their sex.
"Women came in droves to Damiens' execution. . . . Our women, whose souls are so
sensitive and whose nervous systems [are] so delicate that they faint before a spi-
der, attended the execution of Damiens!" wrote journalist Louis-Sébastien Mercier.
"[T]hey were the last to detach their gaze from the most horrible and disgusting
punishment that justice has ever dared to imagine."[7]

Attempting to explain why so many spectators were drawn to Damiens's
execution, statesman and philosopher Edmund Burke wondered whether human

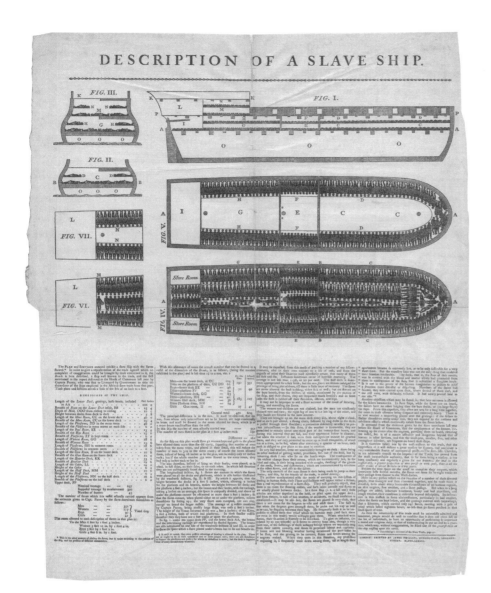

Fig. 3
Printed by James Phillips (1745–1799), *Description of a Slave Ship*, 1789. Engraving, 62.6 × 48.5 cm. Houghton Library, Harvard University, Gift of O. Peck, 1845, p EB75 A100 789pb.

beings, although naturally averse to pain, might be fascinated by it at a safe distance: "When danger or pain press too nearly, they are incapable of giving any delight, and are simply terrible; but at certain distances, and with certain modifications, they may be, and they are delightful."[8] In other words, Burke posited the existence of a gawking instinct that competes with our instinct for compassion. "[W]e have a degree of delight," he wrote, "in the real misfortunes and pains of others."[9] If a fire or an earthquake were to destroy London, he suggested, thousands would flock "to behold the ruins, and amongst them many who would have been content never to have seen London in its glory."[10] Two years later, however, Adam Smith seemed to dismiss Burke's observations, insisting that the sight of someone else's suffering automatically elicits a sympathetic, phantom pain in our own bodies,

Paul Friedland

because we cannot help imagining what we ourselves would feel under similar circumstances: "When we see a stroke aimed and just ready to fall upon the leg or arm of another person, we naturally shrink and draw back our own leg or our own arm; and when it does fall, we feel it in some measure, and are hurt by it as well as the sufferer."[11]

Burke's rationalization of gawking aside, the attack on female spectators and Smith's ideas on automatic flinching signaled the beginning of a cultural revolution: witnessing the suffering of others—regardless of one's sex—was becoming increasingly problematic. While penal reformers would soon try to mitigate the suffering of criminals, they were equally concerned with hiding that suffering from spectators. The guillotine was hailed as a humane invention not simply because death was instantaneous and the criminal would feel no pain, but because spectators were spared the sight of suffering. Although initially unpopular, executions by guillotine eventually drew large crowds, prompting later attempts to make executions even less visible, such as by moving them outside the city center, eliminating the raised scaffold, and restricting them to dawn and dusk.

The second half of the eighteenth century saw a great many contemporary practices come under renewed scrutiny, now that human beings were believed to be reflexively sympathetic to the suffering of others. Europeans had been enslaving Africans since the 1500s, but it was only in the mid- to late eighteenth century that public opinion began to express concern about the suffering of enslaved people during the middle passage or about the conditions under which they lived and died in the New World (see Fig. 3, originally published in 1789 by abolitionists hoping to raise awareness about the inhumanity of the slave trade, and p. 87). Some proposed making slavery more "humane" by banning various forms of corporal punishment; the Marquis de Lafayette, for example, established an experimental "humane plantation" in Guiana, exchanging letters with George Washington about his ideas.[12] Others, particularly in Britain, believed that abolition was the only humane solution. The French had largely spared themselves the discomfort of witnessing the suffering of the enslaved by banning slavery in the metropole while encouraging it in the Caribbean colonies, where nearly a million people were enslaved, out of sight and largely out of mind for the inhabitants of metropolitan France.

Just as intellectuals had theorized that the human capacity for compassion extended beyond our species, public opinion in the second half of the eighteenth century grew increasingly concerned about the suffering of animals—or more specifically, the *sight* of animal suffering. The first target of reformers was "needless" suffering and cruelty toward animals (see Hogarth's prints, which draw a link between animal cruelty and criminality), but even the sight of animal slaughter for meat soon became problematic. Although slaughter had traditionally taken place in city centers, enabling customers to select their cut directly from the carcass of freshly butchered animals, from roughly 1760 onward this practice would prove increasingly difficult for many to see. "What could be more revolting and more disgusting," one journalist asked, "than to slit the throat of cattle and cut them into pieces in public?"[13] The solution to the problem was not to end animal suffering

but, as with the suffering of people, to remove it from public view. In 1810, Napoleon ordered the construction of five slaughterhouses outside the walls of Paris, a decision that the *Encyclopédie nouvelle* later praised as humane: "[T]he inhabitants of cities are no longer condemned to the disgusting spectacle of the blood of victims flowing in the middle of streams of muck. . . . [Nature] forces us to kill animals in order to maintain our own flesh with theirs, but it is humane and beneficial to let a veil fall over the picture of killing."[14] In this case as in so many others, "humane" meant sparing people an unpleasant sight.

The images discussed in this essay were all produced in the midst of a cultural revolution, a moment when attitudes about cruelty and the sight of suffering were in flux. Although many of these works purport to edify the viewer by exposing cruelty and suffering, they also make the viewer complicit in the act of gawking, prompting us to consider whether Burke had a point: Does the viewer, safely distanced from the scene of suffering, find a certain delight in looking?

1. "Journal de Jacques Mauger," in *Recueil de journaux caennais, 1661-1777, publiés d'après les manuscrits inédits*, ed. Gabriel Vanel (Rouen: Société de l'histoire de Normandie, 1904), 173-76.

2. On the extraordinary popularity of public executions, see Paul Friedland, *Seeing Justice Done: The Age of Spectacular Capital Punishment in France* (Oxford: Oxford University Press, 2012).

3. Michel de Montaigne, "De la Cruauté," in *Essais de Montaigne*, vol. 2 (Paris: 1843), 265. For a more complete discussion of Montaigne's views on animal cruelty within the context of the time, see Paul Friedland, "Friends for Dinner: The Early Modern Roots of Modern Carnivorous Sensibilities," *History of the Present* 1 (1) (Summer 2011): 84-112.

4. William Wollaston, *The Religion of Nature Delineated* (London: Printed for J. Beecroft, J. Rivington, J. Ward, R. Baldwin, W. Johnston, S. Crowder, P. Davey and B. Law, and G. Keith, [1722] 1759), 258-60. See also Anthony Ashley Cooper, Earl of Shaftesbury, *Characteristics of Men, Manners, Opinions, Times, Etc.*, vol. 1 (London: G. Richards, [1711] 1900), 331.

5. Charles Collé, *Journal historique, ou mémoires critiques et littéraires sur les ouvrages dramatiques et sur les événements les plus mémorables, depuis 1748 jusqu'en 1772, inclusivement*, vol. 2 (Paris: Imprimerie bibliographique, 1807), 177.

6. Voltaire, "Curiosité," in *Dictionnaire philosophique II, Oeuvres complètes de Voltaire*, vol. 18 (Paris: Garnier frères, 1878), 308.

7. Louis-Sébastien Mercier, *Tableau de Paris*, vol. 2 (Hamburg: Virchaux & Compagnie, 1781), 129, 132-33.

8. Edmund Burke, *A Philosophical Enquiry into the Origin of Our Ideas of the Sublime and Beautiful* (London: Printed for R. and J. Dodsley in Pall-Mall, [1757] 1764), 60.

9. Ibid., 72.

10. Ibid., 77.

11. Adam Smith, *The Theory of Moral Sentiments* (London: Printed for W. Strahan, J. & F. Rivington, W. Johnston, T. Longman; T. Cadell in the Strand; and W. Creech at Edinburgh, 1774), 3.

12. "Marquis de Lafayette's Plan for Slavery," George Washington's Mount Vernon, https://www .mountvernon.org/library/digital history/digital-encyclopedia /article/marquis-de-lafayette -s-plan-for-slavery.

13. Louis-Sébastien Mercier, *Tableau de Paris*, vol. 5 (Amsterdam: 1783), 28.

14. "Abattoir," in *Encyclopédie nouvelle ou dictionnaire philosophique, scientifique, littéraire et industrielle offrant le tableau des connaissances humaines au dix-neuvième siècle*, vol. 1 (Paris: Librairie de C. Gosselin, 1836), 3.

Marie-Gabrielle Capet
Self-Portrait

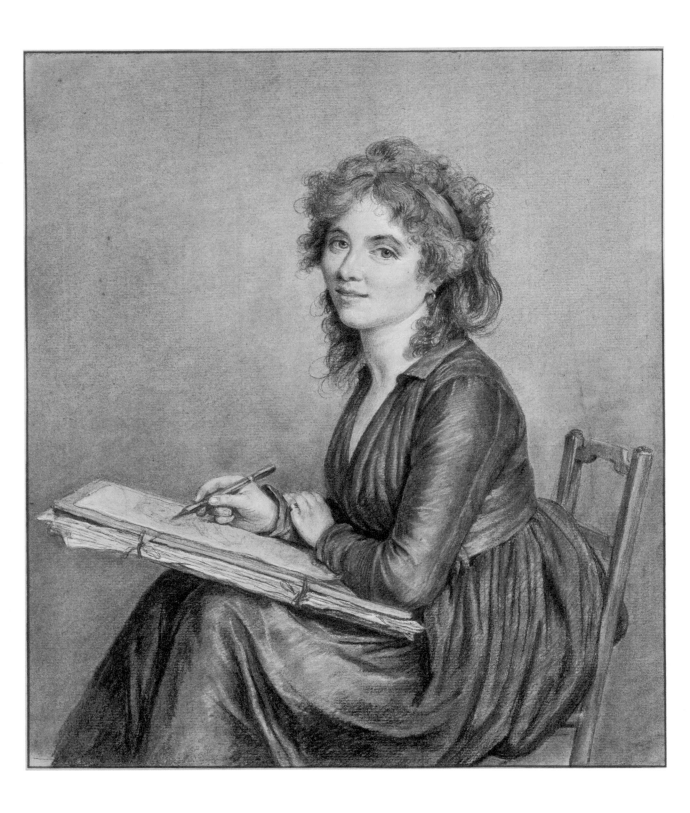

Despite the hefty portfolio of drawings resting on her lap in the work shown here, few sheets positively attributed to Marie-Gabrielle Capet survive, preventing us from appreciating the full range of her considerable talent. Denied membership in the Royal Academy of Painting and Sculpture—then limited to only four women—she benefited nonetheless from the training, housing, and protection of two illustrious academicians, Adélaïde Labille-Guiard and François-André Vincent.

Here, in one of her many self-portraits, Capet depicts herself wearing a simple, dark dress from the 1790s and seated in a modest wooden chair against a spare, light-filled background. The austerity of the scene encourages the viewer to focus on the artist and her distinguished activity. Momentarily distracted from sketching preliminary sanguine contours, Capet turns toward the viewer and her own reflection, chalk in hand, to get another look. The loose strands of hair falling on her brow and shoulders; the parting of her lips, as if about to speak; and the intensity of her gaze reinforce the immediacy of the image. These aspects of the portrayal would have pleased Diderot, who in his review of the Salon of 1767 celebrated artists who attempted to capture the inexplicable combination of nature, movement, decoration, and the metaphysical characteristics of a sitter's disposition that make the individual unique. The measured elegance of Capet's blend of black, red, and white chalk (*trois crayons*) demonstrates the suitability of the media for rapidly transposing the evanescent qualities of a person's character.

Fusing observation, skill, and reason, drawing is widely recognized as the foundation of the visual arts. Capet's decision to depict herself mid-sketch linked her to a celebrated line of predecessors and contemporaries, both male and female, who likewise rendered themselves engaged in the task.

Marie-Gabrielle Capet (1761–1818), *Self-Portrait*, c. 1790. Black, red, and white chalk, 34 × 29.4 cm. The Horvitz Collection, Wilmington, Del., D-F-429.

Alvin L. Clark, Jr.

DRAWING

Edouard Kopp

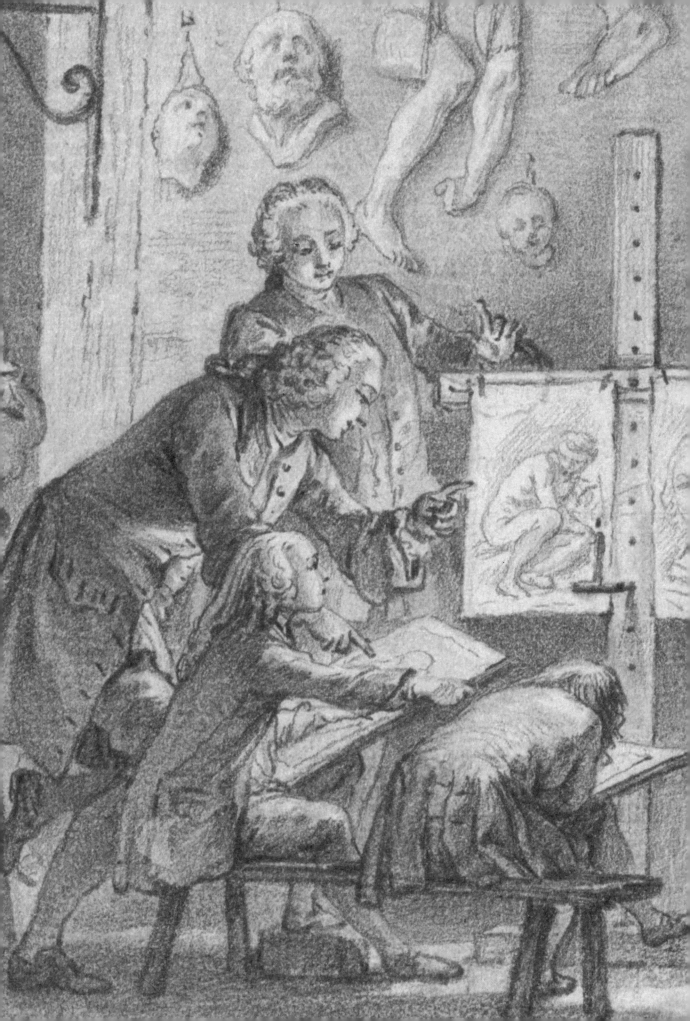

Deanna Petherbridge has perceptively noted that "although drawing participates in the same systems of representation and cultural contexts as painting, printing and sculpture and other forms of visual art, it has its own techniques, its own typologies, codes, systems and strategies, its own power relations, its own market and collectors, and a very specific history."[1] The ideas that we hold today about drawing's unique place in the arts were largely inherited from the Enlightenment, whose conception of the medium was itself indebted to a longer discourse dating back to the Renaissance that was then mobilized in accordance with new ambitions and epistemological assumptions.

From the outset, drawing played an essential role in artistic theory and practice. In the Renaissance, the Italian term *disegno* signified both the physical act of the draftsman and the broader notion of "design" as a creative or intellectual pursuit. The concept of *disegno* theorized by sixteenth-century artist and writer Giorgio Vasari elevated drawing to the status of "father" of the visual arts, giving it primacy over painting, sculpture, and architecture, which it ennobled to the level of the liberal arts. The role of drawing in artistic training and practice became formalized with the establishment in 1648 of the Royal Academy of Painting and Sculpture in France, which was then followed by the creation of academies across Europe over the next century and a half. The Academy promoted the centrality of drawing as a teaching tool for young artists, an aspect Charles-Nicolas Cochin thematized in a vignette for the *Encyclopédie* entry on "dessein" (Fig. 1). His is an idealized depiction of the Academy, where students are seen engaged in different stages of the state-sanctioned curriculum, from copying drawings and prints to drawing after sculpture and, finally, from life. Further to drawing's didactic value, Cochin's composition underscores its foundational role in the conception and execution of works of art, which aligned the medium with the liberal rather than the mechanical arts. The institutional theory and practice of drawing were disseminated beyond the Academy's walls, notably through instruction books such as Charles-Antoine Jombert's *Méthode pour apprendre*

Fig. 1
Charles-Nicolas Cochin le jeune
(1715–1790), *The Drawing School*,
1763. Black chalk, 11.9 × 22 cm.
Staatliche Museen zu Berlin,
Kupferstichkabinett, KdZ 26344.
(Detail on p. 53.)

DRAWING

54

Fig. 2
Charles de Wailly (1729–1798),
*View of the Pulpit, Saint Sulpice, Paris
(Second Project)*, 1789. Black ink,
brush and watercolor, and black
chalk, 57.8 × 47.3 cm. Cooper Hewitt,
Smithsonian Design Museum,
New York, Smithsonian Institution,
Purchased for the Museum by the
Advisory Council, 1911-28-293.

le dessein (Method for Learning Drawing; 1740), one of the most famous drawing manuals of the period.

Drawing assumed an increasingly significant role in the age of Enlightenment, owing to inherent qualities such as its portability, its economy, its profound physical and conceptual agility, and its remarkable effectiveness in representing, articulating, and communicating visual knowledge about the world. In effect, the medium's role was rethought, its techniques enriched, its scope expanded, and its status elevated, all within wider social, cultural, and geographic contexts. Traditionally tied and in practice often subservient to other arts, particularly painting, drawing took on a new degree of aesthetic autonomy.[2] It was no longer necessarily thought of as preparatory work to be realized in other media, but could serve as a full-fledged medium in its own right. The variety of uses, materials, and potential degrees of finish opened up a range of possibilities for artists. Highly finished works, exemplified by Charles de Wailly's view of the pulpit in the Church of Saint Sulpice (Fig. 2), became more common.

Edouard Kopp

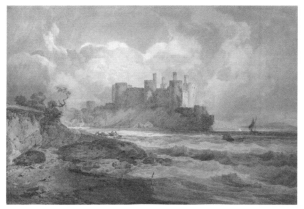

PUBLIC

NATURE

This shift in appreciation aligned with the development of connoisseurship, whose discourse emphasized the unique, unmediated qualities of drawing, which were thought to bring the viewer closer to the artist's hand and mind.[3] Drawings were perceived to be purer and more truthful indexes of an artist's individual manner than paintings, for example, and their study was therefore thought to form a sound basis for art history and theory.[4] Connoisseurship, with its emphasis on observation, description, comparison, and categorization, was considered a science by its practitioners and directly linked to visual epistemological models, whereby empirical knowledge was acquired through experience and thus accessible to anyone willing to exercise their sensory and rational faculties.[5] In aiming to assess the authorship, quality, and authenticity of works, connoisseurship affirmed the status and appreciation of drawings as a form of artistic expression, regardless of their original purpose, while making them more intelligible and attractive as objects of collection and display.

Beginning in 1737, drawing was regularly featured in the Paris Salon exhibitions, which greatly increased the medium's visibility at a time when the concept of a public sphere was emerging ◉. The advent of drawing as a subject of public critical discourse further strengthened its status as an autonomous field.[6] At the Salon, a large number of works executed in a range of media competed for the viewer's attention; as a result, such exhibitions tended to favor drawings with "wall power." This stirred in artists an urge to produce and show drawings that were large, graphically assertive, and/or colorful. It is no surprise, then, that the majority of drawings meant for display were executed in wash, gouache (opaque watercolor), or pastel (often used for portraiture), which allowed artists to effectively rival some of the effects of painting (Fig. 3). In the context of a flourishing art market, drawings became more marketable commodities and the focus of important private collections, as well as a point of social distinction.[7]

Color came to play an unprecedented role in drawing practice even outside the Salon, particularly in genres such as history, natural history illustration ◉, and landscape. Landscape drawing benefited much from the development of watercolor, a technique favored by British professionals and amateurs alike and valued for its luminosity, transparency, and freshness of color. Watercolor was also prized for its

ability to convey feeling, including a sense of the sublime, the picturesque (Fig. 4), or the otherworldly.[8]

Drawing was generally well-suited to the needs of travelers intent on keeping a record of the sites, people, and cultures they encountered, and as such, the rise of European tourism (exemplified by the Grand Tour) and of scientific voyages and illustrated travels accounts ◉ resulted in a dramatic broadening of the medium's horizons and domains of application: from the artist's studio and the academy, its scope was vastly expanded to the world at large, and to a range of scientific disciplines, from astronomy to zoology. Still a powerful means of artistic expression, drawing proved to be a cogent tool for the production and transmission of knowledge and affirmed its role in the formation of the self (see p. 51).[9] Moreover, it became a source of pleasure, both as a discipline practiced by amateurs and as an object sought after by collectors in a period that held sensory experience, especially the visual, in increasingly high esteem.

1. Deanna Petherbridge, *The Primacy of Drawing: Histories and Theories of Practice* (New Haven, Conn.: Yale University Press, 2010), 2.

2. See Ewa Lajer-Burcharth, "Drawing: Medium, Discourse, Object," in *Drawing: The Invention of a Modern Medium*, ed. Ewa Lajer-Burcharth and Elizabeth M. Rudy (Cambridge, Mass.: Harvard Art Museums, 2017), 12–39.

3. See Carol Gibson-Wood, "Jonathan Richardson and the Rationalization of Connoisseurship," *Art History* 7 (1984): 38–56.

4. See Kristel Smentek, "New Perspectives on Drawing in the Long Eighteenth Century," *Eighteenth-Century Studies* 38 (2) (Winter 2005): 376–81.

5. See Carol Gibson-Wood, *Jonathan Richardson: Art Theorist of the English Enlightenment* (New Haven, Conn.: Yale University Press, 2000); and Kristel Smentek, *Mariette and the Science of the Connoisseur in Eighteenth-Century Europe* (Farnham, U.K.: Ashgate, 2014).

6. See Edouard Kopp, "Drawing Exposed: Bouchardon and the Salon, 1737–46," in *The Learned Draftsman: Edme Bouchardon*, by Edouard Kopp (Los Angeles: J. Paul Getty Museum, 2017), 113–49.

7. On the market for drawings, see Colin Bailey, "*Toute seule elle peut remplir et satisfaire l'attention*: The Early Appreciation and Marketing of Watteau's Drawings during the Reign of Louis XV," in *Watteau and His World: French Drawings from 1700 to 1750*, ed. Alan Wintermute (New York: American Federation of the Arts, 1999), 68–92; and Patrick Michel, "Collection de dessin et marché de l'art en France au XVIIIe siècle," in *Liber Memorialis Erik Duverger: Bijdragen tot de Kunstgeschiedenis van den Nederlanden*, ed. Henri Pauwels, André van den Kerkhove, and Leo Wuyts (Wetteren: Universa, 2006), 169–220.

8. See Ann Bermingham, *Learning to Draw: Studies in the Cultural History of a Polite and Useful Art* (New Haven, Conn.: Yale University Press, 2000); and Kim Sloan, *"A Noble Art": Amateur Artists and Drawing Masters, c. 1600–1800* (London: British Museum, 2000). On watercolor as a technique, see Marjorie B. Cohn and Rachel Rosenfeld, *Wash and Gouache: A Study of the Development of the Materials of Watercolor* (Cambridge, Mass.: Fogg Art Museum, 1977).

9. See Bermingham, *Learning to Draw*.

Edouard Kopp

EXPEDITION

Edouard Kopp

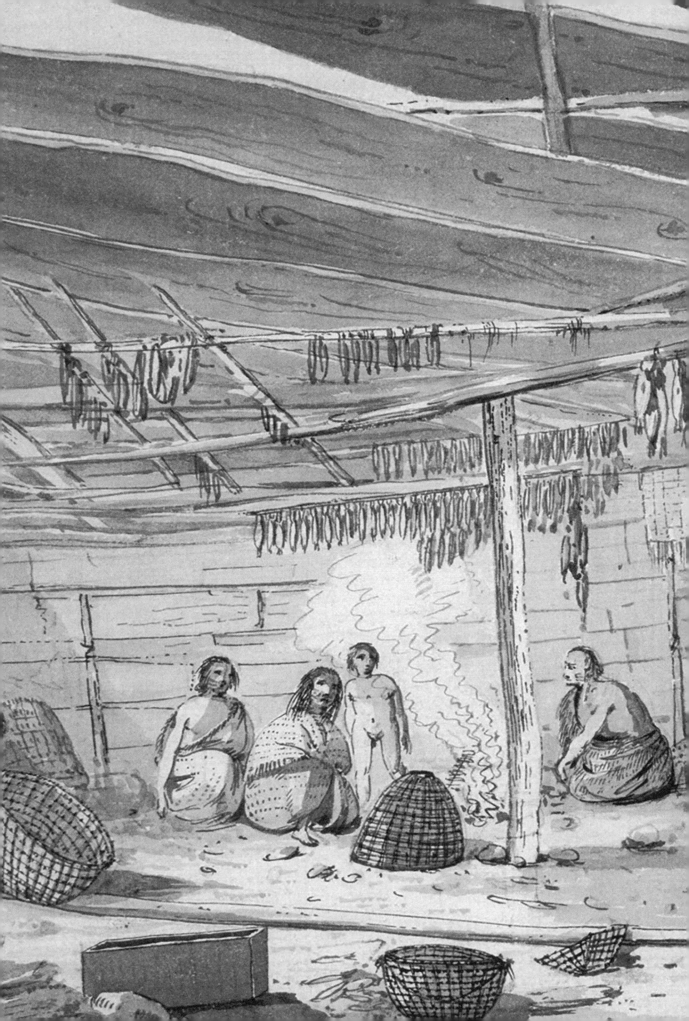

The expedition—an organized voyage undertaken by professionals or experts with a specific purpose, such as geographic exploration or scientific discovery—played a significant role in the Enlightenment, marking a new, encyclopedic project of observation, inquiry, and inventory of the world. Unlike the Grand Tour, a journey of initiation for young aristocrats that was largely aimed at self-knowledge and the ritual experience of famous sites in southern Europe, the expedition involved people from varied social backgrounds and was a search for the unknown, generally in a faraway region, and was therefore inherently risky and often dangerous. Vaunted for their curiosity, fearlessness, and determination, explorers gained unprecedented prominence in the European imagination, as illustrated by the 1794 print *The Apotheosis of Captain Cook* (Fig. 1).[1] Here, storied British explorer, navigator, and cartographer James Cook is celebrated as a mythical hero, carried aloft by Britannia and a winged personification of Fame in the skies above Karakakooa Bay, the anchorage in Hawai'i where he was killed.

Expeditions became increasingly specialized in the eighteenth century, requiring more scientists and, particularly from the 1760s onward, greater participation of artists, who were typically called on to make visual records of notable topography, flora and fauna, and Indigenous populations and their traditions. Among the ambitious unfinished projects of the era were the mapping of the known continents (North America, for example, remained largely uncharted despite two centuries of European presence) and the exploration of the oceans. The Arctic, the Antarctic, and the Pacific were relatively unsailed by Europeans at the beginning of the century, but it was the Pacific, then called the South Seas, that was most alluring: suspected of containing a considerable landmass (*terra australis*) in temperate latitudes, the ocean was believed to be a commercial and strategic asset.[2]

During this period, maritime exploration became not only safer but also more efficient thanks to technical innovations that greatly improved cartography and facilitated navigation, particularly the ability to find longitude at sea, the scientific and technological challenges of which had long stymied seafaring nations.[3] Notable improvements were made to precision clocks, the telescope, the compass (see p. 151), and the sextant; ships were generally built better; and methods were discovered for counteracting scurvy. More effective navigation ushered in significant advances in disciplines such as geography ◉, astronomy, physics, and the natural sciences ◉, as well as the birth of ethnology.

GEOGRAPHY, NATURE

Expeditions also paved the way for European powers to colonize and exploit new lands for wealth, labor, knowledge, and skills while captivating the imaginations of people back home, where audiences were in the process of reassessing their own values and their views on the nature and origins of mankind.[4] Whether their ostensible goals were scientific or mercantile, such voyages generally benefited from official support, which was often inextricably tied to the strategic interests of, and vigorous rivalry among, major geopolitical powers, such as Spain, Britain, France, and Russia, in addition to more modest ones like Denmark. Thus, the project to know the world was strengthened by a desire to rule it.

In 1737–38, Danish naval officer Frederik Ludvig Norden set out on an ambitious trade mission, traveling up the Nile to Ethiopia on behalf of the Danish crown.

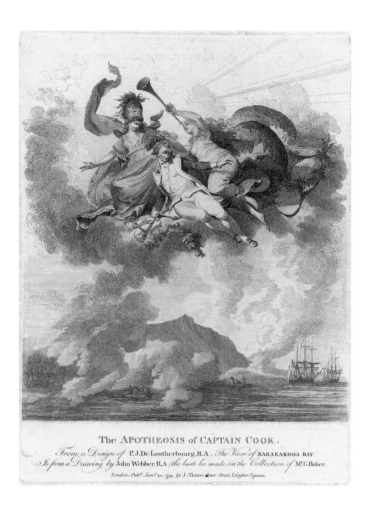

The APOTHEOSIS of CAPTAIN COOK.

From a Design of P.J.De Loutherbourg, R.A . *The View of* KARAKAKOOA BAY
Is from a Drawing by John Webber, R.A *(the last he made)in the Collection of* Mr G.Baker.

London. Publd Jany 20. 1794. by J.Thane, Spur Street, Leicester Square.

Fig. 1
After Philippe Jacques de
Loutherbourg (1740–1812) and John
Webber (1751–1793), *The Apotheosis
of Captain Cook*, 1794. Etching,
31.1 × 22 cm. The British Museum,
London, 1867,1214.281.

While the expedition itself was a failure, Norden made a cultural impact nonetheless, a credit to his curious and open mind and to his background as a cartographer and antiquarian with a knowledge of Egypt.[5] He took detailed notes and measurements and made hundreds of exacting drawings of Egyptian sites and antiquities.[6] His findings were published posthumously in the 1755 volume *Voyage d'Egypte et de Nubie* (Travels in Egypt and Nubia), including faithful engravings by Carl Marcus Tuscher after Norden's line drawings (Fig. 2).[7] Norden's marvel at the beauty and technical ingenuity of ancient Egyptian art and architecture raised a controversial question: should Egypt, more so than Greece, be looked to as a precedent for art and science? A source of Danish national pride, *Voyage d'Egypte et de Nubie* proved essential to eighteenth-century debates on the relative roles of ancient Egypt and Greece in the formation of European identity 👁.[8]

The late 1730s also witnessed the world's first cooperative, international scientific expedition. Comprising a team of French and Spanish scientists and naval officers, the so-called Geodesic Mission to the Spanish colony of Peru was organized by the French Academy of Sciences with the sponsorship of the Navy. It aimed at making measurements with the most advanced surveying and astronomical instruments to calculate the precise length of one degree of latitude at the equator (Fig. 3);

ANTIQUITIES

Edouard Kopp

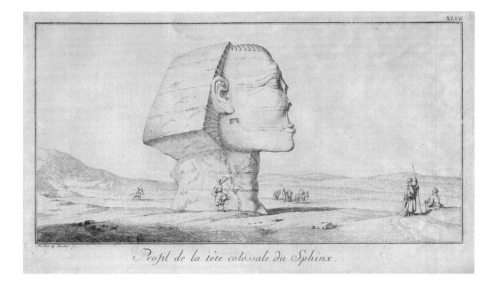

Profil de la tête colossale du Sphinx.

the ultimate goal was to establish whether the earth's circumference was greater around the equator or at the poles.[9] The true shape of the earth had been a hotly debated topic since the late seventeenth century, when René Descartes and Isaac

NATURE

Newton espoused opposing views on the matter ⊙.

A similar French mission was led by Pierre-Louis Moreau de Maupertuis in the Arctic Circle in 1736–37. Maupertuis, a mathematician and scientist who had been elected to the Academy of Science when he was only 26 years old and would eventually come to head that institution, ventured to Lapland to take measurements that would prove Newton's theory that the earth is flattened at the poles. A portrait print by Jean Daullé and Jean-Georges Wille after a painting by Robert Levrac-Tournières shows the scientist dressed in animal skins, pushing down on a model of the earth with his right hand to emphasize the point (Fig. 4).[10] The Lapland and Peru expeditions both led to the conclusion that Earth is not a sphere but an oblate spheroid, thereby validating Newton over Descartes.

In 1761 and 1769, numerous expeditions were organized by European scientists to various parts of the world to observe the transit of Venus across the face of the sun—a rare, predictable, and important astronomical occurrence that allowed

VENUS

astronomers to measure the distance between the sun and the earth ⊙.[11] The French Academy of Sciences alone sent three expeditions to study the phenomenon: Alexandre-Guy Pingré on Rodrigues Island in the Indian Ocean; Jean-Baptiste Chappe d'Auteroche in Siberia and California; and Guillaume Le Gentil de la Galaisière in Pondicherry, who was least successful in achieving the original goal.[12] Le Gentil spent over eight years traveling in Southeast Asia without ever observing the transits of Venus. He returned to France to find that he had been presumed dead and that his vacant seat at the Academy had been filled, as none of the letters he had sent had reached their destinations. However, based on the vast amounts of data he collected, he published the major two-volume publication *Voyage dans les mers de l'Inde* (Voyage to the Indian Ocean) in 1779–81. The book dealt with the geography and culture of India, the Philippines, and Madagascar, including a long passage on

Brahman astronomy, complete with figures representing the constellations associated with the zodiac (see p. 257). Le Gentil contended that the science had ancient origins, a claim that contemporaries (including Voltaire) disputed and scholars have since rejected.[13]

Organized by the Admiralty and carried out with the discipline of the British Navy, Cook's three transoceanic voyages of discovery constituted the major scientific event of the second half of the eighteenth century. This distinction is a tribute to the era's interest in geographic discovery but also to Cook's undeniable feat: he surveyed practically half the globe. Consistent with his primary goals of exploration and documentation, he brought with him some of the best scientific and artistic talent available.

After first exploring the South Pacific between 1768 and 1771, Cook decided to return in search of new islands and to accurately map the position of territories previously visited by other expeditions, including "Easter Island, the situation of which is so variously laid down that I have little hopes of finding."[14] That island, now known as Rapa Nui, is situated at the eastern corner of the Polynesian Triangle. During the voyagers' brief stay there in March 1774, the expedition's artist, landscapist William Hodges, completed two walking tours across the island, encountering colossal stone sculptures that dominated the landscape. Printmaker William Woollett based his engraving *Monuments in Easter Island* (Fig. 5), published in the official account of the journey, on a drawing that Hodges made in situ and is now lost.[15] The picture features no Eden but a forbidding coastal landscape beneath a darkening sky, with a half-skeleton prominently displayed at the foot of the partly ruined statues that overshadow the islander at left. Grounded in reality, the composition clearly references the fact that Cook and the voyage's naturalist, Georg Forster, observed human remains in the vicinity of the monuments, leading them to postulate that the monolithic figures served a funerary purpose, a thesis now widely accepted.[16]

Fig. 3
Vincente de la Fuente, *Astronomical and Physical Observations Made in the Kingdoms of Peru*, from *Observaciones Astronómicas y Phísicas en los Reynos del Perú*, by Jorge Juan and Antonio de Ulloa (Madrid: 1773). Engraving, plate: 6.8 × 15 cm. John G. Wolbach Library, Harvard University, QB291 .J9.

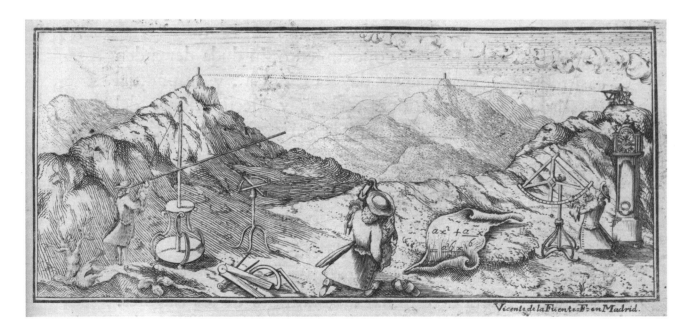

Edouard Kopp

Believed by Cook to be ancient, the statues were evidence of the local civilization's historical depth. Furthermore, as Harriet Guest has argued, the sense of decline in Hodges's image seems to indicate that the Indigenous Rapa Nui culture was not timeless but subject to its own historicity, and even that European historiographic models of progress, decline, and fall might apply and thus prove universal.[17]

The goal of Cook's third and final voyage (1776–80) was to discover the mysterious Northwest Passage, the hypothesized Arctic sea route between the Atlantic and Pacific Oceans.[18] Artist John Webber was hired, as Cook put it, "to make the result of our voyage entertaining to the generality of our readers, as well as instructive to the sailor and scholar . . . [and] for the express purpose of supplying

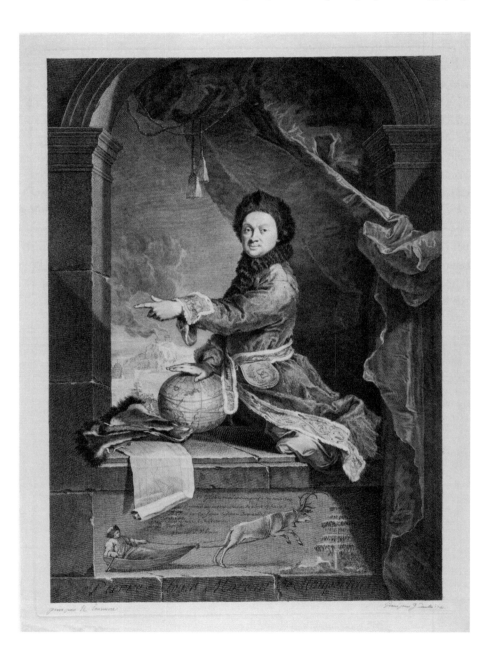

Fig. 4
Jean Daullé (1703–1763) and Jean-Georges Wille (1715–1808), after Robert Levrac-Tournières (1667–1752), *Pierre-Louis Moreau de Maupertuis*, 1741. Etching and engraving inscribed with a quatrain by Voltaire (proof before letters with hand-lettered inscription in brown ink), plate: 50.8 × 37.2 cm. Philadelphia Museum of Art, The Muriel and Philip Berman Gift, acquired from the John S. Phillips bequest of 1876 to the Pennsylvania Academy of the Fine Arts, with funds contributed by Muriel and Philip Berman, gifts (by exchange) of Lisa Norris Elkins, Bryant W. Langston, Samuel S. White 3rd and Vera White, with additional funds contributed by John Howard McFadden, Jr., Thomas Skelton Harrison, and the Philip H. and A.S.W. Rosenbach Foundation, 1985, 1985-52-37871.

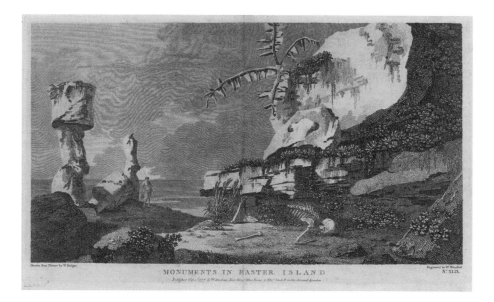

MONUMENTS IN EASTER ISLAND

Fig. 5
William Woollett (1735–1785),
after William Hodges (1744–1797),
Monuments in Easter Island, from *A
Voyage Towards the South Pole and
Round the World. Performed in His
Majesty's Ships the Resolution and
Adventure, in the Years 1772, 1773, 1774,
and 1775,* by James Cook (London:
1777). Etching and engraving, sheet:
28.3 × 45 cm. Philadelphia Museum
of Art, The Muriel and Philip
Berman Gift, acquired from the
John S. Phillips bequest of 1876 to
the Pennsylvania Academy of the
Fine Arts, with funds contributed
by Muriel and Philip Berman, gifts
(by exchange) of Lisa Norris Elkins,
Bryant W. Langston, Samuel S.
White 3rd and Vera White, with
additional funds contributed
by John Howard McFadden, Jr.,
Thomas Skelton Harrison, and the
Philip H. and A.S.W. Rosenbach
Foundation, 1985, 1985-52-38306.

the unavoidable imperfections of written accounts, by enabling us to preserve, and
to bring home, such drawings of the most memorable scenes of our transactions, as
could only be executed by a professed and skillful artist."[19] Webber worked closely
with Cook; many of his drawings correspond to passages in Cook's journal, which
suggests that the artist acted at the captain's instruction.[20] He produced more than
two hundred drawings of regions and peoples previously known only through verbal
accounts.[21] In March and April 1778, the expedition's ships, the HMS *Resolution*
and HMS *Discovery*, anchored at King George's Sound, also called Nootka Sound,
on Vancouver Island. Webber accompanied Cook to the village of Yuquot, where
they gained entry to dwellings of the Nootka (Nuu-chah-nulth) people. Webber
made watercolors documenting a wealth of details (Figs. 6–7), including, as Cook
explained, "the construction of the houses, household furniture and utensils, and
striking peculiarities of the customs and modes of living of the inhabitants."[22]
In the end, Cook's legacy proved far reaching and complex; it is profoundly
contested today.

Ultimately, expeditions generated a mass of new empirical knowledge, includ-
ing many potent images that elicited further support for such voyages and stimulated
interest in their findings. Even though it had become clear by the end of the eigh-
teenth century that scientists had not—could not—uncover all the mystery and
splendor the world has to offer, journeys of discovery decisively transformed rep-
resentations of nature, the traveler's relationship to the spaces traversed, and more
broadly, humankind's understanding of its place in the universe.[23]

Edouard Kopp

Figs. 6–7
John Webber (1750–1793), *Interior of Habitation at Nuu-chah-nulth Sound*, April 1778. Black ink, watercolor, and white gouache, 25.4 × 48.5 cm (top); black ink and gray wash over black chalk, 18.3 × 43.9 cm (bottom). Peabody Museum of Archaeology & Ethnology, Harvard University, Gift of the Estate of Belle J. Bushnell, 1941, 41-72-10/499–500. (Detail on p. 59.)

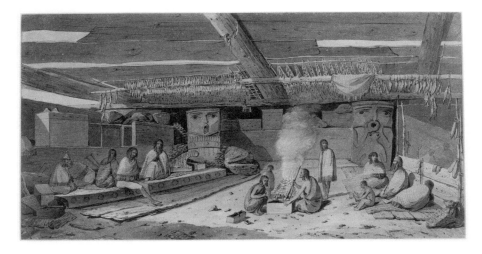

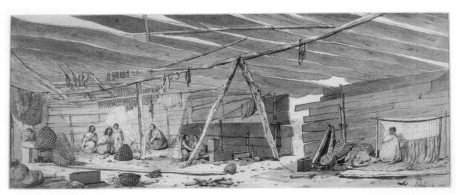

1. Marie-Noëlle Bourguet, "L'explorateur," in *L'homme des Lumières*, ed. Michel Vovelle (Paris: Éditions du Seuil, 1996), 285–346.

2. Daniel A. Baugh, "Seapower and Science: The Motives for Pacific Exploration," in *Background to Discovery: Pacific Exploration from Dampier to Cook*, ed. Derek Howse (Berkeley: University of California Press, 1990), 1–55.

3. While latitude could be determined relatively easily from the height of the sun, longitude was much harder to calculate at sea. This had increasingly preoccupied sailors and natural philosophers since the seventeenth century. To measure longitude required very accurate technology along with careful observations and complicated calculations of the positions of the moon and stars. See William J.H. Andrewes, ed., *The Quest for Longitude* (Cambridge, Mass.: Collection of Historical Scientific Instruments, Harvard University, 1993); and Katy Barrett, "Looking for 'the Longitude,'" *British Art Studies* 2 (2016), https://doi.org/10.17658/issn.2058-5462/issue-02/kbarrett.

4. Rob Iliffe, "Science and Voyages of Discovery," in *Cambridge History of Science*, Vol. 4: *Eighteenth-Century Science*, ed. Roy Porter (Cambridge: Cambridge University Press, 2003), 618–46, esp. 620.

5. During the expedition, Norden corresponded with noted antiquarian, art collector, and diplomat Philipp von Stosch, who had become a mentor to him after the pair met in Florence years earlier. Stosch spurred Norden's interest in Egyptian antiquity.

6. See Marie-Louise Buhl, *Les dessins archéologiques et topographiques de l'Egypte ancienne faits par F.L. Norden 1737–1738* (Copenhagen: Det Kongelige Danske Videnskabernes Selskab, 1993).

7. Norden specifically requested that Tuscher, an associate of Stosch, work on the project. The drawing on which Tuscher based *A Profile View of the Colossal Head of the Sphinx at Giza* is reproduced in ibid., no. 47, p. 93.

8. See Paul John Frandsen, *"Let Greece and Rome Be Silent": Frederik Ludvig Norden's Travels in Egypt and Nubia, 1737-1738* (Copenhagen: Museum Tusculanum Press, 2019). Well-disseminated, Norden's book was published in French, English, and German between 1755 and 1779 alone.

9. On this topic, see Neil Safier, *Measuring the New World: Enlightenment Science and South America* (Chicago: University of Chicago Press, 2012). Several French and Spanish publications resulted from the Geodesic Mission, notably those by Pierre Bouguer, by Charles-Marie de la Condamine, and by Jorge Juan y Santacilia and Antonio de Ulloa y de la Torre-Guiral.

10. The print is inscribed at bottom: *Ce Globe mal connu qu'il a sçu mesurer / Devient un Monument où sa gloire se fonde / Son sort est de fixer la figure du monde / De lui plaire et de l'éclairer. / Par Mr de Voltaire* (This little-known globe that he found a way to measure / Becomes a monument to his glory / His fate is to determine the figure of the earth / To please the world and to enlighten it).

11. No fewer than 120 scientists located in different parts of the world are recorded to have observed the transit of Venus in 1761; in 1769, 150 witnessed it. See Harry Woolf, *The Transits of Venus: A Study of Eighteenth-Century Science* (Princeton, N.J.: Princeton University Press, 1959), 135-40 and 182-87, respectively.

12. On Pingré, see Jean-Michel Racault, "L'observation du passage de Vénus sur le soleil. Le voyage de Pingré dans l'Océan Indien," *Dix-huitième siècle* 22 (1990): 107-20. For an account of Chappe d'Auteroche's expedition, see Jean-Baptiste Chappe d'Auteroche, *Voyage en Sibérie fait par ordre du Roi en 1761*, 3 vols. (Paris: 1768).

13. Guillaume Joseph Hyacinthe Jean Baptiste Le Gentil de la Galaisière, *Voyage dans les mers de l'Inde*, vol. 1 (Paris: 1779-81), 256, 261. See also Woolf, *The Transits of Venus*, 129.

14. James Cook in J. C. Beaglehole and Philip Edwards, eds., *The Journals of Captain Cook* (London: Penguin Books, 1999), 333.

15. The inscription on the Woollett print clearly states that the composition was "Drawn from Nature by W. Hodges." None of Hodges's Easter Island drawings have survived; see John McAleer and Nigel Rigby, *Captain Cook and the Pacific: Art, Exploration & Empire* (New Haven, Conn.: Yale University Press, 2017), 136. On the art from this expedition, see Rüdiger Joppien and Bernard Smith, *The Art of Captain Cook's Voyages*, vol. 2 (New Haven, Conn.: Yale University Press, 1985), 74-76; and Geoff Quilley and John Bonehill, eds., *William Hodges, 1744-1797: The Art of Exploration* (New Haven, Conn.: Yale University Press, 2004), 106-7.

16. Hodges would later spell out his image making ethos in the context of expeditions: "[T]he imagination must be under the strict guidance of cool judgement, or we shall have fanciful representations instead of the truth." See William Hodges, *Travels in India, during the Years 1780, 1781, 1782, and 1783* (London: 1794), 153.

17. Harriet Guest, *Empire, Barbarism, and Civilisation: James Cook, William Hodges, and the Return to the Pacific* (Cambridge: Cambridge University Press, 2007), 5.

18. See Glyndwr Williams, "The Achievement of the English Voyages, 1650-1800," in Howse, *Background to Discovery*, 73.

19. James Cook, *Voyage to the Pacific Ocean*, vol. 1 (London: 1784), 5.

20. See William Frame with Laura Walker, *James Cook: The Voyages* (Montreal: McGill-Queen's University Press, 2018), 167.

21. See William Hauptman, *John Webber, 1751-1793: Landschaftsmaler und Südseefahrer. Pacific Voyager and Landscape Artist* (Bern: Kunstmuseum Bern, 1996), 134; and Rüdiger Joppien, "John Webber's South Sea Drawings for the Admiralty: A Newly Discovered Catalogue among the Papers of Sir Joseph Banks," *The British Library Journal* 4 (1) (Spring 1978): 49-77.

22. See David I. Bushnell, Jr., "Drawings by John Webber of Natives of the Northwest Coast of America, 1778," *Smithsonian Miscellaneous Collections* 80 (10) (March 1928): 4.

23. François Moureau, "L'oeil expert: Voyager, explorer," *Dix-huitième siècle* 22 (1990): 10-11.

Edouard Kopp

FLIGHT

Elizabeth Saari Browne

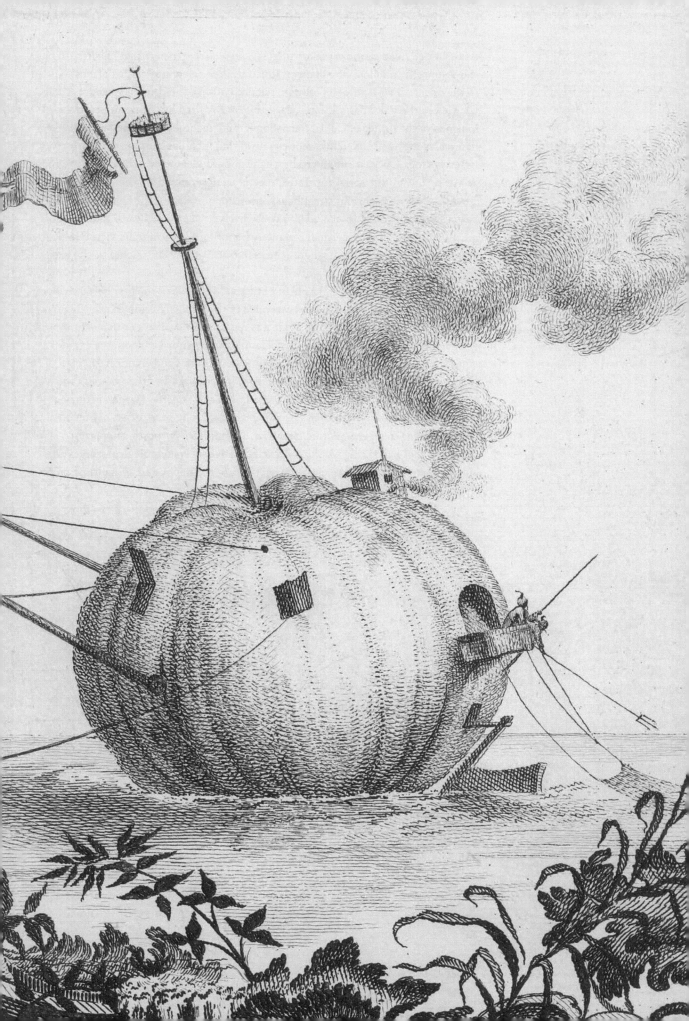

As described in its caption, the etching *La rentrée du char triomphant* (The Return of the Triumphant Balloon) by Mancest illustrates the celebrated return of a balloon to the *cabinet de physique* of its captain, science enthusiast Jacques-Alexandre-César Charles, in the Place des Victoires, Paris (Fig. 1). Escorted by the torch-bearing footmen of the prince of Conti, the balloon, more technically referred to as an aeronautical globe, is attended by a motley crowd that includes laurel-bearing fishwives in heavy clogs, a beggar supported by a cane and wooden prosthesis, a child excitedly gesturing toward the aerial apparatus, spectators observing from their apartment windows, and even curious street dogs. Borne upon a chariot, the balloon is paraded past a swelling throng, indicated by a dense mass of half-dome heads. The scene recalls a Roman Triumph, a civil ceremony honoring a homecoming victor: here, the balloon itself returns from its flight (the path traced in the cartouche), as the text concludes, "with the greatest glory."[1]

Invented by brothers Joseph and Étienne Montgolfier, the first hot-air balloon (eponymously called a *montgolfière*) ascended to the skies of Annonay, near Lyon in southern France, on June 4, 1783. Yet it was not until December 1 of that year that the people of Paris witnessed the official launch of a manned balloon, the event commemorated in Mancest's etching.[2] Piloted by Charles and engineer Nicolas Marie-Noël Robert, the balloon, inflated with hydrogen rather than hot air (and known, colloquially, as a *charlière*), launched from the Tuileries Garden before an estimated four hundred thousand people, realizing a long-held dream of human flight presaged to serve scientific, practical, and military purposes. Supporters predicted that ballooning would, for instance, advance meteorological studies and aid commerce, and could be used to better survey geography and agriculture, more

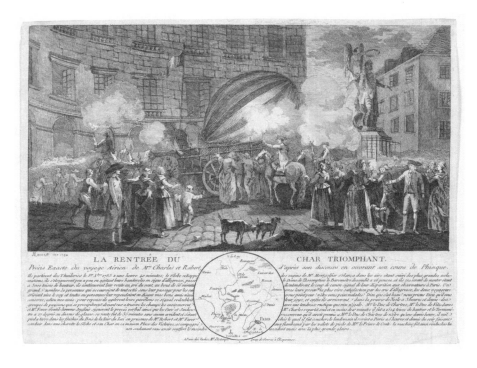

Fig. 1
Mancest (active late 18th century), *La rentrée du char triomphant* (The Return of the Triumphant Balloon). Etching, sheet: 21.5 × 28 cm. Yale University Art Gallery, New Haven, Conn., Purchased with a gift from Allan Appel and Suzanne Boorsch in memory of Georges May, 2003.148.2.

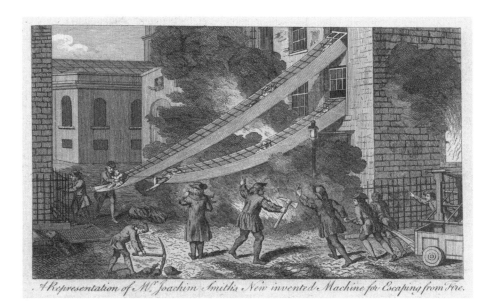

Fig. 2
Unidentified artist, *A Representation of Mr. Joachim Smith's New Invented Machine for Escaping from Fire.* Engraving, sheet: 12.7 × 19.1 cm. Yale Center for British Art, New Haven, Conn., Paul Mellon Collection, B1977.14.18692.

directly transport mail, help an airborne army defeat unsuspecting ground troops, and even rescue upper-floor occupants from disastrously common house fires (a plan substituted by the far more practical chute of Joachim Smith; Fig. 2). As public demonstrations, balloon launches were also commercialized: spectators purchased aeronautical goods, such as scientific instruments and commemorative souvenirs, and styled themselves in fashions and coiffeurs *à la montgolfière*. Furthermore, cultural capital could be amassed by attending the event, by possessing knowledge of ballooning physics, or by ascending into the air oneself.[3] Although France was first in flight, ballooning quickly became a global phenomenon, and in the 1780s, balloons were launched all over the world, including in Naples, Barcelona, Oaxaca, Moscow, Ghent, Dublin, Baltimore, and Cap Français, Saint-Domingue (present-day Cap-Haïtien, Haiti; see p. 288). By 1785, aeronaut Jean-Pierre Blanchard had demonstrated the vehicle's capacity for international travel, crossing the English Channel from Dover to Calais on January 7.

Even before the dream of human flight was realized, the fantasy stimulated political imaginings in philosophy and fiction. In works such as John Wilkins's *Discovery of a World in the Moone* (1638), Cyrano de Bergerac's *Voyages to the Moon and the Sun* (1657/62), Jean-Jacques Rousseau's *The New Daedalus* (1742), Voltaire's *Micromégas* (1752), Rudolf Erich Raspe's *The Surprising Adventures of Baron Munchausen* (1781), and Nicolas Edme Restif de la Bretonne's *The Discovery of the Austral Lands by a Flying Man; or, the French Daedalus* (1781), the trope of air travel was employed to offer a bird's-eye (or interstellar) view on the social and cultural conditions of Europe, or as a means of escaping oppressive regimes, accomplished by flight to foreign or even cosmic locales.[4] Following the astronomical advances of the seventeenth century, when Galileo Galilei first observed the lunar surface through a telescope, evidence of mountains and lakes (craters) on the moon supported the hypothesis of many that life existed, or could exist, on other planetary bodies.

Elizabeth Saari Browne

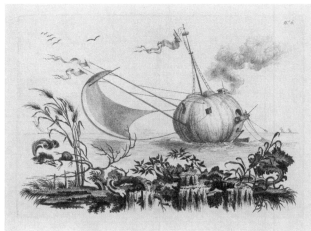

Figs. 3–4
Filippo Morghen (1730–after 1807),
Title plate (left) and *Zucca che serve
per barca da Pescare* (A Pumpkin
Used as a Fishing Boat) (right),
from the series *Raccolta delle cose
più notabili vedute dal Cavaliere Wild
Scull, e dal Sigr. de la Hire nel lor famoso
viaggio dalla Terra alla Luna* (Suite
of the most notable things seen
by Cav. Wild Scull and Sig. de la
Hire on their famous voyage from
the Earth to the Moon), 1766–67.
Etching, plates: 27.5 × 37.6 cm
(left) and 28 × 38.8 cm (right). Yale
University Art Gallery, New Haven,
Conn., Everett V. Meeks, B.A.
1901, Fund, 2012.19.1.1, 2012.19.1.7.
(Detail on p. 69.)

IMAGINATION

Still, artists and writers relied on European conceptions of cultural dif-
ference to distinguish themselves in picture and prose from these alien beings.
Wilkins, for instance, suggested that "the inhabitants of [the moon] are not men as
wee are, but some other kinds of creatures which beare some proportion and like-
nesse to our natures."[5] In a suite, or *raccolta*, of ten etchings supposedly recording
"the most notable things seen by Cav. Wild Scull [the above-mentioned Wilkins,
author of *Discovery of a World in the Moone* and founder of the Royal Society] and
Sig. de la Hire [French astronomer Philippe de la Hire] on their famous voy-
age from the Earth to the Moon," the artist likewise assumed hominal similarity
between earthlings and extraterrestrial beings.[6] Etched by Florentine artist Filippo
Morghen—though perhaps designed by French painter Pierre-Louis-Laurent
Houël, as Amy Worthen has argued—the suite envisions the two Europeans' imag-
ined flight to the moon, accomplished through a sort of wooden box with wings
like folding fans (Fig. 3; in the third edition of the series, a hydrogen balloon would
be added to their spaceship).[7]

In these fantastical etchings of lunar landscapes and the creatures that
inhabit them, the artist also demonstrated his own flight—one of fancy. Defined in
the eighteenth century as an unrestrained imagination 👁 characterized by spon-
taneity and improvisation, fancy was thought to also tend toward "excess, oddness,
irrationality," and perhaps even toward the most extreme folly, lunacy, occasioned
by the waxing and waning of the moon.[8] The vignettes of the *raccolta* gravitate
toward this capriciousness. Staged upon imaginative rocaille platforms of damp
and dripping verdure that blur the boundaries of the viewer's space and the printed
celestial space, the moon as envisioned in the series is home to winged serpents,
outsize vermin, palm trees, elephants, and giant turtles, as well as habitations made
of pumpkins and boats propelled by enormous bellows and birds (Fig. 4). Following
Wilkins's assumption, the men in these vignettes "are not men as wee [Europeans,
such as Cav. Wild Scull and Sig. de la Hire] are." To signify their difference, the
artist accorded the lunar inhabitants attributes associated with peoples from Asia
and the Americas, such as mustaches and queues, turbans, and long smoking pipes;
he also placed them in a more "primitive" state (referring to them in the legend as

selvaggio, or wild) by depicting them nearly nude and engaging in hunting, sailing, and fishing, the labor of "nature" rather than "culture." Far from an unbiased record, or even pure speculative fancy or fiction, the images of the *raccolta* reinforce Eurocentric period beliefs about historical and geographical development, to say nothing of the ways they essentialize and devalue groups of people. In the frontispiece, the elegantly dressed La Hire presents his flying apparatus to elderly sages who consult their ancient calculations while an exoticized individual in the background advances upon the scene, a compositional arrangement that posits European progress—in flight and in general—at a (literal) universal scale.

The space race would not, of course, begin in earnest for another two centuries. Yet the contest for and colonization of other territories rapidly accelerated in the eighteenth century, a practice that could also be abetted by flight. For instance, in Restif de la Bretonne's utopian novel, published just two years before balloon flight was realized, protagonist Victorin invents a set of mechanical wings that he uses to establish a new republic, first on an otherwise inaccessible cliffside and then in the distant Austral islands (Fig. 5). Inspired by the recent South Sea voyages and travel accounts of Captain Cook and Louis-Antoine de Bougainville ☉, these lands existed, for Restif, beyond the purported reach of established European class hierarchies and laws. On the islands, Victorin and his son Alexandre encounter nocturnal humans, whom they tame, and establish commercial trading with genteel giants (one of whom Alexandre marries). They capture various human-animal hybrids—including creatures half bear, half pig, half frog, half snake, half elephant, half tiger, and half oyster—and fly them back to Victorin's primary island. There, they integrate these beings into Victorin's civilization through teaching and breeding, then return them to their islands of origin to spread his ideals and genetics. Like the Daedalus of Ovid's *Metamorphoses*, Victorin created his wings to escape unjust rule.[9] Restif's "French Daedalus," however, perpetuates hierarchies and structures that he claims to flee. In Victorin's empire, status is conferred neither by rank nor by wealth; it is determined by what is assumed to be technological and commercial progress and human improvement, accomplished through proto-capitalist and proto-eugenic ends.

Even the most didactic eighteenth-century accounts of flight presuppose its implications for European advantage. Though the text of *La rentrée du char triomphant* claims to provide a disinterested and scientific account of the event—an "exact report . . . according to his [Charles's] speech given at the opening of his physics course"[10]—Mancest's composition is nonetheless suggestive of the anticipated potential of the balloon to realize cultural and political change. The artist sets a scene in which people and science triumph over royal power and superstition. This is particularly evident in the juxtaposition of the balloon with the seventeenth-century statue of Louis XIV by Martin Desjardins, the latter relegated to the right of the print. Desjardins's tribute is overlooked by the diverse crowd, whose density obscures the sculpted captives chained at the monument's base, symbolic of the nations defeated by Louis XIV in the Franco-Dutch War: Spain, the Holy Roman Empire, Brandenburg, and Holland. Unlike the imprisoned bronze figures, whose faces express revolt, grief, and resignation, the French men and women in the crowd are free to imagine, delight in, and wonder at their

Elizabeth Saari Browne

Fig. 5

Fig. 5
Nicolas Edme Restif de la Bretonne
(1734–1806), Frontispiece to *La
découverte australe par un homme volant*
(The Discovery of the Austral Lands
by a Flying Man) (Paris: Leïpsick,
1781). Engraving in bound book,
18.2 × 11 cm. Houghton Library,
Harvard University, Gift of Francis
Greenwood Peabody, 1952, GEN
*FC7.R3135.781d (A).

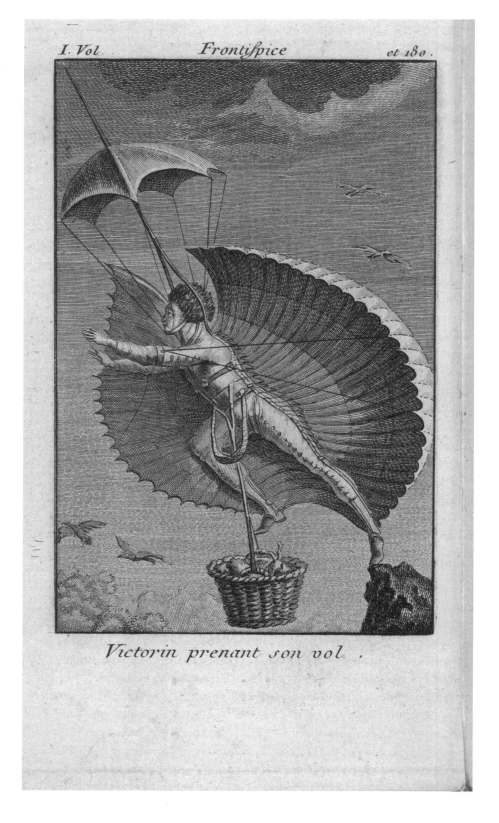

Victorin prenant son vol .

country's scientific and social future. Facing away from this marvel of human ingenuity and daring, the statue and stature of Louis XIV are eclipsed by the balloon, illuminated by flames that cast the Sun King—symbolic of the unenlightened, absolutist ancien régime—into shadow.

1. In the original French: "avec la plus grande gloire."

2. The viewing of an earlier manned flight, in a *montgolfière* piloted by Pilâtre de Rozier on November 21, 1783, was limited to the royal family and their retinue. On the history of ballooning, see Michael R. Lynn, *The Sublime Invention: Ballooning in Europe, 1783–1820* (London: Pickering & Chatto, 2010).

3. For the scientific and commercial potential of ballooning, see ibid.; and Bernadette Bensaude-Vincent and Christine Blondel, eds., *Science and Spectacle in the European Enlightenment* (Burlington, Vt.: Ashgate, 2008).

4. On the balloon as a vehicle for techno-scientific and political utopias, advanced first in fiction, see Mi Gyung Kim, *The Imagined Empire: Balloon Enlightenments in Revolutionary Europe* (Pittsburgh: University of Pittsburgh Press, 2016).

5. John Wilkins, *The Discovery of a New World; or, A Discourse Tending to Prove that 'tis Probable there may be Another Habitable World in the Moon*, vol. 1 (London: T. M. & J. A. for J. Gillibrand, 1684), 145; originally published as *The Discovery of a World in the Moone; or, A Discourse Tending to Prove, that 'tis probable there may be Another Habitable World in that Planet* (London: Printed by E. G. for Michael Sparke and Edward Forrest, 1638).

6. Amy Worthen recognized "Wild Scull" as John Wilkins; see Amy N. Worthen, "Filippo Morghen, after Houël's *Raccolta delle cose più notabilit*," in *A Perspicacious Tenure: Suzanne Boorsch at Yale*, ed. Elisabeth Hodermarsky and Tiffany Sprague (New Haven, Conn.: Yale University Art Gallery, 2018), 68.

7. See ibid., 67–73. Worthen (at p. 69) points out the addition of the hydrogen balloon to the frontispiece of the third edition.

8. Melissa Percival, introduction to *"Fancy" in Eighteenth-Century European Visual Culture*, ed. Melissa Percival and Muriel Adrien, Oxford University Studies in the Enlightenment (Liverpool: Liverpool University Press, 2020), 3.

9. Ovid recounted the story of Daedalus in Book 8 of the *Metamorphoses* (8 CE). Daedalus created wings to flee the unjust rule of King Minos of Crete, as well as to escape the human-animal hybrid (the Minotaur) that he had been forced to keep trapped in a labyrinth.

10. "Précis exacte du voyage aërien de Mrs. Charles et Robert, d'après son discours en ouvrant son cours de physique."

Elizabeth Saari Browne

GEOGRAPHY

J. Cabelle Ahn

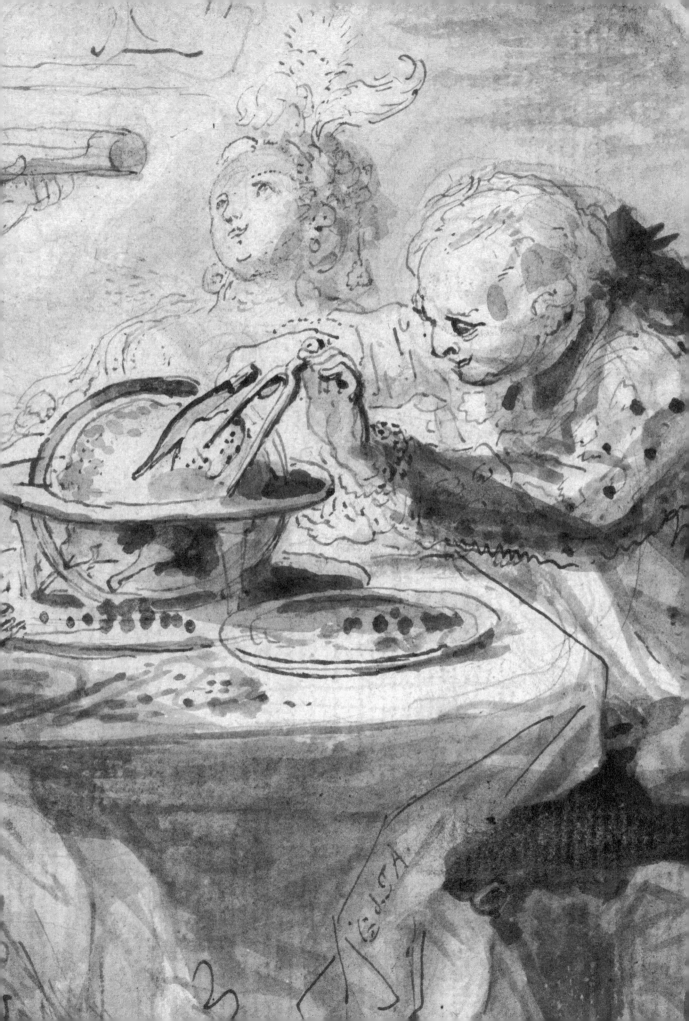

To survey geography *in* the Enlightenment is to reconsider the geography *of* the Enlightenment. Geography is a system of knowledge that takes the graphic arts as its primary tools (a fact made evident by its original Greek suffix, *graphia*) and remains foundational to how the world is described, analyzed, and controlled. One of the defining characteristics of the European Enlightenment was its dependence on geographic thinking. Jean le Rond d'Alembert, co-editor of the *Encyclopédie*, defined his magisterial publication as "a kind of world map."[1]

Although the once commanding prominence of geography as an academic discipline seems to have waned today (Harvard, for instance, disbanded its program in 1948), the field has covertly remained an apparatus of power. For example, communities in the United States still feel the effects of redlining, a discriminatory federal policy that used complex socioeconomic data projected onto maps to deny mortgage loans to underrepresented groups in the wake of the Depression. In recent years, increasing attention has been paid to critical geography, a branch that seeks to root out inequality and promote social change. The Decolonial Atlas, a project founded in 2014, creates thematic maps with renamed and redrawn borders that debunk the presumed neutrality of geographic practice.[2] Even the visual form of maps has been called into question: as recently as March 2021, astrophysicist J. Richard Gott proposed a new double-sided map that presents the world in two disks, an attempt to fix distortions in the ubiquitous Mercator projection.[3] Through a critical lens, this essay charts the primacy of the graphic arts in geographical thinking and foregrounds the hidden systems of mythmaking embedded in the discipline.

The vast purview of geography is encapsulated in the subject's entry in the *Encyclopédie*, which includes Natural, Historical, Civil and Political, Sacred, Ecclesiastical, and Physical subsections.[4] Geography served as a philosophical awning as well, even spurring French publisher and writer Charles-Joseph Panckoucke to produce extensions of the *Encyclopédie* under the subheadings *Géographie ancienne* and *Géographie moderne*. The discipline's popularity among philosophers is acutely lampooned in Gabriel Jacques de Saint-Aubin's drawing of a dinner party in which the host uses a compass and scalpel to carve up a roast capon served in the armature of a globe (Fig. 1). Here, the era's vociferous appetite for cartographic, scientific, and geographic knowledge leads the guests to consume geography itself ◉.[5] The potency of this image is underscored in James Gillray's well-known satirical cartoon *The Plumb-Pudding in Danger* (1805), which depicts British prime minister William Pitt and Napoleon Bonaparte cutting up a globe-shaped plum pudding—an obvious allegory of the conflict between the two nations' imperialistic ambitions.

The globe, a ubiquitous stand-in for geography conspicuously featured in Augustin Pajou's portrait of famed naturalist Georges-Louis Leclerc, Comte de Buffon (see p. 163), takes on a subtler character in John Brown's *The Geographers* (Fig. 2), a grisaille drawing of men poring over a blank portfolio. Their slumped posture—far removed from the expected physicality of an explorer-cartographer—is comparable to the agonizing psychological topography immortalized in Francisco Goya's *El sueño de la razón produce monstruos* (The Dream/Sleep of Reason Produces Monsters; p. 106). The link between geography and philosophy is further reinforced by the teachings of German philosopher Immanuel Kant, who lectured on geography

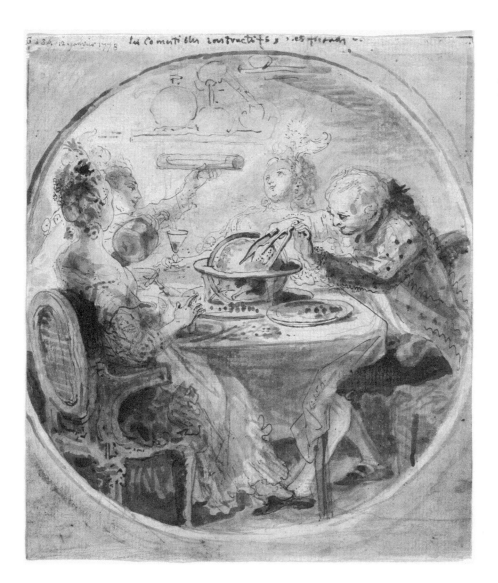

Fig. 1
Gabriel Jacques de Saint-Aubin
(1724–1780), *The Instructive and
Appetizing Meal: Voltaire and Three
Dinner Companions(?)*, 1778. Black
and brown ink and gray wash on
off-white antique laid paper, 18.5 ×
15.2 cm. Harvard Art Museums/Fogg
Museum, Gift of Charles E. Dunlap,
1955.189. (Detail on p. 77.)

more times than on any other topic in his lifetime (including forty-nine lectures
between 1756 and 1796). Incidentally, these were his most popular and best-attended
courses. For Kant, geography, together with anthropology, was a core building
block of knowledge, central to his students' education.[6] Brown's drawing captures
this inherent paradox of geography, a metaphysical discipline built on its graphic
by-products.

While cartography, the science of mapmaking, is one of the primary branches
of geography, examining the business of creating, disseminating, and consuming
maps reveals that they were far from objective mirrors of the visible world. In the
eighteenth century, Paris and London supplanted Amsterdam as capitals of the
European map trade.[7] Just as the historiography of the Enlightenment has been
Francocentric, John Brewer has demonstrated that geographic textbooks available to
the reading public in this period were statistically centered on France. The Cassini

J. Cabelle Ahn

Fig. 2
John Brown (1749–1787), *The Geographers*. Gray and black ink, gray wash, and graphite, sheet: 18.1 × 25.7 cm. Yale Center for British Art, New Haven, Conn., Paul Mellon Collection, B1977.14.4152.

family further positioned Paris as the epicenter of cartography via their *Carte de France* (1750–1815), a colossal endeavor printed on 182 separate sheets and identified as the first complete cartographic survey of a nation using triangulation.[8] Maps were essential to how the Bourbon monarchs consolidated power throughout the century; for example, all provincial maps were amassed and corrected under Louis XIV, which facilitated central governance over economic planning, allocation of natural resources, and even ecclesiastical structure.[9] The impact of maps is particularly evident in the case of the partition of the Polish-Lithuanian Commonwealth. As the territory was divided among Prussia, Austria, and Russia from 1772 to 1795, maps cemented and contributed to the disappearance of national borders, effectively dissolving a nation.

This compulsion for mapmaking extended beyond the terrestrial to the celestial. The most famous case of both is the still-surviving pair of colossal globes—one terrestrial, the other celestial—made by Italian mapmaker Vincenzo Coronelli and gifted by Cardinal César d'Estrées to Louis XIV in 1683. With a diameter of four meters, the terrestrial globe was embellished with visualizations of travelers' accounts and allegories that exalted the cartographic reach of the French empire, while the celestial globe memorialized the constellations on the king's birthday.[10] Across the Channel, John Russell's drawings of the moon (see p. 250) and George Smith's map of a solar eclipse (Fig. 3) demonstrated a similar preoccupation with the celestial plane. The latter improved on eclipse maps by Edmond Halley (he of the famed comet). Bordered by twenty-four vignettes of the phenomenon in various cities, including Cork, Vienna, St. Petersburg, Boston, and Jerusalem, the image unites disparate geographies through their view of the sky.[11]

This new spatial understanding prompted renewed interest in sacred, classical, and fantastical geographies. Notable early modern exemplars include representations

of paradise in *mappae mundi* and Sandro Botticelli's infamous map of hell from Dante's *Inferno*. Frenchman George Psalmanazar launched an elaborate hoax in early eighteenth-century London by posing as a resident of Formosa (present-day Taiwan) and publishing *An Historical and Geographical Description of Formosa* (1704), later revealed to be entirely fictitious and thus replete with proto-Orientalist fantasies. Fictional geography in literature was largely facilitated by printed maps. For example, the first edition of Jonathan Swift's *Travels into Several Remote Nations of the World* (1726), better known as *Gulliver's Travels*, included five maps of the countries invented for the novel. Such prints endow the tales with a veneer of authenticity—a strategy previously used in Thomas More's *Utopia* (1516), which featured a woodcut map of the titular island—and interrogate the symbiotic relationship between fiction, truth, and (geo)graphic production.

How were maps made and studied? Geographical instruction unfolded on both domestic and institutional levels. In France, the École royale des ponts et chaussées was specifically established to promote cartography, and French architects and artists alike found the study of geography in their respective Académies indispensable to their artistic training.[12] The growing prevalence of overseas exploration prompted a geographic interest within the upper classes, inspiring the publication of maps, textbooks, and games. A key example of the last is a puzzle map of Asia by John Spilsbury (Fig. 4), who is often credited as the inventor of jigsaw puzzles. Initially called dissected maps, these early jigsaw puzzles were essentially engravings of maps pasted onto thin slivers of mahogany and cut along national borders. Spilsbury's maps of European countries, continents, and ancient geographies proved immensely popular and helped animate a subject previously learned through rote memorization. Around this time, John Jeffreys in London is attributed with inventing the first board game that had a map for a playing surface—a revision of the popular "Game of the

Fig. 3
George Smith (1700–1773), *The geography of the great solar eclipse of July 14 MDCCXLVIII: Exhibiting an accurate map of all parts of the Earth in which it will be visible with the North Pole according to the latest discoveries*, 1748. Engraving, 30 × 44 cm. Harvard Map Collection, Gift of J. Lovering, Mar. 13, 1849, MAP-LC G3211.B1 1748.S6.

J. Cabelle Ahn

Goose," but with nationalistic undertones.[13] Jane Austen illustrated the relevance of geographic games as a way of distinguishing the educated set in *Mansfield Park* (1814), in which the protagonist's cousins mock her inability to assemble a jigsaw puzzle map of Europe.[14]

This cartographic sensibility pervaded landscape compositions of the era. A prime instance may be Paul Sandby's landscape drawings and prints after them. These sheets are indelibly tied to his role as chief draftsman for the Military Survey of Scotland. Established in the wake of the Jacobite rebellion of 1745, this survey sought to systematically map Scotland as part of an overt political strategy to establish peace in the region by laying claim to the land. Sandby's role as surveyor and the exercising of cartography as an instrument of authority are thus imprinted on his later pastoral visions of the English, Welsh, and Scottish countrysides ◉.

The eighteenth century was a period of heightened focus on celebrating new canonical destinations for travel and discovery. For travelers embarking on the Grand Tour, visits to classical and geological sites of import were an essential part of the itinerary. The Bay of Naples, another favored stop for eighteenth-century British tourists, is captured with meticulous topographical fidelity in a panoramic watercolor by Giovanni Battista Lusieri (Fig. 5). It is one of three watercolors commissioned from Lusieri by the British envoy to the court of Naples, Sir William Hamilton, as a memento of his stay. Drawn on the spot over a period of two years, the image depicts the view of the bay from Hamilton's residence in the Palazzo Sessa. Previously, the

Fig. 4
John Spilsbury (1739–1769), *Asia in Its Principal Divisions*, 1767. Engraving and wood in 37 pieces, hand-colored, 44 × 47 cm. The British Library, London, Maps 188.v.13.

GEOGRAPHY

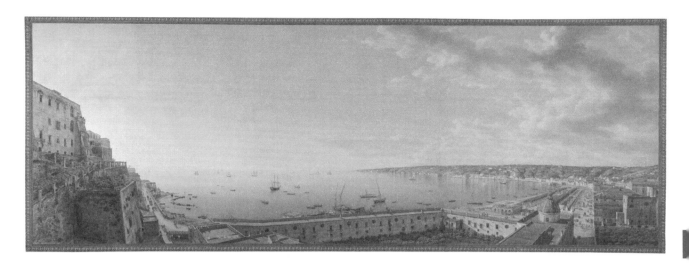

Fig. 5
Giovanni Battista Lusieri (c. 1755–1821), *A View of the Bay of Naples, Looking Southwest from the Pizzofalcone towards Capo di Posilippo*, 1791. Watercolor, gouache, graphite, and ink on six sheets of paper, 101.8 × 271.9 cm. J. Paul Getty Museum, Los Angeles, 85.GC.281.

incredible architectural detail was erroneously attributed to Lusieri's use of a camera obscura or telescope. In fact, this near photographic vista is the product of prolonged observation and the artist's mastery of pure watercolor.[15]

Throughout the Enlightenment, geographical knowledge—and the attendant specter of geopolitical engineering—infiltrated everything from the renovations of the gardens of Versailles, to military surveys, to parlor games. In the words of geographer Brian Harley, one of the foundational voices of critical cartography, "maps anticipate empire."[16] Indeed, drawings and prints have abetted rationalizations, disseminations, and consolidations of knowledge complicit in shaping national identities and facilitating geographic explorations founded on the exploitation of Indigenous and enslaved peoples. Parsing the graphic component of geographic production enables us to reconsider the discipline's assumed scientific objectivity and gain fresh insight into its role in accelerating imperialism across epochs and cultures.

The contemporary German artist and filmmaker Hito Steyerl has argued that the "calculable, navigable, and predictable" characteristic of linear perspective in maps facilitated the rise of linear time and the assumption of linear progress. She calls this reinvention of time and space "an additional tool kit for enabling Western dominance, and the dominance of its concepts."[17] Indeed, drawings of the visible world are still often embroiled in assumed scientific objectivity, which has long cloaked a Eurocentrism that defined the geography of the Enlightenment and continues to shape how we envision the globe today.

1. In the original French: "une espece de Mappemonde." Jean le Rond d'Alembert, "Discours Préliminaire," in *Encyclopédie, ou, Dictionnaire raisonné des sciences, des arts et des métiers*, vol. 1, ed. Denis Diderot and Jean le Rond d'Alembert (Paris: 1751–65), xv.

2. The Decolonial Atlas, https://decolonialatlas.wordpress.com.

3. Joshua Sokol, "Can This New Map Fix Our Distorted Views of the World?" *The New York Times*, February 24, 2021, https://www.nytimes.com/2021/02/24/science/new-world-map.html.

4. Didier Robert de Vaugondy, "Géographie," in *Encyclopédie, ou, Dictionnaire raisonné des sciences, des arts et des métiers*, vol. 7, ed. Denis Diderot and Jean le Rond d'Alembert (Paris: 1751–65), 613.

5. The bird is identified as a capon in Sarah Grandin, "Knowledge," in *Drawing: The Invention of a Modern Medium,* ed. Ewa Lajer-Burcharth and Elizabeth M. Rudy (Cambridge, Mass.: Harvard Art Museums, 2017), 274.

6. Stuart Elden and Eduardo Mendieta, eds., *Reading Kant's Geography* (Albany: State University of New York Press, 2011), 1.

7. David Woodward, *Maps as Prints in the Italian Renaissance: Makers, Distributors and Consumers* (London: British Library, 1997), 89; and Mary Sponberg Pedley, *The Commerce of Cartography: Making and Marketing Maps in Eighteenth-Century France and England* (Chicago: University of Chicago Press, 2005).

8. John Brewer, *The Pleasures of the Imagination: English Culture in the Eighteenth Century* (London: Routledge, 2013), 144–45; and Daniel Roche, *France in the Enlightenment* (Cambridge, Mass.: Harvard University Press, 1998), 20.

9. David Buisseret, *Monarchs, Ministers, and Maps: The Emergence of Cartography as a Tool of Government in Early Modern Europe* (Chicago: University of Chicago Press, 1992), 99.

10. The globes remained on display in the King's Library. See their inclusion in the building's plan in the *Recueil des Plans des Maisons Royales du Département de Paris 2,* now in the Morgan Library & Museum in New York (1955.12).

11. Smith published a short pamphlet to accompany the map, *A dissertation on the general properties of eclipses; and particularly the ensuing eclipse of 1748, considered thro' all its periods* (London: 1748). He previously published eclipse maps in the *Gentleman's Magazine,* which circulated these specialized diagrams to a wider audience.

12. Christian Michel, *The Académie Royale de Peinture et de Sculpture: The Birth of the French School, 1648-1793* (Los Angeles: Getty Research Institute, 2018), 91; Jacques-François Blondel's *Cours d'architecture,* particularly *De l'utilité de joindre à l'étude de l'architecture* (Paris: Veuve Desaint, 1771), 39–40; and Josef W. Konvitz, *Cartography in France, 1660-1848: Science, Engineering, and Statecraft* (Chicago: University of Chicago Press, 1987).

13. Jeffreys's game, A Journey through Europe; or, The Play of Geography (1759), is a precursor of the now popular board game Risk. Diane Dillon, "Consuming Maps," in *Maps: Finding Our Place in the World,* ed. James R. Akerman and Robert W. Karrow (Chicago: University of Chicago Press, 2007), 338–41.

14. Jane Austen, *Mansfield Park,* vol. 1 (London: T. Egerton, 1814), 33.

15. Carlo Knight, "Hamilton's Lusieris," *The Burlington Magazine* 135 (1085) (1993): 536–38; and Aidan Weston-Lewis et al., *Expanding Horizons: Giovanni Battista Lusieri and the Panoramic Landscape* (Edinburgh: National Galleries of Scotland, 2012), 29, 97–100.

16. John Brian Harley, "Maps, Knowledge, and Power," in *The Iconography of Landscape: Essays on the Symbolic Representation, Design, and Use of Past Environments,* ed. Denis Cosgrove and Stephen Daniels (Cambridge: Cambridge University Press, 1988), 288.

17. Hito Steyerl, "In Free Fall: A Thought Experiment on Vertical Perspective," *e-flux* 24 (April 2011).

René Lhermitte

Plan, Profile, and Layout of the Ship La Marie-Séraphique *from Nantes, France*

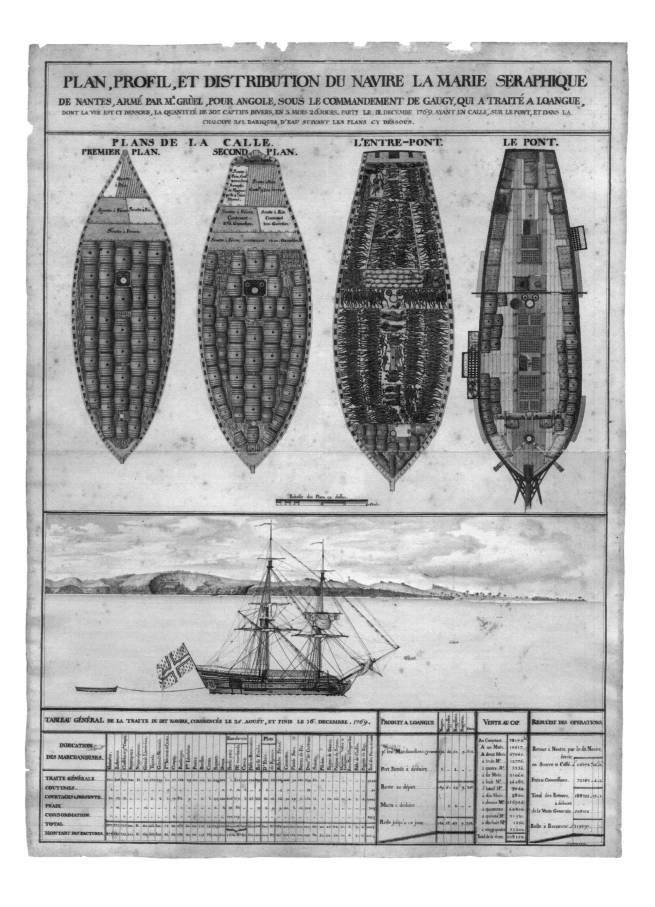

In the fall of 1769, the French slaving vessel *Marie-Séraphique* anchored in Saint-Domingue after a four-month journey from the Loango coast in West Africa. With a round, load-bearing hull to support its "human cargo," the *Marie-Séraphique* exemplified developments in eighteenth-century slave ship design, optimized for trafficking enslaved Africans across the Atlantic.[1]

To celebrate its successful journey, the owner of the ship commissioned second lieutenant René Lhermitte to make this water-color showcasing the vessel's construction. Using a very fine brush, Lhermitte emulated the graphic specificity of industry manuals, painting *Marie-Séraphique* like an engraved illustration. Tasked with commemorating the technical and financial triumphs of the ship, Lhermitte was unlikely to relay the true extent of its violence, yet his diagrams offer a glimpse of the vessel's crowded horrors.[2]

While the ledger at bottom translates the captive humans into tidy numbers and the ship's profile excludes them altogether, the deck plans figure each person. Their bodies, abstracted and anonymous, become the metrics that define the capacity of the ship. Lhermitte's graphic precision captures the mechanical grandeur of the *Marie-Séraphique* with a technical mastery that obfuscates the chilling experiences of the hold. In the uppermost register of *l'entre-pont*, how-ever, the silhouette of a mother with a child disrupts the pretense of diagrammatic objectivity. Her humanity underscores the anonymity of those around her, speaking to the tension inherent in the visual logics of slavery: neither subject nor object, the enslaved person was a liminal body. In the late eighteenth century, abolitionists began to appropriate the diagrammatic language of slave ships to expose this paradox.[3] The ship motif thus became a powerful testimony to and reminder of the abuses suffered behind cool emblems of technical innovation.

René Lhermitte (active 18th century), *Plan, profil et distribution du navire la Marie-Séraphique de Nantes* (Plan, Profile, and Layout of the Ship *La Marie-Séraphique* from Nantes, France), 1770. Ink and watercolor, 74.6 × 53.4 cm. Château des ducs de Bretagne, Musée d'histoire de Nantes, 2005.3.1.

1. Bertrand Guillet, *La Marie-Séraphique, navire négrier* (Nantes: Musée d'histoire de Nantes, 2009), 50.

2. Nicholas Radburn and David Eltis, "Visualizing the Middle Passage: The Brooks and the Reality of Ship Crowding in the Transatlantic Slave Trade," *Journal of Interdisciplinary History* 49 (4) (March 7, 2019): 533–65.

3. Cheryl Finley, "Form: Essential Elements," in *Committed to Memory: The Art of the Slave Ship Icon* (Princeton, N.J.: Princeton University Press, 2018).

Rachel Burke and Kéla Jackson

HUMAN

Ewa Lajer-Burcharth

The Enlightenment witnessed a radical reconceptualization of the human, a project that centered on the body as the locus of identity, diversity, sexuality, reproduction, and mental and moral functioning. Visual representation played a key role in this inquiry. More than mere illustrations, images served as agents of meaning, the active sites where new ideas about bodily difference and the less tangible aspects of personhood were formed. The diverse group of objects discussed in this essay demonstrates the important and complex ways in which the visual arts contributed to the study of the human.

The desire to systematize human diversity first emerged in the eighteenth century, a period marked by scientific development as well as travel, commerce, and conquest. Newly exposed to peoples from around the world, Europeans were inspired to construct a natural history of the human species. Yet this effort was far from ideologically innocent. The project's deep roots in Europe's colonial ambitions are evident in its relentless focus on the African body.[1] While humanity was divided into four distinct groups on the basis of skin color, it was the dark complexion of Africans that served as the favored differential factor—one that allowed most clearly to distinguish and define the white European.[2]

Over the course of the eighteenth century, the African body was submitted to an extensive anatomical investigation whose goal was to track and measure Blackness as a physical and physiological phenomenon.[3] Although the Enlightenment did not produce a monolithic account of Blackness, it helped construct an epistemology of difference based in the connection between skin color and cultural value that later crystallized into the notion of biological race ⊙.[4] Art and visual culture contributed significantly to the prejudicial construction of the Black body, albeit not without ambivalence and complexity.[5]

A stunning portrait of a Black sitter now in the Morgan Library & Museum exemplifies this ambivalence (Fig. 1).[6] The man is seated erect, his torso propped against the back of a chair, his head turned toward the viewer. His features—tall forehead; lively, roundish eyes; high cheekbones; short, broad nose; full lips—are drawn with great care and skill. But the task of rendering the color of his skin is what seems to have most absorbed the draftsman. An intricate pattern of strokes in *trois crayons* (black, red, and white chalk) registers every chromatic nuance of the man's dark complexion, to the point where one might consider this first and foremost a portrait of skin.

The scrupulous account of the sitter's face—and especially its insistent focus on skin—contrasting with the only sketchily suggested rest of his torso reveals the fraught position of the Black body in the Enlightenment discourse on the human. On the one hand, physiognomic accuracy may be seen as a sign of representational respect for the Black sitter and thus a testimony to the inclusiveness of the era's gaze on humanity. In this sense, the drawing relates to other eighteenth-century examples in which a Black subject is respectfully portrayed, such as Maurice-Quentin de La Tour's *Young Black Man Buttoning His Shirt* (Fig. 2).[7] At the same time, however, the Morgan drawing's avid registration of the man's complexion and its attention to certain physiognomic details (the glistening fleshiness of the lower lip, the

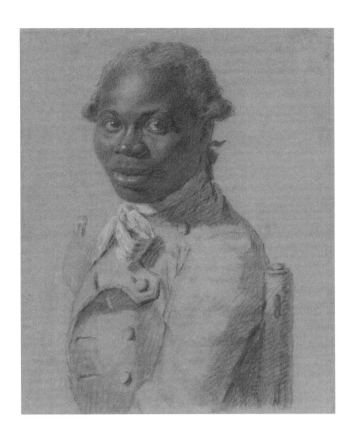

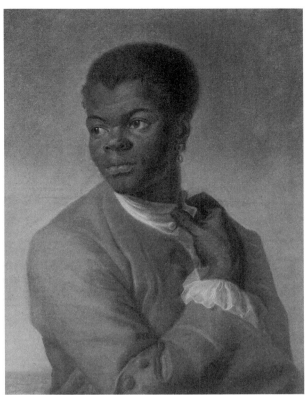

highlighted stubbiness of the nose) lead us to wonder where individuation ends and racial condescension begins. Is this mode of depiction motivated by the need to convey the sitter's physiognomic specificity, or by a desire to position him in relation to the presumed whiteness of the artist and viewer?

Insofar as stereotypically African facial features, such as a broad nose and full lips, were construed in the eighteenth-century pseudoscience of physiognomy as signs of aesthetic and moral inferiority, the draftsman's eager focus on these parts of the body cannot but be seen as prejudicial.[8] So may be the painstaking rendition of the man's complexion, given the period's intense scrutiny of Black people's anatomy. The draftsman's use of meticulous crosshatching to visually "locate" color on the sitter's face uncannily resembles the methods of natural scientists conducting epidermic dissections to determine where black pigment was stored.[9] This act of portrayal thus amounts to epistemic discrimination, turning an individual into an incarnation of race. Even the white cravat *à l'anglaise* tightened around the sitter's neck—a residual evocation of the slave collar worn by Black pages in portraits of the European elite— hints at degradation rather than elegance. (An indirect reference to slavery may also be seen in the curious gesture of La Tour's sitter, who fumbles with his shirt collar.)

Though no doubt a record of an encounter with a specific person, the Morgan drawing suggests that the Enlightenment gaze on the Black subject was inseparable from a desire to differentiate and distance this subject from the white self, resulting in a likeness that, while faithful and individualized, was inscribed by indelible alterity.

Fig. 1
Attributed to Joseph Ducreux (1735–1802), *Portrait of a Gentleman*, c. 1800. Black, brown, red, and white chalk on gray-blue laid paper, 52.1 × 41.3 cm. The Morgan Library & Museum, New York, Estate of Mrs. Vincent Astor, 2012.23.

Fig. 2
Maurice-Quentin de La Tour (1704–1788), *Young Black Man Buttoning His Shirt*, 1741. Pastel, sheet: 65 × 53.5 cm. Musée d'art et d'histoire, Geneva, Bequest of Edouard Sarasin, 1917, 1917-0028.

Ewa Lajer-Burcharth

The treatment of other people of color in the visual culture of the eighteenth century indicates that the period notion of alterity was, however, far from uniform.[10] Peoples native to North America, for example, performed a different function in the Enlightenment imagination than Africans. Rather than labeled inferior, Indigenous people were seen as a potential model for regenerating contemporary French society. They were associated with a "natural" mode of living characteristic of the eighteenth-century idea of the "noble savage," a role in which, notwithstanding its equally—if differently—othering effects, Africans were never cast.[11] First introduced by Michel de Montaigne in the sixteenth century, the concept of the *bon sauvage* gained traction during the Enlightenment search for the origins of society. In the writings of Jean-Jacques Rousseau, it served as a tool for critiquing modern civilization, in particular the contemporary mores and customs of the French.[12]

François-Robert Ingouf's *Canadians Weeping over the Tomb of Their Child* functions in a similar vein, conjuring the notion of the noble savage expressly for an eighteenth-century French audience (Fig. 3). Ingouf engraved the image after a painting by Jean-Jacques-François Lebarbier, who represented an Iroquois custom mentioned in Abbé Raynal's 1770 *Histoire philosophique et politique des établissements et du commerce des Européens dans les deux Indes* (A Philosophical and Political History of the Settlements and Trade of the Europeans in the East and West Indies). An excerpt from the volume inscribed on an edition of the print not pictured here describes the custom it portrays: according to the text, in the land that is now called Canada, Iroquois parents who had lost an infant would visit the grave six months after the child's death, and the mother would lactate over the burial site.[13] Rather than simply illustrate this practice, the image presents a primitivist fiction carefully calibrated for French eyes.[14] Set in a landscape evoking the Swiss Alps more than Canadian territory, the scene harks back to *Et in Arcadia ego*, Nicolas Poussin's classical vision of Arcadia in which shepherds likewise gather around a tomb. The Iroquois couple in Ingouf's print are also classicized, their sorrow fitted into European representational conventions. While the fair-skinned woman in antique garb squeezing milk from her breast conflates the iconography of Roman Charity and the Madonna, her melancholy darker-skinned spouse recalls the Hellenistic sculpture of the *Dying Gaul*. These resonances enhanced the universality of the Iroquois grieving practices, quickening the pace of the French viewer's identification with them. The thatched tent in the background and the man's attributes (the bow and quiver at his feet and the ball club hanging from the tree trunk) evoke a nature-bound existence, reinforcing the Rousseauian argument that, before the advent of property, Indigenous peoples were governed by natural laws. In this capacity, the couple provided a model to be emulated by Parisian society.

Subtending this vision of the noble savage was another cherished notion of the Enlightenment: sensibility. The result of an effort to formulate a universal understanding of human nature, the concept of sensibility bridged the domains of the physical and the moral, establishing causal connections "between the human body

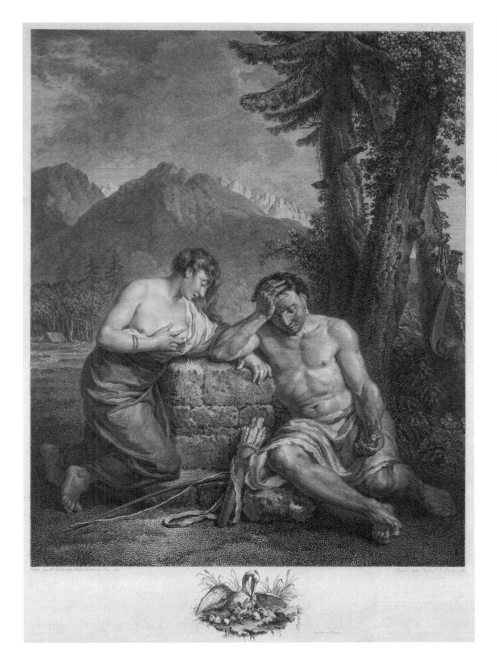

Fig. 3
François-Robert Ingouf (1747–1812), after Jean-Jacques-François Lebarbier (1738–1826), *Canadians Weeping over the Tomb of Their Child*, 1786. Engraving, sheet: 54.5 × 40.2 cm. Harvard Art Museums/ Fogg Museum, Gift of Belinda L. Randall from the collection of John Witt Randall, R7923. (Detail on p. 89.)

and the psychological, intellectual, and ethical faculties of human kind."[15] A physiological expression of grief, the flow of milk from the mother's breast is an eloquent illustration of *sensibilité* as a physical as well as moral phenomenon. Here, the milk does not provide nourishment to the long-dead infant, but like tears acts as a bodily substance that establishes the woman's emotional connection to her lost child. The improbability of the lactation, given its occurrence six months after the death of the child, underscores the secondary symbolic dimension of the female figure as an embodiment of sensibility, defined by the *Encyclopédie* as "the mother of humanity."[16] On another level, as a sign of irrecuperable loss, the Iroquois woman's gesture calls to

Ewa Lajer-Burcharth

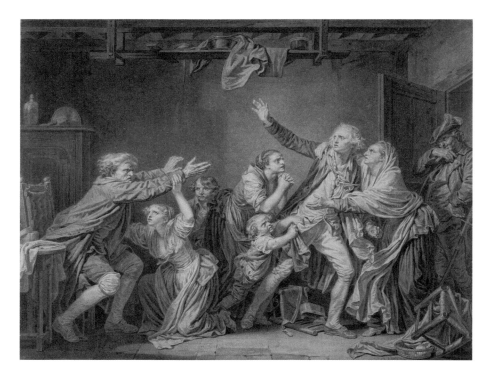

mind France's defeat in the Seven Years' War, when control of Canada, known then as New France, was ceded to Britain.[17]

It is the mother's double symbolic role—as an allegory of La Nouvelle France underwritten by *sensibilité*—that appealed to the French viewer. By depicting the milk actually spouting from her breast (a detail neglected in Lebarbier's painting), Ingouf introduced a trope of whiteness that, though incongruous with the woman's Iroquois identity, brought her blanched body closer to the French self. That the engraving was an instant commercial success when it was published in 1786 may have been a measure of the mother's resonance with the public.[18]

* *

No artist's oeuvre has been as closely associated with the notion of sensibility as that of Jean-Baptiste Greuze. His scenes of familial affection and conflict—subjects favored in the literature of *sensibilité*—proposed not only a new aesthetic but also a new cultural model of the human. Drawing both on conventions of history painting and on the study of the life model—practices uncommon for a genre painter—he developed a visual language based on the expressiveness of the whole body.[19] This approach marked a shift from the Cartesian mechanistic model that had informed Charles Le Brun's influential system of facial expressions to a vitalist, physiological understanding of affect associated with *sensibilité*. Displaying emotion as a corporeal process, Greuze's "living figures" (*figures vivantes*) appealed to the viewer more directly, at once physically and psychologically.[20]

The Father's Curse (also known as *The Ungrateful Son*) exemplifies this aspect of Greuze's work (Fig. 4). Set in a rural interior, the scene dramatizes a familial rift: the

oldest son is shown leaving his numerous family to join the army, while his father reacts in anger. With arms extended toward his son, the old man raises from his chair to deliver his curse. The son, looking back at his father, expresses astonishment and anguish. His mother and younger siblings implore him to stay; a toddler tears at his vest in an attempt to retain him. Another sister kneels by the father, trying to mitigate his wrath, while her younger brother looks on from behind, immobilized by fear. Leaning against the doorframe, the enlisting officer observes the scene with a smirk.

This highly finished drawing made in gray wash and squared for reproduction was executed by Greuze after his own 1777 painting to serve as a model for an engraver.[21] Though only about a third of the painting's size, the drawing renders the scene—including the figures' facial features—in even greater detail.[22] While this facilitated the task of the engraver, Greuze's careful attention to the family members' expressions also demonstrates that he was mindful of how the various figures would communicate their meaning to the viewer after their translation to another medium.

Presenting a human gallery of emotion, Greuze's composition invites the viewer to identify with any one of the family members.[23] The conflict between the main protagonists, however, prompts us to side with one of two factions. The son, having wreaked havoc in the family with his decision to enlist, is clearly at fault in this scenario; the father, justly indignant about it, is theoretically in the right. Yet Greuze's exaggerated, almost caricatural rendition of paternal wrath makes it hard to empathize with the patriarch. It is the son, portrayed as traumatized by the violence of his father's reaction, who is more likely to elicit our sympathy, despite his insensitive act. Confronted with a moral dilemma—who is it right to identify with?—we are thus left to solve it on our own.

This is where the ethical import of Greuze's work resides. By placing such decisions in the hands of the viewer, rather than with social institutions or divine authority, the artist contributed to the formation of an autonomous moral subject.[24] A basis for work destined for broad circulation, his drawing illustrates the active role of images in modeling new forms of humanity to the public.

* * *

If Greuze attests to art's ability to pose ethical problems, the anatomical atlas demonstrates the epistemological importance of images. Illustrated anatomical books are known to have existed since the Renaissance, but the publications that emerged in the eighteenth century distinguished themselves from their predecessors by their physical size and the preponderance of images over text. Introducing large-format engravings in unprecedented visceral detail, these volumes provided a new understanding of the female body as a site of human reproduction ◉. XXX

William Smellie's *Sett of anatomical tables* (1754), for instance, initiated a new way of visualizing pregnancy, from early stages to delivery.[25] Smellie, a Scottish physician, belonged to the rising professional class of man-midwives that emerged in mid-eighteenth-century Britain, when male doctors started to use their medical expertise and authority to establish themselves in an enterprise traditionally

Ewa Lajer-Burcharth

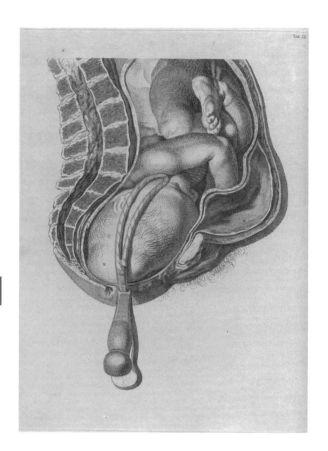

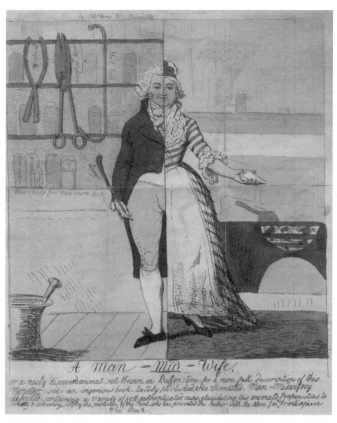

A Man — Mid — Wife.

or a newly discovered animal, not known in Buffon's time, for a more full description of this
Monster, see, an ingenious book lately published price 3/6 entitled, Man-Midwifery
dissected, containing a variety of well authenticated cases, elucidating this animal's Propensities to
cruelty & indecency, nobly by the midwife, by the Aunt, who has presented the Author with the Hove [in Frontispiece
to his Book.

Fig. 5
Charles Grignon, after Jan van Riemsdyk, Plate XXI, from *A sett of anatomical tables, with explanations and an abridgement, of the practice of midwifery, with a view to illustrate a treatise on that subject, and collection of cases*, by William Smellie (London: [1758] 1761). Engraving, sheet: 54.6 × 36.9 cm. Francis A. Countway Library of Medicine, Harvard Medical School, Rare Books ff, RG526.S34 1761 c.1.

Fig. 6
Isaac Cruikshank (1764–1811), Frontispiece to *Man-midwifery dissected; or, The obstetric family-instructor for the use of married couples and single adults of both sexes*, by Samuel William Fores (London: Samuel William Fores, 1793). Hand-colored etching, 24.5 × 19.5 cm. Francis A. Countway Library of Medicine, Harvard Medical School, RG93. F76.

reserved for women. Addressed specifically to male practitioners and anatomists, obstetric atlases played a key role in both the medicalization and masculinization of midwifery.[26] Smellie's atlas provided fresh insight into the woman's pregnant body by adopting a representational strategy inspired by dissection. In doing so, it grounded midwifery in the anatomical know-how of male practitioners, suggesting that the processes of gestation and childbirth involved irregularities and pathologies that only a doctor could treat.

Plate XXI of Smellie's atlas supports this argument (Fig. 5). It depicts forceps delivery, a procedure that was introduced and practiced exclusively by male accoucheurs. As the inventor of an improved version of forceps and a pioneer of related techniques, Smellie was well aware of the challenges posed by the instrument.[27] In the brief text accompanying the plate, he explains how forceps must be handled in order to properly deliver a wrongly positioned infant whose head has been deformed due to compression of the pelvis. It is telling how Smellie illustrates this delicate operation. By representing the maternal body as an anatomical fragment pushed up and partly off the page, the plate makes room for the full display of the forceps as a tool and token of man-midwives' obstetric authority. The very structure of the image enacts the cultural displacement of women from both the discursive realm of reproduction and childbirth and the professional domain of midwifery. The plate thus demonstrates that, in the *Sett of anatomical tables* and in similar illustrated atlases, visual representation was not a neutral tool for disseminating information about the

human body, but served more broadly as a powerful instrument for gendering the medical profession and knowledge.[28]

Isaac Cruikshank's caricature is a direct commentary on the re-gendering of midwifery (Fig. 6). This hand-colored print served as the frontispiece to Samuel William Fores's *Man-midwifery dissected; or, The obstetric family-instructor for the use of married couples and single adults of both sexes* (1793), a critique of male midwifery's impact on society.[29] Cruikshank mobilized the doubly resonant trope of dissection—the surgical procedure that helped elevate professional accoucheurs and the rhetorical strategy Fores used to denounce male midwifery—to represent a man-midwife as a split-figure "monster." One half a smartly dressed gentleman holding a lever for removing the child's head from the womb, the other half a woman brandishing a simpler, pear-shaped scooping device presumably used for the same purpose, this hybrid creature reveals the duplicity of the new profession. The contrast between the domestic setting of the midwife and the professionalized space of her male counterpart, with its ostentatious display of obstetric instruments, underscores the false pretenses of the accoucheur. It suggests that forceps, scissors, and hooks are mere accoutrements of an impostor laying claim to a practice that can be performed at home, without any complicated technology. Inscribed "For my own use," the lower shelf of the man-midwife's dispensary further compromises his reputation: vials of "Love water," "Eau de vie," "Cream of violets" and "Cantharides" (a topical solution used to treat warts) expose his incompetence and his seductive designs on his female clients.

Diverse as they are in their cultural status, medium, and purpose, the works discussed here demonstrate that visualization played a decisive role in recasting the understanding of the human in the Enlightenment.

1. Alexander Cook, Ned Curthoys, and Shino Konishi, "The Science and Politics of Humanity in the Eighteenth Century: An Introduction," in *Representing Humanity in the Age of Enlightenment*, ed. Alexander Cook, Ned Curthoys, and Shino Konishi (London: Pickering & Chatto, 2013).

2. Roxann Wheeler, *The Complexion of Race: Categories of Difference in Eighteenth-Century British Culture* (Philadelphia: University of Pennsylvania Press, 2000); and Andrew S. Curran, *The Anatomy of Blackness: Science and Slavery in an Age of Enlightenment* (Baltimore: Johns Hopkins University Press, 2011).

3. Curran, *The Anatomy of Blackness*, 2. See also Renato G. Mazzolini, "Skin Color and the Origin of Physical Anthropology (1640–1850)," in *Reproduction, Race, and Gender in Philosophy and the Early Life Sciences*, ed. Susanne Lettow (New York: SUNY Press, 2014), 131–61.

4. Nicholas Hudson, "From 'Nation' to 'Race': The Origins of Racial Classification in Eighteenth-Century Thought," *Eighteenth-Century Studies* 29 (3) (Spring 1996): 247–64; and Mazzolini, "Skin Color and the Origin of Physical Anthropology," 145.

5. David Bindman, *Ape to Apollo: Aesthetics and the Idea of Race in the 18th Century* (Ithaca, N.Y.: Cornell University Press, 2002); Anne Lafont, "How Skin Color Became a Racial Marker: Art Historical Perspectives on Race," *Eighteenth-Century Studies* 51 (1) (Fall 2017): 89–113; and Anne Lafont, *L'Art et la race: l'Africain (tout) contre l'oeil des Lumières* (Dijon: Les presses du réel, 2019). See also Mechthild Fend, *Fleshing Out Surfaces: Skin in French Art and Medicine, 1650–1850* (Manchester: Manchester University Press, 2017).

Ewa Lajer-Burcharth

6. We know little about this drawing. Its attribution to Joseph Ducreux is tentative, and although a tantalizing proposition in the Morgan curatorial files suggests that the drawing could represent renowned African abolitionist Olaudah Equiano, this identification remains speculative.

7. On La Tour, see Xavier Salmon, *Le voleur d'âmes: Maurice Quentin de La Tour* (Versailles: Artlys, 2004), 40; and Lafont, *L'Art et la race*, 147, 153–54.

8. On physiognomy, see Bindman, *Ape to Apollo*, 79–150.

9. On epidermic dissections, see Mazzolini, "Skin Color and the Origin of Physical Anthropology," 137–38.

10. Ibid., 135; and Lafont, *L'Art et la race*, 135–37.

11. Lafont, *L'Art et la race*, 135–37.

12. Jean-Jacques Rousseau, *Discours sur l'origine et les fondements de l'inégalité parmi les hommes* (Amsterdam: Marc Michel Rey, 1755).

13. "On voit quelque fois deux époux aller, après six mois, verser des larmes sur le tombeau d'un Enfant, et la Mère faire couler du lait de ses mamelles." (One sometimes sees the parents go, after six months, to weep over the tomb of their child, the mother letting the milk flow from her breast on it.) Abbé Guillaume-Thomas Raynal, *Histoire philosophique et politique des établissements et du commerce des Européens dans les deux Indes* (Geneva: J. L. Pellet, 1780), 22–23.

14. My discussion draws on the work of J. Cabelle Ahn, "A Postmortem Arcadia: Jean-Jacques Le Barbier, Abbé de Raynal and the Recollection of La Nouvelle France," Ph.D. qualifying paper, Harvard University, 2017.

15. Anne C. Vila, *Enlightenment and Pathology: Sensibility in the Literature and Medicine of Eighteenth-Century France* (Baltimore: Johns Hopkins University Press, 1998), 2.

16. Chevalier de Jaucourt, "Sensibilité, Sentiment [Morale]," in *Encyclopédie, ou, Dictionnaire raisonné des sciences, des arts et des métiers*, vol. 15, ed. Denis Diderot and Jean le Rond d'Alembert (Paris: 1751–65); cited in David Denby, "Sensibility," in *Encyclopedia of the Enlightenment*, vol. 4, ed. Alan Charles Kors (New York: Oxford University Press, 2003).

17. Ahn, "A Postmortem Arcadia."

18. On the print's commercial success, see Kristel Smentek, "Sex, Sentiment, and Speculation: The Market for Genre Prints on the Eve of the French Revolution," in *French Genre Painting in the Eighteenth Century*, ed. Philip Conisbee (Washington, D.C.: National Gallery, 2007), 229.

19. Edgar Munhall, *Jean-Baptiste Greuze, 1725–1805* (Hartford, Conn.: Wadsworth Atheneum, 1976), 170; and Willibald Sauerländer, "Pathosfiguren im Oeuvre des Jean-Baptiste Greuze," in *Walter Friedlaender zum 90. Geburtstag: Eine Festgabe seiner europäischen Schüler, Freunde und Verehrer*, ed. Georg Kauffmann and Willibald Sauerländer (Berlin: De Gruyter, 1965), 143–50.

20. Charles-Joseph Mathon de La Cour, *Troisième lettre à Monsieur* *** (Paris: 1765), 11; cited in Munhall, *Jean-Baptiste Greuze, 1725–1805*, 112n2. On Greuze's complex mode of address, see Kevin Chua, "Painting Paralysis: *Filial Piety* in 1763," in Conisbee, *French Genre Painting in the Eighteenth Century*, 170.

21. Edgar Munhall, *Greuze the Draftsman* (London: Merrell; New York: Frick Collection, 2002), 228.

22. Ibid.

23. Emma Barker, *Greuze and the Painting of Sentiment* (Cambridge: Cambridge University Press, 2005).

24. Emma Barker, "Putting the Viewer into the Frame: Greuze the Sentimentalist," in Conisbee, *French Genre Painting in the Eighteenth Century*, 118–20.

25. William Smellie, *A sett of anatomical tables, with explanations and an abridgement, of the practice of midwifery, with a view to illustrate a treatise on that subject, and collection of cases* (London: 1754).

26. Lyle Massey, "Pregnancy and Pathology: Picturing Childbirth in Eighteenth-Century Obstetric Atlases," *The Art Bulletin* 87 (1) (March 2005): 77.

27. Ibid.

28. In the rich literature on this topic, see the essential Ludmilla Jordanova, "Gender, Generation, and Science," in *William Hunter and the Eighteenth-Century Medical World*, ed. W. F. Bynum and Roy Porter (Cambridge: Cambridge University Press, 1985), 385–412; and Karen Newman, *Fetal Positions: Individualism, Science, Visuality* (Stanford, Calif.: Stanford University Press, 1996).

29. "Samuel William Fores," National Portrait Gallery, London, accessed January 18, 2021, https://www.npg.org.uk /collections/search/person /mp61380/samuel-william-fores.

Ewa Lajer-Burcharth

IMAGINATION

Edouard Kopp

Imagination—the capacity of the mind to conjure things not present to the senses, or to envisage that which is not real—enjoys an overwhelmingly favorable status in today's culture, where it carries such positive connotations as creativity, expansiveness, projection, transcendence, freedom, and sense of self. Yet, as an elusive and often confusing human faculty, imagination was long viewed with suspicion due to its ontological fragility, semantic ambiguity, and connection to the emotions, which was perceived as dangerous because it could lead to excess.[1] This essay considers a handful of works on paper that participated in the Enlightenment exploration of the imagination, reflecting period understandings of its nature, possibilities, and risks.

Most moralist thinkers of the seventeenth century, who prized reality, clarity, and order, denigrated the imagination as a source of error and falsehood. Crucially, however, rationalist René Descartes saw it as a positive instrument of knowledge that was tied (though subservient) to intellect, and sensualist John Locke, for whom sense perception was the primitive basis of all knowledge, considered it a primordial aspect of the mental functions of combination and coordination, necessary for associating

KNOWLEDGE

ideas and elaborating analogies 👁.[2] Locke and Descartes provided the foundation for Enlightenment thinkers to reconsider the imagination and to partially reevaluate its role, granting it more essential to human endeavor and more valid as a source of knowledge, in spite of the dangers it posed.

The great value Enlightenment thinkers placed on critical rationality is thematized in Charles-Nicolas Cochin's *Reason, Disguised as Fable, Chastises the Ridicules and Crushes the Vices* (Fig. 1). A large number of Cochin's drawings belong to the field of book illustration, attesting to his central role in the evolution of the genre in the eighteenth century and even earning him the informal title "illustrator of the Enlightenment."[3] Highly finished, the drawing under consideration was engraved by Benoît-Louis Prévost, a printmaker who also reproduced Cochin's frontispiece to the *Encyclopédie*. Prévost's print after the drawing shown here served as frontispiece to Guillaume-Antoine Lemonnier's *Fables, Contes et Epîtres* (Fables, Tales and Epistles), published in Paris in 1773. The main protagonist of Cochin's allegorical composition is the female personification of Reason, who, resting on soft, billowing clouds, covers her face with the mask of a horse. Holding a horse whip in her right hand, she fixes her gaze on a group of three figures below her: Vanity (adorned with a crown of peacock feathers), Ignorance (blindfolded and with donkey ears), and Folly (dressed as a jester), all about to suffer the power of Reason's wrath. The lower part of the composition is populated with shriveled, snake-haired personifications of vices, struck down by lightning emanating from the clouds that support Reason and her entourage. Cochin's frontispiece celebrated the effectiveness of fable in imparting moral instruction at a time when Jean-Jacques Rousseau and others had begun to warn of the genre's ability to confuse and seduce rather than instruct.[4]

In addition to reason, Enlightenment thinkers prized the authority of empirical reality. Yet they also recognized the pivotal importance of the imagination as a link between the human soul and the world, and more specifically, as a potent engine of artistic creation virtually without limits. Moreover, imagination was understood as a source of pleasure—and of pain.[5] In his *Encyclopédie* article on the topic, Voltaire made the distinction between two kinds of imagination: one he

called passive imagination, the other active imagination. Passive imagination, or reproductive imagination, is independent from judgment; it is what allows us to retain a sense impression of objects, but does not go much beyond memory in that regard. It is, according to Voltaire, the source of errors (due to misremembering or misinterpretation) and passions that are able to control the will—and is therefore dangerous. By contrast, active imagination, or creative imagination, joins reflection and combination with memory; it allows invention and is thus crucial to the scientist, the poet, and the artist as they try to gain insights into this world or to envision new ones, for the benefit of personal and collective well-being.[6]

A graphic artist such as Giovanni Battista Piranesi emblematizes the way in which active imagination, uninhibited by convention or material constraints, could be let loose on paper, and how its exploration could in a sense become a key aim of artistic creation. Inspired by Greco-Roman precedents and Baroque stage design, Piranesi had an antiquarian's preoccupation with archaeological reconstruction that required leaps of the imagination to supplement classical erudition.[7] He also had a lifelong fascination with the imaginative potential of the architectural capriccio, or fantasy, as a means of creative release, formal analysis, aesthetic experiment, and compelling communication. Linked to no extant physical monument or etched plate, *Roman Architectural Fantasy* (Fig. 2) demonstrates Piranesi's ability to combine widely

Fig. 1
Charles-Nicolas Cochin le jeune (1715–1790), *Reason, Disguised as Fable, Chastises the Ridicules and Crushes the Vices*, 1773. Red chalk on cream antique laid paper, 20.8 × 12.7 cm. Harvard Art Museums/Fogg Museum, Richard Norton Memorial Fund and the Marian H. Phinney Fund, 2016.195. (Detail on p. 101.)

Fig. 2
Giovanni Battista Piranesi (1720–1778), *Roman Architectural Fantasy*, 18th century. Red chalk, brown ink, and brown and gray wash on white antique laid paper, 52.9 × 38.9 cm. Harvard Art Museums/Fogg Museum, Friends of Art, Archaeology and Music at Harvard Fund, 1945.10.

Edouard Kopp

diverse architectural and iconographic elements into a single image with novel compositional devices, exaggerating scale and bending the rules of perspective.[8] In the spirit of high Baroque scenography, it depicts a building, seen from a corner, with multiple vanishing points, thereby defying the logic of Euclidian space.[9] Backlighting is another illusionistic device Piranesi employed here: the select areas of the sheet left in reserve act as a light source, while pen and brush render the shadows. The result is a dense, eclectic, and ultimately ambiguous space, whose complexity is heightened by the layering of the mixed media, effects of transparency, and the broad, energetic mark-making in ink and red chalk. Faced with such a complicated yet partly undefined monumental structure that causes perceptual uncertainty, the spectator is inescapably engaged in the imaginative process.

Piranesi's remarkable powers of imagination reached a fever pitch in his *Invenzioni capric di Carceri* (Capricious Inventions of Prisons), a series of sixteen large etchings that first appeared in 1749–50 and were then reissued, following significant reworking, in 1761 (Fig. 3). Figments of the architectural imagination, his are arcane and unrealizable structures, where, in the words of Louis Marchesano, "the monumental appears to have been inseparable from the kind of ambiguity that obtains when ordinary vision is made impotent by the overwhelming scale of worlds that are impossible to grasp or imagine in their entirety."[10] Moreover, the structural immensity, spatial complexity, and apparent infinity of Piranesi's somber architectural structures would have elicited in viewers an awe-inspiring sense of the sublime.[11]

Another artist working in the genre of architectural fantasy was Frenchman Charles-Michel-Ange Challes, whose idealized view of antiquity was deeply inspired by Piranesi's compositions and graphic style. In a large and boldly conceived drawing

Fig. 3
Giovanni Battista Piranesi (1720–1778), *The Gothic Arch*, from the series *Invenzioni capric di Carceri* (Capricious Inventions of Prisons), 1749–50. Etching, first state, plate: 41.4 × 54.6 cm. Harvard Art Museums/Fogg Museum, Program for Harvard College Fund, M13599.

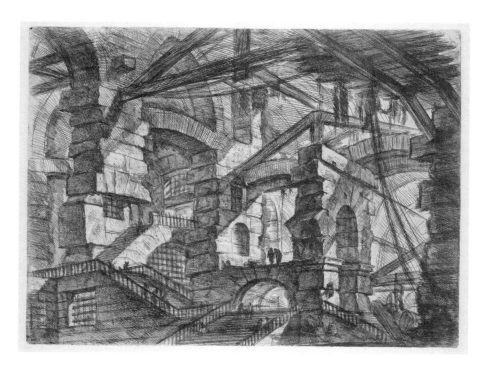

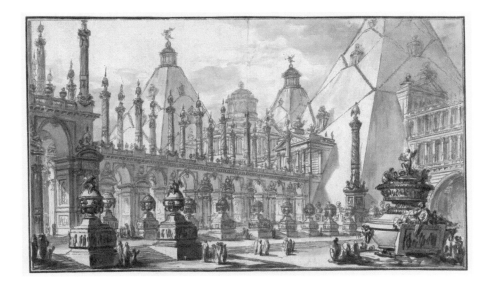

Fig. 4
Charles-Michel-Ange Challes (1718–1778), *Architectural Fantasy*, 1747. Brown ink with gray-black wash, 40.2 × 67 cm. The Morgan Library & Museum, New York, Gift of Mrs. W. Murray Crane, 1952.31.

now at the Morgan Library & Museum (Fig. 4), Challes offers a dramatic depiction of an ancient forum adorned with grandiose architecture: triumphal arches, surmounted by columns, appear to connect several monumental pyramidal structures.[12]

While imagination played a protean if dizzying part in Piranesi's (and Challes's) work, it was highly controlled in the case of visionary architect Claude-Nicolas Ledoux. Profoundly imaginative, Ledoux's allegorical composition *Coup d'œil du théâtre de Besançon* (View of the Theater of Besançon; see p. 175) features an eye in whose pupil and iris is mirrored the empty, circular auditorium of Ledoux's theater in Besançon, an eighteenth-century performance and social space designed with all the rigor of illuminist reason. The ocular theme of the engraving stresses the fact that, per the sensualist epistemology associated with the French Enlightenment, sight was first among the senses, which were thought to be at the origin of knowledge and imagination 👁. By the late eighteenth century, as Pannill Camp has noted, "the eye no longer represented just the mechanics of sensory knowledge production; it was metaphorically linked with imagination, the faculty by which the presentations of sense, but also memory and fantasy, were rendered in the mind and the faculty upon which the generation of ideas depended in the prevalent materialist formula."[13] In other words, Ledoux's eye does not merely *reflect* the artist's architectural vision: its centrality in the print symbolically conveys how crucially tied the organ is to the imagination involved in creating that vision.

If imagination played a highly generative part in the work of both Piranesi and Ledoux, despite being subject to widely varying degrees of rational control, its role is ambivalent and unnerving in Francisco Goya's *El sueño de la razón produce monstruos* (The Dream/Sleep of Reason Produces Monsters; Fig. 5). The etching is part of his *Caprichos* (Caprices), a series of prints that highlight the foibles and follies of human beings while simultaneously probing the tension between two kinds of vision: observation and fantasy.[14] The plate is one of several evoking dreamlike states, "the ambiguity of consciousness, the dialectic established between the rational and irrational worlds."[15] It depicts an artist, possibly Goya himself, asleep at his desk in

OCULUS

Edouard Kopp

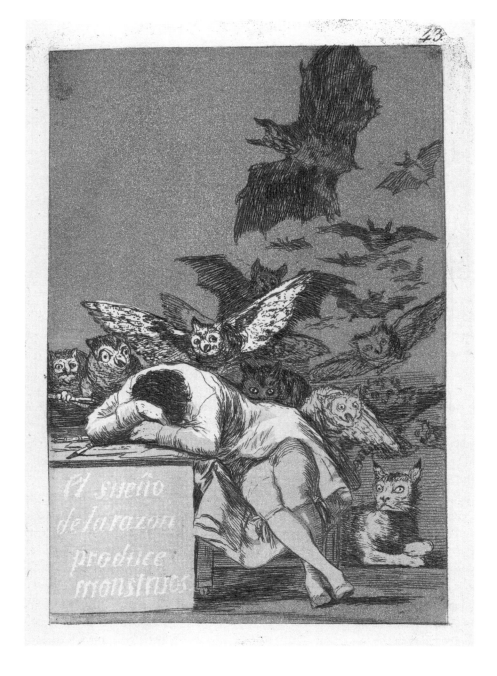

the dark. Swarming around him are ominous yet realistic nocturnal creatures that emerge from his dreams: owls, bats, a cat, and a lynx stare at him from the background, their wide-open eyes a reminder of their ability to see at night. The bats and owls attack him, while the lynx and the cat lie in wait. In this image, the threat comes not from the physical world but from within the artist's own mind, its uneasiness signified by the nightmarish creatures.

Commenting on this composition, Goya issued a warning: "Imagination abandoned by Reason produces impossible monsters; united with her, she is the mother

of the arts and the source of their marvels."[16] This language echoes classical thought, notably the norm articulated by German artist Anton Raphael Mengs, wherein imagination needed to be counterbalanced by reason if it was to engender valid creations. Otherwise, art "becomes a work of mere chance," as Mengs put it.[17] Indeed, the unregulated exercise of imagination might yield absurd and confusing reveries. Goya's statement also stresses the central role of imagination in the artistic process, and with its emphasis on reason, situates the image firmly within the Enlightenment discourse, although the image itself is admittedly ambiguous, in that it represents a situation where reason is incapacitated and the forces of darkness hold sway. If Goya's composition argues for the importance of reason to creativity, however, it does not seem to suggest that the unruly products of an unchecked imagination should be altogether dismissed: they are not necessarily aberrant, incomprehensible, and useless imaginings, as they can reveal deeper psychic truths and expand the range of human and artistic experience. Guided by reason, the artist can be discerning in his selection and thus avoid the precipice of irrationality; in giving shape to terror, he could somehow try to exorcise it.[18]

While nothing agitated Enlightenment savants more than the idea of a world that could not be apprehended through the senses, some artists were less hesitant to explore the darkest corners of the human mind and to create fictions that could begin to operate as realities.[19] On a continuum that extends all the way to madness, these artists ventured past the midway point, where imagination is held in check. Goya was one such artist; another was Louis-Jean Desprez, a man credited by leading figures in society for his "vast imagination."[20] Active primarily in the fields of

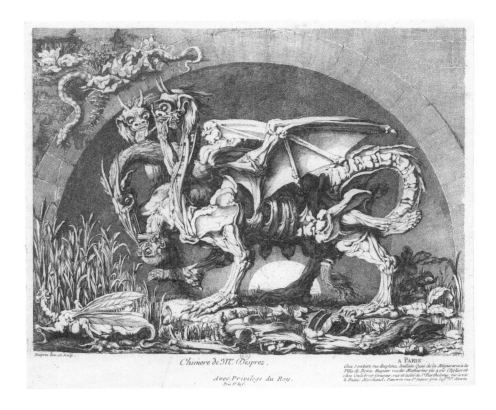

Fig. 6
Louis-Jean Desprez (1743–1804), *La Chimère de Monsieur Desprez* (Monsieur Desprez's Chimera), 1771. Etching, 27.5 × 35.5 cm. Bibliothèque nationale de France, Département des Estampes et de la Photographie, HA-52 FT-4.

Edouard Kopp

architecture and stage design, Desprez invented one of the most bizarre and strikingly gruesome prints of the late eighteenth century: a large, highly detailed and refined etching of a monstrous creature, a feat of horrific fantasy (Fig. 6). The undigested corpse of a human victim is visible through the ribcage of the three-headed monster, while skeletal remains lay scattered on the ground.[21] The creature, and by extension the print, became known as *La Chimère de Monsieur Desprez* (Monsieur Desprez's Chimera). The fifth state was published with a legend explaining its macabre subject: a "horrific beast born in the burning sands of Africa" ◉ that endlessly devours animals and unwary travelers. The caption thus mobilized negative associations of violence and cruelty with the continent of Africa, possibly to give the monster a fearsome backstory. Ultimately, however, the chimera was a reflection of the artist himself: as Pascal Griener has demonstrated, it celebrated Desprez's artistic genius in its purest and freest expression.[22]

Desprez's chimera is a product of what Enlightenment thinkers would have considered a diseased imagination. It stemmed from the passive imagination, to employ Voltaire's terminology, the kind that leads to delusions, violent urges, and fanaticism. In sum, imagination was seen as a remarkably potent faculty—integral to artistic creativity and to progress more broadly, but also a source of danger.

1. For a perceptive history of imagination in French thought, see Matthew W. Maguire, *The Conversion of Imagination: From Pascal through Rousseau to Tocqueville* (Cambridge, Mass.: Harvard University Press, 2006). See also Annie Becq, *Genèse de l'esthétique française: De la raison classique à l'imagination créatrice, 1680–1814*, 2 vols. (Pisa: Pacini, 1984). On the British context, see John Brewer, *The Pleasures of the Imagination: English Culture in the Eighteenth Century* (London: Routledge, 2013).

2. See Patrick Graille, "Imagination," in *Dictionnaire européen des Lumières*, ed. Michel Delon (Paris: Quadrige, 2007), 664–67.

3. See Christian Michel, *Charles-Nicolas Cochin et le livre illustré au XVIIIe siècle* (Geneva: Droz, 1987), 102.

4. I am grateful to Austėja Mackelaitė for the research she did on this drawing when it was acquired by the Harvard Art Museums in 2016.

5. In a didactic poem titled "The Pleasures of the Imagination," first published in 1744 (and translated into French in 1759 by encyclopedist Baron d'Holbach), English author Mark Akenside discussed the sources and effects of imaginative pleasure. His poem was based largely on Joseph Addison's essay on the imagination, published in the *Spectator* in 1712. See John Norton, "Akenside's *The Pleasures of Imagination*: An Exercise in Poetics," *Eighteenth-Century Studies* 3 (3) (1970): 366–83.

6. See Voltaire, "Imagination, Imaginer," in *Encyclopédie, ou, Dictionnaire raisonné des sciences, des arts et des métiers*, vol. 8, ed. Denis Diderot and Jean le Rond d'Alembert (Paris: 1751–65), 560–61.

7. See Peter N. Miller, "Piranesi and the Antiquarian Imagination," in *Piranesi as Designer*, ed. Sarah E. Lawrence (New York: Cooper Hewitt, National Design Museum, Smithsonian Institution, 2007), 123–37.

8. See the entry by Jonathan Bober in *The Famous Italian Drawings at the Fogg Art Museum in Cambridge*, by Agnes Mongan, Konrad Oberhuber, and Jonathan Bober (Milan: Silvana Editoriale, 1988), no. 74.

9. See Werner Oechslin, "L'intérêt archéologique et l'expérience architecturale avant et après Piranèse," in *Piranèse et les Français: Colloque tenu à la Villa Médicis, 12–14 mai 1976*, ed. Georges Brunel (Rome: Edizioni dell'Elefante, 1978), 404–5, esp. n. 49.

10. Louis Marchesano, "*Invenzioni capric di carceri*: The Prisons of Giovanni Battista Piranesi (1720–1778)," *Getty Research Journal* 2 (2010): 151.

11. See John Wilton-Ely, "The Fever of the Imagination," in *The Mind and Art of Giovanni Battista Piranesi*, by John Wilton-Ely (London: Thames & Hudson, 1978), 81–91.

12. On this drawing, see Richard P. Wunder, "Charles Michel-Ange Challe: A Study of His Life and Work," *Apollo* 87 (1968): 28, 31; and the entry by Cara D. Denison in *Exploring Rome: Piranesi and His Contemporaries*, ed. Cara D. Denison, Myra Nan Rosenfeld, and Stephanie Wiles (New York: Pierpont Morgan Library; Montreal: Canadian Centre for Architecture, 1993), cat. 85, p. 155.

13. Pannill Camp, "Theatre Optics: Enlightenment Theatre Architecture in France and the Architectonics of Husserl's Phenomenology," *Theatre Journal* 59 (4) (December 2007): 617, 620.

14. See Andrew Schulz, *Goya's* Caprichos: *Aesthetics, Perception and the Body* (Cambridge: Cambridge University Press, 2005), 11–12.

15. Mark McDonald, *Goya's Graphic Imagination* (New York: Metropolitan Museum of Art, 2021), 27.

16. Quoted in Alfonso E. Pérez Sánchez and Eleanor A. Sayre, *Goya and the Spirit of Enlightenment* (Boston: Museum of Fine Arts, 1989), 114.

17. Quoted in Werner Hofmann, *Goya: "To Every Story There Belongs Another"* (London: Thames & Hudson, 2003), 123.

18. On this point, see ibid., 123, 133.

19. See Lorraine Daston, "Fear & Loathing of the Imagination in Science," *Daedalus* 134 (4) (Fall 2005): 16–30.

20. In a June 4, 1779, letter to the Comte d'Angiviller, director of the Bâtiments du Roi, the Abbé de Saint-Non referred to Desprez as "un homme d'une vaste imagination." See Régis Michel, ed., *La Chimère de Monsieur Desprez* (Paris: Réunion des musées nationaux, 1994), 217.

21. On this print, see the entry by Victor I. Carlson, in *Regency to Empire: French Printmaking, 1715-1814*, ed. Victor I. Carlson and John W. Ittmann (Baltimore: Baltimore Museum of Art, 1984), 236–37, no. 80; ibid.; Rena Hoisington, "Etching as a Vehicle for Innovation: Four Exceptional Peintres-Graveurs," in *Artists and Amateurs: Etching in 18th-Century France*, ed. Perrin Stein (New York: Metropolitan Museum of Art, 2013), cat. 52, p. 89; and the excellent essay by Pascal Griener, "La mise en scène tragique du Génie. *La Chimère de Monsieur Desprez* (1771) de Louis-Jean Desprez," in *Das Tragische im Jahrhundert der Aufklärung. Le tragique au siècle des Lumières*, ed. Vanessa de Senarclens (Hanover: Wehrhahn, 2007), 191–204.

22. Griener, "La mise en scène tragique du Génie," 196–97.

Edouard Kopp

JEST Elizabeth M. Rudy

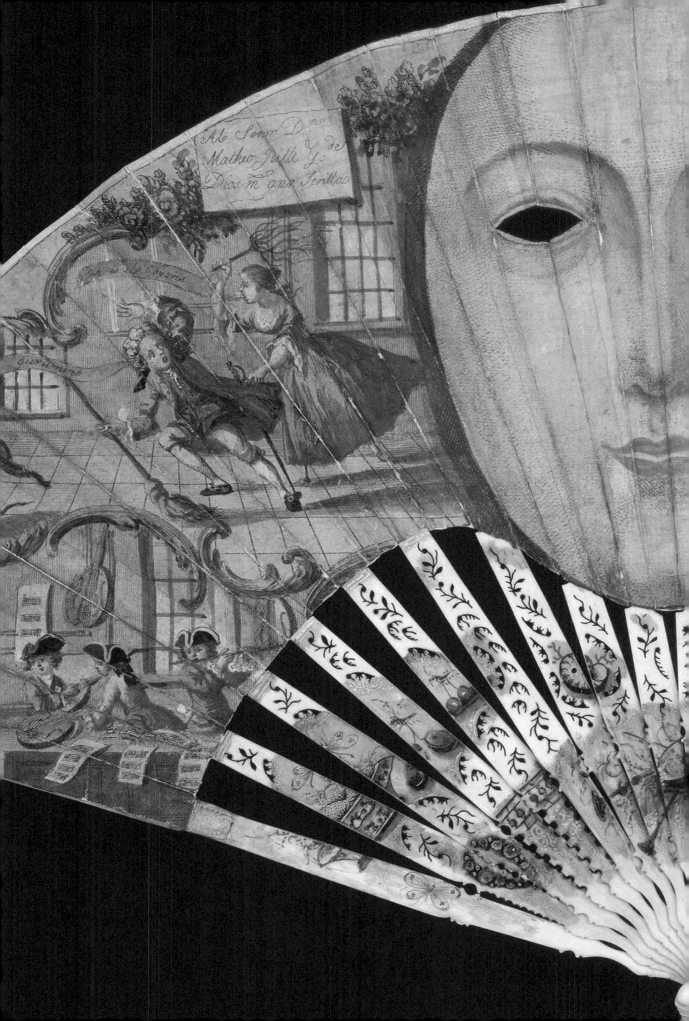

Fig. 1
Unidentified artist, *The Female
Philosopher Smelling Out the Comet*,
1790. Etching with hand-coloring,
24.5 × 17.5 cm. The British Museum,
London, 1985,0119.362.

PUBLIC

Humor in the graphic arts of the eighteenth century was disparate and wide-ranging. With the emergence of the concept of "the public" ◉ and a burgeoning international market of consumers, the interconnected but distinct categories of caricature and satire in particular exploded, appearing in every facet of visual culture. Nothing was spared the parodic lens.[1] Consider, for example, the caricature of Caroline Herschel, a German astronomer and the first woman to earn a royal pension from King George III for her work as a scientist (Fig. 1).[2] The print derides several things simultaneously: Herschel's foreignness in England, her female sex, her worldwide fame. Referring to her as "the female philosopher," it ridicules Herschel's difference from elite social and academic groups as much as her distinction within them.

Jokes from the era, like this caricature, might strike twenty-first-century viewers as cruel and retrograde. Frequently vicious, they were made at the expense of individuals, especially women, people of color, and the most vulnerable members of society.[3] At odds with Enlightenment debates about the ethics of comedy and empathy, pictorial jests could be pernicious because they were routinely counterfeited or copied from one center of production to the next, allowing harmful aspects to infiltrate different cultures and thrive in new contexts.[4] In seeking laughs, they often embraced the sinister and the obscene.

Humorists frequently employed the trope of the mask to exploit the dissonance between semblance and reality. A device of both disguise and revelation for the wearer, the accessory has the power to beguile, frustrate, and transfix the viewer. The mask is the central component of a folding paper fan in the Museum of Fine Arts, Boston; featuring a life-sized face whose eyeholes are cut out, the fan itself functions

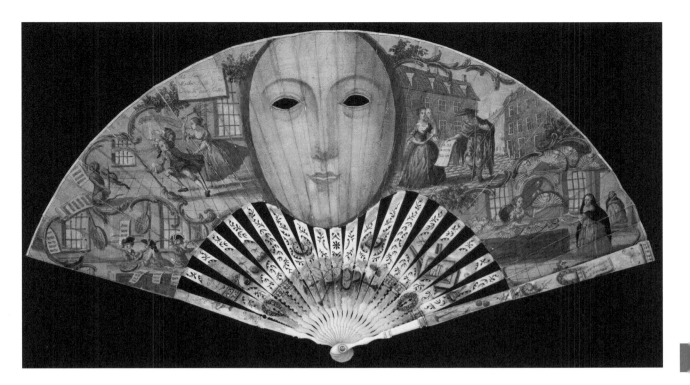

as a disguise (Fig. 2). The face is surrounded by four comedic vignettes, two of which self-reflexively proclaim the object's practicality and advocate for its ingenuity as a commercial good: to the immediate right, a woman attempting to buy a newspaper finds that her hands are full, a mask in one and a fan in the other, while at far right, a shopkeeper presents a solution to this problem by selling products that double as both.

The humorous scenes, trompe l'oeil details, and mask keep the object in a state of constant banter with the viewer, an active participant in the masquerade of daily life. In a depiction of domestic violence at left, a man tumbles to the ground while his attacker, a woman, lunges at him with a cat-o'-nine-tails. The humor is meant to lie in the adjacency of his painful humiliation to the monkey playing the viola d'amore: the incongruity of what should be (marital bliss) and what is (marital distress).[5]

Folding fans like this were introduced to Europe from East Asia in the sixteenth century, and by the mid-eighteenth century, fan making was a booming industry in European centers, from London to St. Petersburg. Fan producers often collaborated with printmakers to speed the production of popular designs; rather than being drawn or painted, the leaves would be printed and then hand-colored, as in this example.[6] Although the MFA fan was made for a collector in Seville and features Spanish inscriptions, it is attributed to an English workshop due to its style and provenance.[7] Bolstering this attribution is the unique London fashion for women to wear masks outside, a practice that foreign travelers remarked upon with surprise and opprobrium.[8] In using this fan, its owner would activate the unifying joke for the entire object: the constant fluctuation between seeing and being seen.

Fig. 2
Unidentified artist (active 18th century), Mask fan, 1740s. Paper leaf patched with skin, etched, engraved, and painted in watercolor; pierced, partially painted, varnished, and gilded ivory sticks; mother of pearl; brass, guard: 26.3 cm; open (max.): 48.5 cm. Museum of Fine Arts, Boston, Oldham Collection, 1976.179. (Detail on p. 111.)

Elizabeth M. Rudy

At costumed balls involving facial disguises, individuals could superficially change everything about themselves, from their social rank to their sex. The temporary inversion of social hierarchies and gender roles bred entertainment, liberation, and folly, but also uncertainty and potential danger.[9] These occasions figure in many of the plates from Francisco Goya's *Los Caprichos* (The Caprices), a work of social critique in eighty prints. The sixth plate is described in an unattributed manuscript from the period as follows: "The world is a masquerade. Face, dress, and voice, all are false. All wish to appear what they are not. All deceive."[10] In a preliminary drawing for the print, Goya depicted three readily identifiable masks: those worn by the couple in the foreground plus the upturned Scaramouche mask of the figure in the background (Fig. 3).[11] The frustration of the gaze is the principal focus here, with the male figure in the foreground bringing his masked face close to that of the seated woman, struggling to discern her features through the mask that obscures half her face.

In the related print, however, Goya changed the composition and gave it the Spanish title *Nadie se Conoce*, which is most often translated as *Nobody Knows Himself* (Fig. 4).[12] Here, the masks themselves are the primary subject, functioning as tools of self-deceit and not simply external disguise. Behind the mask, each figure is robbed of the most intimate thing possible: a sense of self. The mask thus poses a danger to a person's perception not of others, but of oneself.[13] The figure looking at the viewer from the upper third of the composition embodies this risk. The face grins below a deeply furrowed brow; the sagging Pulcinella hat does nothing to dissipate the threat of the terrifying countenance. If this is a mask, its edges are barely visible; the figure is literally monstrous. In fact, but for the seated figure's mask, all of the face coverings are difficult to discern, their edges demarcated by a sole etched line amid dotted fields of aquatint, if at all.

The focal point of the scene is the erotic charge between the two figures in the foreground, whom Goya altered significantly from the drawing to the print. In the drawing, the figures are distinctly male and female; the man holds his open palm out to the woman, close to her dress as if to meet her hand, which is pushed down into her pocket near her genitalia. But in the print, this leaning figure appears feminine: her posterior is larger, her hairstyle is similar to that of the seated figure wearing a dress, and more significantly, her mask mirrors the skin of her object of desire.[14] The seated figure's face is bathed in bright light, a burst of the paper's reserve untouched by etching or aquatint; with her neck and chest in shadow, defined in aquatint that printed as speckled gray, the light cast on her face takes on the appearance of a second mask. The standing figure's face and mask are also rendered in aquatint, except for the L-shaped area of white at left. Both figures are thus subtly linked on a material, technical level, where the mask of one is partially rendered in the same way as the other's actual face.[15]

Goya made an additional change to the composition in the print, increasing its eroticism. Here, the hand of the standing figure (now presumed to be a woman) no longer approaches the seated figure's dress but penetrates its folds, three of her fingertips disappearing from sight. The inherent danger of the masks thus becomes rooted in the potential for a same-sex liaison—nobody knows *herself*, it could now be

Nadie se conoce.

said.[16] The two demon-masked figures peer down encouragingly from above: the one at right grins broadly at the seated woman, while the other glares terrifyingly at the standing figure and possibly also at the viewer. They are in on the joke, approving of the same-sex dalliance. This connivance casts a negative, even frightening pall over the action taking place, as if the women's amorousness is somehow the fulfillment of the monsters' will.

The multiple scenes presented on the MFA fan and the evolution of Goya's print speak to the expansive complexities of visual satire, the pictorial expression of which culminated in the medley print ◉. Especially popular in early eighteenth-century England, these composite trompe l'oeil images incorporated every type of graphic material, from the cheap and diminutive trade card to the single-sheet fine print. Medley prints created a constantly shifting universe in which everything was relational: symbols, puns, and irreconcilable contradictions coexisted, provoking the viewer to decipher their possible meanings.[17] Constructed from a specific cultural moment, the confluence can often appear cacophonous, confusing, or simply not that funny to modern eyes. But identifying the targets of the jokes within this seemingly indiscriminate field—as in all forms of humor—reveals some of the preoccupations as well as the biases and anxieties of the era.

WAGER

Elizabeth M. Rudy

1. See Todd Porterfield, ed., *The Efflorescence of Caricature, 1759–1838* (London: Ashgate, 2011).

2. See Michael A. Hoskin, *Caroline Herschel: Priestess of the New Heavens* (Sagamore Beach, Mass.: Science History Publications, 2013).

3. See especially Bernadette Fort and Angela Rosenthal, eds., *The Other Hogarth: Aesthetics of Difference* (Princeton, N.J.: Princeton University Press, 2001); Trevor Burnard, "'A Compound Mongrel Mixture': Racially Coded Humor, Satire, and the Denigration of White Creoles in the British Empire, 1784–1834," in *Seeing Satire in the Eighteenth Century*, ed. Elizabeth C. Mansfield and Kelly Malone, Studies on Voltaire and the Eighteenth Century (Oxford: Voltaire Foundation, 2013), 149–66; and Temi Odumosu, *Africans in English Caricature, 1769–1819: Black Jokes, White Humour* (London: Harvey Miller, 2017).

4. Simon Dickie, *Cruelty and Laughter: Forgotten Comic Literature and the Unsentimental Eighteenth Century* (Chicago: University of Chicago Press, 2011). For a case study of an oft-reissued caricature in France, see Kathryn Desplanque, "Repeat Offenders: Repeating Visual Satire across France's Long Eighteenth Century," *RACAR* 40 (1) (2015): 17–26.

5. Anna G. Bennett, *Unfolding Beauty: The Art of the Fan, The Collection of Esther Oldham and the Museum of Fine Arts, Boston* (London: Thames and Hudson, 1988), 142.

6. The design would either be etched or engraved, then hand-colored and attached to ivory, bone, or wood mounts. See Miriam Volmert and Danijela Bucher, eds., *European Fans in the 17th and 18th Centuries: Images, Accessories, and Instruments of Gesture* (Berlin: Walter de Gruyter GmbH, 2020), esp. 225–64.

7. Bennett, *Unfolding Beauty*, 142.

8. Christoph Heyl, "The Metamorphosis of the Mask in Seventeenth- and Eighteenth-Century London," in *Masquerade and Identities: Essays on Gender, Sexuality, and Marginality*, ed. Efrat Tseëlon (London: Routledge, 2001), 114–34.

9. See, among others, Terry Castle, "Eros and Liberty at the English Masquerade, 1710–90," *Eighteenth-Century Studies* 17 (2) (1983): 156–76.

10. "El mundo es una máscara; el rostro, el traje y la voz, todo es fingido. Todos quieren aparentar lo que no son, todos engañan y nadie se conoce." Prado manuscript transcribed in Aureliano de Beruete y Moret, *Goya, Grabador* (Madrid: Blass y cía, 1918), 39. This is one of several contemporary manuscripts that provide descriptive titles for *Los Caprichos*; see Mark McDonald, *Goya's Graphic Imagination* (New York: Metropolitan Museum of Art, 2021), 98.

11. For an overview of the production and publication of *Los Caprichos*, see Alfonso E. Pérez Sánchez and Eleanor A. Sayre, *Goya and the Spirit of Enlightenment* (Boston: Museum of Fine Arts, 1989), xcv–civ.

12. Francisco José de Goya y Lucientes, *Album of Prints [Los Caprichos]* (Madrid: 1799), 6.

13. See Dror Wahrman, *The Making of the Modern Self: Identity and Culture in Eighteenth-Century England* (New Haven, Conn.: Yale University Press, 2004), esp. 161–62.

14. The feminized aspects of the central figure are noted in Juliet Wilson-Bareau, *Goya: La Década de Los Caprichos, Dibujos y Aquafuertes* (Madrid: Real Academia de Bellas Artes de San Fernando, 1992), 18. For a related discussion about masquerade and sexual ambiguity in another *Los Caprichos* plate, see pp. 67–71.

15. Goya achieved this whiteness by applying stopping-out varnish to the copperplate with a brush. For more on this process, see Rena Hoisington, *Aquatint: From Its Origins to Goya* (Washington, D.C.: National Gallery of Art, 2021), 215.

16. Andrew Schulz explores a similar combination of masks and sexual ambiguity in plate 57 of *Los Caprichos*. See Andrew Schulz, *Goya's Caprichos: Aesthetics, Perception, and the Body* (Cambridge: Cambridge University Press, 2005), 145–48.

17. See Mark Hallett, "The Medley Print in Early Eighteenth-Century London," *Art History* 20 (2) (December 2003): 214–37.

Elizabeth M. Rudy

Pl. VI.

rants dans la Comté d'Antrim en Irlande.

cette Planche est complétement expliquée
à l'article PAVÉ DES GÉANTS.

Benard Fecit

SPOTLIGHT 5

Le Roÿ Del.
AAA *Articulations qui ont la forme d'une couronne antique.*
BBB *Autres Articulations sur lesquelles les précédentes s'adaptent.*
CCC *Articulations convexes par les deux cotés.*

Histoire Naturelle, Pavé des G

Susanna Drury
A View of the Giant's Causeway:
East Prospect

This large engraving from the *Encyclopédie*—one of the few foldouts in the publication—evokes the impressive specter of the Giant's Causeway in the eighteenth-century imagination, when the rocky outcrop on the coast of what is today Northern Ireland emerged at the center of a lively debate among naturalists. At issue was the formation of prismatic basalt, and whether fire or water was the responsible force. In the accompanying text, Nicolas Desmarest correctly determined the site's igneous origins despite never having visited the region. As was common, he instead relied in part on prints, in this case an earlier version of the *Encyclopédie* engraving and its companion, whose attentiveness to scale, textural detail, and the mechanics of jointing reveal their beginnings as drawings made on the spot.[1]

Absent from the *Encyclopédie*, however, is any mention of the woman responsible for these firsthand observations: Susanna Drury, an Irish artist who created a series of gouache drawings while residing near the causeway.[2] Several years after winning a prize for her work from the Dublin Society in 1740, Drury arranged to have two of the views—an east and a west prospect—engraved. The descriptive prints, an improvement on earlier renderings, prompted renewed geological speculation. Moreover, *how* these two views were often displayed—side by side, creating the false impression of a conical projection—may have unexpectedly contributed to Desmarest's groundbreaking thesis by leading him to believe, erroneously, that the causeway was at the base of a volcano, a nonetheless productive fiction for his vulcanist conclusion.

Susanna Drury (c. 1698–c. 1770), *A View of the Giant's Causeway: East Prospect*, from *Encyclopédie, ou, Dictionnaire raisonné des sciences, des arts et des métiers* (Encyclopedia; or, Analytical Dictionary of the Sciences, Arts, and Trades), vol. 23, ed. Denis Diderot (Paris: 1762–72). Engraving in book, sheet: 38.7 × 66 cm. MIT Libraries, Distinctive Collections, AE25.D555 1751 Plates.

1. On Desmarest, the basalt controversy, and broader neptunist/vulcanist debate, see Kenneth L. Taylor, "Nicolas Desmarest and Geology in the Eighteenth Century," in *Toward a History of Geology*, ed. Cecil J. Schneer (Cambridge, Mass.: MIT Press, 1969), 339–56; reprinted in Kenneth L. Taylor, *The Earth Sciences in the Enlightenment: Studies on the Early Development of Geology* (Aldershot, England; Burlington, Vt.: Ashgate/Variorum, 2008). Taylor also discusses Desmarest's use of the prints in note 7 to his translation of the *Encyclopédie* plate group. See Nicolas Desmarest, "Natural history—Mineral kingdom—[6] Sixth collection," The Encyclopedia of Diderot & d'Alembert Collaborative Translation Project, trans. Kenneth L. Taylor, 2020, accessed June 12, 2022, http://hdl.handle.net/2027/spo.did2222.0001.527. Originally published as "Histoire naturelle—Règne mineral—[6] Sixième collection," in *Encyclopédie, ou, Dictionnaire raisonné des sciences, des arts et des métiers*, vol. 6 (plates), ed. Denis Diderot (Paris: 1768).

2. Martyn Anglesea and John Preston, "'A Philosophical Landscape': Susanna Drury and the Giant's Causeway," *Art History* 3 (3) (September 1980): 252–73.

Ashley Hannebrink

KNOWLEDGE

Kristel Smentek

When the protagonist of Louis-Sébastien Mercier's futuristic novel *L'An 2440* (The Year 2440) wakes up in Paris after a nearly seven-hundred-year nap, he is pleasantly surprised by the changes he encounters: a monument to the militant Black "avenger" who led the enslaved and the colonized of the New World to freedom, statues honoring men of science and philosophy, and a culture committed to the education of children. In the twenty-fifth century, youngsters learn their ABCs by reciting the names of such celebrated eighteenth-century thinkers as naturalist Georges-Louis Leclerc, Comte de Buffon (see p. 163), and philosophes Jean-Jacques Rousseau and Voltaire (p. 3). To the narrator's astonishment, the multivolume *Encyclopédie*, one of the most ambitious publications of the Enlightenment, is every child's primer.[1] First published in 1771, Mercier's best seller promotes a view of the Enlightenment that would become canonical: a philosophical movement with the *Encyclopédie* as its defining text and the dissemination of knowledge, even to children (whose education was a topic of significant debate in the eighteenth century), at its heart.

The questions of what we should know, how we come to know it, and the best ways to organize and communicate this knowledge were central to the massive illustrated publication that Mercier imagined as a future textbook for young people. Spearheaded from 1747 by Denis Diderot and Jean le Rond d'Alembert, the *Encyclopédie* was originally planned as a French translation of Ephraim Chambers's two-volume *Cyclopaedia; or, An Universal Dictionary of Arts and Sciences*, first published in London in 1727–28.[2] The French project, however, took on unanticipated proportions. When the *Encyclopédie, ou, Dictionnaire raisonné des sciences, des arts et des métiers* (Encyclopedia; or, Analytical Dictionary of the Sciences, Arts, and Trades) was finally completed in 1772, it comprised seventeen folio volumes of text and eleven folio volumes housing nearly three thousand prints.[3] This number of plates far exceeded the thirty illustrations in Chambers's book as well as the six hundred images Diderot and d'Alembert had initially announced to their subscribers.[4]

This exponential increase in images is indicative of the importance of visual demonstration to the *Encyclopédie*. To witness for oneself was integral to Enlightenment epistemology, for to see and do and to reflect critically on what one OCULUS experienced was to begin to understand 👁. Images were presumed to map more transparently onto things in the world than words; as Diderot wrote of the plates, "a glance at the object or at its representation tells more about it than a page of text."[5]

The *Encyclopédie* was a formidable work of synthesis, with the ambition to collate all knowledge—not only to preserve it, but to advance it.[6] This task and the expertise it demanded were beyond the capabilities of any single person, and thus unlike Chambers's *Cyclopaedia*, the *Encyclopédie* was an explicitly collaborative project. Its entries were authored by more than one hundred different contributors, several of them named, in contrast to earlier conventions of authorship. Diderot and d'Alembert adopted Chambers's alphabetical organization, a novelty that dispensed with the thematic arrangement of earlier encyclopedias and, theoretically at least, placed equal value on the variety of topics found in the *Encyclopédie*. To counter the fragmentation that alphabetization introduced, the editors adapted Chambers's use of cross-references, the analog equivalent of today's hyperlinks, to connect related articles and images.[7] In the *Encyclopédie*, famously, these cross-references were also

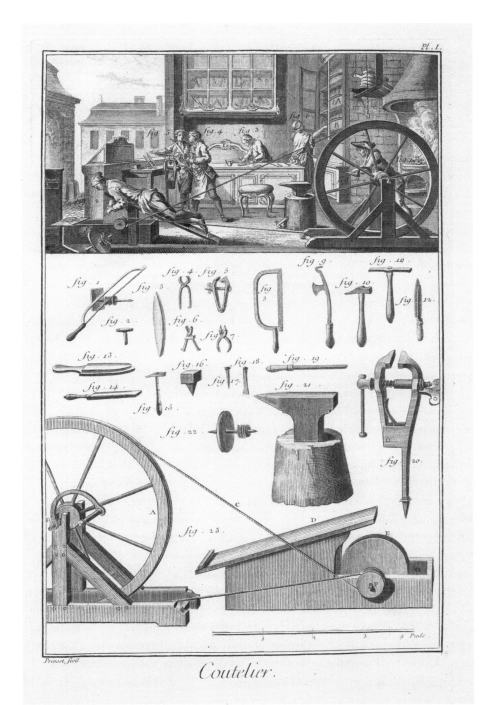

Fig. 1
Benoît-Louis Prévost (1735–1804),
after Jean-Michel Moreau, called
Moreau le jeune (1741–1814), *The
Cutler's Workshop*, from *Encyclopédie,
ou, Dictionnaire raisonné des sciences,
des arts et des métiers* (Encyclopedia;
or, Analytical Dictionary of the
Sciences, Arts, and Trades), vol. 20,
ed. Denis Diderot (Paris: 1763).
Engraving, plate: 35.2 × 22.3 cm. The
Horvitz Collection, Wilmington,
Del., C-F-41a.

vehicles for ironic or subversive commentary. Diderot described them as possessing a "secret utility, the silent effects of which will become sensible with time."[8] For instance, cross-references at the end of the article on cannibals (anthropophages), published in the first text volume in 1751, encouraged the reader to consult entries on the Eucharist, Communion, and altars. Such anticlerical attacks would lead

Kristel Smentek

to the official suppression of the *Encyclopédie* project in 1759. After that date, the remaining ten text volumes were produced clandestinely and published under a false Swiss imprint.

Production of the plates continued openly, however. The same year that the text volumes were suppressed, the *Encyclopédie*'s publishers secured a new publication privilege for the plates, which would be issued under a separate title, *Recueil de planches sur les sciences, les arts libéraux et les arts méchaniques* (Collection of Plates on the Sciences, Liberal Arts, and the Mechanical Arts), with a Paris imprint, from 1762 to 1772. These plates continued the work of "changing the common mode of thinking," as Diderot put it, not only by summarizing knowledge in visual form but by enabling the reader's critical engagement with it.[9] As articulated by d'Alembert in his "Preliminary Discourse" to the *Encyclopédie*, published in the first text volume in 1751, the project was explicitly premised on the experimental philosophy of Francis Bacon, the sensationist psychology of John Locke, and the experimental method of Isaac Newton.[10] In constructing this genealogy, d'Alembert aligned the *Encyclopédie*, and by implication its readers, with the empirical methods of natural philosophy and a model of knowledge acquisition in which we form ideas about the world by processing sensory information rather than through any innate knowledge 👁. To truly know was to physically experience, to see and do, and to compare and analyze data for oneself rather than to rely on received opinion.

SKIN

Among the most striking images included in the *Encyclopédie* were those dedicated to the trades, a field of human endeavor whose study was encouraged by Bacon but which remained little analyzed in previous encyclopedias in part because of their association with manual labor rather than intellectual work. These plates showed the *Encyclopédie*'s privileged readers the production of such everyday items as pins, corks, and cutlery (Fig. 1). In keeping with the empiricist epistemology they claimed, the editors promised readers that the texts and images were based on firsthand experience; in other words, that the authors had visited workshops and built models of machines and tools to better understand them.[11] In reality, preexisting images formed the basis of many of the plates in the *Encyclopédie*, including those of the trades (see, for instance, p. 121).[12] Print sequences depicting trade occupations were based on images made for the *Description des arts et métiers* (Description of the Arts and Trades), an illustrated publication project instituted by the Academy of Sciences in Paris in the late seventeenth century but not realized until the 1760s. In the *Encyclopédie*, as in the prints they emulated, depictions of the trades usually opened with a vignette depicting the workshop and its workers, followed by individual renderings of relevant tools and deconstructions of machines, often distributed over several plates. Explanatory texts keyed to the images prefaced each sequence.

New drawings for prints, like the study for the vignette that opens the two-plate section on the art of the cutler, were also commissioned for the *Encyclopédie* (Fig. 2). This pen, ink, and wash drawing is one of a group of six sheets for the publication that came to light in 2003. They have been attributed to Jean-Michel Moreau, called Moreau le jeune, an important draftsman whose contributions to Diderot's project were little known prior to the discovery (see pp. 185–86).[13] (The published print features only an attribution to its engraver, Benoît-Louis Prévost; see

Fig. 1). As in other vignettes in the *Encyclopédie*, Moreau le jeune condenses together the storefront, with its finished goods on shelves and neatly dressed saleswoman, and the workshop where the wares are produced. Pentimenti in the drawing record his process of working out the placement of objects and bodies, such as the anvil at center and the position of the knife grinder's tilted head, and how best to incorporate the forge, bellows, and multiple steps of fabrication and sharpening of cutting implements with the very different environment of a Parisian salesroom. His solution was to foreground the human-powered grindstone, whose straps stretch across the width of the drawing, and the worker balanced cross-legged on the inclined plank who sharpens an implement on it. A comparison of the drawing with the finished print reveals simplifications in the decoration of the shop and the architecture of the street that privilege the didactic elements of the scene. The housing of the grindstone was also reduced in size in the print, a modification possibly introduced after consultation with related drawings from the *Description des arts et métiers* project.[14]

Layouts in the *Encyclopédie* image volumes approximate the paths to understanding outlined in the preliminary discourse. Knowledge was a matter of experience, and understanding an object, technology, or experiment required replicating it, in actuality or imaginatively, using its constituent materials and instruments. In a classic essay on the *Encyclopédie*'s plates, French cultural and literary critic Roland Barthes argued that reading a print like that depicting the trade of the cutler models the kinds of active, analytical procedures promoted by the book's editors. Reading top to bottom and across the multiple plates of a given sequence, the viewer proceeds from the experiential (the finished goods available in the shop) to the causal (the labor, tools, and raw materials of their making).[15]

A particularly evocative example of the interrelation between eighteenth-century theories of knowledge acquisition and the *Encyclopédie*'s images is the opening spread of the nineteen plates depicting letterpress printing (Fig. 3). In this spread, apparently original to the *Encyclopédie*, the sequential presentation of images imposed by the book format is used to maximal effect.[16] The sequence opens with a view into the compositing room where sorts, the individual characters or letters of a type font, are selected and set for printing. Drawn by Diderot's trusted draftsman,

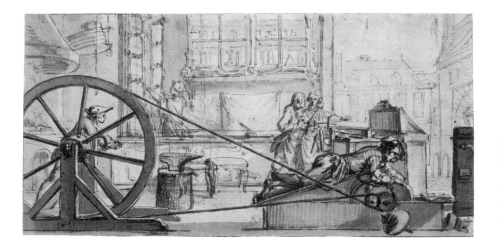

Fig. 2
Jean-Michel Moreau, called Moreau le jeune (1741–1814), *The Cutler's Workshop*. Black ink and brush with gray wash over traces of black chalk, 10.3 × 20.5 cm. The Horvitz Collection, Wilmington, Del., D-F-1090.

Kristel Smentek

Louis-Jacques Goussier, this vignette may have been based on on-site studies, as were several of Goussier's nearly nine hundred images for the project (and as Moreau le jeune's may have been). As shown by the completed typeset text depicted at the bottom right of the page, the reversal of the printing process required typesetters to place sorts backward. This reversal is vividly demonstrated by the "printed" text on the facing page. In a further activation of the sequential format of the book, viewers were prompted to imaginatively enter the space of the printshop and virtually participate in its activities. The accompanying text invited readers to pass through the door in the background of the opening vignette into the room with the printing press. To reach the printing press, depicted in plate 14, the viewer virtually replicated the setting of type in preparation for printing by traversing twelve intervening images showing the processes of selecting and placing sorts in great detail.[17]

The scientist under whose aegis d'Alembert placed the *Encyclopédie*—Newton—loomed large over the eighteenth century. Among natural philosophers, he was esteemed for the scientific discoveries published in his *Principia* (1687) and *Optics* (1704), but an even wider public associated his name with learning and method more generally. Newtonianism's cultural legacy prompted homages as diverse as Étienne-Louis Boullée's designs for a cenotaph to Newton in the 1780s (see p. 227) and London publisher John Newbery's highly successful children's book *The Newtonian System of Philosophy, Adapted to the Capacities of Young Gentlemen and Ladies*, first published in 1761, in which the protagonist, a youthful Tom Telescope, instructs the "Liliputian Society" using familiar toys as his apparatus.[18] Tom Telescope's entertaining and educational demonstrations for young people paralleled those held by men of science (or those pretending to be ⦿) for non-specialist adult audiences that modeled experimental methods, explained new discoveries, and instilled trust in science. This domestication of science also generated such arresting prints as William Pether's mezzotint after Joseph Wright of Derby's *A Philosopher Giving a Lecture on the Orrery* (see p. 149), a demonstration that communicated the new understanding of planetary motion made possible by Newton's theory of universal gravity.[19]

To make public their commitment to the advancement of the arts and sciences, private organizations such as the Felix Meritis Society, founded in Amsterdam in 1777, also made use of prints. Produced between the early 1790s and 1802, Reinier Vinkeles's engraving of a physics theater, after a drawing by Jacques Kuyper and Pieter Barbiers, is one of four interior views of the grand new classicizing building erected by the society in central Amsterdam in 1788 (Fig. 4).[20] In addition to concerts, readings, and drawing lessons, this place of sociability offered its members demonstrations of experiments, such as the production of an electrical current by the electrostatic generator seen at center of the print. Built by British instrument maker John Cuthbertson, the machine was a portable and thus more convenient version of the more famous and much larger one Cuthbertson built for the Teylers Museum in the Hague in 1784.[21] Though the demonstration of the new science of electricity is the primary focus, the electrostatic generator is but one of many of the room's sophisticated features highlighted in the image. A spectator at far right who looks up rather than at the experiment directs our view to an Argand oil lamp, the latest in lighting technology. Also notable is the circular aperture in the ceiling,

QUACK

Fig. 3
Robert Bénard (b. 1734), after
Louis-Jacques Goussier (1722–1799),
Letterpress Printing, Setting Type (and
facing page), from *Encyclopédie, ou,
Dictionnaire raisonné des sciences, des
arts et des métiers* (Encyclopedia;
or, Analytical Dictionary of
the Sciences, Arts, and Trades),
vol. 24, ed. Denis Diderot (Paris:
1769). Engraving, spread: 38.4 ×
49.5 cm. Department of Distinctive
Collections, MIT Libraries, AE25.
D555 1751.

which echoes a circular opening in the floor as well as similar apertures in rooms
above and below the physics theater. With its sections opened and closed as needed,
this "tube" through the four stories of the building facilitated experiments with
falling bodies from different heights.[22] In Vinkeles's print, the well-dressed audience
members, not all of whom pay attention to the demonstration, exemplify the degree
to which scientific inquiry, or some familiarity with it, had become a marker of
polite sociability, at least for men. Experimental science, this image proclaims, is not
for women, who are conspicuously absent here, in contrast to the engravings of the
society's concert hall and lecture room.[23]

The experimental method could challenge religious and political authority, a
potential the *Encyclopédistes* embraced. This connection is visualized in Marguerite
Gérard's etching *To the Genius of Franklin* (Fig. 5). Produced after a wash drawing
by her brother-in-law, Jean-Honoré Fragonard, this large allegorical print depicts
Benjamin Franklin as the acclaimed man of science and political celebrity he had
become. The image visually interprets the Latin verse that captions the print, writ-
ten in 1776 in honor of Franklin by French statesman Anne-Robert-Jacques Turgot:
"He snatched lightning from the sky and the scepter from tyrants." Like its caption,
the image links the advances of experimental science to freedom from oppression;
in this case, the oppression of American colonists by the British. Dressed in classical
robes and occupying the center of the scene, Franklin deflects lightning with the
assistance of a goddess who combines the allegorical attributes of Minerva, god-
dess of wisdom, with the wings and flames of Genius.[24] At the same time, Franklin
commands a militant figure, usually understood to be Mars, god of war, to destroy
Tyranny, identifiable by her iron crown, yoke, and sword. To Tyranny, explicitly

invoked by Turgot, Fragonard added an allegory of Avarice, known by her bursting bag of coins—a particularly apt choice for representing a war in America propelled in part by taxation.[25] Franklin was renowned for his experiments with lightning, which he correctly surmised to be electrical and whose danger to humans he diverted through the development of the lightning rod. He was equally celebrated in France as the envoy of the American colonies, whose war for independence from Britain was formally joined by the French in February 1778. The print, like the advertisement for Gérard's etching circulating in French and American newspapers, predicts the victory of this "revolution in the New World." America, who "calmly gazes upon her vanquished enemies," is represented by the crowned female figure seated at Franklin's feet, one arm resting on the knee of the illustrious man of science and political revolutionary.[26]

Fig. 4
Reinier Vinkeles (1741–1816), after Jacques Kuyper (1761–1808) and Pieter Barbiers (1749–1842), *Salle de Physique* (Physics Theater), 1794–1802. Etching and engraving, plate: 37.5 × 51.2 cm. Museum of Fine Arts, Boston, Katherine E. Bullard Fund in memory of Francis Bullard, 2016.242.4.

ZAAL DER NATUURKUNDE
IN HET GEBOUW der MAATSCHAPPYE FELIX MERITIS
BINNEN AMSTERDAM.

SALLE DE PHIJSIQUE
DANS L'EDIFICE de la SOCIÉTÉ FELIX MERITIS
A AMSTERDAM.

Fig. 5
Marguerite Gérard (1761–1837),
after Jean-Honoré Fragonard
(1732–1806), *To the Genius of Franklin*,
1778. Etching, sheet: 55.1 × 41 cm.
Philadelphia Museum of Art, Gift of
Mrs. John D. Rockefeller, Jr., 1946,
1946-51-249. (Detail on p. 123.)

1. Louis-Sébastien Mercier, *L'An 2440: Rêve s'il en fût jamais* (Paris: 1771), 57–58, 147.

2. Ephraim Chambers, *Cyclopaedia; or, An Universal Dictionary of Arts and Sciences, Containing the Definition of the Terms and Accounts of the Things Signified Thereby*, 2 vols. (London: 1727–28).

3. The letterpress volumes were published between 1751 and 1765 and the plate volumes from 1762 to 1772. Five supplemental volumes and multiple translations and abridgments followed. See Robert Darnton, *The Business of Enlightenment: A Publishing History of the Encyclopédie, 1775–1800* (Cambridge, Mass.: Belknap Press, 1979). The text and plate volumes of the first edition of the *Encyclopédie* have been fully digitized by the University of Chicago's ARTFL Encyclopédie Project, https://encyclopedie.uchicago.edu. English translations of many of its texts are available at The Encyclopedia of Diderot & d'Alembert Collaborative Translation Project, https://quod.lib.umich.edu/d/did.

Kristel Smentek

4. Denis Diderot, *Prospectus* [for the *Encyclopédie*] (Paris: Le Breton, 1750), 5; and ARTFL Encyclopédie Project, https://encyclopedie.uchicago.edu/node/174.

5. "Un coup d'oeil sur l'objet ou sur sa représentation en dit plus qu'une page de discours." Diderot, *Prospectus*, 4.

6. In a particularly dramatic passage in his entry "Encyclopédie," Diderot invoked an apocalyptic scenario of revolution in which the potential loss of all human knowledge is mitigated by the survival of the *Encyclopédie*. Denis Diderot, "Encyclopedia," The Encyclopedia of Diderot & d'Alembert Collaborative Translation Project, trans. Philip Stewart, 2002, accessed December 15, 2021, http://hdl.handle.net/2027/spo.did2222.0000.004. Originally published as "Encyclopédie," in *Encyclopédie, ou, Dictionnaire raisonné des sciences, des arts et des métiers*, vol. 5, ed. Denis Diderot and Jean le Rond d'Alembert (Paris: 1755), 635–648A.

7. Daniel Rosenberg, "An Eighteenth-Century Time Machine: The *Encyclopédie* of Denis Diderot," in *Postmodernism and the Enlightenment: New Perspectives in Eighteenth-Century French Intellectual History*, ed. Daniel Gordon (New York: Routledge, 2001), 45–66; and Daniel Brewer, "The *Encyclopédie*: Innovation and Legacy," in *New Essays on Diderot*, ed. James Fowler (Cambridge: Cambridge University Press, 2011), 47–58.

8. Diderot, "Encyclopedia."

9. Ibid.

10. Jean le Rond d'Alembert, "Preliminary Discourse," The Encyclopedia of Diderot & d'Alembert Collaborative Translation Project, trans. Richard N. Schwab and Walter E. Rex, 2009, accessed December 15, 2021, http://hdl.handle.net/2027/spo.did2222.0001.083. Originally published as "Discours Préliminaire," in *Encyclopédie, ou, Dictionnaire raisonné des sciences, des arts et des métiers*, vol. 1, ed. Denis Diderot and Jean le Rond d'Alembert (Paris: 1751), i–xlv.

11. Diderot, *Prospectus*; and d'Alembert, "Preliminary Discourse."

12. Madeleine Pinault-Sørenson has written extensively on the sources for the *Encyclopédie*'s plates. For an overview of her findings, see her "La fabrique de l'Encyclopédie," in *Tous les savoirs du monde: Encyclopédies et bibliothèques, de Sumer au XXIe siècle*, ed. Roland Schaer (Paris: Bibliothèque nationale de France, 1996), 383–410, with additional relevant entries by Annie Berthier, Gérard Colas, and Catherine Fournier. For an analysis of the plates in relation to transformations of scientific seeing, see John Bender and Michael Marrinan, *The Culture of Diagram* (Stanford, Calif.: Stanford University Press, 2010). On the plates in relation to emergent constructs of race, see Andrew Curran, "Diderot and the *Encyclopédie*'s Construction of the Black African," in *Diderot and European Culture*, ed. Frédéric Ogée and Anthony Strugnell (Oxford: Voltaire Foundation, 2006), 35–53.

13. Madeleine Pinault-Sørenson, "Sur un collaborateur énigmatique de l'Encyclopédie: Jean Michel Moreau dit le Jeune," *Recherches sur Diderot et sur l'Encyclopédie* 43 (October 2008): 141–51.

14. Ibid.

15. Roland Barthes, "The Plates of the *Encyclopédie* (1964)," in *A Barthes Reader*, ed. Susan Sontag (New York: Hill and Wang, 1982), 229.

16. My thanks to Sarah Grandin for sharing her knowledge of the *Description des arts et métiers* materials related to letterpress printing. See Sarah Grandin, "The Bignon Commission's Measured Bodies: Inventing Typeface and Describing the Mechanical Arts under Louis XIV," *Journal18* 9 (Spring 2020), https://www.journal18.org/4814; and Madeleine Pinault-Sørenson, "Dessins pour un *Art de l'Imprimerie*," in *Actes du 112e Congrès national des sociétés savantes, Lyon, 1987, Section d'histoire des sciences et des techniques*, Vol. 2: *Archéologie industrielle et progrès technique en région lyonnaise* (Paris: C.T.H.S., 1988), 73–85.

17. "Imprimerie en caractères," in *Encyclopédie, ou, Dictionnaire raisonné des sciences, des arts et des métiers*, vol. 24, ed. Denis Diderot (Paris: 1769), sec. 3, pp. 1, 7.

18. James A. Secord, "Newton in the Nursery: Tom Telescope and the Philosophy of Tops and Balls, 1761–1838," *History of Science* 23 (1985): 127–51. An equally best-selling popularization of Newtonian science was Francesco Algarotti's *Newtonianism for Ladies*, first published in Italian in 1737 and issued in multiple translations and editions thereafter.

19. On the domestication of science in the eighteenth century and its visual representations, see Barbara Maria Stafford, *Artful Science: Enlightenment Entertainment and the Eclipse of Visual Education* (Cambridge, Mass.: MIT Press, 1994).

20. The other prints depict the concert hall, lecture hall, and drawing gallery. A preparatory drawing for the physics theater with figures by Kuyper and architecture by Barbiers that is now in the Stadsarchief Amsterdam, collectie Van Eeghen (327), is dated 1791. A finished drawing, signed and dated 1794 by Kuyper, is in the Amsterdam Museum (TA 10641). On the earlier sheet, see Boudwijn Bakker, E. Fleurbaay, and A. W. Gerlagh, *De verzameling Van Eeghen: Amsterdamse tekeningen, 1600–1950* (Zwolle: Waanders, 1988), cat. 327. On the later drawing, see Frans Grijzenhout and Carel van Tuyll van Serooskerken, eds., *Edele eenvoud: Neo-classicisme in Nederland 1765–1800* (Zwolle: Waanders, 1989), 253, cat. 275. On the society's new building and images of it, see Freek Schmidt, *Passion and Control: Dutch Architectural Culture of the Eighteenth Century* (Farnham, U.K.: Ashgate, 2016), 241–79.

21. Lissa Roberts, "Science Becomes Electric: Dutch Interaction with the Electrical Machine during the Eighteenth Century," *Isis* 90 (4) (1999): 694–96; H. A. M. Snelders, "Het departement natuurkunde van de Maatschappij van Verdiensten Felix Meritis in het eerste kwart van zijn bestaan," *Documentatieblad Werkgroep Achttiende Eeuw* 15 (1983): 200; and Schmidt, *Passion and Control*, 269.

22. Huib J. Zuidervaart and Rob H. Van Gent, *Between Rhetoric and Reality: Astronomical Practices at the Observatory of the Amsterdam Society* Felix Meritis, *1786–1889* (Hilversum: Verloren, 2013), 40–41.

23. Although not frequently represented as doing so, eighteenth-century women actively pursued scientific interests. For the Dutch context, for example, see Margaret C. Jacob and Dorothée Sturkenboom, "A Women's Scientific Society in the West: The Late Eighteenth-Century Assimilation of Science," *Isis* 94 (2) (June 2003): 217–52.

24. For a detailed analysis of Fragonard's allegory, see Mary D. Sheriff, "'Au Génie de Franklin': An Allegory by J.-H. Fragonard," *Proceedings of the American Philosophical Society* 127 (3) (June 1983): 180–93. In his preparatory drawing, now in the White House, Fragonard generalized Franklin's features. As Sheriff points out, the recognizable likeness in Gérard's print is likely based on drawings by Fragonard after portrait busts of Franklin by sculptors Jean-Antoine Houdon and Jean-Jacques Caffieri. For the preparatory drawing, see William Kloss et al., *Art in the White House: A Nation's Pride* (Washington, D.C.: White House Historical Association, 1992), 60–61.

25. Sheriff, "Au Génie de Franklin," 183.

26. *Journal de Paris*, November 15, 1778; cited and translated in Rena M. Hoisington and Perrin Stein, "*Sous les yeux de Fragonard*: The Prints of Marguerite Gérard," *Print Quarterly* 29 (2) (2012): 158. See also "To the Printer of the Pennsylvania Packet," *Pennsylvania Packet*, June 3, 1780. Another advertisement was placed in the *Connecticut Gazette* on June 30, 1780. See Hugh Honour, *The European Vision of America* (Cleveland: Cleveland Museum of Art, 1975), cat. 206.

Kristel Smentek

LAVA

Elizabeth M. Rudy

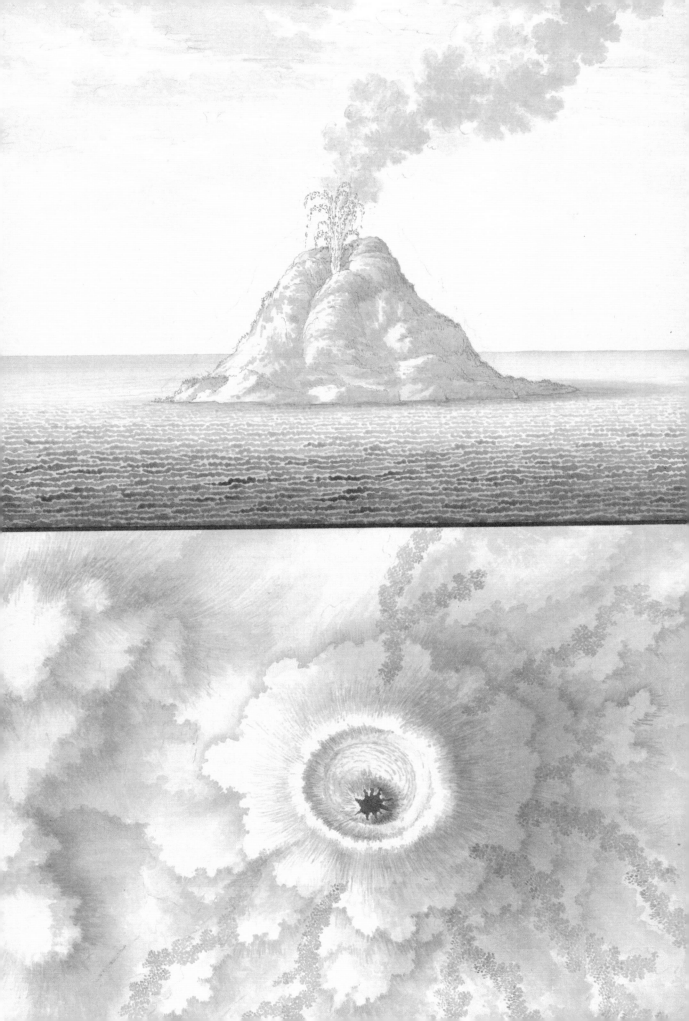

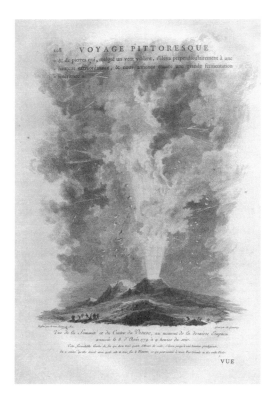

In eighteenth-century Europe, volcanoes were everywhere—stoking the collective imagination both literally and figuratively, in spheres from the scholarly to the social. Reports about volcanic eruptions worldwide filled newspapers near annually; scientists fiercely debated the causes of eruptions, searching for answers in the fields of chemistry, physics, and mineralogy; tourists, often wealthy travelers visiting the Italian peninsula on the Grand Tour, embarked on guided excursions to the craters and penned dramatic accounts of their experiences; religious leaders cited eruptions as a deistic corrective for human frailty and sin; artificial volcanoes appeared as decorative, entertaining features in contexts ranging from private gardens to stage sets; and at the end of the century, the volcano was often used as a metaphor to rationalize the upheaval of political revolutions.[1]

The volcano loomed so large, in fact, that it resisted representation. Contemporaries grappled with its scale, drama, and threat in their written texts, acknowledging their inability to document its complexity in full. Mount Vesuvius and the Phlegraean Fields, in the vicinity of Naples, received particular attention for their almost ceaseless activity. The profound instability of volcanoes, especially their shape-shifting convulsions during eruption, guaranteed a degree of futility to their chroniclers and posed a steep challenge to artists: how to represent the unrepresentable?

In his influential book on Naples and Sicily, the Abbé de Saint-Non outright conceded that it was impossible to capture an eruption with images. "We know how difficult it is, if not impossible, to represent one of the biggest and most terrifying events in nature," he wrote. "There are some that art cannot achieve, and this one is among them."[2] To mitigate this, he broke with one of the fundamental traits of

Fig. 2
Francesco Piranesi (1750–1810) and
Louis-Jean Desprez (1743–1804), *The
Fireworks above Castel Sant'Angelo*, 1781
or 1783. Etching with watercolor and
gouache, sheet: 78.4 × 57.5 cm. New
York Public Library, Miriam and
Ira D. Wallach Fund, 105853b.

illustrated books: rather than devote an entire page to the illustration of an eruption, he printed the image over the text, so that Vesuvius appears to spew lava and rocks onto the text itself (Fig. 1).[3] The words can only be read *through* the image, forcing the reader to consume the narration and visualization of the cataclysmic event simultaneously. This is a strategy that Saint-Non employed elsewhere in the book, too, but here it is especially resonant.

Some artists sought to negotiate this challenge on a material level, using specific techniques and substances that narrowed the gap between their immense subject and its portrayal in text and image. When Sir William Hamilton sent his report and geological samples from Vesuvius to London's Royal Society in 1767, he included an image of lava made with translucent pigments. Though that work is now lost, he elucidated his goals in the accompanying text: "[I]t is painted with transparent colours, and, when lighted up with lamps behind it, gives a much better idea of Vesuvius, than is possible to be given by any other sort of painting."[4] While this was possibly a marketing ploy by Hamilton—a recourse to the realm of gimmickry, as David McCallam argues—it was also an acknowledgment of the visual complexity of lava.[5] Hamilton claimed that the shimmering effect that resulted when the pigments and permeable surface were lit from behind more accurately conveyed the shifting, unstable colors and layers of the rock itself.

While volcanoes challenged representation in their fullness, they also constituted a kind of supra-subject, promising innumerable opportunities for visual and intellectual stimulation. Even the mere association with volcanic substances spawned demand for a certain paint pigment from Italy. In his late seventeenth-century

Elizabeth M. Rudy

treatise on painting, Andrea Pozzo referred to lead antimonate yellow, a pigment that had been used by artists since antiquity, as "Naples yellow" ☉. Based solely on this nomenclature, people for generations believed that it derived from volcanic rocks in the surrounds of Naples—a rumor dispelled only when the French botanist Auguste-Denis Fougeroux de Bondaroy successfully manufactured the pigment and published his recipes in 1766, proving that there was no need for painters outside Italy to pay for imported natural varieties.[6]

Depictions of volcanoes as the epitome of the sublime appeared frequently in written descriptions of every genre, finding cognates in artists' scenes of the landforms in full eruption, a natural phenomenon that was literally spectacular. The Chevalier de Jaucourt was one of many authors to personify an eruption, writing in his article for the *Encyclopédie*: "In its transports of rage, it attacks everything together, the air, the ground and sea, and carries everywhere fear, desolation and death."[7] The mortal threat of such attacks was urgent: Hamilton attested to the injuries suffered by some of his companions during an ascent of Vesuvius in 1766, and the

excavations at the cities of Herculaneum and Pompeii ☉ were constant reminders of the indiscriminate, expansive destruction caused by flowing, molten lava.[8] To depict this voracious expulsion and consumption, artists invoked the melodrama of every possible visual mode, and painters such as Pierre-Jacques Volaire and Joseph Wright of Derby satisfied collectors' eagerness to own dramatic, painted scenes of eruptions.[9] Wright of Derby even produced pendant paintings juxtaposing the eruption of Vesuvius with the Roman fireworks display known as the Girandola. As he wrote in a letter dated January 15, 1776, "the one is the greatest effect of Nature the other of Art that I suppose can be."[10]

Just over ten years later, Louis-Jean Desprez and Francesco Piranesi produced a similar pair of images that was likely based on Wright of Derby's example; their Vesuvius and Girandola were part of a collaborative series of hand-colored etchings marketed to wealthy tourists.[11] For each work in the series, Piranesi etched the outline of the composition, producing a set of black and white images that were essentially identical and which Desprez then hand-colored to create individualized versions of the scene. This method allowed the artists to replicate the original design indelibly—with the addition of drawing media, the printed outlines would not smudge or disappear—and to promote each finished work as a unique collectible. Their depiction of the Girandola focuses on the spectacular and public aspects of the event, showing throngs of spectators engaged in various activities and illuminated by the fiery orb of exploding fireworks above (Fig. 2). The Girandola had been celebrated in Rome for centuries before this scene was depicted; it was a remarkable, highly anticipated event involving hundreds of rockets and projectiles shot high into the sky from a spiraling wheel.[12] Witnesses routinely compared the display to volcanic eruptions, and Onorato Caetani wrote in 1774 that the wheel's design was based on Mount Stromboli, the volcanic island north of Sicily in the Tyrrhenian Sea, though the claim is apocryphal.[13]

Outside the contexts of entertainment and the sublime, artists used a similarly wide range of visual strategies to account for volcanoes as natural phenomena and to advance a scientific understanding of their components and behavior through careful

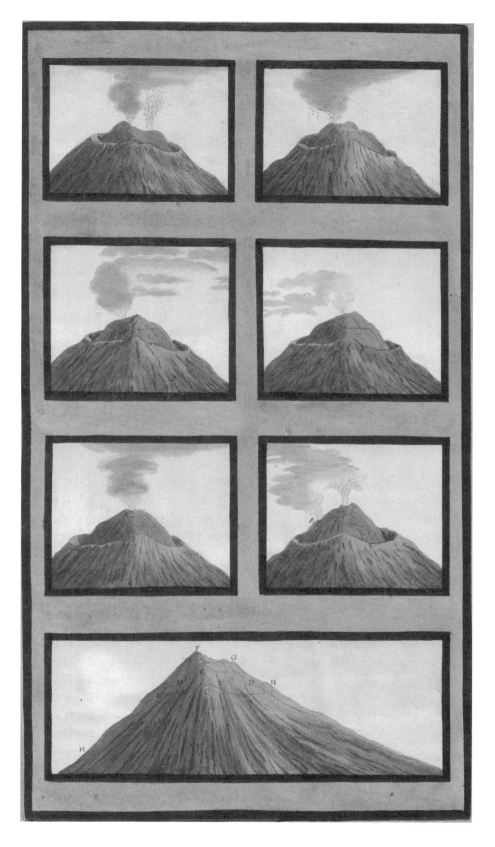

Fig. 3
Pietro Fabris (1740–1792), Plate 2, from *Campi Phlegraei: Observations on the Volcanoes of the Two Sicilies*, by Sir William Hamilton, vol. 2 (Naples: 1776). Etching with gouache, sheet: 47 × 35.3 cm. Houghton Library, Harvard University, Gift of Philip Hofer, pf Typ 725.76.447.

Elizabeth M. Rudy

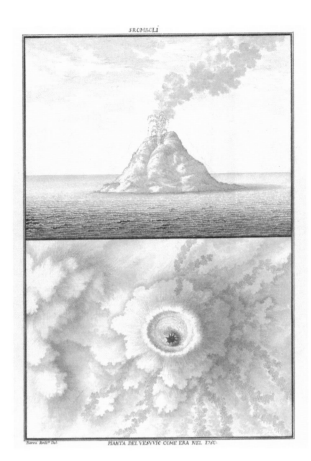

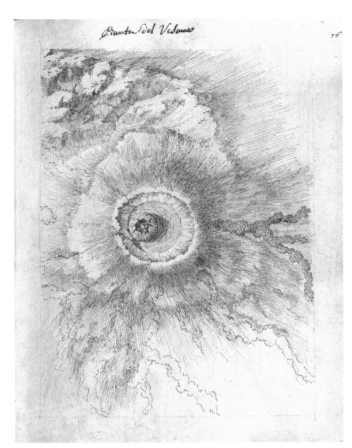

Fig. 4
Giovanni Battista Borra (1713–1770),
Stromboli and Vesuvius, 1750. Black
ink with gray wash over graphite,
sheet: 54.3 × 37.9 cm. Yale Center for
British Art, New Haven, Conn., Paul
Mellon Collection, B1977.14.1015.
(Detail on p. 135.)

Fig. 5
Giovanni Battista Borra (1713–1770),
Plan of Vesuvius, from *Another
sketchbook in pencil and ink by Borra,
covering Naples, Asia Minor and
Egypt*, 1750. Graphite and ink on
parchment, 28 × 22 cm. Special
Collections, Hellenic and Roman
Library, Senate House, University of
London, Wood/16.

illustrations. Often, artists relied on multiplicity as a solution, producing a series of related images that cohered to form a single representation, conveying information in aggregate and illustrating a volcano's change over time. Hamilton embraced this approach holistically. The British envoy to the court of King Ferdinand IV, he lived in the foothills of Vesuvius and claimed to have climbed to the summit fifty-eight times.[14] Through repeated observation and documentation of the volcano's activity over a period of years, Hamilton made an enduring contribution to the emerging field of geology and to debates about the formation of the earth.[15] His accounts were illustrated in the opening plates of his *Campi Phlegraei: Observations on the Volcanoes of the Two Sicilies*, each of which features multiple scenes that are enumerated and elucidated in the accompanying text. The second plate shows seven views of the summit of Vesuvius, all but one rendered from the same vantage point between July 8 and October 29, 1767 (Fig. 3). Dotted lines on each image demarcate the transformation of the rock formation from the previous scene, tracing the evolution of the setting from one moment in time to the next.

Careful observation, documentation, and verification are recurring themes throughout the illustrations to the *Campi Phlegraei*. Depictions of Hamilton and the volume's artist, Pietro Fabris, in many of the plates speak to their collaboration in the conception of the scenes and underscore their shared methodology for representing volcanoes in text and image.[16] Each plate was etched after gouache drawings by

Fabris, and those etchings were then individually colored with gouache. As in the collaborative works by Desprez and Piranesi, this method assured that the outline of every form in each plate would be the same, while the gouache reworking bestowed a greater vividness and depth to the plates than color printing could achieve. Yet despite claims of authenticity and an ability to depict volcanic events more brightly and with greater detail than previously possible, the body and opacity of gouache necessarily injected a degree of summarization to the objects and landscapes represented.

In a similar way, the architect-engineer Giovanni Battista Borra is credited with applying his celebrated technical approach to the representation of Stromboli and Vesuvius, which he drew in the initial phase of an expedition to the Levant led by Anglo-Irish classicist Robert Wood (Fig. 4).[17] Borra's drawing adopts a bisected format, a mode common in scientific book illustration, yet his use of gray wash generalizes the details and his study of Vesuvius is indebted to the engraved plates accompanying Francesco Serao's widely read book about the volcano's 1737 eruption.[18]

The official diary chronicling Wood's expedition opens in Naples and states that drawings were made of both volcanoes, possibly indicating the group's early intention to begin their published account with views from the first days of their journey.[19] Borra's personal diaries contain a preliminary sketch resembling the outline of Stromboli and three views of Vesuvius: a distant view of the volcano erupting, inscribed with the date May 20, 1737; a close view of the crater; and an aerial view of the summit.[20] The first two are very similar to the engravings in Serao's book. Like the other aerial drawings in Borra's sketchbooks, which include shorelines and fortifications, the bird's-eye view of the crater (Fig. 5) was achieved through mathematical calculations typically used in the fields of architecture and cartography. It relates directly to the lower half of the later drawing at the Yale Center for British Art, rotated 90 degrees; but rendered in graphite and ink, it conveys much more detail than the later version. The vent of the crater, for instance, plunges to a smaller shape in the depths, while in the Yale drawing this orifice is an opaque form with no additional detail. The crater is seen from a more distant vantage point in the Yale drawing, where the fluid movement of the wash aptly conveys the shapes and shifting edges of the strata but not fine details. Borra's depiction of Stromboli above also charts a reconsidered approach, where a faint line in graphite shows his initial outline of the mountain, larger than the final version defined in ink.

Artists confronted the limitations of the graphic arts to represent fully the sensorial and conceptual grandeur of volcanoes by grappling with media such as gouache and wash, which produced dramatic color but precluded fine detail, and by employing mathematical methods to compensate for the physical impossibility of occupying certain vantages. These challenges were surmounted in the ultimate representation of volcanoes: their simulation through fireworks and operational replicas. Vesuvius and Mount Etna were regular features in fireworks displays during the annual Chinea festival in Rome,[21] and scientists and amateurs alike manufactured miniature volcanoes in their homes to better understand them.[22] Replicas also proliferated in gardens as curiosities; one of the most notable was in the Gartenreich Dessau-Wörlitz, where the fake volcano (still operational today) would erupt as public entertainment, enabled by the careful, choreographed operations of laborers nestled inside its cavity.[23]

Elizabeth M. Rudy

1. The most comprehensive account of volcanoes in the age of Enlightenment is David McCallam, *Volcanoes in Eighteenth-Century Europe: An Essay in Environmental Humanities*, Oxford Studies in the Enlightenment (Oxford: Voltaire Foundation, 2019).

2. "On sent combien il est difficile, pour ne pas dire impossible, de représenter un des effets les plus gigantesques & des plus effrayants de la nature. Il en est auxquels l'art ne peut atteindre, & celui-ci étoit du nombre." Jean Claude Richard, Abbé de Saint-Non, "Explication des Vignettes, Fleurons et Ornemens," in *Voyage pittoresque, ou, Description des royaumes de Naples et de Sicile*, vol. 1 (Paris: 1781), ix. Saint-Non had editorial authority over the *Voyage pittoresque* and authored the descriptions of the plates. See Antony Griffiths, "The Contract between Laborde and Saint-Non for the 'Voyage Pittoresque de Naples et de Sicile,'" *Print Quarterly* 5 (4) (December 1988): 408–14.

3. A recent examination of the sheet through a pocket microscope revealed that the printed lines of the image sit atop the letters, indicating that the image was printed after the text. Though an inscription on the print credits Hubert Robert as the designer, Petra Lamers asserts that Saint-Non erroneously ascribed another artist's drawing to Robert when the engraving was made. See Petra Lamers, *Il viaggio nel Sud dell'Abbé de Saint-Non* (Naples: Electa Napoli, 1995), 72, 195–96, cats. 163, 163a.

4. Sir William Hamilton, *Observations on Mount Vesuvius, Mount Etna, and Other Volcanos: In a Series of Letters Addressed to the Royal Society* (London: T. Cadell, 1772), 41.

5. McCallam, *Volcanoes in Eighteenth-Century Europe*, 113.

6. Joris Dik, "Scientific Analysis of Historical Paint and the Implications for Art History and Art Conservation: The Case Studies of Naples Yellow and Discoloured Smalt," Ph.D. thesis, Van 't Hoff Institute for Molecular Sciences, University of Amsterdam, 2003, 49–52.

7. "[D]ans les transports de sa rage, il attaque tout ensemble, l'air, la terre & la mer, & porte partout la crainte, la désolation & la mort." Chevalier de Jaucourt, "Vésuve," in *Encyclopédie, ou, Dictionnaire raisonné des sciences, des arts et des métiers*, vol. 17, ed. Denis Diderot and Jean le Rond d'Alembert (Paris: 1751–65), 219.

8. Hamilton, *Observations on Mount Vesuvius, Mount Etna, and Other Volcanos*, 8.

9. See Mark. A. Cheetham, "The Taste for Phenomena: Mount Vesuvius and Transformations in Late 18th-Century European Landscape Depiction," *Wallraf-Richartz-Jahrbuch* 45 (1984): 131–44.

10. Quoted in Kevin Salatino, *Incendiary Art: The Representation of Fireworks in Early Modern Europe*, Biographies and Dossiers 3 (Los Angeles: Getty Publications, 1998), 49.

11. Ibid., 77. See also Régis Michel, ed., *La Chimère de Monsieur Desprez* (Paris: Réunion des musées nationaux, 1994), 47–50.

12. Simon Werrett, *Fireworks: Pyrotechnic Arts and Sciences in European History* (Chicago: Chicago University Press, 2010), 19–20.

13. Salatino, *Incendiary Art*, 76.

14. Sir William Hamilton, *Supplement to the Campi Phlegraei* (Naples: 1779), 2.

15. Karen Wood, "Making and Circulating Knowledge through Sir William Hamilton's 'Campi Phlegraei,'" *The British Journal for the History of Science* 39 (1) (March 2006): 67–96; see also McCallam, *Volcanoes in Eighteenth-Century Europe*, 51–85.

16. Ian Jenkins and Kim Sloan, *Vases & Volcanoes: Sir William Hamilton and His Collection* (London: British Museum Press, 1996), 168. Plate 38 of the *Campi Phlegraei* showcases this idea most dramatically by representing Hamilton escorting a royal entourage to view flowing lava at night while Fabris sketches in the middle ground.

17. Scott Wilcox, ed., *The Line of Beauty: British Drawings and Watercolors of the Eighteenth Century* (New Haven, Conn.: Yale Center for British Art, 2001), 77, cat. 59. For more on Borra's draftsmanship, see Paola Bianchi and Karin Wolfe, eds., *Turin and the British in the Age of the Grand Tour* (Cambridge: Cambridge University Press, 2017), 263–78.

18. Francesco Serao, *Istoria dell'incendio del Vesuvio accaduto nel mese di maggie dell'anno MDCCXXXVII. Scritta per l'Accademia delle scienze* (Naples: Novello de Bonis, 1738).

19. C. A. Hutton, "The Travels of 'Palmyra' Wood in 1750–51," *The Journal of Hellenic Studies* 47 (1) (1927): 103–4. Two groundbreaking publications resulted from this voyage: *The Ruins of Palmyra: Otherwise Tedmor, in the Desart* [*sic*] (London: 1753) and *The Ruins of Balbec: Otherwise Heliopolis in Cœlosyria* (London: 1757).

20. For Stromboli, see leaf 22 recto in *Wood 15. Sketchbook by Giovanni Battista Borra covering the tour. Sketches are in ink or pencil*; for Vesuvius, see leaves 16 recto, 18 recto, and 20 recto in *Wood 16. Another sketchbook in pencil and ink by Borra, covering Naples, Asia Minor and Egypt*. Both sketchbooks are in the Special Collections, Hellenic and Roman Library, Senate House, University of London.

21. Salatino, *Incendiary Art*, 55.

22. McCallam, *Volcanoes in Eighteenth-Century Europe*, 57–58.

23. Joachim von der Thüsen, *Schönheit und Schrecken der Vulkane: Zur Kulturgeschichte des Vulkanismus* (Darmstadt: Wissenschaftliche Buchgesellschaft, 2008), 111–27.

Elizabeth M. Rudy

MICROSCOPE

Brandon O. Scott

"Look into my eyes." In human-to-human encounters, this demand often precedes an appeal to truth—a petition sought through seeing, through the eyes, windows to the soul. But what does it mean when the request is proffered by a fly, like the one in scientist Robert Hooke's magnified image of the insect (Fig. 1)? Is it still a call for truth? And if so, which of the hundreds if not thousands of eyes do you stare into? Do you look straight on, or sidelong?

Before we turn to these questions, however, there is the enigma of the fly itself, its gaze at once an incandescent array of stars emerging from a dark, cross-hatched silhouette and an opaque glass that reveals nothing of what's inside, offering only a mirror reflection infinitely refracted, as if by a kaleidoscope. Already bewildering, Hooke's image is made still more alien by the fly's huge head—a head made up almost entirely of eyes, and lacking a body. Hooke explains:

> I took a large grey *Drone-Fly*, that had a large head, but a small and slender body in proportion to it, and cutting off its head, I fix'd it with the forepart or face upwards upon my Object Plate. . . . Then examining it according to my usual manner, by varying the degrees of light, and altering its position to each kinde of light, I drew that representation of it which is delineated in the 24. *Scheme*, and found these things to be as plain and evident, as notable and pleasant.[1]

The fly was not the only thing Hooke scrutinized with his "polymorphous visual fluency": sewing pins and plant seeds, fabrics and flint all appear in engravings of exquisite detail, presenting some of the earliest closeup views of these materials—views enabled by the microscope.[2] When Hooke's *Micrographia* was first published in 1665, the technology was already well known: in 1610, Galileo Galilei found that by shortening his telescope he could magnify small creatures, granting himself access to both the macrocosm and the microcosm through one device.[3] *Micrographia* was therefore about not the discovery of microscopy, but rather its dissemination. Long a best seller, the book was successful in this aim; the 1745 copy whose plate is reproduced here was published nearly a century after the first edition. Of the volume's thirty-eight engravings, fourteen depict insects, and they have proved detailed enough that modern entomologists can classify them. The fly is a horsefly, genus *Tabanus*.[4]

In 1644, eleven years before *Micrographia* was published, Italian priest Giovanni Battista Hodierna published *L'occhio della mosca* (The Eye of the Fly) with the aid of his *occhialino*, or "little eye," an early name for the microscope.[5] The images of flies in these two books are quite distinct. Hodierna's woodcut (Fig. 2) strives for visual comfort, inserting the insect's head and eyes between two types of fruit—a mulberry on the left and a strawberry on the right. He offers an analogy: though your eyes cannot readily look into the fly's unaided, imagine them as the aggregate parts of fruit, the strangeness of the head abated by the sweetness of berries.

But Hooke's fly cannot be viewed askance; you must look at it directly. Larger than life, looming, lustrously legible, it affirms the scientist's intent to act *"as*

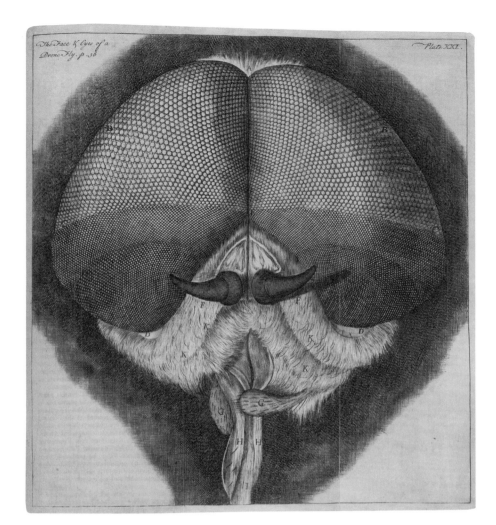

Fig. 1

Robert Hooke (1635–1703), Plate 21, from *Micrographia restaurata; or, The copper-plates of Dr. Hooke's wonderful discoveries by the microscope, reprinted and fully explained* (London: John Bowles, 1745). Engraving in book, open: 37 × 52 × 6 cm. Ernst Mayr Library of the Museum of Comparative Zoology, Harvard University, F413. (Detail on p. 145.)

a sincere Hand, *and a* faithful *Eye, to examine, and to record, the things themselves as they appear*."[6] Hooke noted that the "number of the *Pearls* or *Hemispheres* in the clusters of this Fly, was neer 14000." Though he reaches for analogy to describe what he sees, it is the facticity of the number that amazes him. He also marvels at the seemingly impeccable craftsmanship of each lens, with "a surface exceeding smooth and regular, reflecting as exact, regular, and perfect an Image of any Object from the surface of them."[7] The insect almost seems to have better instruments at its disposal than the natural scientist. Indeed, Hooke did not use the best microscopes available in his day; while his instrument contained two lenses, like a telescope, the finest versions of the tool, such as Antonie van Leeuwenhoek's simple microscopes, had only one.[8]

Though Hooke readily acknowledged the higher power of simple microscopes, he described them as "very troublesome to be us'd, because of their smallness."[9] In exchange for resolution, he got versatility, as his preferred microscope allowed the use of a tripod and an adjustable stage, making it much easier to view and manipulate specimens. Hooke called the microscope his "Mechanical

Brandon O. Scott

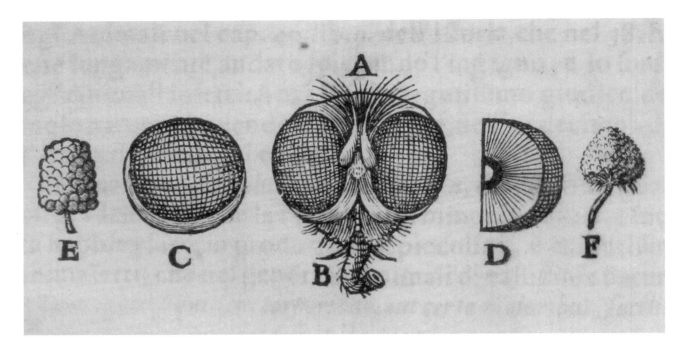

NATURE

help" because it, like other tools of science, ameliorated the "infirmities" of the "Senses," facilitating, "*as it were, the adding of* artificial Organs *to the* natural," so that ultimately "*every considerable improvement of* Telescopes *or* Microscopes" would aid in "*producing new Worlds and* Terra-Incognita's to our view."[10] One such unexplored territory was the fly's compound eye. The longer Hooke looked into it with his microscope, the more he was confounded: "[W]hat must needs the component parts be of that *Retina*, which distinguishes the part of an object's Picture that must be many millions of millions less then [*sic*] that in a man's eye?" he asked. "And how exceeding curious and subtile must the component parts of the *medium* that conveys light be, when we find the instrument made for its reception or refraction to be so exceedingly small?"[11]

Look into the hemispheres of a fly's eye, then, and you will find windows not into another soul, but into a space of wonder that refracts the scientist's scrutinizing gaze into states of speculation 👁. Look into the celestial cosmos through another kind of sphere, and you will find sightlines similarly redirected in William Pether's 1768 mezzotint *A Philosopher Giving a Lecture on the Orrery* (Fig. 3), after a painting by Joseph Wright of Derby from roughly 1766. An orrery, like the one by Peter and John Dollond (Fig. 4), is a mechanical instrument showing the motions of the entire solar system (also called a planetarium) or of the moon, earth, and sun specifically (a tellurion). The room depicted in Pether's print is nearly without light, a condition perfectly suited for mezzotint, a technique that begins in darkness—as a roughened copper sheet that would print pitch black if run through the press unaltered—and gains light only as the artist scrapes and smooths away the total nightfall, creating halftones (*mezzo-tints*) of luminance. Thus, the artist's practice brings light to the picture, as the scientist's gives light to the "sun"-lit room, in turn allowing Reason to enlighten the audience on the wonders of the cosmos. Wright painted his *Orrery* after

he created *Three Persons Viewing the Gladiator by Candlelight* (1765), in which a copy of the *Borghese Gladiator* charges in place as three men look intently upon the model of human form perfected. Though swordless, the gladiator, cast in chiaroscuro, cuts through the light with his commanding figure.

The differences between the two paintings are instructive: not only is a classical art object displaced by a scientific one, but the adult male audience is supplanted by adolescence—in the later work, two boys lean on the cosmos as a girl pokes at it with her pointer finger. These new viewing subjects underscore the many novel ways of looking introduced by spectacles of science ◉. One by one, each face seems to present a different state of engagement, like phases of the moon: not looking, glimpsing, half looking, looking closely, looking directly, looking away, looking past, looking fleetingly.[12] With so many ways of seeing comes numerous ways of interpreting the scene, especially as Wright's painting became Pether's print. Disseminated to a general public, this demonstration of candlelit science was as likely to be understood as enlightened education as it was shadow-filled entertainment—and indeed it carries aspects of both, to varying degrees, just as the faces of the model public depicted in the room do. Altogether, their various sightlines would seem to make it possible "to have an eye every way, and to be really circumspect," as Hooke said of his fly.[13] With their multidirectional tunnel vision, they form a human *Tabanus*.

But not all take kindly to insects, "artificial Organs," or the profusion of perspectives therein. Poet Alexander Pope perhaps had Hooke in mind when he wrote, in his *Essay on Man* (1734), "Why has not Man a microscopic eye? / For this

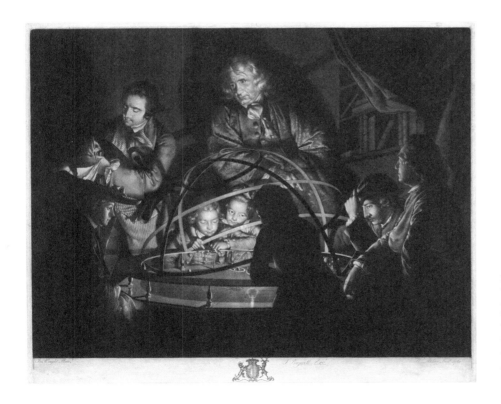

Fig. 3
William Pether (1731–c. 1795), after Joseph Wright of Derby (1734–1797), *A Philosopher Giving a Lecture on the Orrery*, 1768. Mezzotint, plate: 44.6 × 58.1 cm. National Gallery of Art, Washington, D.C., Paul Mellon Fund, 2001, 2001.96.12.

Brandon O. Scott

plain reason, Man is not a Fly."[14] The possibility of a fly-man-microscope cyborg is here curbed by a couplet. Empiricist philosopher John Locke, too, pondered the usefulness of a man endowed with "microscopical eyes," concluding that they would be useless "if such an acute sight would not serve to conduct him to the market and exchange."[15] In other words, tools must help form communities and maintain commerce on a common (that is, human) scale. The microscope would have to prove its worth, like the mariner's dry compass before it (Fig. 5). By dividing the cardinal directions into thirty-two points of orientation, the compass facilitated the precise navigation across seas—to actual "Terra-Incognita," not just Hooke's epistemic one ◉.

EXPEDITION

Gabriel Jacques de Saint-Aubin satirized both kinds of territorial ambitions in *The Instructive and Appetizing Meal* (see p. 79). Depicted in a rounded frame, as if espying the social gathering through a lens, three gourmands drink wine from beakers as they are served by a fourth, who wields another kind of compass around an armillary sphere. The frame no longer contains the universe, but instead a roast capon. Humor is apparent in this scene, but also horror, for such "Mechanical helps" did indeed empower their European users to set much of the world on a table, as it were, to scrutinize it and cut it up just as Hooke did his fly, and as painter John Russell would do to the moon in the late eighteenth century.

Writing to a patron in 1789, Russell reminisced: "About twenty-five years since, I first saw the moon through a Telescope, which I now recollect must have been about two Day after the first quarter; you will conclude how much struck a young Man conversant with Light, and Shade, must be with the Moon in this state"—a state when the moon is a mezzotint.[16] Between 1764, when he first saw the celestial body through a telescope, and 1805, Russell made at least 187 drawings of the lunar surface.[17] Three perfect moons resulted from his piecemeal labors: a nearly five-foot-wide pastel drawing (1795); a three-dimensional globe model (marketed as a *Selenographia*, 1797); and two prints, the *Lunar Planispheres*, published just after his death in 1806 (see p. 251). Russell depicted one of the *Planispheres* in flat light and the other lit obliquely, to better

Fig. 4
Peter Dollond (1730–1820) and John Dollond (1706–1761), Portable orrery, c. 1787. Brass, mahogany, and ivory, with paper face engraved with watercolor, orrery: 12.2 × 25.6 × 23 cm; case: 15.6 × 26.5 × 25.3 cm. Collection of Historical Scientific Instruments, Harvard University, DW0701.

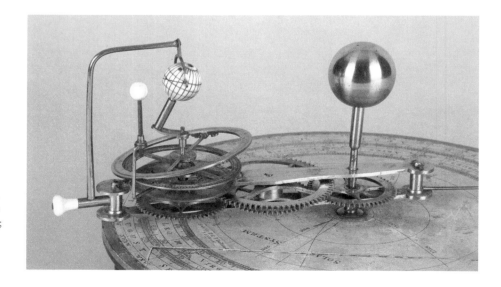

Fig. 5
Edward Nairne (1726–1806),
manufactured by Eade & Wilton
(active 1740–1765), Mariner's
dry-card compass, 1765. Glass, oak,
brass, and lead, with engraved card,
16.8 × 31 × 29.4 cm. Collection of
Historical Scientific Instruments,
Harvard University, 0094.

give the lay of the lunar land; for just as Pether and Hooke before him, Russell knew that to best see "things themselves" requires a half-light.[18] Enlightenment does not come from direct observation under the midday sun, which will all but "drown the appearance" of things; rather, it is a process of scraping away just enough of the dark's edge to look at a fly, up to the moon, and into the cosmos.[19]

1. Robert Hooke, *Micrographia; or, Some Physiological Descriptions of Minute Bodies Made by Magnifying Glasses, with Observations and Inquiries Thereupon* (London: John Martyn, 1667), 175. Italics in this quote and others are Hooke's.

2. For more on Hooke's image making practices and "fluency," see Matthew C. Hunter, "Experiment, Theory, Representation: Robert Hooke's Material Models," in *Beyond Mimesis and Convention*, ed. Roman Frigg and Matthew C. Hunter, Boston Studies in the Philosophy of Science 262 (Dordrecht: Springer, 2010), 193–219.

3. On the difficulty of precisely dating the microscope's invention, see Adam Max Cohen, *Technology and the Early Modern Self* (New York: Palgrave Macmillan, 2009), 173–75.

4. Mark A. Jervis, "Robert Hooke's *Micrographia*: An Entomologist's Perspective," *Journal of Natural History* 47 (39–40) (October 2013): 2543.

5. For a comparison of insect images by Hodierna, Hooke, and others in the seventeenth century, see Domenico Bertoloni Meli, "The Representation of Insects in the Seventeenth Century: A Comparative Approach," *Annals of Science* 67 (3) (2010).

6. Hooke, *Micrographia*, n.p. (preface).

7. Ibid., 175.

Brandon O. Scott

8. On the magnification power of early microscopes, see Catherine Wilson, *The Invisible World: Early Modern Philosophy and the Invention of the Microscope* (Princeton, N.J.: Princeton University Press, 1995), 80.

9. Hooke, *Micrographia*, n.p. (preface).

10. Ibid.

11. Ibid., 180.

12. For the moon interpretation, see Louise Siddons, "Sensibility and Science: Motherhood and the Gendering of Knowledge in Two Mezzotints after Joseph Wright of Derby," *Frontiers* 36 (2) (2015): 130–31.

13. Hooke, *Micrographia*, 175.

14. Alexander Pope, *Pope's Essay on Man, and Essay on Criticism*, ed. Joseph B. Seabury (New York: Silver, Burdett, and Co., 1900), 195.

15. John Locke, *An Essay Concerning Human Understanding*; quoted in Christa Knellwolf, "Robert Hooke's *Micrographia* and the Aesthetics of Empiricism," *The Seventeenth Century* 16 (1) (2001): 192.

16. Quoted in E. J. Stone, "Note on a Crayon Drawing of the Moon by John Russell R.A., at the Radcliffe Observatory, Oxford," *Monthly Notices of the Royal Astronomical Society* 56 (3) (1896): 91.

17. This is based on the number of sheets found in *The Complete Collection of Russell's Drawings of the Moon*, a folio album at the Oxford University Museum of History. Some sheets, as W. F. Ryan notes, contain more than one sketch. See W. F. Ryan, "John Russell, R.A., and Early Lunar Mapping," *Smithsonian Journal of History* 1 (1) (1966): 46.

18. On the 1795 pastel drawing, see Stone, "Note on a Crayon Drawing of the Moon by John Russell R.A., at the Radcliffe Observatory, Oxford." On the three-dimensional model, see John Russell, "Proposals for publishing by subscription, a globe of the moon" (1797), 1–3; and John Russell, *A description of the selenographia: an apparatus for exhibiting the phenomena of the moon. Together with an account of some of the purposes which it may be applied to* (London: W. Faden, 1797). On the two prints, see ibid.

19. Hooke, *Micrographia*, n.p. (preface).

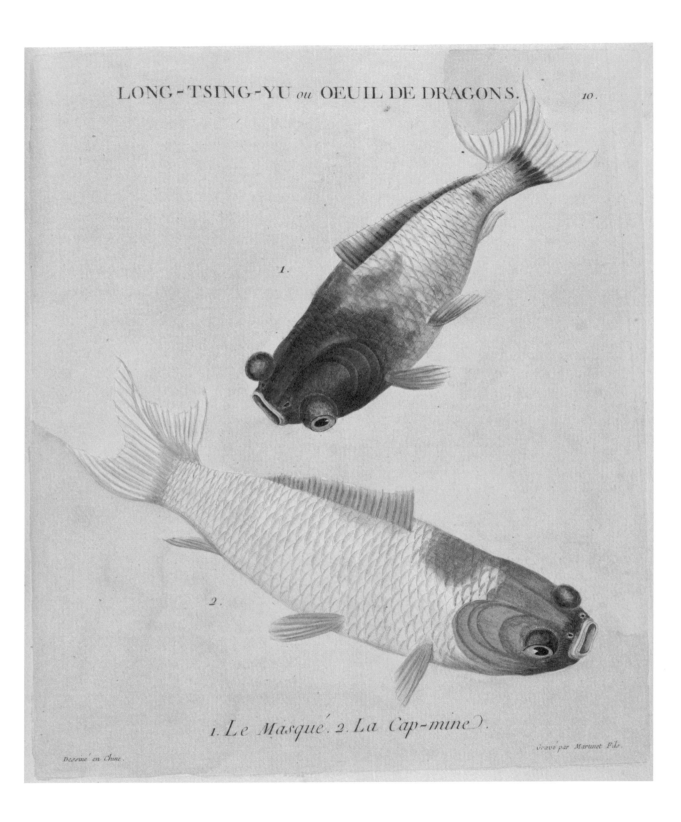

1.

2.

1. Le Masqué. 2. La Cap-mine.

Dessiné en Chine.

Gravé par Marinet F.ls.

Fig. 1
Detail of plate 38

Fig. 2
Detail of plate 10

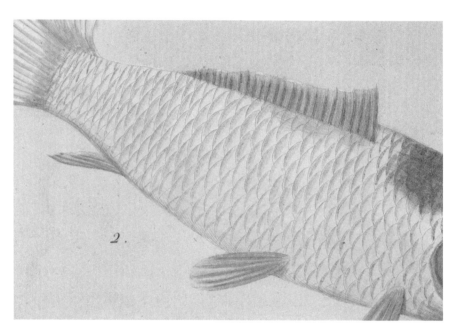

François Nicolas Martinet and Aaron Martinet
Plate 10, from *Natural History of Chinese Goldfish*

In 1780, an illustrated volume on the ornamental goldfish of China was published in France. Native to East Asia, the fish were little known in Europe at the time; author Edme-Louis Billardon de Sauvigny based his text on a handwritten account sent to Paris by a French missionary in Beijing. Draftsman and printer François Nicolas Martinet and his son, Aaron, produced the accompanying prints. Each of the forty-eight plates features one to three goldfish (most have two). The fish, which appear to be reproduced in relative scale, are copied from a 1772 scroll painted in China and sent to Henri Bertin, France's secretary of state.[1] The scroll is preserved in the Muséum national d'Histoire naturelle in Paris, along with an eighteenth-century copy of the manuscript that accompanied it.[2]

The fish are all swimming, with fins and tails spread so that their morphology and coloring can be fully admired. The plates are engraved and etched with some stippling and roulette (Fig. 1), and the text is printed in letterpress.[3] Most of the plates are printed in black ink, but a good number of the fish—sometimes the entire plate—are rendered in various hues of reddish ink, ranging from brown, to orange, to golden (Fig. 2). There are also a few fish printed in blue ink. The ink was applied *à la poupée*, the various colors dabbed onto their respective areas of the plate in quick succession and printed all at once. This keen attention to detail suggests the exceptional nature of the project; indeed, it is a rare example of such careful translation of Chinese scroll designs into book format in eighteenth-century France.

The rest of the coloring was done by hand. Most of the backgrounds are plain blue, with ample evidence that they were hand-applied, including drying lines, brushstrokes, small skips where the color of the paper comes through, and occasionally, color outside the platemark. A few prints depict water plants, also added by hand.

While copies of the volume are rare, it was possible to compare the Harvard volume with one in the library of the Academy of Natural Sciences of Drexel University.[4] There are significant differences in the details of the hand-coloring: tails that are colored in one volume are not in the other, and certain fish feature spots of different colors.[5] This seems to suggest that the book was written for rarefied enjoyment, rather than to relay precise scientific information about fish species. For both volumes, Martinet and his son hand-colored the prints in both opaque and transparent washes, overlaying colors on top of each other in select areas.[6] There are some bronzed highlights and passages with added sheen, the latter likely indicating that an additional material, such as gum arabic, was used to create depth. The detailing is extensive and well executed—all part of a semi-lavish production intended to introduce Europeans to fish that were greatly admired in China but relatively unknown at home.

François Nicolas Martinet (1734–c. 1804) and Aaron Martinet (1762–1841), Plate 10, from *Histoire naturelle des dorades de la Chine* (Natural History of Chinese Goldfish), by Edme-Louis Billardon de Sauvigny (Paris: 1780). Letterpress with intaglio illustrations in book, 32.2 × 24.5 cm. Ernst Mayr Library of the Museum of Comparative Zoology, Harvard University, Special Collections (Martinet).

1. George Hervey, *The Goldfish of China from the XVIII Century* (London: China Society, 1950).

2. The painted scroll is Ms. 5066(2) and the text is Ms. 5066(1); http://www.calames.abes.fr/pub/mnhn.aspx#details?id=Calames-20209181191571586.

3. The paper in the volume is a relatively thick, off-white, medium-textured handmade printing paper. There are various watermarks throughout that point to the paper's manufacture in the Auvergne region of France, home to many paper mills. Not all the papers are the same—near the end of the volume, slightly thicker, unwatermarked off-white blued papers are used—but their general character is the same.

4. Thank you to Kelsey Manahan-Phelan of the Academy of Natural Sciences of Drexel University for sharing images of that copy.

5. In at least one case (plate 3), the plate itself is different; the single fish is reversed, and the inscription below the fish is longer in the Harvard version.

6. Louis Hautecœur, "Une Famille de Graveurs et d'éditeurs Parisiens: Les Martinet et les Hautecœur (XVIIIe et XIXe siècles)," *Paris et Île-de-France* (18–19) (1967): 205–340.

Penley Knipe

NATURE

Edouard Kopp

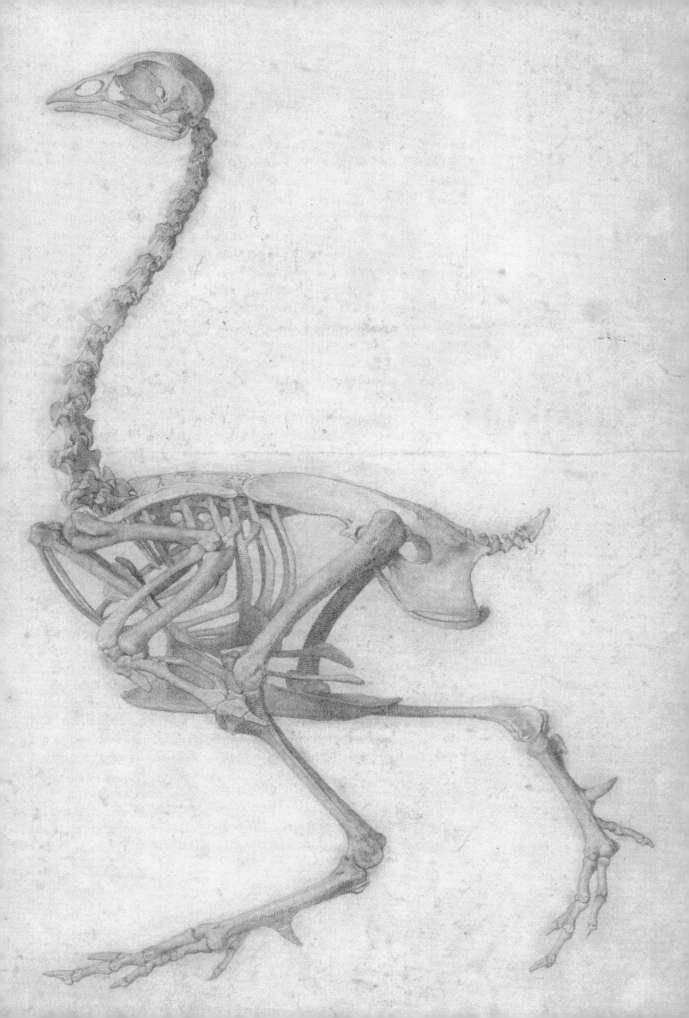

The term "nature" had myriad applications in the eighteenth century, in fields as varied as mythology, poetry, aesthetics, theology, philosophy, morality, law, and science. The sheer range of contexts in which it was employed and the frequency with which it was invoked imbued the term with a sense of importance; but it was also complex, sometimes even contradictory.[1] The concept of "nature" was so broad that ultimately it could seem vague, as Jean le Rond d'Alembert conceded in the *Encyclopédie*.[2] This essay considers one specific aspect of nature: namely, its status as an object of investigation by natural philosophy, or the science of nature, a discipline that expanded the study of physics to the animal, vegetal, and mineral kingdoms. In the age of Enlightenment, the discipline was a key area of scientific development, and it contributed to an epistemological reflection on models of knowledge and on the role of visual representation. It also raised religious and philosophical questions: is nature governed by a divine power (*natura naturata*), or does it exist and operate independently from God (*natura naturans*)?

From the late 1680s to the 1740s, the prevailing doctrine of natural philosophy was the mechanical view, which used the assumptions and methodology of mathematical reasoning to explain natural phenomena. "The overriding impulse," writes Peter Hanns Reill, "was to transform contingent knowledge into certain truth, to reduce the manifold appearances of nature to simple principles."[3] The first widely accepted model was the hypothetical physics of René Descartes, who proposed that the natural world was made up of building blocks (including ones invisible to us) that acted like a machine, affected by force and causation.[4] For Descartes, who approached the study of nature from a theological context, these building blocks were the product of Creation.

The Cartesian model was then called into question and gradually supplanted by the empirical physics of Isaac Newton, who postulated that matter is made up of individual particles, each subject to the laws of motion and universal gravitation. (The shape of the earth was another area of disagreement 👁.) Newton's became the prevailing scientific system. Instrumental in the dissemination of Newtonian ideas on the European continent were Voltaire's *Lettres philosophiques* (Philosophical Letters; 1734) and his *Éléments de la philosophie de Newton* (Elements of the Philosophy of Newton; 1738), as well as *Il Newtonianismo per le dame* (Newtonianism for Ladies; 1737) by Francesco Algarotti, cosmopolitan connoisseur of the arts and sciences. Together, these works brought the revolutionary scope of Newton's theories to a much larger audience. Images also played a part 👁 (see also p. 227).[5] *Allegorical Monument to Sir Isaac Newton* (Fig. 1), a print published in 1741 after a painting by Giovanni Battista Pittoni and others that was commissioned a year after the scientist's death, depicts the apotheosis of a man deemed semi-divine by his eighteenth-century admirers. In the lower register of the composition, an angel leads mourning figures, including Minerva, the Roman goddess of wisdom, and muses of science, toward a large urn containing Newton's ashes. Next to the urn is a pedestal supporting allegories of Truth and Mathematics; on either side, ancient and modern philosophers debate and study scientific instruments and copious tomes. They form an ideal assembly of savants reminiscent of Raphael's *School of Athens*. Meanwhile, Newton's famous optical experiment is carried out overhead: in the middle of the composition, a ray of light strikes a

EXPEDITION

KNOWLEDGE

Vivida vis animi pervicit, et extra
Processit longé flammantia mænia mundi,
Atque omne immensum peragravit mente animoque.

Mac. S

Edouard Kopp

prism and splits into a spectrum of colors, thereby demonstrating the heterogeneity of white light. What made Newton's theories so powerful compared to Descartes's was that they could be tested and proven empirically—and in public.

In the eighteenth century, demonstrations were a key way in which the scientific understanding of nature entered the public consciousness and gained authority, and thus they participated in the mediating role of the Enlightenment in sharing new knowledge more widely.[6] Commenting on the period's fad for natural philosophy, Voltaire noted as early as 1735 that "everyone is pretending to be a geometer and a physicist."[7] William Pether's print after Joseph Wright of Derby's celebrated painting *A Philosopher Giving a Lecture on the Orrery* (p. 149) features a demonstration to laypeople, including a woman and three children, around a mechanical model of the solar system. The orrery is not, strictly speaking, a scientific instrument in the way that an astrolabe is, for example; it does not take measurements or assist in the collection of data. Rather, it is an apparatus designed to show the wonders of the universe. In Wright of Derby's composition, a lamp has replaced the sun, illuminating the orbiting planets so that the changing seasons and eclipses seen from Earth can be explained. Pether's mezzotint successfully renders the dramatic light and shadow of the painting, as well as the revelatory experience of uncovering nature's mysteries. It also makes clear that such experiences were constructed and controlled, like the print itself, to stimulate particular effects on an audience (understanding, pleasure, wonder). As Lorraine Daston and Katharine Park explain, "natural philosophers interpreted wonder as the usual response not only to the rare and unfamiliar, but also to the phenomenon of unknown cause."[8]

Demonstrations like the one featured in Pether's print were predicated upon Newton's theory of universal gravitation, and it is no coincidence that the philosopher featured here resembles Sir Isaac himself.[9] More broadly, such exhibitions participated in the notion that nature is a spectacle to admire, a popular idea at the time. Between 1732 and 1751, abbé Noël-Antoine Pluche published eight volumes of his richly illustrated *Spectacle de la nature*, an oft-translated and best-selling volume that fostered a widespread interest in natural history in Europe.[10] Addressing the curiosity of the young (and the young at heart), Pluche invited his readers to discover nature in a leisurely fashion, guided mostly by the exhilarating pleasure of the senses, rather than the tedious discipline of intellect.[11] He dissuaded his lay audience from devoting too much time to investigation, advocating a deliberately superficial interest in the world: "But to seek to plumb the very essence of Nature, to seek to link the effects to their particular causes, & to understand the artifice or play of the first causes, and the smallest elements of which these first causes are composed, is a bold enterprise. We leave it to these geniuses of a superior order, to whom it has been given to enter these mysteries & to see. As for us, we believe that it is more suitable for us to limit ourselves to the external decoration of this world, & to the effect of the machines that shape the spectacle."[12] For Pluche, who viewed the world in the context of Christian theology, the complexity and perfection of nature implied the existence of a creator, so there was no imperative to look closely at the machinery within. It behooved his aesthetics of wonder to preserve the mystery of nature's first

Fig. 2
Augustin Pajou (1730–1809), *Monument to Buffon*, c. 1776. Fabricated red chalk, 37.4 × 23.9 cm. J. Paul Getty Museum, Los Angeles, Purchased in part with funds provided by the Disegno Group, 2015.16.

principles, especially since an understanding of the latter might reveal religiously inconvenient truths.[13]

By the middle of the eighteenth century, some of the core assumptions of mechanical philosophy and its systems met with a wave of skepticism among the next generation of thinkers, who believed that the power of reason was limited; that nature's operations were complex and thus could not be explained with a few simple, all-encompassing laws; and that nature was continuously transforming and therefore had a history.[14] Among them was Georges-Louis Leclerc, Comte de Buffon, whose monumental *Histoire naturelle* (Natural History) rapidly became an Enlightenment

best seller. Comprising thirty-six volumes published between 1749 and 1789, the work was the largest of its kind since the days of Pliny the Elder, whose famed *Natural History* was first published in 77 CE.[15] Buffon's was an attempt to apply Newtonian mechanism to the whole of nature, including living matter, which the mechanists had neglected in their focus on inorganic matter.[16] A towering figure, Buffon had enormous influence on the field of natural history. A sense of his import is conveyed in a drawing by sculptor Augustin Pajou (Fig. 2) after the statue Pajou had created for the natural history cabinet of the Jardin du Roi, the French center for teaching and research in the field of natural history led by Buffon from 1739 to 1788.[17] The drawing is a finely executed and faithful record of the monument, complete with self base. The naturalist is shown at full length, dressed in a toga, with his chest bare and his hair long, like an ancient philosopher—an apt portrayal for a man sometimes called the French Pliny. He holds a tablet in one hand and a stylus in the other, recording the phenomena of nature. Buffon, ever striving for truth, confessed that "the discovery of a new fact in Nature has always sent me into transports."[18] A terrestrial globe is at his side, and coral, a lion, and a snake—symbols of the plant and animal kingdoms—lie at his feet.

Like Pluche, Buffon looked upon God's creation with awed fascination, but unlike the more popular naturalist, who aimed to stimulate wonder, Buffon sought rational explanations for the life history of every animal. An empiricist, he thought that substantial progress could be made through patient observation and detailed description in text and images. He believed that reality resided in the particularity of individuals, not species, which he saw as belonging to an artificial system of classification. Despite this, his approach to anatomy tended toward generalization; his methods included morphological and functional comparisons of species. He and his collaborator, Louis-Jean-Marie Daubenton, made major advances in comparative anatomy by studying a wide range of animals.

New theories in this area inspired animal painter and anatomy enthusiast George Stubbs to create *A Comparative Anatomical Exposition of the Structure of the Human Body with That of a Tiger and a Common Fowl*, a work comprising sixty engraved plates with explanatory letterpress text published in English and French editions.[19] The combination of subject matter (human, tiger, and fowl) may seem peculiar; however, it reflects contemporary scientific thinking about the shared structure of all living beings and appears also to have been a function of which specimens the artist had access to.[20] In addition, the amalgamation may have been a way for Stubbs, who was well aware of precedents in the field of artistic anatomy (pioneered by Leonardo and Michelangelo), to make an original contribution by not focusing on a single species, human or equine. Intended for the use of artists, the work was his most ambitious anatomical project. He conceived of it as early as 1765 (a year before his *Anatomy of the Horse* was published and acclaimed by members of the scientific community) but did not begin work on it for another thirty years. Only half of the plates were published by the time of his death in 1806, although he had finished the preparatory drawings (Figs. 3–4) and written four volumes of accompanying text.[21] Leaving nothing to chance, Stubbs "executed the whole himself, from Nature; that is, the Injection, Dissection, Drawing, Explanation, and Engraving."[22] He showed much

dedication in making the drawings illustrated here, which are sophisticated tonal renderings in graphite, and he specifically chose stipple as opposed to line engraving to translate as faithfully as possible the careful shading of his works.[23]

The age of Enlightenment saw significant developments in botany as well. While the eminent Swedish naturalist Carl Linnaeus is generally believed to have transformed botanical practice by largely avoiding the process of illustrating plants, relying on literary descriptions of specimens instead, his knowledge was in fact profoundly visual, and he understood the epistemological value of images in the production of natural knowledge. His diagrams of plant parts, such as leaves (Fig. 5), were meant to demonstrate the observable features that could help classify plants according to his system of binomial nomenclature, which defined organisms by genus and species.[24]

To be sure, botanical illustration proliferated in the period, particularly in watercolors, which allowed artists to render the full range of nature's shapes and colors. The genre required a dual expertise in botany and drawing, so it was effectively practiced by specialists, many of them women. German artist Barbara Regina Dietzsch was one such practitioner. Based in Nuremberg, the second most prominent European center for botanical illustration in the eighteenth century after London, Dietzsch was part of a noted family of botanical illustrators.[25] *A Branch of Gooseberries with a Dragonfly, an Orange-Tip Butterfly, and a Caterpillar* (Fig. 6) is typical of her approach. The image resembles an herbarium page, as it depicts a

Figs. 3–4
George Stubbs (1724–1806), *Human Skeleton, Lateral View (Close to the Final Study for Table III but Differs in Detail)* (left) and *Fowl Skeleton, Lateral View (Finished Study for Table V)* (right), c. 1795–1806. Graphite, each: 54.6 × 40.6 cm. Yale Center for British Art, New Haven, Conn., Paul Mellon Collection, B1980.1.50, B1980.1.5. (Detail on p. 159.)

Edouard Kopp

decontextualized specimen against a neutral black background. In his landmark
Philosophia botanica (first published in 1751), Linnaeus recommended that specimens
of only one species be mounted per single herbarium sheet; naturalist Christoph
Jacob Trew, Dietzsch's patron, required the same of botanical images.[26] In the pres-
ent composition, Dietzsch described the spiky stem, the leaves and fruits, and the
insects resting on the gooseberry with remarkable attention to detail and sensitive
skill. Depicting species according to the taxonomy of the time was an important
dimension of such images; since watercolors of this kind "formed part of naturalists'
collections, and circulated among experts and connoisseurs alongside seeds, plant
specimens and other natural historical objects," they had to be true to nature and
precisely represent the distinctive properties of each organism.[27] Owing to their
realism, Dietzsch's opaque watercolors were occasionally reproduced in botani-
cal treatises of the period, such as Trew's *Hortus nitidissimus* (1750–92).[28] Unlike
Linnaeus's generalized depictions of flora, which were synthesized from a number
of individual examples in order to eliminate idiosyncrasies and establish archetypal

NATURE

characteristics, Dietzsch's images were meant to be delicate and faithful portraits of individual specimens; rather than seeking what Lorraine Daston and Peter Galison have called "truth-to-nature," they expose nature's true diversity.[29]

The graphic arts played a key role in the rise of natural philosophy during the Enlightenment, facilitating the description of nature in its infinite variety and complexity at a time when empiricism had become central to the formation of knowledge. Prints and drawings were instrumental in generating and communicating new visual information about the animal, vegetal, and mineral kingdoms and about the underlying principles of nature more broadly. In that capacity, the graphic arts were inextricably linked to wider philosophical questions about our world and its representation: did nature exist and function in relation to God, or did it follow its own laws?

Edouard Kopp

1. There is substantial literature on the idea of nature in the eighteenth century. For more about the term's complexity in the French context, for example, see Daniel Mornet, *Le sentiment de la nature en France de J.-J. Rousseau à Bernardin de Saint-Pierre: Essai sur les rapports de la littérature et des mœurs* (Paris: Hachette, 1907); Jean Ehrard, *L'idée de nature en France dans la première moitié du XVIIIe siècle* (Paris: S.E.V.P.E.N., 1963); Lester G. Crocker, *Nature and Culture: Ethical Thought in the French Enlightenment* (Baltimore: Johns Hopkins University Press, 1963); D. G. Charlton, *New Images of the Natural in France: A Study in European Cultural History, 1750–1800* (Cambridge: Cambridge University Press, 1984); Andrée Corvol, ed., *La nature en Révolution, 1750–1800* (Paris: L'Harmattan, 1993); Jacques Roger, *Les sciences de la vie dans la pensée française du XVIIIe siècle: La génération des animaux de Descartes à l'Encyclopédie* (Paris: Albin Michel, 1993); Emma C. Spary, *Utopia's Garden: French Natural History from Old Regime to Revolution* (Chicago: University of Chicago Press, 2000); Bernard Quemada and Marie Leca-Tsiomis, "'Nature,' du dictionnaire de Richelet à l'Encyclopédie: Une impossible définition?" *Dix-Huitième Siècle* 45 (1) (2013): 45–60.

2. "Nature . . . a term that is quite vague, often employed, but little defined." See the editors' note in Denis Diderot and Jean le Rond d'Alembert, eds., *Encyclopédie, ou, Dictionnaire raisonné des sciences, des arts et des métiers*, vol. 2 (Paris: 1752).

3. Peter Hanns Reill, *Vitalizing Nature in the Enlightenment* (Berkeley: University of California Press, 2005), 5.

4. Rob Iliffe, *Newton: A Very Short Introduction* (Oxford: Oxford University Press, 2007), 22–23.

5. Newton was the subject of numerous representations in the eighteenth century; see Francis Haskell, "The Apotheosis of Newton in Art," *Texas Quarterly* (Autumn 1967): 218–37; and Milo Keynes, *The Iconography of Sir Isaac Newton to 1800* (Woodbridge, U.K.: Boydell Press, 2005).

6. See Michael R. Lynn, *Popular Science and Public Opinion in Eighteenth-Century France* (Manchester: Manchester University Press, 2006).

7. Voltaire to Pierre Robert le Cornier de Cideville, 16 April 1735, in Voltaire, *Correspondance*, vol. 87, ed. Theodore Besterman (Geneva: Institut et Musée Voltaire, 1965), 132.

8. Lorraine Daston and Katharine Park, *Wonders and the Order of Nature, 1150–1750* (New York: Zone Books, 1998), 110.

9. See Judy Egerton, *Wright of Derby* (New York: Metropolitan Museum of Art, 1990), 54–55.

10. See Dennis Trinkle, "Noël-Antoine Pluche's *Le spectacle de la nature*: An Encyclopaedic Best Seller," *Studies on Voltaire and the Eighteenth Century* 358 (1997): 94–134.

11. See Françoise Gevrey, Julie Boch, and Jean-Louis Haquette, eds., *Écrire la nature au XVIIIe siècle: Autour de l'abbé Pluche* (Paris: Presses Université Paris-Sorbonne, 2006).

12. Noël-Antoine Pluche, *Le spectacle de la nature*, vol. 1 (Paris: Estienne, 1732–51), x.

13. Tili Boon Cuillé, introduction to *Divining Nature: Aesthetics of Enchantment in Enlightenment France* (Stanford, Calif.: Stanford University Press, 2021), esp. 1–4.

14. Reill, *Vitalizing Nature in the Enlightenment*, 5–6.

15. See Jacques Roger, *Buffon, un philosophe au Jardin du Roi* (Paris: Fayard, 1989).

16. Reill, *Vitalizing Nature in the Enlightenment*, 42–43.

17. See James David Draper and Guilhem Scherf, *Augustin Pajou, Royal Sculptor, 1730–1809* (New York: Metropolitan Museum of Art, 1997), 280–90. Measuring 290 centimeters tall, the marble monument, today in the Muséum national d'Histoire naturelle in Paris, is inscribed *MAJESTATI NATURAE PAR INGENIUM* (A genius equal to the majesty of Nature).

18. Georges-Louis Leclerc, Comte de Buffon, *Histoire naturelle, générale et particulière. Supplément*, vol. 3 (Paris: 1774–89), 14.

19. See Christopher Lennox-Boyd, Rob Dixon, and Tim Clayton, *George Stubbs: The Complete Engraved Works* (Abingdon, U.K.: Stipple Publishing Limited, 1989), 313–33.

20. See Terence Doherty, *The Anatomical Works of George Stubbs* (Boston: David R. Goldine, 1975), 18. Stubbs's project is discussed and illustrated in full on pp. 17–24, 111–279.

21. Stubbs made a total of 125 drawings related to the project. They are now in the Yale Center for British Art, along with his manuscript text; see Gillian Forrester in Scott Wilcox, Gillian Forrester, Morna O'Neill, and Kim Sloan, *The Line of Beauty: British Drawings and Watercolors of the Eighteenth Century* (New Haven, Conn.: Yale Center for British Art, 2001), 82–85.

22. Quoted in Lennox-Boyd, Dixon, and Clayton, *George Stubbs*, 315.

23. The artist used three different media to make the series of drawings: graphite, red chalk, and ink.

24. See Isabelle Charmantier, "Carl Linnaeus and the Visual Representation of Nature," *Historical Studies in the Natural Sciences* 41 (4) (Fall 2011): 365–404.

25. See Eyke Greiser, "Barbara Regina Dietzsch (1706–1783) und Ihre Familie," in *Maria Sibylla Merian und die Tradition des Blumenbildes von der Renaissance bis zur Romantik*, ed. Michael Roth, Magdalena Bushart, and Martin Sonnabend (Berlin: Kupferstichkabinett Staatliche Museen zu Berlin; Frankfurt: Städel Museum, 2017), 205–11.

26. See Kärin Nickelsen, "Image and Nature," in *Worlds of Natural History*, ed. Helen Anne Curry, Nicholas Jardine, Jim Secord, and Emma Spary (Cambridge: Cambridge University Press, 2018), 227.

27. See ibid., 221.

28. See W. L. Tjaden, "Hortus nitidissimus," *Taxon* 20 (4) (August 1971): 461–66.

29. See Lorraine Daston and Peter Galison, *Objectivity* (New York: Zone Books, 2007), chap. 2, "Truth-to-Nature," 55–113, and on Linnaeus specifically, 55–63, esp. 60.

OCULUS

Elizabeth M. Rudy

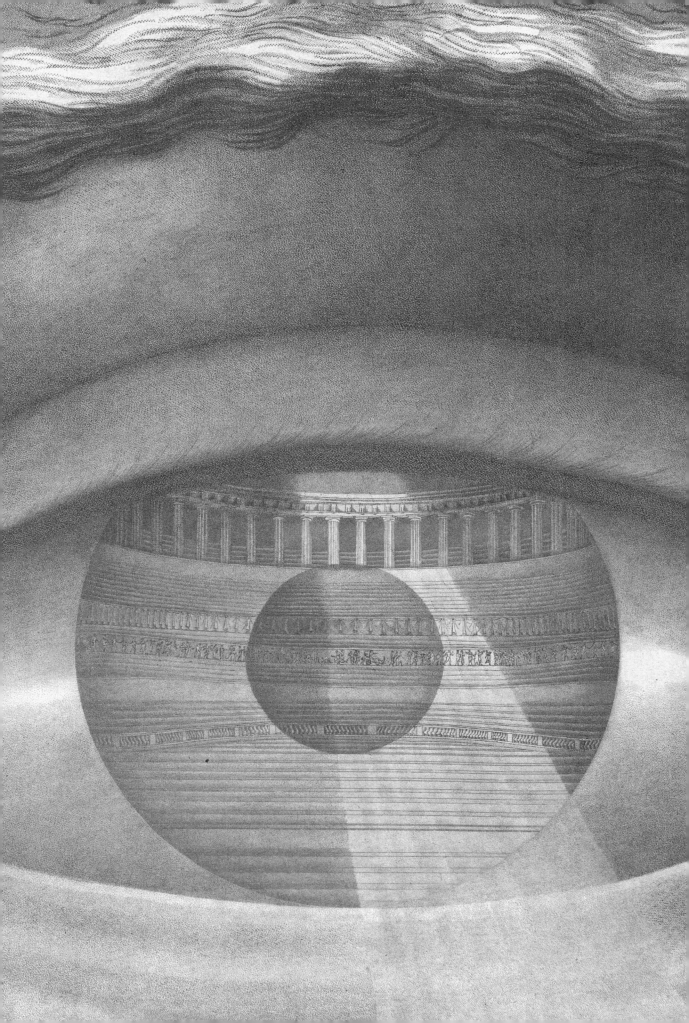

The image of a disembodied, open eye—or oculus—was a frequent symbol in the visual arts dating back to ancient Egypt. In Europe, it was codified in sixteenth-century emblem books, most significantly in César Ripa's *Iconologia* (Iconology) of 1593, where it was said to represent both divine vigilance and the human gaze: it could denote intellectual concepts, such as reason and power, but also emotions, including jealousy and curiosity. During the Enlightenment era, this expansive signification persisted, and the open eye appeared in a variety of contexts, from official government documents to the iconography of secret societies, such as the Freemasons. All-seeing or human, emotional or purely rational, the oculus served disparate purposes, including, as contemporary scholars have theorized, the symbolic embodiment of the Enlightenment's correlation between truth and vision.[1]

As in previous centuries, the open eye appeared in eighteenth-century European political allegories to assert the guiding force and vigilance of God. Present in representations of monarchies and democracies alike, the symbol offered the same reassuring claim that the invisible, omnipotent force of divine providence bolstered the political leadership depicted. William Barton's winning design for the obverse of the official seal of the United States in 1782 featured an open eye surrounded by a glory, or rays of divine light (Fig. 1). Joined with the first half of the Latin motto meaning "favor of God," the eye is emblematic of divinity, who watches over a pyramidal stack of thirteen steps representing the former colonies. This motif would later be circumscribed by a triangle to denote the summit of a pyramid, just as it was often represented in early allegories of the new French Republic.[2]

In 1761, Gabriel Jacques de Saint-Aubin used the open eye to emphasize the righteousness of a punitive legal decision handed down by the Parlement of Paris against the Jesuits on August 6 of that year. The ruling condemned Jesuit books and forbade members of the order from teaching, a decision that would lead to their expulsion from France three years later.[3] In a preparatory drawing and related etching, both housed in the Museum of Fine Arts, Boston, Saint-Aubin depicted the two facets of the ruling as part of a balance scale: the scenes are set in circles that rest on semicircular pans attached by chains to a horizontal beam above (Fig. 2). The beam passes through an open eye and is held up by a royal scepter serving as its pillar. In other words, the very linchpin of the scale, and thus of the events themselves, is the support of King Louis XV and the divine justice that guides him.

One of the most famous depictions of a symbolic eye is Claude-Nicolas Ledoux's *Coup d'œil du théâtre de Besançon* (View of the Theater of Besançon; Fig. 3). Enlarged and reimagined, here the eye is not explicitly political. Depicted within the iris as if being perceived through the eyeball is the auditorium of Ledoux's theater in the French city of Besançon, which opened to the public in 1784.[4] The curvilinear banks of empty seats are shown as they would be viewed from the stage, a vantage point not experienced by the audience. A shaft of light originates from above, recalling the architectural definition of the oculus (a circular window), although there was no such opening in the actual theater—instead, an oval, trompe l'oeil painting of the sky occupied the ceiling. The ray of light terminates outside the eye, on the edge of the print, spilling into the viewer's space. Notably, the composition features not just the eye but a closeup *view* of the organ on what

Fig. 1
William Barton, *Design for the Recto of the Great Seal of the United States* (detail), 1782. Watercolor, full sheet: 30.2 × 36.8 cm. National Archives, Washington, D.C., Reports on Administrative Affairs of the Congress, Papers of the Continental Congress, 1774–1789, Records of the Continental and Confederation Congresses and the Constitutional Convention, Record Group 360, 595258.

is presumably a face: small, irregular dots made with toothed instruments extend beyond the lids to the margins of the image.

This enigmatic composition, in which mimesis and abstraction intertwine, has provoked extensive analysis and debate, particularly among historians of architecture.[5] Fueling this discourse is the text accompanying the print, where Ledoux alternately alludes to divinity, human physiology, and architectural theory. He describes the eye as the "transparent mirror of nature," the conduit for human emotions that are encouraged by the imagination, and refers to the specificity of the architect's eye or vision ◉.[6] By turns transparent and reflective, universal and individual, and not definitively gendered, Ledoux's open eye remains stubbornly opaque.

IMAGINATION

Despite the abundant attention this composition has received as an image, it has not been substantially studied as a printed work of art.[7] It was produced for the first volume of Ledoux's opus *L'Architecture considérée sous le rapport de l'art, des mœurs et de la législation* (Architecture Considered in Relation to Art, Mores, and the Law), published in 1804. Ledoux began writing the book while imprisoned during the Terror; while he planned to complete five volumes, the series remained unfinished upon his death in 1806.[8] *Coup d'œil* is the first of ten illustrations for the section on the Besançon theater. Rendered almost entirely with roulettes, it is distinctive from the other illustrations, which are etched and engraved in the standard mode of architectural prints.

Roulettes are made up of metal wheels (they can be narrow or wide, toothed or textured) attached to handles. They create irregular marks on the metal plate and yield an overall greater range of textures than line etching or engraving, which are produced with instruments that incise single lines into a plate. Both linear and textural methods are employed in *Coup d'œil*, establishing a distinct contrast between the eye and its surrounding area, which are completed almost entirely with roulettes, and the theater seats, which are made with etching alone.[9] The combination of these techniques highlights the difference between the interior and exterior components

Elizabeth M. Rudy

of the composition, but most significantly, it emphasizes the humanity of the eye. Although Ledoux apprenticed as a printmaker at a young age and his name is inscribed in the bottom left corner of the sheet, where the designer of the image is typically attributed, it seems unlikely that he actually made the print.[10] The technical sophistication of the roulette work, particularly in the range of shadows in the iris and ray of light, points to an artist well versed in this method of printmaking.

The conflation of visual modes in *Coup d'œil* is especially confounding in the context of Enlightenment debates about the epistemology of the eye as the primary organ of sight and observation, and by extension, its reliability as a witness.[11] The stakes of these debates were highest for a collective understanding of ephemeral events and phenomena that were invisible to the human eye but represented textually and visually. Authors often used the pseudonym Eye-Witness to recount natural disasters such as earthquakes and volcanic eruptions , public events such as state executions, and atrocities such as slavery. It provided anonymous authority for these authors, many of whom challenged the prevailing version of events. Consider this preamble to a report "by an eyewitness" about an incident during the Seven Years' War (1756–63): "The various accounts given of our last landing on the French coast, and the several Misrepresentations made of it . . . calls on every Lover of Truth that was in the Way of being informed, to acquaint the Publick with the real State of Facts."[12] The author asserts that what ensues is historical fact, while expressing anxiety that the reigning interpretation of those events contravenes his own lived experience.

LAVA

Fig. 2
Gabriel Jacques de Saint-Aubin (1724–1780), *Expulsion of the Jesuits*, 1761. Etching, trial proof with hand additions in brush and gray wash, plate: 18 × 20.8 cm. Museum of Fine Arts, Boston, Katherine E. Bullard Fund in memory of Francis Bullard, 62.604.

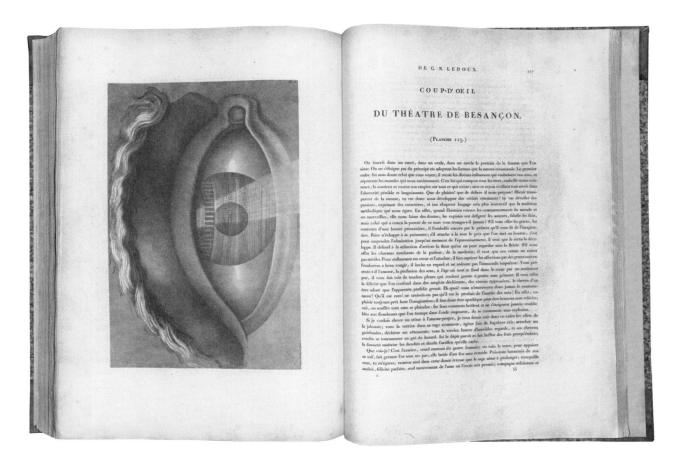

These kinds of written testimonials were crucial for judging the veracity of phenomena that were invisible, such as spirits and miracles, but their validity came under new scrutiny during the Enlightenment 👁. For believers, the accounts were evidentiary proof; for critics, unfounded hearsay.[13] The followers of Johann Joseph Gassner, a Catholic priest in southern Germany who practiced exorcisms that he claimed could heal people of all manner of ailments, wrote numerous accounts validating his methods; their reports were debated fiercely across Germany from 1774 until Gassner's denunciation in 1776.[14] Decades earlier, proponents of Jansenism in France started the journal *Nouvelles Ecclésiastiques, ou, Mémoires pour servir à l'histoire de la Constitution Unigenitus* (New Ecclesiastics; or, Memoirs to Be Used for the History of the Unigenitus Bull) as a repository for written and visual explications of their doctrines.[15] The political implications of their beliefs, which challenged the authority of the Catholic Church, dictated that their journal could not be published by sanctioned, official outlets, but only by the clandestine press.

An illustrated compendium of diverse texts attesting to Jansenist miracles between 1728 and 1735 made a more powerful statement than textual documentation could alone, for the images, designed by Jean Restout, portrayed visually the transformation that the witnesses claimed to have seen. It appeared in 1736 under the title *La vérité des miracles opérés à l'intercession de M. de Pâris* (The Truth of Miracles Performed

BELIEVE

Fig. 3
Claude-Nicolas Ledoux (1736–1806), *Coup d'œil du théâtre de Besançon* (View of the Theater of Besançon), in *L'Architecture considérée sous le rapport de l'art, des mœurs et de la législation* (Architecture Considered in Relation to Art, Mores, and the Law), 1804. Etching and roulette, plate: 25.6 × 38.9 cm. Fleet Library, Rhode Island School of Design, Special Collections, LF NA1053.L4 A5 1804. (Detail on p. 171.)

Elizabeth M. Rudy

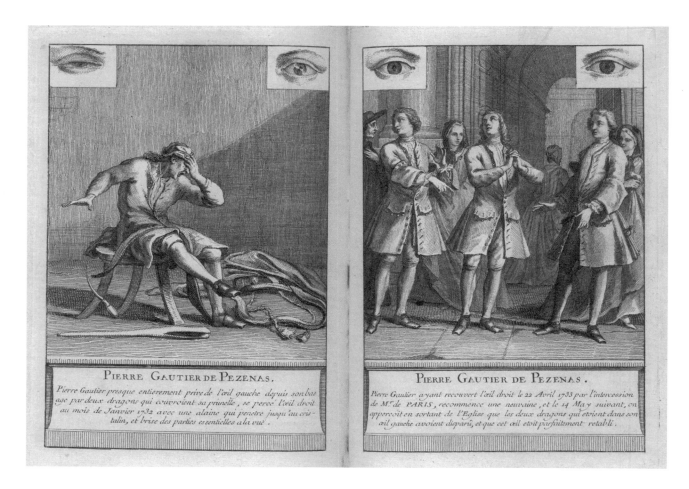

PIERRE GAUTIER DE PEZENAS.

Pierre Gautier presque entierement privé de l'œil gauche depuis son bas age par deux dragons qui couvroient sa prunelle, se perce l'œil droit au mois de Janvier 1732 avec une alaine qui penetre jusqu'au cristalin, et brise des parties essentielles à la vûe.

PIERRE GAUTIER DE PEZENAS.

Pierre Gautier ayant recouvert l'œil droit le 22 Avril 1733 par l'intercession de M.r de PARIS, recommence une neuvaine, et le 14 May suivant, on apperçoit en sortant de l'Eglise que les deux dragons qui etoient dans son œil gauche avoient disparû, et que cet œil etoit parfaitement rétabli.

Fig. 4
Unidentified artist, after Jean Restout (1692–1768), *The Illness & Healing of Pierre Gautier de Pézenas*, in *La vérité des miracles opérés à l'intercession de M. de Pâris* (The Truth of Miracles Performed through the Intercession of Mr. de Pâris), compiled by Louis-Basile Carré de Montgeron, vol. 1 (Paris: 1737–41). Engraving in bound book, spread approx. 27 × 38.1 cm. Houghton Library, Harvard University, Phil 6990.1*.

through the Intercession of Mr. de Pâris) and sparked one of the most notorious episodes in the history of Jansenism. The compiler, Louis-Basile Carré de Montgeron, was an aristocrat who held the powerful position of *conseiller*, or magistrate, in the Parlement of Paris. Restout took an innovative approach to the illustration of Montgeron's book: for each miracle, he drew one view of the individual afflicted by a bodily ailment and a second view showing the individual cured, and each drawing included large depictions of the affected organ or limb in the upper register. In the publication, the "before" and "after" prints are juxtaposed, providing a visual narrative of the miraculous transformation (Fig. 4).

One of the healed individuals was a man named Pierre Gautier, an apprentice saddler who struck himself in the right eye with an awl, a piercing tool used to punch holes in thick pieces of fabric.[16] In Restout's first drawing, Gautier has dropped the awl, which is just inches from clattering to the floor, and cries out in pain (Fig. 5). Giant eyes hover above him in the upper third of the sheet, clarifying the extent of his injuries for the reader. In an evocative pictorial choice, the enlarged eyes and their owner occupy the same space, suggesting the coexistence of earthly and otherworldly realms. This connotation is eradicated in the print, where the eyes are much smaller and circumscribed by rectangular boxes in the format of scientific illustration. The unidentified printmaker who created the print also failed to

replicate the orientation of the drawing, so Gautier's injured right eye now appears at upper left.[17] Far less interesting, this depiction compromises the ethereal potential of Restout's drawing.

Montgeron famously transgressed royal protocols by presenting *La vérité des miracles* to Louis XV himself in the royal dining room of Versailles, a breach of decorum that earned him immediate imprisonment. He protested, however, that he believed the book's contents to be valid and that his actions, which he knew would bring him personal harm, were justified in the service of the greater good, namely to alert authorities and the public to a suppressed, verifiable truth.[18] This episode is a powerful reminder of the vital role that visual perception—during the Enlightenment as today—plays in the construction of fact.

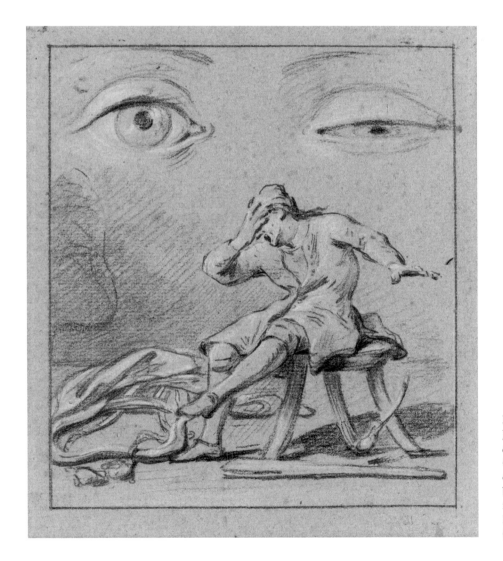

Fig. 5
Jean Restout (1692–1768), *Preparatory drawing for "The Illness of Pierre Gautier de Pézenas,"* c. 1735. Black chalk with white chalk highlights, brown and black wash on blue paper, 18 × 15.6 cm. Musée national de Port-Royal des Champs, 1980.2.006 (PRD 25).

Elizabeth M. Rudy

1. Hanneke Grootenboer, *Treasuring the Gaze: Intimate Vision in Late Eighteenth-Century Eye Miniatures* (Chicago: University of Chicago Press, 2012), 62–71. For examples of the all-seeing eye in Masonic iconography, see Reva Wolf and Alisa Luxenberg, eds., *Freemasonry and the Visual Arts from the Eighteenth Century Forward: Historical and Global Perspectives* (New York: Bloomsbury Visual Arts, 2020).

2. For more on the evolution of the great seal, see *The Citizen's Almanac: Fundamental Documents, Symbols, and Anthems of the United States* (Washington, D.C.: U.S. Government Printing Office, 2011). On the symbols used during the French Revolution, see François Furet, *Dictionnaire critique de la Révolution française* (Paris: Flammarion, 1988).

3. Colin Bailey, Kim de Beaumont, Suzanne Folds McCullagh, Christophe Leribault, Pierre Rosenberg, Marie-Catherine Sahut, and Perrin Stein, *Gabriel de Saint-Aubin, 1724–1780* (New York: Frick Collection, 2007), 146–47.

4. See Anthony Vidler, *Charles-Nicolas Ledoux: Architecture and Utopia in the Era of the French Revolution*, 2nd ed. (Basel: Birkhäuser, 2021), 83–93.

5. Many of these avenues of interpretation are explored in Rodolphe el-Khoury, *See Through Ledoux: Architecture, Theatre, and the Pursuit of Transparency* (San Rafael, Calif.: ORO Editions, 2006).

6. *L'Architecture de C.N. Ledoux* (Princeton, N.J.: Princeton Architectural Press, 1983), 217–18. Daniel Rabreau interprets the composition in the context of multiple citations from *L'Architecture*, not just the text accompanying the print; see his *Claude-Nicolas Ledoux (1736–1806): L'Architecture et les fastes du temps*, Annales du Centre Ledoux 3 (Paris: Université de Paris-I, 2000), 142–47.

7. Research being conducted at the Université Paris-Nanterre promises to resolve the persistent questions of attribution for this print and to shed new light on Ledoux's book. A three-year project led by Dominique Massounie and Fabrice Moulin to digitize the published and unpublished components of Ledoux's *L'Architecture* and provide critical analysis by leading scholars will appear online in *LABEX: Les Passés dans le présent*. I am grateful to two of the project's contributors, Basile Baudez and Séverine Guillet, for bringing this important work to my attention, and I am indebted to Séverine for generously sharing with me her current thinking on the questions of attribution and technique in *Coup d'œil*.

8. For an overview of this publication, see the introduction to Vidler, *L'Architecture de C.N. Ledoux*, i–x.

9. Working up a printing plate with roulettes and other toothed instruments was one of the most notable innovations in print-making during the eighteenth century, invented simultaneously by Dutch and French artists. It was initially applied to the replication and imitation of drawings, but in the ensuing decades, this type of tonal mark-making became fashionable apart from its association with drawing. Its elaboration in two related techniques, stipple and roulette engraving, were especially popular in Europe—stipple in England and roulette in France. On stipple, see Antony Griffiths, *The Print before Photography: An Introduction to European Printmaking, 1550–1820* (London: British Museum, 2016), 484–86. On roulette engraving, see Ad Stijnman, *Engraving and Etching, 1400–2000: A History of the Development of Manual Intaglio Printmaking Processes* (Houten: Archetype Publications Ltd., 2012), 191–92. See also Stéphane Roy, "Imiter, reproduire, inventer: Techniques de gravure et statut du graveur en France au 18e siècle," *Intermédialités* 17 (Spring 2011): 31–51.

10. Michel Gallet, *Claude-Nicolas Ledoux: Unpublished Projects*, trans. Michael Robinson (Berlin: Ernst & Sohn, 1992), 14.

11. For an analysis of Ledoux's composition in the context of epistemologies of the eye and contemporary shifts in theater design, see Pannill Camp, *The First Frame: Theatre Space in Enlightenment France* (Cambridge: Cambridge University Press, 2014).

12. *An Impartial Narrative of the Last Expedition to the Coast of France, by an Eye-Witness* (London: J. Wilkie, 1758), 1.

13. For an overview of the historical evolution of evidence for miracles in Europe, see Lorraine Daston, "Marvelous Facts and Miraculous Evidence in Early Modern Europe," *Critical Inquiry* 18 (1) (Fall 1991): 93–124.

14. H. C. Erik Midelfort, *Exorcism and Enlightenment: Johann Joseph Gassner and the Demons of Eighteenth-Century Germany* (New Haven, Conn.: Yale University Press, 2005).

15. See Christine Gouzi, *L'Art et le jansénisme au XVIIIe siècle* (Paris: Nolin, 2007), 69–146. Jansenism was a movement within Catholicism that deviated from the Church on certain theological grounds and was therefore denounced by the papacy and monarchy from its founding in the seventeenth century.

16. Léa Bossa-Chaumette, Christine Gouzi, and Philippe Luez, *Jean Restout et les miracles de Saint-Médard, 1692–1768* (Montigny-le-Bretonneux: Yvelinédition, 2013), 118.

17. The identity of the printmakers involved in this project remains unknown; see ibid., 84–86.

18. See Michèle Bokobza Kahan, "Ethos in Testimony: The Case of Carré de Montgeron, a Jansenist and a Convulsionary in the Century of Enlightenment," *Eighteenth-Century Studies* 43 (4) (Summer 2010): 419–33.

Elizabeth M. Rudy

PUBLIC

Joachim Homann

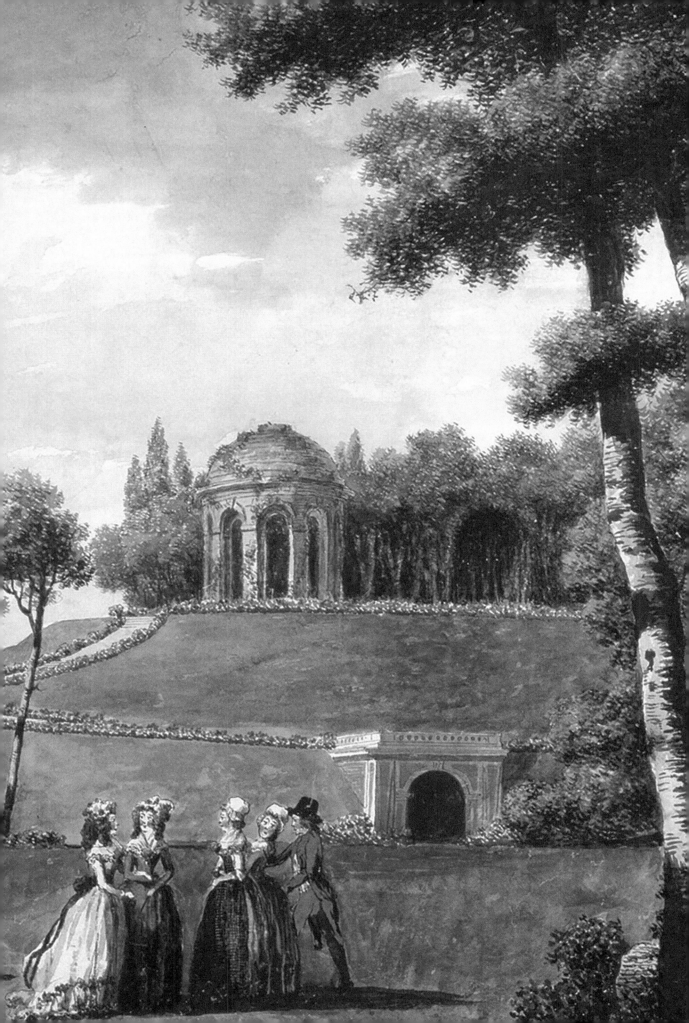

Enlightenment era writers and visual artists routinely addressed a public audience in their work. In doing so, figures such as philosopher, editor, and critic Denis Diderot and painter Jean-Baptiste-Siméon Chardin helped mold the conception of that very public.[1] Diderot and Chardin frequently met at the Paris Salon, the biennial exhibition organized by the Royal Academy of Painting and Sculpture in the galleries of the Louvre. For several years, Chardin was charged with installing the show, and Diderot reviewed the works in newsletters now recognized as foundational to the literary genre of art criticism.[2] Reading Diderot with an eye on Chardin, and examining Chardin's work with Diderot's writing in mind, this essay traces their ideas of a public across text and image. A new belief in the power of vision 👁 made Chardin's and Diderot's work timely and relevant. Art exhibitions, theater performances, and public parks all presented citizens with opportunities to see others and to be seen—a reciprocal exchange of gazes that visually constituted the public.

Diderot understood that political systems visibly inscribe themselves in people's demeanor and conduct. Figurative art, then, if it wanted to be truthful, had to express individuals' appearances as they were conditioned by their respective political circumstances. He wrote in his *Notes on Painting*:

> The republic is a state based on equality. Each subject thinks of himself as a little monarch. The bearing of a republican should be erect, resolute, and proud. In a monarchy, in which orders are given and obeyed, the prevailing characteristics should be grace, sweetness, honor, and gallantry. In a despotic state, the prevailing form of beauty will be that associated with slavery. Here show me docile, submissive, timid, circumspect, suppliant, and modest faces. Slaves walk with their heads bowed; it's as though they are always prepared for a sword to strike them off.[3]

Appearing in a chapter about expression, these remarks were intended first and foremost to instruct readers in how to judge figures in works of art—a topic of central importance to the neoclassical mode of the day. In hindsight, however, what Diderot offered was an endorsement of art as a moralizing and educational tool, with liberating effects, for a society in which democratic freedoms marked the opposite of servitude.

Moreover, while academicians valued narrative, or *historia*, as the pinnacle of artistic achievement, Diderot suggested the possibility that a sympathetic representation of a personality could deliver a profound lesson. "Sympathy," he explained, "I understand . . . to be that rapid, sudden, automatic impulse that draws two beings together at first sight. . . . It's the immediate, reciprocal attraction exercised by some virtue. Beauty gives way to admiration; admiration to esteem, desire, and love."[4] Painting, according to Diderot, was indeed born out of portraiture, and portraits had a significant impact on society at large. He proposed that "portrait-painting and bust-making should be honored by a republican people accustomed to having citizens'

Fig. 1
Jean-Baptiste-Siméon Chardin
(1699–1779), *Portrait of a Man*, 1773.
Pastel on tan laid paper with blue
fibers, wrapped around and adhered
to canvas, 54.8 × 44.2 cm. Harvard
Art Museums/Fogg Museum, Gift of
Grenville L. Winthrop, Class of 1886,
1939.89.

attention focused on the defenders of their laws and their liberty."[5] In the decades
before the French Revolution, the boundaries between political images and action
were as unstable as they had ever been, making Diderot's words all the more resonant.[6]

The *Notes on Painting* were attached to a book-length review of the Salon of
1765, which, as Diderot claimed, was based in part on conversations with visitors
young and old and with artists—the formation of a nascent public opinion. Yet
at the time, his readership was still limited to a highly exclusive group, including
members of the European royalty, and his homeland was governed by a king, not
the people. The first modern republics, those of the United States and France,
would not be formed for another one or two decades, respectively. Slavery, on the
other hand, was all too real in parts of the world; Diderot himself had included an
article on the cruelty of the institution in the *Encyclopédie*,[7] in addition to address-
ing it in his own writings.[8]

Joachim Homann

How, then, did artists express political conditions that differed from the monarchy in which they themselves lived? For now, painters wanting to record likenesses of independently minded members of a republic had to find examples among their historical forerunners, or on the stage. Chardin, one of the artists mentioned most frequently in Diderot's review, did both.

The slightly later pastel portrait of a man shown here is a rare foray for an artist celebrated for his still lifes and genre scenes (Fig. 1). Women and children are often found in Chardin's domestic imagery, but adult males seldom are. In this bust-length portrait, a middle-aged man eyes the viewer intently—perhaps defiantly—from below his puffy, beribboned red velvet hat. The warm sunlight on his rounded cheeks and a mouth that seems ready to open at any moment animate the drawing. His face, framed by a ruff, suggests curiosity, alertness, and confidence. A muted red-purple jacket with bluish-black collar over a bright red shirt makes for a striking costume. Chardin's handling of the pastel crayons, characterized by the buildup of a dense surface through unblended strokes in different colors, has found admirers ever since his work in the medium was first exhibited at the Salon of 1773, the year this drawing was made.

While the portrait is signed and dated and its authenticity has never been in doubt, the identity of the sitter has puzzled scholars since 1985, when Suzanne McCullagh and Pierre Rosenberg questioned the prevailing theory.[9] The historicizing costume likely provides a clue. Present among a gallery of printed portraits of historical revolutionaries made by Pierre Michel Alix in the mid-1790s is a man in a surprisingly similar red outfit—complete with fanciful hat, ruff, and an equally detailed jacket.[10] According to the inscription, the subject is legendary Swiss hero William Tell, who famously declined to bow to the Austrian Vogt's hat and was arrested for his defiance. The Vogt subsequently forced Tell to shoot an arrow at an apple balanced on his son's head—an authoritarian overreach that, according to legend, galvanized anti-Habsburg sentiment and ultimately led to the founding of the Swiss republic.

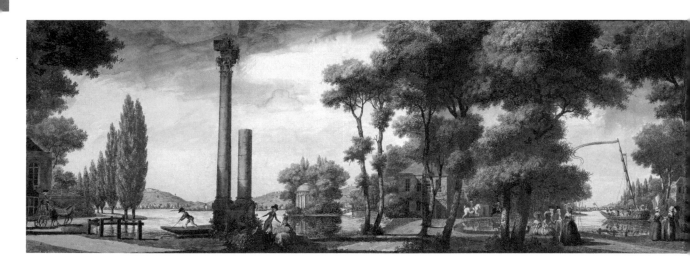

Fig. 4
Gabriel Jacques de Saint-Aubin (1724–1780), *Vue du Salon de 1765* (View of the Salon of 1765), 1765. Brown ink, gray ink, heightened white, watercolor, and graphite, 24 × 46.7 cm. Musée du Louvre, Paris, Département des Arts graphiques, INV 32749.

The wandering gaze that theatergoers trained on other spectators was also brought to the *rouleau transparent*, a moving image often considered a predecessor of cinema. One of the rare survivors of the genre is a work by artist Louis Carrogis de Carmontelle (Fig. 3), who put his many talents to use as garden designer and master of entertainments at the court of the duc d'Orléans and as a playwright and painter.[16] Working in watercolor, Carmontelle visualized a park scene on ten sheets of conjoined paper that could be wound around rollers inserted into a backlit box.[17] The vistas that unfurled when the box's cranks were turned are perhaps even more delightful today than they would have been for an eighteenth-century audience, as they allow us to step into a bygone world. On a leisurely stroll through the sprawling gardens, the viewer encounters groups of revelers as they engage in polite conversation, share boat rides, take in the grand architecture, find a quiet spot for a tête-à-tête, or generally enjoy a beautiful summer's day in each other's company. In the distance, villages and towns, churches, and windmills hint at everyday life. In the park, however, nothing distracts from the holiday atmosphere. This is not a space for private contemplation of awesome natural beauty; it is a vision of harmony among people and their well-groomed surroundings—with little acknowledgment of the social tensions and often difficult living conditions in the cities that made escape to the countryside so desirable.

Back in Paris, art exhibitions provided another communal viewing experience that helped define the Enlightenment era public. They combined aspects of the theater and the public park, allowing visitors to become engrossed in painted narratives or to gaze upon faces in portraits as they ambled through the galleries. Gabriel Jacques de Saint-Aubin's rendering of the Salon of 1765 reveals the density of the display and, in its unfinished state, suggests how visitors could easily be overwhelmed by the seemingly endless viewing experience (Fig. 4). It was impossible to see everything in the exhibition, just as Saint-Aubin was unable to record every work. Chardin, who in his role as tapissier was responsible for the Salon's layout from 1761 to 1773 (the year he presented the pastel portrait), offered minimal guidance as to how visitors should navigate

The face of Chardin's sitter resembles contemporary portraits of Lekain.[12] Rather than an individual likeness, however, Chardin conceived the pastel as a study of expression. "If a man's soul or nature has stamped his face with an expression of benevolence, justice, and liberty," Diderot proposed, "you'll sense this because you carry images of these virtues within yourself, and you'll graciously receive anyone displaying them to you. Such a face is a letter of recommendation written in a language known to all men."[13] In light of Diderot's thoughts on the political preconditions of facial expression, and assuming the sitter is indeed Lekain in the role of William Tell, one could argue that Chardin's pastel presents a sympathetic description of the transformative power of liberty on the individual lives that make up a democratic public.

It is not by coincidence that Chardin's exemplar came from the stage. The educational benefits of public performance had recently been highlighted in the *Encyclopédie*, which included extensive discussion and many illustrations of theater architecture. A drawing in the Harvard Art Museums brings the theater-going experience to life by placing viewers inside an enormous, tightly packed opera house (Fig. 2). Visible across the orchestra pit, the stage is graced with a palatial hall in classicizing decor that matches the building's overall design. A performance is underway, and the audience fills the parterre, two tiers of boxes, and three additional levels of balconies to the very last seat (totaling roughly two thousand, to judge from attendance in the larger performance spaces of the time). The artist is less concerned with the performance and set design than with the magnitude and management of the spectatorship.[14] Theater audiences like the one shown here paid careful attention not only to the action on stage, but also to the vast crowd around them, all the while presenting themselves to other distracted eyes.[15] Thanks to the organization of theatrical spaces of the late eighteenth century, viewers themselves became part of the spectacle, without disturbing the illusionistic mise-en-scène for which theater reformers—including Lekain—advocated.

Fig. 3
Louis Carrogis de Carmontelle (1717–1806), *Figures Walking in a Parkland*, 1783–1800. Watercolor and gouache with traces of black chalk underdrawing on translucent Whatman paper, 47.3 × 377 cm. J. Paul Getty Museum, Los Angeles, 96.GC.20. (Detail on p. 181.)

Fig. 2
Jean-Michel Moreau, called Moreau
le jeune (1741–1814), *A Scene at the
Opera*, 18th–19th century. Black
ink and brown wash over traces of
black chalk on off-white antique
laid paper, partially incised, 23.9 ×
38.8 cm. Harvard Art Museums/
Fogg Museum, Purchase through
the generosity of an anonymous
donor, 1993.254.

Alix's print reproduces a painting by Swiss artist François Sablet, who spent
his career in Paris. Sablet in turn likely based his rendering on the performance
of Antoine-Marin Lemierre's play *Guillaume Tell*, which opened at the Theatre
Français in December 1766 and was later revived. The first run starred Lekain (born
Henri-Louis Cain), the celebrated tragic actor and theater reformer.[11] In spite of
Lekain's reputation, the play initially found little success, presumably because its
regicidal theme offended aristocratic theater subscribers. The most loyal patrons
of the first staging were Swiss expatriates. During the Revolution, however, a new,
more explicit and more popular version of the play was performed for broader audi-
ences, with a different lead. Tell's famous shot, which had only been narrated in the
first version, was now acted out. This second iteration firmly introduced the Swiss
folk hero into the canon of historic revolutionaries.

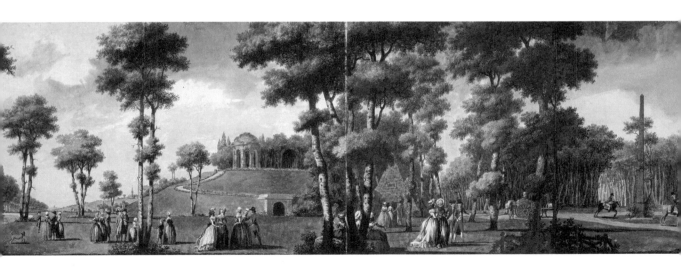

Joachim Homann

the installation. As they chose where to look and how much time to spend with certain objects, members of the public would observe each other responding to the works on display and would engage in debate about their own assessments.

Throughout his review of the Salon of 1765, Diderot comments both on Chardin's choice of hang and the works the artist himself contributed. He even addresses Chardin's dual role as artist and curator explicitly when he, in jest, notes the proximity of works by a lesser artist to Chardin's: "As if the faults in this composition weren't obvious enough, imagine that this mischievous Chardin has hung on the same wall, and at the same height, two works by Vernet and five by himself that are so many masterpieces of truth, color, and harmony. Monsieur Chardin, one shouldn't do such things to a colleague; you didn't need such a foil to make your own pictures look better."[18] Modeling observation, analysis, and judgment, Diderot set before readers the meritocratic rules of a new game: participation in a public. Chardin's organization of the Salon, and the content of his own work, laid the playing field. For both writer and artist, the public was a reference point in the creative imagination and a call for artistic intervention.

1. The magisterial treatment of this topic is Thomas E. Crow, *Painters and Public Life in Eighteenth-Century Paris* (New Haven, Conn.: Yale University Press, 1985).

2. Christopher S. Wood, *A History of Art History* (Princeton, N.J.: Princeton University Press, 2019), 157–60.

3. Denis Diderot, "Notes on Painting," in *Diderot on Art*, vol. 1, ed. John Goodman (New Haven, Conn.: Yale University Press, 1995), 213.

4. Ibid.

5. On a practical level, Diderot also believed portraiture to be foundational to painting, as empiricism was to medicine. Ibid., 229.

6. Diderot's description of the politics of representation remains relevant to artists and activists to this day. Referencing the philosopher, Peter Weibel recently advocated for "democratic participation in the performance of the political and thus a change from representing politics to performing politics." Peter Weibel, "Art and Democracy: People Making Art Making People," in *Making Things Public: Atmospheres of Democracy*, ed. Bruno Latour and Peter Weibel (Karlsruhe, Germany: Center for Art and Media in Karlsruhe; Cambridge, Mass.: MIT Press, 2005), 1026.

7. Chevalier de Jaucourt, "Slave Trade," The Encyclopedia of Diderot & d'Alembert Collaborative Translation Project, trans. Stephanie Noble, 2007, http://hdl.handle.net /2027/spo.did2222.0000.114.

8. Ann Thomson, "Colonialism, Race and Slavery in Raynal's *Histoire des deux Indes*," *Global Intellectual History* 2 (3) (August 2017): 251–67.

9. Alvin L. Clark, Jr., *French Drawings from the Age of Claude, Poussin, Watteau, and Fragonard: Highlights from the Collection of the Harvard Art Museums* (Cambridge, Mass.: Harvard Art Museums, 2022), cat. 61, pp. 172–73, 306. Clark writes, "One possibility to consider is that this portrait depicts either an actor or a patron who wished to be portrayed in the historic costume—reminiscent of the age of Henri IV—that was popular for masquerades at the French court in the second half of the eighteenth century."

10. See the British Museum 1958,0712.624, https://www.britishmuseum.org/collection/object/P_1958-0712-624.

11. The stage directions describe Tell as follows: "Tell, Mechtal & tous le Conjurés doivent être vêtu à la Suisse, d'un pourpoint large, avec des vestes de couleur tranchante, le haut-de-chausse tailladé, & les manches découpées" (Tell, Mechtal & all the conspirators must be dressed in the Swiss style, with wide doublet, boldly colored vests, slashed breeches, & sliced sleeves). Antoine-Marin Le Mierre, Renaud Bret-Vitoz, and Pierre Frantz, *Guillaume Tell: Tragédie*, Collection Textes Rares (Rennes: Presses universitaires de Rennes, 2005), 69.

12. See Louis Carrogis de Carmontelle's portrait of the actor in the role of Nero in the Waddesdon Manor collection (55.2006), https://waddesdon.org.uk/the-collection/item/?id=15451.

13. Goodman, *Diderot on Art*, 212.

14. The drawing attentively captures the chandelier's illumination of the cavernous space and allows a glimpse of the rafters through the central opening in the ceiling—a detail that reveals the period concern with ventilation. Between 1781 and 1794, the opera was housed at a provisional theater at the Saint-Martin gate in Paris, erected by investor and architect Samson-Nicholas Lenoir in record time after a devastating fire shut down the royal opera house in the Palais Royal. The venue would have been comparable to the structure recorded in this sheet, and according to Jean Gourret had roughly two thousand seats. Jean Gourret and Jean-Pierre Samoyault, *Histoire des salles de l'Opéra de Paris* (Paris: G. Trédaniel, 1985), 85–94. Further research is needed to confirm whether this might indeed be a rendering of that stage's inaugural performance, Niccolò Piccinni's *Adèle de Ponthieu*, on October 27, 1781. The second act takes place in a palace hall, and the female lead's court dress *sur le grand panier* would have been appropriate for the time.

15. Jeffrey S. Ravel, *The Contested Parterre: Public Theater and French Political Culture, 1680–1791* (Ithaca, N.Y.: Cornell University Press, 1999).

16. Edouard Kopp, *Capturing Nature's Beauty: Three Centuries of French Landscapes* (Los Angeles: J. Paul Getty Museum, 2009), cat. 25.

17. Laurence Chatel de Brancion, *Carmontelle's Landscape Transparencies: Cinema of the Enlightenment* (Los Angeles: J. Paul Getty Museum, 2008).

18. Goodman, *Diderot on Art*, 59.

Joachim Homann

Henry Fuseli
Agamemnon Pursuing a Trojan near the Tomb of Ilos

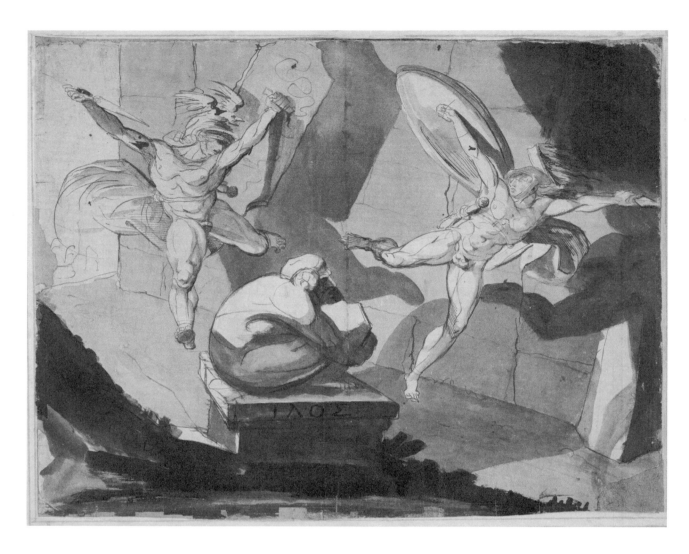

Fig. 1
Transmitted infrared digital
photograph of nude study

In the years leading up to the French Revolution, supply shortages, high taxes, and other factors made paper difficult to come by.[1] It makes sense, then, that an artist such as Henry Fuseli would seek to reuse the papers in his possession. Indeed, recent technical examination of Fuseli's *Agamemnon Pursuing a Trojan near the Tomb of Ilos* revealed a second drawing, a long-overlooked nude study, rendered on a sheet used for support behind the Trojan scene.

Agamemnon was executed on a thin laid paper, which in turn was adhered to a thick laid paper album mount decorated with gray pen lines along its outer edges.[2] Although this mounting is similar to other works by the artist, the strong vertical fold lines and creases that are evident in the primary sheet are not visible on its album mount, suggesting that the mount is not original to the drawing. In addition, losses along the edges of the drawing were awkwardly toned with black chalk, requiring that the mount be removed to fully examine the work. After removing the mount, it was discovered that the drawing is laid down on a second sheet of paper. This secondary laid paper, of medium weight, exhibits the same vertical creases as the drawing sheet, indicating that the two papers were folded or manipulated as one prior to being mounted to the album page. While sometimes conservators must separate supports to gain new information, in this case the decision was made to keep the adhered sheets intact to preserve the artist's original intent—or possibly his own intervention.

Using transmitted infrared illumination, a rather full sketch of a seated female nude otherwise hidden in the right half of the drawing was discovered (Fig. 1).[3] The resulting transmitted infrared digital photograph, along with the black chalk visible along the lower edge, indicates that the newly observed drawing is on the secondary support, rather than on the verso of the primary sheet. The corresponding fold lines strongly suggest that this mounting is original to the drawing and that a third sheet was needed for additional support or presentation. It is unclear who adhered the secondary paper to the back of the drawing. Without historical evidence or documentation to the contrary, one can only speculate that it was the artist himself.

Henry Fuseli (1741–1825), *Agamemnon Pursuing a Trojan near the Tomb of Ilos*, c. 1768–70. Brown ink, red gouache, and brown and gray wash over graphite on off-white laid paper, 44 × 56 cm. Harvard Art Museums/Fogg Museum, Bequest of Grenville L. Winthrop, 1943.706.

1. Camilla Baskcomb and Ute Larsen, "Henry Fuseli: Necessity or Frugality? The Artist's Selection of Drawing Papers," *Journal of the Institute of Conservation* 32 (1) (2009): 23.

2. This type of mounting was used for several Fuseli drawings now in the Art Institute of Chicago (1956.33, 1980.1089, 1922.2151).

3. Infrared illumination is widely used by conservators to reveal underdrawings executed in graphite or other carbon-rich materials. The Video Spectral Comparator (VSC 8000) by Foster + Freeman was used to examine this drawing. Designed for forensic investigation of falsified documents, the machine is now routinely used in the examination of works of art.

Anne Driesse

QUACK Elizabeth Kathleen Mitchell

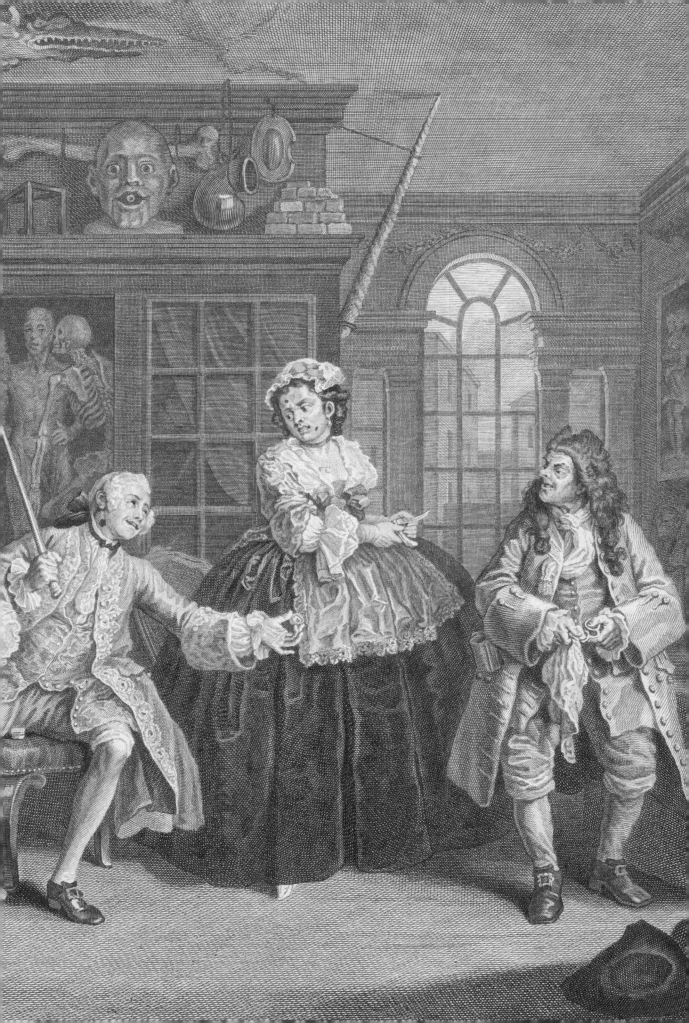

An etched and engraved plate from William Hogarth's 1745 series *Marriage à la Mode* endures as the Enlightenment's best-known and most richly articulated representation of a medical quack (Fig. 1). Quack physicians—also called mountebanks, charlatans, or empirics in England—featured in an array of print genres in vogue during the eighteenth century. In Holland and Britain especially, prints featuring the figures infiltrated the popular and high ends of the burgeoning international art market. Sinister and comical quacks pop up in rustic village scenes, moralizing satires on contemporary life and mortality, and satiric images savaging controversial physicians and politicians. Hogarth's depiction of a quack at work and a later etching by Austrian artist Franz Anton Maulbertsch, *The Quacksalver*, expose some of the contradictions inherent in visually defining quackery in an age of unprecedented medical discovery and profound shifts in thinking about health and treatment.

"Quack" had multiple connotations in the Enlightenment. The concept encompassed con artists as well as inept doctors, though the latter were scrutinized more often in media because they could be harder to recognize. Ephraim Chambers's 1738 *Cyclopaedia* described "empirics" as descendants of the ancient, misguided medical practitioners who shunned knowledge gained through dissection and direct anatomical study. Chambers wrote that the term "empiric" had grown "more odious than ever" because it had become interchangeable with "quack" when describing those who seemingly "practice physic at random, without a proper education, or understanding . . . of the art."[1] Similarly, John Quincy's 1736 medical dictionary classified together "all Quacks, and illiterate Dabblers in Medicine."[2]

KNOWLEDGE

The Enlightenment preoccupation with the pursuit and standardization of knowledge ⊙ gave rise to organized and centralized hospital medicine. This facilitated diagnosis based in empirical encounters with patients and the new, modern way of looking directly inside the body to describe its mysterious workings—a system of observation that Michel Foucault called "the clinic."[3] It was understood, however, that formal education did not guarantee adequate treatment. Hogarth's friend, the author Henry Fielding, addressed this paradox in his 1732 adaption of Molière's play *The Mock Doctor; or, The Dumb Lady Cur'd*: "The Quack still succeeds, / or fails by his Deeds, / If he kills you, he gets not a Shilling; / But who denies Fees / To the Quack, whose Degrees / Once give him a License for Killing?"[4]

The plot of Hogarth's plate revolves around a heated consultation between a quack apothecary and a dissatisfied gentleman customer. The Earl Squanderfield, the agitated dandy seated at left, raises his cane with one hand and holds out a pill container with the other, complaining that the dose the apothecary had previously sold him was ineffective. In the first two plates of the series, a black silk patch appears on Squanderfield's neck—an attempt to cover the symptoms of the sexually transmitted disease for which he seeks treatment. A bonnet belonging to the earl's companion, the young girl covering her lip with a cloth, can be seen in his pocket in plate 2, suggesting that his disease preexisted their relationship. The shabby apothecary, with his rumpled coat and unpowdered wig, is not a gentleman, but he dresses for the wealthy, discretion-seeking clientele he desires. He stands at right, on the other side of his scalpel-wielding wife, wiping his thick spectacles as he defends his remedy to the man of rank.

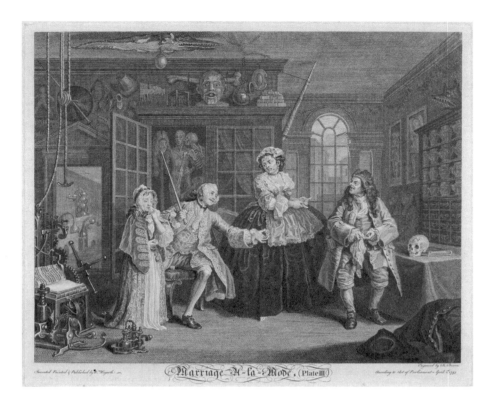

Fig. 1
Bernard Baron (1700–1762), after
William Hogarth (1697–1764),
Plate 3, from the series *Marriage à la
Mode*, 1745. Etching and engraving,
plate: 38.9 × 46.6 cm. Harvard Art
Museums/Fogg Museum, Gift of
William Gray from the collection of
Francis Calley Gray, G1831. (Detail
on p. 195.)

A keen observer of the fine details of contemporary life in London, Hogarth
fashioned the apothecary character after French-born doctor Jean Misaubin. The art-
ist regularly drew inspiration from the city's famous—and infamous—public figures,
spurring people in the know to flock to his shop to see if they recognized the faces in
his latest engravings. The model for the pill prescriber in the work shown here came
from a family of apothecaries. He married into the French Huguenot community
around St. Martin's Lane in 1709 and achieved the rank of master at the Apothecaries
Company in London in 1719.[5] Misaubin opened a business on St. Martin's Lane and
became known for his pill to treat sexually transmitted diseases. As early as 1724, a
mock-heroic poem invoked the apothecary in a young man's battle against syphi-
lis: "Too late repentance comes! And pills too late / Nor can even Misaubin revers
his fate!"[6]

Hogarth first represented Misaubin a few years later, in plate 5 of his 1732
landmark print series *A Harlot's Progress* (Fig. 2). Misaubin inspired the tall, thin man
at right, aggressively defending his potions against those of his seated rival, notorious
quack Richard Rock, in the presence of their dying patient. That same year, a poem
describing the thrill of seeing oneself depicted in popular prints stated, "Would you
be drawn in Mezzotin— / As Polly, or a Misaubin / . . . You may be wonder'd at while
living."[7] Even after his death in 1734, Misaubin's association with his famous pills
lingered in the London zeitgeist. A 1739 etched caricature portrait of the apothecary
standing in a graveyard, originally drawn in London in 1719 by Antoine Watteau,
does not identify Misaubin by name. Instead, it is simply inscribed "Prenez des
Pilules, prenez des Pilules" (Take pills, take pills).

Elizabeth Kathleen Mitchell

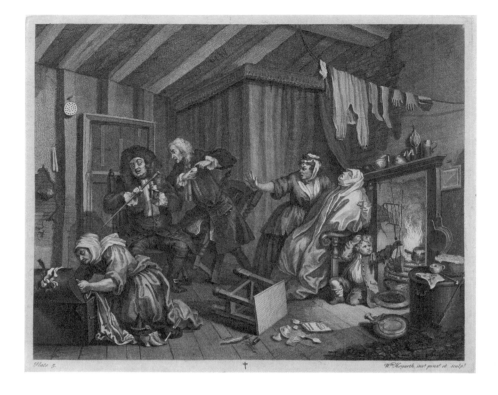

Indications that the apothecary figure in *Marriage à la Mode* is a quack—and that he references Misaubin—appear throughout plate 3. The scene is set in a private consultation room that doubles as a cabinet of *naturalia* and medical curiosities. The museum-like spectacle alludes to the actual collection that Misaubin and his wife maintained at 96 St. Martin's Lane.[8] The narwhal tusk, mummy cases, and human skull were all common props in seventeenth-century images of physicians and occultists, suggesting dangerously outmoded medical practices to eighteenth-century viewers. Such examples of materia medica were gradually expulsed from seventeenth-century art collections and found their way into medical cabinets and collections during the Enlightenment.[9]

The oddities and relics contrast with more modern tools of study, such as the whole, flayed human body displayed in the cabinet behind the earl. A symbol of contemporary observation-based anatomical research, the specimen is being groped by a skeleton, a more traditional emblem of mortality. Resting on a machine in the left foreground are folios, one of which mentions medical "machines superbes" invented by "Monsr. de la Pillule," another reference to the real Misaubin. In the 1730s, Hogarth operated a drawing academy on Peter's Court, which extended off St. Martin's Lane, not far from Misaubin's place. His graphic reimagining of the apothecary's cabinet juxtaposes contradictory signs of outmoded quackery and competence with experimental research. Hogarth's composition addresses society's distrust of the rapidly changing world of modern medicine, and how closely dangerous quackery resembled experimental innovation to the average person.

In its visual style, choice of setting, and figure types, Maulbertsch's *The Quacksalver* reveals Hogarth's influence on the younger Austrian artist's work (Fig. 3).[10] Published four decades after *Marriage à la Mode*, it offers a different but equally complicated representation of questionable medicine. One of Maulbertsch's quack characters appears to be an itinerant barber-surgeon traveling with a medical show that has set up for business on an abandoned stage. At the front right corner of the platform, he dabbles in open-air dentistry in front of a crowd. A male patient rests his head in the quack's lap and grasps the medical man's arm while his mouth is probed. In the composition's front right corner, near the feet of the current patient, a woman tends to a man crumpled on the ground in pain. He holds a cloth to his mouth; the absence of blood may indicate that he is next in line to have a tooth pulled.

Maulbertsch's surgeon is an anonymous figure but a recognizable type of worker, functioning without a private office ornamented with pretentious trappings of learning. In spite of this, he performs a real and necessary service for much of society, producing results that are clearer and more immediate than Hogarth's pill-selling apothecary. Moreover, he and his companions enjoy the luxury of leaving town before infections set in and remedies disappoint. In 1785, the year *The Quacksalver* was published, the Imperial Academy of Medicine and Surgery was established in Vienna, accelerating the standardization of medical education that had taken root in England earlier in the century. Maulbertsch's surgeon represents the ongoing experience of the poor and members of the laboring classes who continued to rely on the services offered by traveling companies of unskilled doctors.

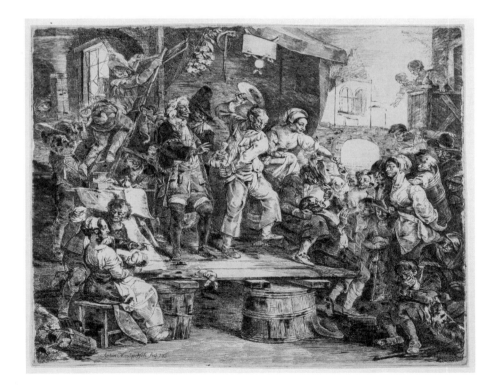

Fig. 3
Franz Anton Maulbertsch
(1724–1796), *The Quacksalver*, 1785.
Etching and drypoint, first state,
sheet: 33.3 × 41.3 cm. Museum of Fine
Arts, Boston, Katherine E. Bullard
Fund in memory of Francis Bullard,
2000.997.

Elizabeth Kathleen Mitchell

The tooth puller is positioned to attract people to the real show, the lively and dramatic quacksalvers loudly advertising potions for sale at center stage. Their spectacle is stagecraft and improvisation; they capitalize on people's fears of pain and death to sell bottles and paper rolls containing remedies. To their immediate left on the stage, a man seated at a desk collects the profits, keeping one hand on the cashbox. Such performative advertising was not unusual, as all types of eighteenth-century medical services were extremely competitive. Trained physicians, apothecaries, charlatan surgeons, and dodgy bonesetters hustled for the same customers and took cues from one another on self-promotion. Despite the grim representation of tooth pulling, the tone of the print is festive, owing in part to the style and figural traditions that Maulbertsch absorbed from his contemporary, Italian painter Giovanni Battista Tiepolo. The clown and the quacksalvers hawking their medicines evoke players from a threadbare commedia dell'arte troupe—an apt metaphor for the roaming medical charlatans and their show.

Even Hogarth's apothecary and Maulbertsch's showmen are the products of a little artistic quackery, a blend of fact with seductively entertaining fiction. But the anxieties that they and other quack characters tapped into—about suffering, death, and knowing whom to trust—were very real to eighteenth-century audiences. By depicting lowly laborers as wielding the power of life and death over others, including people of rank, representations of medical quackery interrupted traditional social codes of gentility, birthright, and control. Moreover, the trope pokes fun at a deadly serious undertaking we continue to wrestle with today: how to distinguish an innovative cure from poison in a pretty bottle.

1. Ephraim Chambers, *Cyclopaedia; or, An Universal Dictionary of Arts and Sciences*, 2nd ed., vol. 1 (London: Printed for D. Midwinter, A. Bettesworth and C. Hitch, J. Senex, R. Gosling [and 12 others], January 1, 1738).

2. John Quincy, *Lexicon physico-medicum; or, A new medicinal dictionary; explaining the difficult terms used in the several branches of the profession, and in such Parts of Natural Philosophy as are introductory thereto: with An account of the Things Signified by such Terms. Collected from the most eminent authors; and particularly those who have wrote upon Mechanical Principles*, 5th ed. (London: Printed for T. Longman, at the Ship in Pater-Noster Row, 1736).

3. Michel Foucault, *The Birth of the Clinic: An Archaeology of Medical Perception* (New York: Vintage Books, 1973).

4. Molière and Henry Fielding, *The Mock Doctor; or, The Dumb Lady Cur'd: A Comedy* (London: Printed for J. Watts, at the Printing-Office in Wild-Court near Lincoln's-Inn Fields, 1732).

5. Barry Hoffbrand, "John Misaubin, Hogarth's Quack: A Case for Rehabilitation," *Journal of the Royal Society of Medicine* 94 (2001): 143–47.

6. Nicholas Amhurst, *Oculus Britanniæ: An heroi-panegyrical poem on the university of Oxford* (London: Printed for R. Francklin, under Tom's-Coffee-House, Covent-Garden, 1724).

7. *Phino-Godol: A poem. In hudibrastick verse. In two canto's* (London: Printed for J. Towers, near Charing-Cross; and sold by the booksellers of London and Westminster, 1732).

8. Ronald Paulson, *Hogarth's Graphic Works*, 3rd rev. ed. (London: The Print Room, 1989), 119.

9. Ken Arnold, "Skulls, Mummies, and Unicorns' Horns: Medicinal Chemistry in Early English Museums," in *Enlightening the British: Knowledge, Discovery, and the Museum in the Eighteenth Century*, ed. R. G. W. Anderson (London: British Museum Press, 2003), 74–75.

10. Peter Cannon-Brookes, "The Oil Paintings of Franz Anton Maulbertsch in the Light of the 1974 Exhibitions," *The Burlington Magazine* 119 (886) (1977): 29.

Elizabeth Kathleen Mitchell

REPRODUCTION

Elizabeth M. Rudy

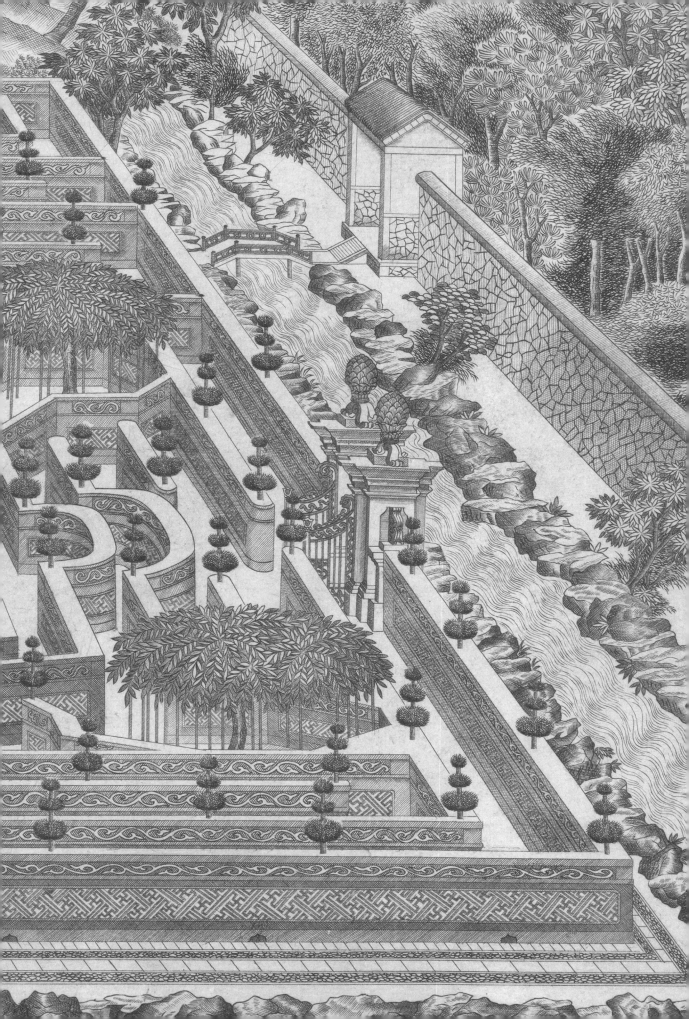

Printmaking's potential for reproduction, in the broadest sense of the term, was the crux of its appeal and power. It allowed for a single image to appear in hundreds of nearly identical copies: an image, carved in wood or inscribed onto metal, could be inked and transferred through the pressure of the printing press onto pliable surfaces such as paper and cloth. Writing in the fifth volume of the *Encyclopédie* (1755), Claude-Henri Watelet declared printmaking to be one of humanity's most singular inventions, preserving for posterity "an almost inexhaustible accumulation of truths, inventions, forms, and methods" from the arts and sciences of any single era 👁.[1] The notions of indelibility and preservation might seem incompatible with works on paper, which are more ephemeral than other media, but their multiplicity was often a bulwark against their destruction or disappearance. By the age of Enlightenment, the production of prints had touched every facet and stratum of society, both in Europe and farther afield.[2]

In the lexicon of printmaking, "reproduction" usually refers to the complex process of producing an image after or in relation to a referent—rendering a painting, sculpture, or a broad concept in two dimensions on a woodblock or a metal plate.[3] This essay considers instead the act of multiplication: the production of a print in multiple copies, or impressions. Inseparable from dissemination, this aspect of print-making has been exploited worldwide since the inception of the medium.[4] Yet the Enlightenment era saw intensified interest in leveraging prints to reach and influence audiences across the globe and through an array of channels, from those that were officially sanctioned and funded to the clandestine or even illegal ones.[5] This essay presents three case studies of how printmakers and their patrons mobilized prints: to sway public opinion in times of social unrest, to unite viewers separated by great distances in a single visual experience of a specific place, and to serve as pedagogical tools for new methods of image making.

Printed images exert enormous power during periods of political and social volatility, and the years leading up to the American Revolution were no exception. On the evening of March 5, 1770, a skirmish in Boston between colonists and the lone British soldier guarding the Customs House escalated into a deadly encounter in which five colonists were killed and six others were wounded. The first colonist killed was Crispus Attucks, a multiracial man believed to have been a sailor. The shootings, later known as the Boston Massacre, heightened tensions between some colonists and the English authorities, and that rancor was only stoked further by the acquittal of the eight British soldiers who were tried for murder.[6] Within weeks of the conflict, three very similar engravings appeared in local print shops, all based on Henry Pelham's depiction of the scene, which portrayed the event as an organized attack. The rigid presentation of the soldiers organized in a phalanx emphasized their professional training and preparedness for mortal combat. The unevenness of the matchup is called out in the title of Pelham's engraving, *The Fruits of Arbitrary Power; or, The Bloody Massacre*, and in the inscription at the top of Paul Revere's close variation, *The Bloody Massacre Perpetrated in King Street, Boston* (Fig. 1). The third engraving, by Jonathan Mulliken, exaggerated the suggestion of cruelty by showing more of the soldiers smiling as they shoot, in addition to

those who grimace 👁.[7]

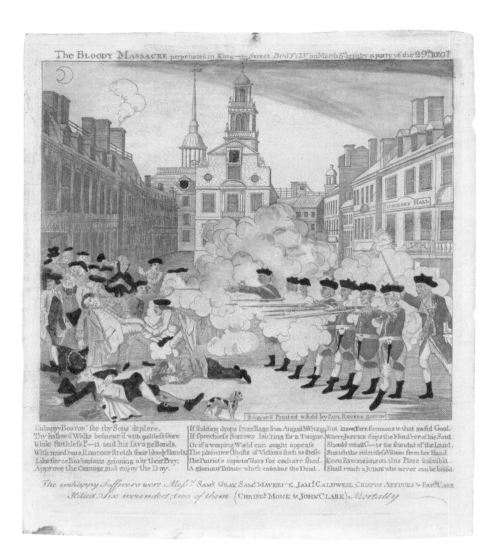

Fig. 1
Paul Revere, Jr. (1734–1818), after
Henry Pelham (1749–1806), *The
Boston Massacre*, 1770. Hand-colored
engraving and etching, sheet: 27.9 ×
24.3 cm. The Metropolitan Museum
of Art, New York, Gift of Mrs.
Russell Sage, 1910, 10.125.103.

Revere initially printed his engraving in a run of two hundred impressions, claiming in the inscription that he alone had engraved, printed, and sold it.[8] That he was able to produce the print one week ahead of Pelham provoked the latter's ire, because Pelham had shown his drawing to Revere in good faith, only to have it appear in print under Revere's name. Pelham wrote a scathing letter to Revere, accusing the metalsmith of having cheated him out of a significant sum of money: if his engraving had emerged first on the market, Pelham argued, he would have made sufficient funds to recuperate his initial investments in the print, which included the cost of the paper and the fee for the printer's labor.[9] The commercial aspirations embedded in this print point to the public demand for a visual expression of this interpretation of the events; one cannot pretend, in other words, that Pelham's and Revere's motivations were purely political.

On the other end of the political spectrum, prints made at the behest of royal and imperial rulers reinforced existing power structures. The printing press for the imperial court of China, located in the Hall of Martial Valor (Wuying

Elizabeth M. Rudy

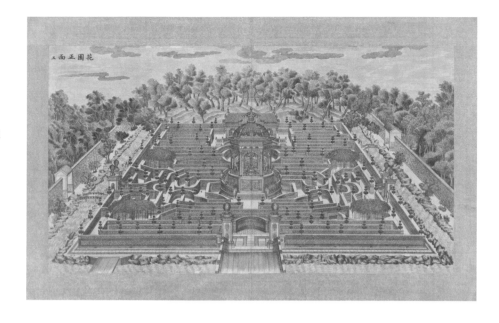

Fig. 2
Ilantai (active at the Qing court
c. 1749–1793), *Huayuan Zhengmian*
(Labyrinth), from the series
Changchun yuan shuifa tu (Pictures
of the European Palaces and
Waterworks), 1781–87. Copperplate
engraving with silk border, 64.9 ×
98.3 cm. Houghton Library, Harvard
University, Philip Hofer Charitable
Trust and Amy Lowell Bequest,
GEN Typ 778.83.274 Plate 5.
(Detail on p. 203.)

Dian), produced documents and imagery for distribution to the provinces.[10] In the eighteenth century, due especially to the interests of the Qianlong emperor (r. 1736–1795), this output featured a steep increase in fine art prints and books ranging from literature to philosophy.[11] While prints had long supported the circulation of knowledge around the world, Qianlong's initiatives forged new possibilities through the medium for both Chinese and European artists.[12] Like his grandfather, the Kangxi emperor (r. 1661–1722), Qianlong sought to diversify the press's woodblock printing with copperplate engraving and printing. Kangxi had first introduced copperplate engraving to the Qing court, enlisting the Catholic missionary Matteo Ripa to teach the technique to imperial artists. This collaboration resulted in the monumental map of China known alternately as the Jesuit or Kangxi Atlas. Comprising forty-one sheets pulled from as many copperplates, it measured over ten by fifteen feet and had an equally outsize impact: impressions of the map were sent to Europe, where it was copied and printed in the 1730s. It endured for many years as the cartographic authority

GEOGRAPHY on Chinese territory ⊙.[13]

The interest in copperplate engraving waned in the ensuing decades, until Qianlong strove to revive it with two projects: the expansion of the Kangxi Atlas, supervised by the French Jesuit Michel Benoist and totaling 104 copperplates; and the commission in 1765 of sixteen prints by artists at France's Royal Academy, engraved after drawings by Jesuits at Qianlong's court depicting military campaigns in East Turkestan between 1755 and 1759. The prints were to be large in scale, in the vein of the monumental battle prints after Georg Philipp Rugendas's designs that had made their way to Beijing.[14] The circumstances of the commission were carefully elucidated in surviving documents: two hundred impressions were to be printed from each plate, and all proofs plus the copperplates were to be returned to China so that they could be studied and emulated by artists at the imperial press.[15] The project is

believed to be the only commission initiated by a Chinese emperor that was executed by artists in Europe.[16]

Qianlong continued to encourage the use of copperplate printing, later directing a series of twenty engravings depicting the emperor's private residence in Yuanming Yuan, in northwest Beijing.[17] Engraved by the Manchu artist Ilantai, *Changchun yuan shuifa tu* (Pictures of the European Palaces and Waterworks; 1781–87) records structures added to the residence as part of an expansion project in the 1750s.[18] The complex was designed by an international team of artists who fused Chinese and European styles of architecture; it included a pleasure garden replete with various buildings, water features, and a maze (Fig. 2).[19] Qianlong commissioned two hundred impressions of Ilantai's suite of engravings, and their production was scrupulously recorded in imperial records, along with the places to which they were distributed across the kingdom.[20] Though the garden was a space few people could or would ever experience in person, the prints allowed Qianlong to provide the same virtual tour to subjects in far-flung locations, comprising a visual record of his illusionistic achievement at Yuanming Yuan and asserting the strength of his imperial leadership.[21]

The combination of Chinese and western modes of visual expression in Ilantai's compositions has been studied extensively, but one of their formal triumphs as prints is the judicious use of reserve.[22] In *Huayuan Zhengmian* (Labyrinth), the white tops of the walls and the ground inside the maze render the overall geometry of the space more visible, in the same way that the empty pathways by the outer walls allow the viewer to readily perceive the different patterns in the adjacent stones and lapping waves. This strategy of leaving certain components free of ink facilitates the illusionism of the designs themselves.

Illusionism is not typically associated with anatomical prints, but the visual information communicated by the genre was often drawn from several patients to form composite representations. Multi-sheet prints displaying the inner workings of the human body in life-size scale presented a view that was observable only during dissection.[23] In the early eighteenth century, the field of surgery emerged in Europe with the study of dissection at its core, and private schools where dissections could take place sprung up outside the royal institutes and academies ⊙. The closest representation of a dissected body was not in the graphic arts but in colored, life-size wax models. Unlike preserved specimens stored in glass jars or rapidly decaying cadavers, these models offered the chance for the sustained examination of human anatomy while delighting the uninitiated with their verisimilitude.[24] Large anatomical wax collections could be found in royal and private holdings across Europe, with Bologna as one of the notable centers.[25]

SKIN

Artists sought to reproduce the effectiveness and usefulness of wax models in life-size prints, asserting their adherence to what Lorraine Daston and Peter Galison have termed "truth-to-nature," or an essential truth not derived from a specific or single referent.[26] Jacques-Fabien Gautier d'Agoty, for instance, claimed that his various series of anatomical prints, which he made using his signature color mezzotint process (see p. 271), were accurate because they were based on two sources: the drawings of anatomist and surgeon

Elizabeth M. Rudy

Jacques-François-Marie Duverney and his own wax models. At the end of the 1751 prospectus for his prints, Gautier offered free admittance to anyone interested in seeing his wax models, noting that he had made them for his own edification and so they were not for sale.[27] The utility of his prints, he continued, made them appropriate for display in a cabinet of curiosities, a pharmacy, a medical school, or a surgery theater, a claim he repeated in a 1770 advertisement in the *Journal de Médecine, Chirurgie, Pharmacie* (Journal of Medicine, Surgery, Pharmaceutics).[28]

In a similar fashion, Antonio Cattani's five-sheet prints from 1780–81 showing male *spellati* (flayed figures) imply a public and didactic use; not only are they life-size, but the muscles are labeled with numbers and identified by name to the right of the figure (Fig. 3). The frontal and rear views of a standing man in the pose of a caryatid were etched after linden wood sculptures installed in Bologna's anatomy theater. Ercole Lelli, a leading anatomist famed for his wax models, made the sculptures for the renovated theater, where they flanked the lector's throne.[29] Like the related wax models, the sculptures were idealized figures based on Lelli's sustained examination of cadavers and skeletons and were explicitly offered for the benefit of artists.[30]

Made decades after the sculpture, Cattani's *Male Écorché Seen from the Rear* (also known as *Hercules*) foregrounds Lelli's achievement. The large inscription at top reads *Hercules Lelli Sculpsit*, identifying the figure as one of Lelli's sculpted *spellati*. However, the word *sculpsit*, which means "carved it," is typically used in prints to identify the printmaker (as in "engraved it"), while the maker of the referent, or design, is identified with the word *delineavit* ("drew it"). In smaller text inscribed on the pedestal at the bottom of the print, Cattani is identified as etcher of the sheets: *Antonio Cattani Placentinus incisit*. By using *sculpsit* as part of what resembles a title emblazoned at the top of the composition, Cattani insists on his role as secondary; the primary authorship and invention are credited instead to Lelli. Cattani thus heralds his print as a two-dimensional reproduction of the sculpture, a point he underscores visually with the shadows cast by the figure to the left. While Cattani's *spellati* are not known in many extant impressions, the artist intended to sell the prints not only in Bologna but in Parma and Venice as well; in this way, he hoped they would help artists in other regions represent the human form with greater naturalism.[31] Like Gautier's prints, then, Cattani's work offered great potential for shaping other types of visual representation.

One of the boldest assertions of the power of printed images in the eighteenth century appeared in Laurence Sterne's 1759 novel *Tristram Shandy* (Fig. 4).[32] In the midst of an episode in which the narrator describes the widespread grief over the death of a character named Yorick, two black rectangles appear where one might expect to find an illustration. Sterne borrowed this trope from seventeenth-century funereal literature, where black printed forms known as "mourning pages" interrupted the text.[33] In *Tristram Shandy*, however, the rectangles fill both recto and verso of the page: they do not merely represent something, such as Yorick's grave or the mourners' despair, but manifest a void in the very paper itself. Sterne surprises the reader with an array of visual tropes throughout his innovative text, but these black rectangles embody the force

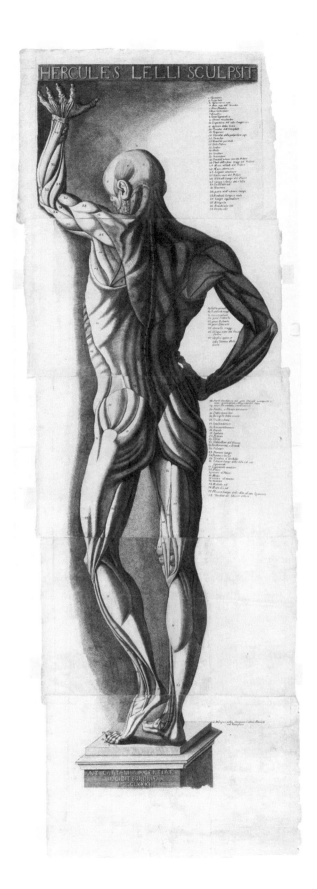

Elizabeth M. Rudy

Fig. 3
Antonio Cattani (active 1770–1780s),
after Ercole Lelli (1702–1766),
Male Écorché Seen from the Rear,
1781. Etching, overall: 201.9 ×
61 cm. Philadelphia Museum of
Art, Purchased with SmithKline
Beckman (later SmithKline
Beecham) Funds for the Ars Medica
Collection, 1995, 1995-9-2.

Fig. 4
Spread from Laurence Sterne's *The Life and Opinions of Tristram Shandy, Gentleman*, vol. 1 (London: 1759). University of Glasgow Library, Special Collections Hepburn 7.

of visual representation. Simultaneously frustrating the reader's expectations and cleverly asserting the literal and conceptual impact of absence, Sterne's ink blocks epitomize the provocation and possibility of printed representation—even when reduced to pure pigment.

1. "[O]n prépare à ceux qui nous suivront un amas presqu'intarissable de vérités, d'inventions, de formes, de moyens qui éterniseront nos Sciences, nos Arts." Claude-Henri Watelet, "Estampe," in *Encyclopédie, ou, Dictionnaire raisonné des sciences, des arts et des métiers*, vol. 5, ed. Denis Diderot and Jean le Rond d'Alembert (Paris: 1755), 1000.

2. The business of printmaking was structured differently by locality, but it universally required numerous types of labor, a diverse array of materials and equipment, financial transactions, and legal and administrative processes. See Ad Stijnman, *Engraving and Etching, 1400–2000: A History of the Development of Manual Intaglio Printmaking Processes* (Houten: Archetype Publications Ltd., 2012), esp. 75–130; and Antony Griffiths, *The Print before Photography: An Introduction to European Printmaking, 1550–1820* (London: British Museum, 2016), esp. "Part II: The European Print Trade," 216–393.

3. While the word "reproduction" is commonplace in print scholarship, some scholars take issue with its use. Antony Griffiths, for one, notes that it was not used in the eighteenth century and adopts the term "translation" instead. See Griffiths, *The Print before Photography*, 464; and Christian Michel, "Les débats sur la notion de graveur/ traducteur en France au XVIIIe siècle," in *Delineavit et sculpsit, mélanges offerts à Marie-Félicie Perez-Pivot*, ed. François Fossier (Lyon: 2003), 151–61.

4. See Sabrina Alcorn Baron, Eric N. Lindquist, and Eleanor F. Shevlin, eds., *Agent of Change: Print Culture Studies after Elizabeth L. Eisenstein* (Amherst: University of Massachusetts Press, 2007).

5. See Elizabeth L. Eisenstein, "Print Culture and Enlightenment Thought," *Réseaux* 6 (31) (1988): 7–38.

6. See Eric Hinderaker, "Contested Meanings," in *Boston's Massacre* (Cambridge, Mass.: Harvard University Press, 2017), 221–55.

7. To compare early engravings of this event in detail, visit the Massachusetts Historical Society's website: https://www .masshist.org/features/massacre /comparison.

8. Hinderaker, "Contested Meanings," 230.

9. Transcribed in Paul Leicester Ford, "Some Copley-Pelham Letters," *The Atlantic Monthly*, April 1893, 500.

10. See Christine Moll-Murata, "Printing in the Service of the State," in *State and Crafts in the Qing Dynasty (1644-1911)* (Amsterdam: Amsterdam University Press, 2018), 213–44.

11. Ibid., 218.

12. On the international circulation of prints over three centuries, see Heather Madar, ed., *Prints as Agents of Global Exchange, 1500-1800* (Amsterdam: Amsterdam University Press, 2021).

13. See Henriette Lavaulx-Vrécourt and Niklas Leverenz, *Berliner Schlachtenkupfer: 34 Druckplatten der Kaiser von China/Battle Engravings: 34 Copperplates for the Emperors of China* (Berlin: Deutscher Kunstverlag, 2021), esp. 33–102. My thanks to John Finlay for bringing this important publication to my attention.

14. Ibid., 51.

15. See Pascal Torres Guardiola, *Les Batailles de l'emperor de Chine: La gloire de Qianlong célébrée par Louis XV, une commande royale d'estampes* (Paris: Musée du Louvre éditions, 2009); and Marcia Reed, "The Qianlong Emperor's Copperplate Engravings," *Harvard Library Bulletin* 28 (1) (Spring 2017): 1–24.

16. Lavaulx-Vrécourt and Leverenz, *Berliner Schlachtenkupfer*, 11.

17. See Greg Thomas, "Yuanming Yuan/Versailles: Intercultural Interactions between Chinese and European Palace Cultures," *Art History* 32 (1) (February 2009): 115–43.

18. For illustrations of the whole suite, see Richard E. Strassberg, "War and Peace: Four Intercultural Landscapes," in *China on Paper: European and Chinese Works from the Late Sixteenth to the Early Nineteenth Century*, ed. Marcia Reed and Paola Demattè (Los Angeles: Getty Research Institute, 2007), 110–19.

19. See Kristina Kleutghen, "Staging Europe: Theatricality and Painting at the Chinese Imperial Court," *Studies in Eighteenth-Century Culture* 42 (2013): 81–102.

20. See Kristina Kleutghen, "The Qianlong Emperor's Perspective: Illusionistic Painting in Eighteenth-Century China," Ph.D. dissertation, Harvard University, 2010, 196–97.

21. Kristina Kleutghen carefully re-creates the experience of visiting the gardens through the prints in *Imperial Illusions: Crossing Pictorial Boundaries in the Qing Palaces* (Seattle: University of Washington Press, 2015), 182–91.

22. Ibid., 168–222.

Elizabeth M. Rudy

23. Beginning in the Renaissance, the European study of human anatomy centered on dissection. Dissections were held publicly in large halls called theaters and were attended by a wide range of people; unfolding according to established rituals, the procedures took place over several days. For people of social standing, scholars, and artists alike, dissections were a humanist pursuit that enabled those in attendance to understand the body in every detail, both visible and invisible. See Barbara Maria Stafford, *Body Criticism: Imaging the Unseen in Enlightenment Art and Medicine* (Cambridge, Mass.: MIT Press, 1991), esp. 47–53; and Martin Kemp and Marina Wallace, *Spectacular Bodies: The Art and Science of the Human Body from Leonardo to Now* (London: Hayward Gallery, 2000), 23–31.

24. See Thisbe Gensler, "Interior Visions: Representing the Body in Three Dimensions," in *Flesh and Bones: The Art of Anatomy*, by Erin Travers, Naoko Takahatake, Thisbe Gensler, and Monique Kornell (Los Angeles: Getty Publications, 2021), esp. 85–88.

25. The city was home to Pope Benedict XIV's Anatomy Museum as well as the wax model workshop of Anna Morandi and Giovanni Manzolini. See Giovanna Ferrari, "Public Anatomy Lessons and the Carnival: The Anatomy Theater of Bologna," *Past & Present* 117 (November 1987): 50–106; and Rebecca Messbarger, *The Lady Anatomist: The Life and Work of Anna Morandi Mazolini* (Chicago: University of Chicago Press, 2010). My thanks to Andaleeb Banta for bringing this latter resource to my attention.

26. See Lorraine Daston and Peter Galison, *Objectivity* (New York: Zone Books, 2007), 17–54.

27. "L'Auteur . . . ne travaille dans ce genre particulier que pour lui-même, ne les vend point, & les garde pour sa satisfaction, & pour montrer avec combien de soin il exécute ses Planches Anatomiques." Jacques-Fabien Gautier d'Agoty, *Projet-General des planches anatomiques* (Paris: 1751), 4. My gratitude to Sarah Lund for photographing this document for me at the Bibliothèque nationale de France.

28. "[P]ropres à orner le Cabinet d'un Sçavant, une Pharmacie, une Ecole de Médécine ou Amphithéatre de Chirurgie." Ibid., 3. "La grande Edition peut être reliée; & on peut aussi la mettre en tableau, & orner des ampithéâtres, les grands cabinets, & les sales [sic] académiques." *Journal de Médecine, Chirurgie, Pharmacie* 33 (July 1770): 92.

29. Harvey Cushing, "Ercole Lelli and His Écorché," *Yale Journal of Biology and Medicine* 9 (3) (1927): 199–213; and Benedetta Basevi, "Gli *Spellati* di Ercole Lelli incisi da Antonio Cattani (1780–1781)," in *Antico e Moderno: Acquisizioni e donazioni della Fondazione Carisbo per la storia di Bologna (2001–2013)* (Bologna: Bononia University Press, 2014), 496–97.

30. Messbarger, *The Lady Anatomist*, 31–32.

31. Travers, Takahatake, Gensler, and Kornell, *Flesh and Bones*, 170.

32. For a discussion of the worldwide reception of this controversial novel, see Peter de Voogd and John Neubauer, eds., *The Reception of Laurence Sterne in Europe* (London: Thoemmes, 2004).

33. See, for instance, Jonathan P. Lamb, "Ben Jonson's Dead Body: Henry, Prince of Wales, and the 1616 Folio," *Huntington Library Quarterly* 79 (1) (Spring 2016): 63–92.

Elizabeth M. Rudy

SKIN

HUMAN

For most early modern anatomists, human skin was significantly less interesting than the bodily interior it concealed. In the late seventeenth century, however, anatomists began to subject human skin itself to dissection and microscopic analysis. The result was a new understanding of skin as a vast sensory organ, a "nervous canvas" whose tactile inputs were vital to development of the self.[1] Equally consequential, in light of the period's extended debate over the causes of human variation ⊙, was the identification of this organ as the anatomical location of skin color. By the end of the eighteenth century, conceptions of human variety as manifested in differences of religion, clothing, or language were supplanted by the social construct of distinct human races, with skin color their most visible marker.

Eighteenth-century printmakers mobilized the tonal technique of mezzotint, in both its color and black and white manifestations, to mediate these new understandings of human skin and to capture its nuances. In the 1730s, printmaker Jan L'Admiral petitioned Leiden anatomist Bernard Siegfried Albinus for the role of illustrating Albinus's research, including his dissections of skin, arguing that the new multi-plate color mezzotint process was best suited to the task. "From a burning and praiseworthy desire to show specimens of his matchless skill, [L'Admiral] did not cease to entreat me until he prevailed upon me to give him a chance," Albinus wrote in the 1737 report *De sede et caussa coloris Aethiopum et caeterorum hominum* (On the Seat and Cause of the Color of Ethiopians and Other Human Beings).[2] Successful in his efforts, L'Admiral used the three-color mezzotint process he had learned from German printmaker Jacob Christoph Le Blon to produce the illustration accompanying Albinus's publication.

Mezzotint is a labor-intensive method that requires the printmaker to burnish or "scrape" intermediate tones and highlights from a roughened copperplate, creating passages of light emerging from darkness. The effort is recompensed by a softness and tonal range unrivaled by the linear techniques of etching or engraving and particularly suited to mediate the new interest in skin's materiality. Although some crispness of detail is sacrificed by the mezzotint process, the addition of gradations of color through the scraping of three separate plates of the same image—the first inked in blue, the second in yellow, and the third in red, each successively printed on the same sheet of paper—immeasurably heightened its value for anatomical

YELLOW

illustrations ⊙.[3] Printed color obviated the inconsistencies of hand-coloring, thus ensuring that all viewers could see and interpret the same evidence. It also conveyed visual information with a vividness and intimacy that neither black and white prints nor textual explanation could match.[4] These "pictures colored after life in a shorthand kind of painting," as Albinus described another anatomical print by L'Admiral, surpassed verbal description: "[W]ords fail me to express the incredible variety of the twisting of these branches [of arteries and veins], as the artist has rendered it in the plate" (Fig. 1).[5] In a further testament to their value, L'Admiral's anatomical prints were trimmed with gold leaf.[6]

L'Admiral's print for *De sede et caussa coloris Aethiopum* depicts fragments of the skin and thumb of the cadaver of an unidentified "Ethiopian" woman, each unsettlingly pinned to the green backdrop L'Admiral used for his anatomical mezzotints (Fig. 2). In the eighteenth century, "Ethiopian" was often used to refer

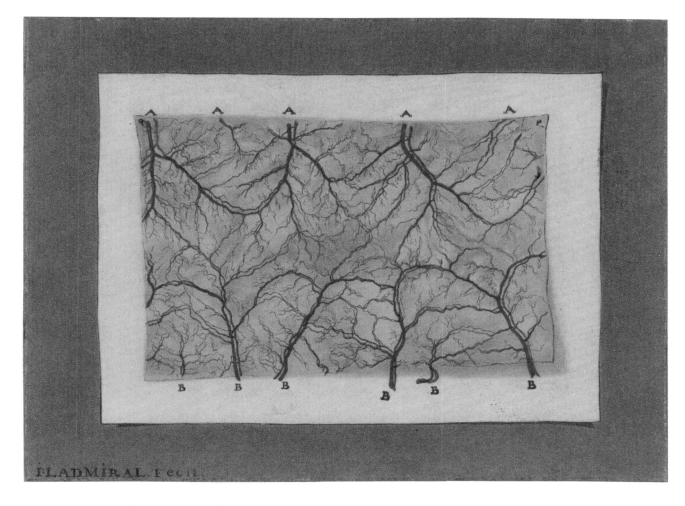

FLADMIRAL. Fecit

indiscriminately to Black Africans. L'Admiral's color mezzotint made visible what Albinus's procedure had confirmed. In 1665, Italian microscopist Marcello Malpighi hypothesized that skin color resided in the *rete mucosum*, the middle or mucous layer between the epidermis and dermis that Malpighi was the first to isolate. The rectangular specimen at upper left in L'Admiral's plate, taken from one of the woman's breasts, is deliberately arranged to show these three layers.[7] The epidermis, or surface layer of the skin, is peeled back to reveal the dark brown *rete mucosum*, which is itself folded back to make visible the lower white layer of the dermis. While some authors had posited that the Malpighian layer (as it is now called) was specific to Africans, Albinus and his Dutch colleague Frederik Ruysch demonstrated that the skin of all human beings (as deliberately referenced in the title of Albinus's report), European and "Ethiopian" alike, has a Malpighian layer and that differences of color reside there under the translucent epidermis possessed by all.[8] L'Admiral's three-plate technique neatly paralleled the three layers of skin Malpighi had identified, as well as the layering of skin color that Albinus's dissection demonstrated. In L'Admiral's mezzotint, as in the findings it visualizes, black and white skin are not fundamentally different from each other in their composition—a point echoed in the printmaking

Fig. 1
Jan L'Admiral (1699–1773),
Arteries and Veins of the Intestine,
from *Dissertatio de arteriis et venis intestinorum hominis. Adjecta icon coloribus distincta* (A Treatise on the Arteries and Veins of the Human Intestine: With the Addition of a Distinct Color Image), by Bernard Siegfried Albinus (Leiden: 1736). Color mezzotint with etching, 13 × 17.1 cm. Francis A. Countway Library of Medicine, Harvard Medical School, R836.L12 c.2. (Detail on p. 215.)

Kristel Smentek

process, where black and white skin tones are both produced by the superimposition
of the three primary colors.[9]

At the same time, L'Admiral's image of sections of a deceased African
woman's breast, foot, and thumb, printed in natural color, oscillates uncomfortably
between scientific illustration and morbid titillation.[10] The print's representa-
tion of a Black body in pieces also anticipates the dehumanizing fragmentation of
Black bodies that would define racist caricatures of the nineteenth century.[11] In
that sense, L'Admiral's plate exemplifies the ways in which the apparently impartial
investigation of human variety could both affirm the unity of humankind and deny
it, and how ostensibly neutral scientific images contributed to the visual construc-
tion of race. Though anatomical dissections of skin were undertaken to analyze
varieties of human complexion, the opposition of black and white structured these
investigations from the start.[12] By one estimate, between 1675 and 1810, European
anatomists performed at least thirty-eight dissections of Africans solely for the
purpose of studying skin color. Although it is difficult to estimate the fraction of
all period dissections represented by this number, anatomical analyses of the skin
color of other peoples are noticeably absent from the eighteenth-century record.[13]
Hovering at the edge of these "objective" questions about the causes of blackness

was the concurrent institution of slavery, which shaped scientific investigations of skin color and the reception of their results.[14] The light epidermis and white dermis common to all humans that anatomists identified and that L'Admiral depicted implicitly established whiteness as the norm from which other skin tones deviated.[15] By the eighteenth century's end, as concepts of human variety hardened into the fixity of race, whiteness would take its place at the top of a racialized hierarchy with blackness at the bottom.

Skin was not only the location of skin color; it was also recognized to be a vast sensory organ integral to the development of human subjectivity. Malpighi's microscopic investigations of human skin, which were motivated by his interest in sense perception, eventually led to his identification of the dermal papillae as the site of tactile sensation. As the organ of touch connected to the brain by nerves, skin was central to debates over the role of sensory experience in human knowledge, an epistemological argument initiated by John Locke in his *Essay Concerning Human Understanding* (1690) and elaborated over the course of the eighteenth century. As Locke famously and provocatively articulated, we enter this world with no innate ideas and come to know both ourselves and our environment by processing the sense impressions that impinge on us. Locke used a suggestive analogy: at birth, the human mind is like a blank page "void of all characters," upon which sensations (such as pressure on the skin) impress themselves, much like type or an engraved copperplate impresses itself on paper.[16] Touch in particular was increasingly understood as fundamental to self-knowledge and to sensibility, an eighteenth-century construct in which a human being's moral action was believed to proceed less from rational thought than from sensate experience, from being "touched" emotionally by what one saw or read and moved to empathy.[17] The refined sensibility of eighteenth-century men and women of feeling was both literally and theoretically bound up with the period's reconceptualization of skin as a primary site of sensitivity and nervous stimulation.[18]

The epistemological importance of touch is foregrounded in the 1760 mezzotint *Young Man in a Turban with Book*, by Irish printmaker Thomas Frye (Fig. 3). In this work, "drawn from nature and as large as life," an unidentified sitter clad in a turban and a fur-lined cloak directly engages the viewer's gaze with his own, while his interlacing fingers simultaneously touch a length of striped silk and the pages and leather covers of the finely bound book before him.[19] The tonal variety of the mezzotint process makes possible the sensuous evocation of the different textures of fabrics, the contrast of light and shadow on skin, as well as the bright points of light reflected in the sitter's pupils that lend *Young Man in a Turban* its uncanny sense of presence.

The work was one of eighteen life-size mezzotints of women and men produced by Frye in London in 1760 and 1761, all of which appeal to the sense of touch in both content and technique. Though taken from life, the prints are, with one exception, not portraits but depictions of models in various costumes and poses that draw on the seventeenth-century tradition of character heads. The tradition was revivified by eighteenth-century Venetian painter Giovanni Battista Piazzetta, whose prints were well received in England and explicitly referenced by Frye in the

Kristel Smentek

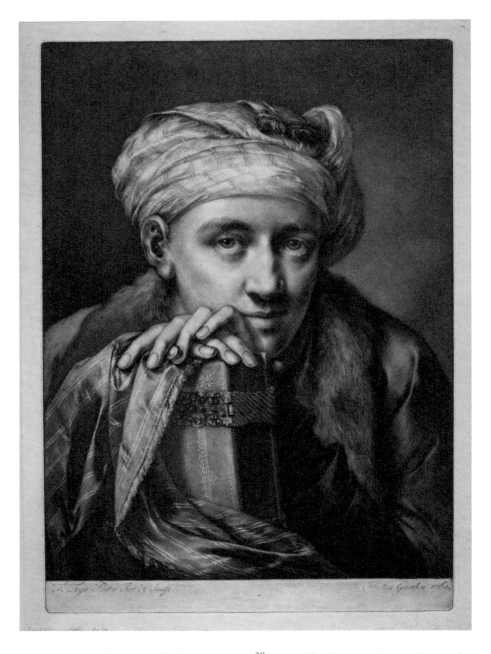

advertisements he placed for his mezzotints.[20] But unlike Piazzetta's series *Icones ad vivum Expressae* (Images Taken from Life), engraved by Giovanni Cattini in 1753, for example, there is at least one hand—the most common signifier of touch—visible in all but one of Frye's eighteen prints. His sitters caress books and drawing instruments, stroke smooth pearls and fan handles, and enjoy the softness of fabrics, fur, and their own skin. The theme of tactility is heightened by the velvety surfaces of Frye's mezzotints, which, particularly in the freshest impressions, seem to invite the viewer to reach out and touch them.[21]

The surface and scale of *Young Man in a Turban* and the particular intensity of the man's gaze set the stage for an intimate intersubjective encounter between

viewer and sitter. This effect is doubled by the self-portrait of Frye himself. Captioned with the Latin word *Ipse* (himself), it is the only work in the series whose subject is identified. In it, Frye locks eyes with the viewer while cradling his head in one hand and gently handling a crayon holder in the other. Both images figure deeply sensitive selves whose interior depths are forged by the sensations elicited by the objects they touch and by the empathetic recognition of oneself in another, a reaction presupposed by the concept of sensibility. In *Young Man in a Turban*, which at least one contemporary identified as representing a "Moor," or Muslim North African, such recognition of a shared humanity extends across cultural and regional differences.[22]

The prints by L'Admiral and Frye foreground one of the central paradoxes of the Enlightenment—an era in which abolitionists explicitly appealed to the fellow feeling of their peers to enlist them in the cause of ending the slave trade, but at the same time, an age in which blackness was instituted, not least through the proliferation of images, as a fixed, visible marker of presumed racial inferiority.[23] As a result of this tension, located at the heart of Enlightenment speculations on what it meant to be human, African chattel slavery would eventually be abolished, but racism against people of color would intensify.

1. "La peau, cette toile nerveuse qui forme un organe general." Henri Fouquet, "Sensibilité, Sentiment [Médicine]," in *Encyclopédie, ou, Dictionnaire raisonné des sciences, des arts et des métiers*, vol. 15, ed. Denis Diderot and Jean le Rond d'Alembert (Paris: 1751–65), 48. See also Mechthild Fend, *Fleshing Out Surfaces: Skin in French Art and Medicine, 1650-1850* (Manchester: Manchester University Press, 2017), 65–104.

2. Bernard Siegfried Albinus, *Dissertatio secunda. De sede et caussa coloris Aethiopum et caeterorum hominum* (Leiden: 1737); translated in Ludwig Choulant, *History and Bibliography of Anatomic Illustration in Its Relation to Anatomic Science and the Graphic Arts*, ed. and trans. Mortimer Frank (Chicago: University of Chicago Press, 1920), 268.

3. In the work illustrated here, L'Admiral relied on etching for his signature, the letters (keyed to an accompanying explanatory text), and the pins. On L'Admiral's technique, see Ad Stijnman, *Jacob Christoff Le Blon and Trichromatic Printing*, 2 vols., New Hollstein Dutch & Flemish Etchings, Engravings and Woodcuts, 1450–1700 (Ouderkerk aan den Ijssel: Sound & Vision Publishers, 2020), 1:lviii–lxiv, 2:105–6, 112–15.

4. Sarah Lowengard, "Colour-Printed Illustrations in Eighteenth-Century Periodicals," in *Book Illustration in the Long Eighteenth Century: Reconfiguring the Visual Periphery of the Text*, ed. Christina Ionescu (Newcastle upon Tyne: Cambridge Scholars Publishing, 2011), 58–62; and Julia Nurse, "Colouring the Body: Printed Colour in Medical Treatises," in *Printing Colour, 1700-1830*, ed. Margaret Morgan Grasselli and Elizabeth Savage (forthcoming).

5. Bernard Siegfried Albinus, *Dissertatio de arteriis et venis intestinorum hominis* (Leiden: 1736); translated in Choulant, *History and Bibliography of Anatomic Illustration in Its Relation to Anatomic Science and the Graphic Arts*, 267.

6. The authority of L'Admiral's anatomical mezzotints continued well into the eighteenth century. In 1791, artist Johannes Prey depicted two of them, including the print illustrated here, in his painting of Aesculapius and other ancients in their laboratory, now in the Wellcome Collection, London (466059i). See Nurse, "Colouring the Body."

Kristel Smentek

7. Albinus was not the only anatomist to confirm Malpighi's speculation about the location of skin color, but he was the first to publish his findings with a printed color illustration of the results. On earlier, related dissections, see Renato G. Mazzolini, "Kiel 1675: La dissezione pubblica di una donna Africana," in *Per una storia critica della scienza*, ed. Marco Beretta, Felice Mondella, and Maria Teresa Monti (Bologna: Cisalpino, 1996), 371–93; Craig Koslofsky, "Superficial Blackness? Johann Nicolas Pechlin's *De Habitu et Colore Aethiopum Qui Vulgo Nigritae* (1677)," *Journal for Early Modern Cultural Studies* 18 (1) (2018): 140–58; and Fend, *Fleshing Out Surfaces*, 146–50.

8. Renato G. Mazzolini, "Skin Color and the Origin of Physical Anthropology," in *Reproduction, Race, and Gender in Philosophy and the Early Life Sciences*, ed. Susanne Lettow (Albany: SUNY Press, 2014), 139.

9. Fend, *Fleshing Out Surfaces*, 150–53; and Mechthild Fend, "Flesh-Tones, Skin-Color, and the Eighteenth-Century Color Print," in *Aesthetics of the Flesh*, ed. Felix Ensslin and Charlotte Klink (Berlin: Sternberg Press, 2014), 203–27. On the intersection of printmaking technique and eighteenth-century debates on skin color, see also Jennifer Y. Chuong, "Engraving's 'Immovable Veil': Phillis Wheatley's Portrait and the Politics of Technique," *Art Bulletin* (June 2022). All my thanks to Jennifer Chuong for sharing her research with me and for generously reading and commenting on a version of this essay.

10. Lowengard, "Colour-Printed Illustrations in Eighteenth-Century Periodicals," 63.

11. Kay Dian Kriz, "Turner's *Slavers*, Race, and the Ridiculous Human Fragment," *Romantic Circles*, December 2014, https://romantic-circles.org/praxis/visualities/praxis.visualities.2014.kriz.html.

12. Claudia Benthien, *Skin: On the Cultural Border between Self and the World*, trans. Thomas Dunlap (New York: Columbia University Press, 2002), 145–46.

13. Mazzolini, "Skin Color and the Origin of Physical Anthropology," 138.

14. Andrew S. Curran, *The Anatomy of Blackness: Science and Slavery in an Age of Enlightenment* (Baltimore: Johns Hopkins University Press, 2011); ibid., 146–47; and James Delbourgo, "The Newtonian Slave Body: Racial Enlightenment in the Atlantic World," *Atlantic Studies* 9 (2) (2012): 185–207.

15. Mazzolini, "Skin Color and the Origin of Physical Anthropology," 140.

16. John Locke, *Essay Concerning Human Understanding* (London: 1690), bk. 2, chap. 1, sec. 2. On printed images as a metaphor for knowledge acquisition, see William B. MacGregor, "The Authority of Prints: An Early Modern Perspective," *Art History* 22 (3) (1999): 389–420.

17. Sarah Cohen and Downing A. Thomas, "Art and the Senses: Experiencing the Arts in the Age of Sensibility," in *A Cultural History of the Senses in the Age of Enlightenment*, ed. Anne C. Vila (London: Bloomsbury Academic, 2014), 191–92; and Lynn Hunt, *Inventing Human Rights: A History* (New York: W. W. Norton and Company, 2007), 35–69.

18. G. J. Barker-Benfield, *The Culture of Sensibility: Sex and Society in Eighteenth-Century Britain* (Chicago: University of Chicago Press, 1992), 6–36; and Barbara Maria Stafford, *Body Criticism: Imaging the Unseen in Enlightenment Art and Medicine* (Cambridge, Mass.: MIT Press, 1991), 38.

19. Thomas Frye, "Proposals for Publishing by Subscription Twelve Metzotinto [sic] Prints," *Public Advertiser*, April 28, 1760. In his preparatory drawing for *Young Man in a Turban*, now in the Seattle Museum of Art (53.91), Frye omitted the length of silk.

20. Ibid.

21. Martha Tedeschi, "Out from Darkness: The Irish Mezzotint Comes of Age," in *Ireland: Crossroads of Art and Design, 1690–1840*, ed. William Laffan and Christopher Monkhouse (Chicago: Art Institute of Chicago, 2015), 153. For a remarkable set of all eighteen of Frye's heads, each framed in early pressed paper gold borders, see pp. 216–17 in that catalogue.

22. The figure is described as a "Moor in contemplation, resting his hands on a book" in "An Account of Mr. Fry's [*sic*] Designs," *The British Magazine; or, Monthly Repository for Gentlemen & Ladies* (May 1760): 314 (mismarked 135). In eighteenth-century usage, "Moor" could refer either to Muslim North Africans or sub-Saharan Africans.

23. David Bindman, *Ape to Apollo: Aesthetics and the Idea of Race in the 18th Century* (Ithaca, N.Y.: Cornell University Press, 2002); Anne Lafont, "How Skin Color Became a Racial Marker: Art Historical Perspectives on Race," *Eighteenth-Century Studies* 51 (1) (Fall 2017): 89–113; and Anne Lafont, *L'Art et la race: l'Africain (tout) contre l'oeil des Lumières* (Dijon: Les presses du réel, 2019).

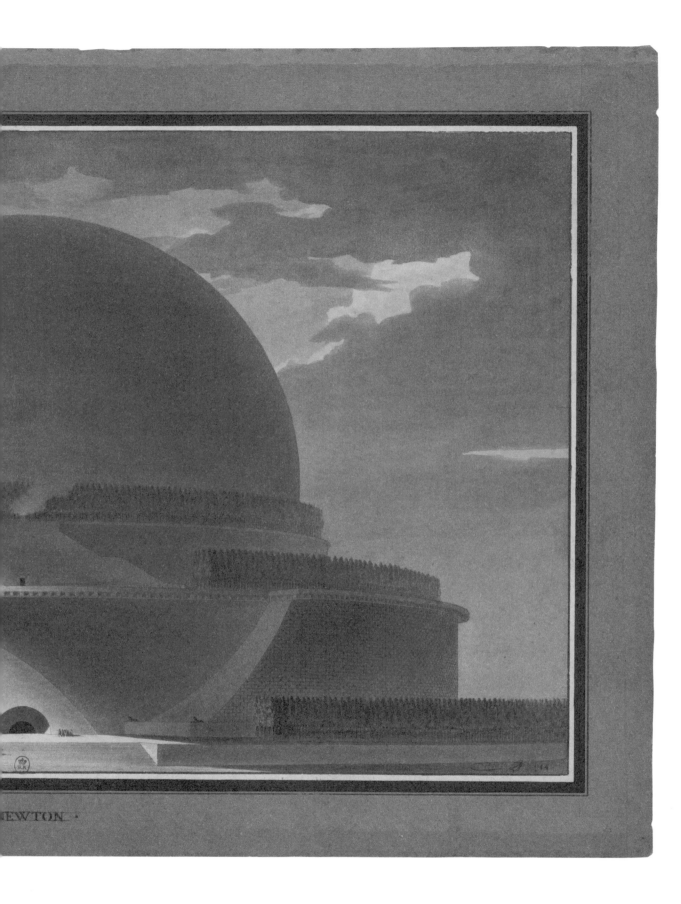

NEWTON .

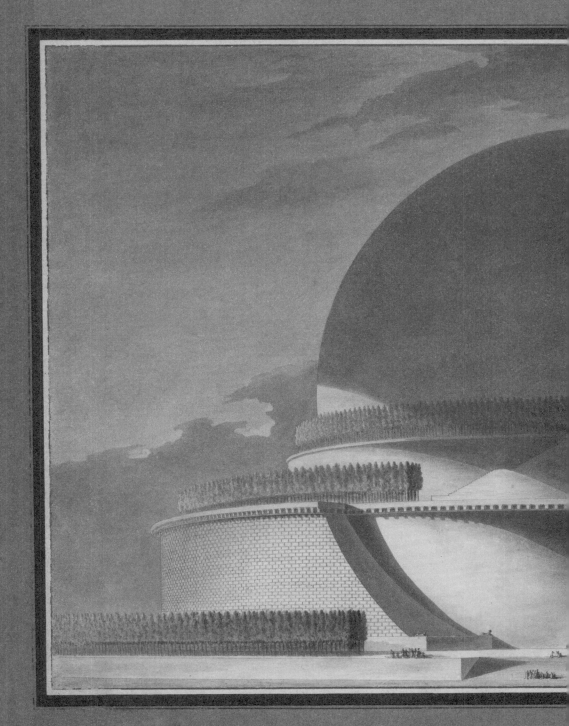

A

Étienne-Louis Boullée
Cenotaph to Newton

Ringed by rows of cypress trees and nearly eclipsed in shadow, Étienne-Louis Boullée's *Cénotaphe de Newton* (Cenotaph to Newton; 1784) rises above small figures rimmed in ink. Gathered as if in Socratic discussion, the figures occupy the brightest spot in the drawing, directly adjacent to its darkest—the abyss-like entry to the tomb. This microcosm, materializing only under close observation, is juxtaposed with the architecture's powerful reductive form, immediately discernible in its totality. The monument fills the frame, allowing no view of the environment beyond. Thus, the miniature human drama at the cenotaph's foothills provides both measure and argument for its fearsome sublimity.

"O Newton!" Boullée wrote in apostrophe to the late natural philosopher, "[Y]ou have defined the shape of the earth; I have conceived the idea of enveloping you with your discovery."[1] As Newton drew on geometry's inductive capacities to reveal laws of the physical world, Boullée proposed an analogous role for architecture. A building of elemental geometric volumes would arouse distinct sensations—of melancholy, of immensity—foregrounding sensory experience as the animating force behind the formation of ideas.

Undertaken during a period of debate concerning the indebtedness of French academic architecture to classical theory, Boullée's gigantic, unrealized project sought alignment with painting over the commercial constraints of building. Like his younger peer Claude-Nicolas Ledoux, Boullée was interested in the capability of a visionary architecture to project new social orders. His use of the sphere, a favored form of Enlightenment empiricists (and the shape of the exploratory hot-air balloons observed above Paris in 1783; see "Flight"), was designed "to paint with nature, i.e. to put nature to work."[2] Yet the crescent of light that splits the shadows has an uncanny stereometric precision. It points to the drawing's other paradoxes, from the altar's metaphysical evocations to the very ambition to compress a boundless universe within a finite structure.

Étienne-Louis Boullée (1728–1799), *Cénotaphe de Newton* (Cenotaph to Newton), 1784. Black ink and gray wash with hues of brown, 44 × 66 cm. Bibliothèque nationale de France, Département des Estampes et de la Photographie, RESERVE HA-57-BOITE FT 4, plate 6.

1. Étienne-Louis Boullée, "Architecture, Essay on Art," in *Boullée and Visionary Architecture*, ed. Helen Rosenau (London: Academy Editions, 1976), 107.

2. Ibid.

Phoebe Springstubb

TIME

Elizabeth M. Rudy and
Tamar Mayer

The present is pregnant with the future.
—Gottfried Wilhelm Freiherr von Leibniz (1770)[1]

Making sense of the contemporary moment—measuring its hours, days, and weeks and assessing the significance of unfolding events—requires looking back at the past and forward into the future simultaneously. Artists in the Enlightenment era grappled with this challenge in their depictions of political change, shaping a notion of historical time for current and future generations. They also imagined the consequences of these contemporary events, constructing visions of possible futures that aligned with ideologies seeking to explain and rationalize the present as part of a larger system of occurrences.[2] These projected futures were neither consistently positive nor negative; rather, there coexisted a wide range of ideas about what realities the new century might trigger for European societies. Alongside the corrective, utopian visions today often considered emblematic of the Enlightenment were horrific, dystopian predictions about the dawning era.

Past, present, and future collided visually and conceptually in the well-established literary genre of almanacs, short texts that were printed in the tens of thousands.[3] Practical guides to an unfolding present, almanacs were written and released ahead of the timeframe they covered and predicted meteorological patterns and events for the coming year. They were issued in different formats, the most common of which was the handheld booklet, and the information contained within was primarily astronomical, detailing the movements of the planets, sun, and moon in dense tables for each month of the year. This offered the reader an accurate method of telling time as well as crucial guidance for agricultural planning. The data was also interspersed with miscellany, such as anecdotes, maxims, stagecoach schedules, and the dates of holidays. A common feature of seventeenth-century almanacs that persisted well into the eighteenth century was a graphic known as the Man of Signs, or Anatomy, a diagram of a person—typically a nude male—surrounded by the signs of the zodiac. Asserting that astrological forces affect specific parts of the body, the Man of Signs suggested opportune times for scheduling medical treatments.[4] Additional imagery, such as illustrated title pages and scattered prints, began to appear in almanacs in the last third of the eighteenth century.

Almanacs were specific to their sites of production, differing based on local conditions and the discretion of regional printers, but they were unanimously devoted to usefulness and diversion. Nathanael Low, author of a popular almanac printed in Boston, boldly claimed in 1785, "[N]o book we read (except the Bible) is so much valued, and so serviceable to the community."[5] Indeed, almanacs were among the first printed material produced by European colonists in the Atlantic world, providing vital information for compatriots who were navigating climates and landscapes they had never experienced before.[6] Each November, when a new almanac was issued by the Worshipful Company of Stationers in London, which held the monopoly on almanac production in England, readers celebrated a highly anticipated event known as Almanac Day.[7]

Inexpensive and easily portable, almanacs were a resource for the semi-literate and literate alike, regardless of financial position.[8] Toward the end of the eighteenth

Calender Narr.
Manie d'almanacs

Fig. 1
Daniel Nikolaus Chodowiecki
(1726–1801), *Calendar Fools; or, The
Mania for Almanacs*, from *Göttinger
Taschen-Calender vom Jahr 1783*
(Göttingen Pocket Calendar for
the Year 1783), by Johann Christian
Dietrich (Göttingen: 1782). Etching,
8.1 × 4.9 cm.

century, however, the genre changed significantly with the emergence of new variants, such as the German *Taschen-Calender*, or pocket calendar, which contained lengthy texts and full-page illustrations and was marketed to an elite audience.[9] This diversification coincided with an increasingly vociferous critique of almanacs as inefficient and impractical, a sentiment encapsulated in Daniel Chodowiecki's etching *Calendar Fools; or, The Mania for Almanacs* (Fig. 1). The print was made for and ultimately included in a pocket calendar for 1783, thus operating as a self-reflexive joke on the consumer: a group of people huddled in the foreground consult the small volume, while one of their party gestures to the clocks and calendars hanging on the wall, rebuking his associates for trusting a less utilitarian method of measuring time.[10]

In spite of this derision, the almanac and its offshoots played a critical role in shaping public opinion about events in the Atlantic world.[11] The moralizing commentaries included in some of these reference guides, such as the calendars put out by the German publisher Georg Christoph Lichtenberg, created a didactic context for the images contained in the booklets.[12] Chodowiecki regularly produced prints for Lichtenberg's calendars, including the 1783 issue in which *Calendar Fools* appeared. Among his more serious and consequential series is a suite titled *Begebenheiten der*

Elizabeth M. Rudy and Tamar Mayer

Fig. 2
Daniel Nikolaus Chodowiecki
(1726–1801), *The Revolt of the Slaves in
Saint Domingo against the French*, from
*Göttinger Taschen-Calender für das Jahr
1793* (Göttingen Pocket Calendar for
the Year 1793), by Johann Christian
Dietrich (Göttingen: 1792). Etching,
sheet: 9.5 × 5.8 cm. Philadelphia
Museum of Art, The Muriel and
Philip Berman Gift, acquired from
the John S. Phillips bequest of 1876
to the Pennsylvania Academy of the
Fine Arts, with funds contributed
by Muriel and Philip Berman, gifts
(by exchange) of Lisa Norris Elkins,
Bryant W. Langston, Samuel S.
White 3rd and Vera White, with
additional funds contributed
by John Howard McFadden, Jr.,
Thomas Skelton Harrison, and the
Philip H. and A.S.W. Rosenbach
Foundation, 1985, 1985-52-33689.

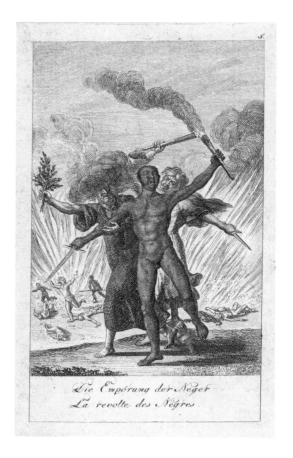

Die Empörung der Neger
La revolte des Nègres

neueren Zeitgeschichte (Incidents of Modern, Contemporary History). Printed in 1792 for the 1793 calendar, the works depict six world events from 1791: a royal wedding, two international peace treaties, and three changes in governance—in Poland, France, and the French colony of Saint-Domingue, modern-day Haiti (Fig. 2).[13] Lichtenberg's own prefatory text qualifies some as "joyful" occurrences and others as "the most dreadful forms of punishment."[14]

Political change in this period was swift, however, and the fortunes of all three regions had turned dramatically by the time the prints reached their audience. Catherine the Great had invaded Poland and suppressed the new Polish constitution; the French monarchy was toppled and readers would learn of regicide in Paris before the end of January 1793; and the uprisings in Saint-Domingue grew more frequent and diversified, with protestors seizing and burning the commercial city of Cap Français (present-day Cap-Haïtien) in the summer of 1793.[15] Absent from the prints are inscriptions specifying the timing of these events, and yet they are interspersed in the bound booklet with calendars for the months of 1793, thus collapsing past and present into one.

Chodowiecki's portrayal of events in Saint-Domingue reinforced a notion that had been crystallizing across Europe: that revolution in the colony was not about gaining society-wide independence from colonial rule, but solely about ending slavery on the island.[16] He underscored this idea by emphasizing the violence and

Fig. 3
Daniel Nikolaus Chodowiecki
(1726–1801), *New Year's Wish for
Germany*, from *Genealogisher Kalendar
auf des 1780. Jahr* (Genealogical
Calendar for the Year 1780), by J. G.
Bereberg (Lauenburg: 1779). Stipple
and line engraving, 10.2 × 6.3 cm.
Cooper Hewitt, Smithsonian Design
Museum, Gift of Eleanor and Sarah
Hewitt, 1921-22-355.

using allegory only selectively. A nude Black man strides forth, clasping a torch and dagger and flanked by the personifications of Cruelty ◉ and Despair.[17] Stepping on a dead child, Cruelty lights the man's torch, while Despair guides him by the arm. The figure's direct confrontation with the viewer and his exuberant pose are features that Chodowiecki employed in other prints, often to express extreme emotions. Consider the depiction of a spirit harboring divine peace, a print that appeared in German and French editions of a pocket calendar for the year 1780 (Fig. 3).[18] This personification of a spirit in direct communion with the divine is apostrophized in the caption, in which the author appeals to him to bring good tidings to Germany in the new year. In the pose of a spirit, the enslaved man from Saint-Domingue likewise embodies hope for a better future. Yet his lack of wings and the presence of Cruelty and Despair mean that any aspirational metaphor that might be intended is neither explicit nor guaranteed, thus allowing for the reader's misapprehension.

CRUELTY

The explanatory text accompanying the print, ascribed to Lichtenberg, likens the violence of the scene to that of the French Revolution ("a Parisian scene on Santo Domingo"[19]), but the manifold complexities of the nascent revolution in Saint-Domingue and its contextualization within the philosophical framework of political freedom are absent from Chodowiecki's scene. Its focus on the uprisings of enslaved people in the northern provinces helped occlude the connection between Enlightenment thought and the early origins of the Haitian Revolution, whose first

Elizabeth M. Rudy and Tamar Mayer

Fig. 4
James Gillray (1757–1815), published by Hannah Humphrey (c. 1745–1818), *Presages of the Millennium*, 1795. Etching and aquatint, hand-colored, sheet: 33 × 37.6 cm. Yale Center for British Art, New Haven, Conn., Paul Mellon Collection, B1981.25.916.

Presages of the MILLENIUM; — with The Destruction of the Faithful, as Revealed to R:Brothers the Prophet, & attested by M.B.Hallhead Esq.
"And e'er the Last Days began, I looked, & behold, a White Horse, & his Name who sat upon it was Death; & Hell followed after him; & Power was given unto him to kill with the Sword, & with Famine, & with Death; And I saw under him, the Souls of the Multitude, those who were destroy'd for maintaing the word of Truth, & for the Testimony —"

calls for political independence were made in 1790 by the Colonial Assembly that governed Saint-Domingue.[20]

As the next century dawned, the future implications of global turmoil seized the popular imagination. Self-proclaimed prophets such as Richard Brothers declared the world to be on the brink of apocalypse, which would herald a utopian period of one thousand years (the millennium) made possible by the return of Jesus Christ to Earth. This assertion was part of a worldview called millenarianism, whose origins can be traced to religious sects from the seventeenth century.[21] Brothers's popularity crested in 1795 with the reprinting of his prophetic pamphlets in two volumes, titled *The World's Doom*, which coincided with a swell of new adherents frustrated with the financial hardships wrought by war with France and the rise of his most powerful devotee, Nathaniel Brassey Halhed, an elected member of British parliament who publicly endorsed Brothers's prophesies and cited them in speeches to the House of Commons.[22]

James Gillray mocks both Brothers and Halhed in his *Presages of the Millennium* (Fig. 4), specifically ridiculing their shared belief that the French Revolution was foretold in two passages from the Bible—namely, the Book of Revelation—and had triggered an apocalypse.[23] Adopting the tone and cadence of Brothers's writings, the caption explicates the dystopian vision above: "And e'er the Last Days began, I looked, & behold, a White Horse, & his Name who sat upon it is Death; and Hell followed after him; & Power was given unto him to kill with the Sword, & with Famine, & with Death; And I saw under him the Souls of the Multitude, those who were destroy'd for maintaining the word of Truth, & for the Testimony."[24] Brothers

also predicted a coup in London that would overthrow King George III on his official birthday—June 4, 1795, the date that Gillray's print was published (it is inscribed below the image, at left). Also on that date, royal authorities seized Brothers for treason; he was convicted and locked in an asylum.

Alongside almanacs and prophetic views of contemporary upheaval, late eighteenth-century artists such as Jean-François Janinet and Alexandre-Evariste Fragonard produced depictions of the ancient past ◉ that simultaneously communicated the optimistic futures promised by the French Revolution. Avoiding the risk of anachronism inherent to the almanacs' portrayal of events in a fast-changing political world, these artists turned to ancient history, shaping it as a solid mold cast with new meaning. Unlike the popular, utilitarian almanacs, their timeless views of the past were produced for the fine art market and Salon audiences.

On the eve of the French Revolution, in 1789, Janinet created *The Virtue of Lucretia*, one of eight prints depicting ancient themes after designs by his contemporary, sculptor Jean-Guillaume Moitte (Fig. 5).[25] The tragic death of the noblewoman Lucretia precipitated ancient Rome's transition from a monarchy to a republic—a story with much political resonance in France in 1789.[26] According to Livy (*Roman History* 1.57–58), the episode was instigated by an argument among the royal princes and Lucretia's husband, Collatinus, about who had the most virtuous wife. To settle their debate, the men decided to surprise the women at night to see what sorts of activities they engaged in when left unattended. The composition captures the moment when the king's son, Sextus Tarquinius, and two companions (at right) burst into Lucretia's home and are surprised to find her spinning wool. Startled by her virtue and purity and overcome with desire, Tarquinius later returns to rape her. The assault and Lucretia's subsequent suicide (the discovery of her death is the subject of another print in the series) spurred a group of Roman noblemen, led by Brutus, to overthrow the last king of Rome, establishing a republic in the monarchy's stead. Moitte's depiction of the theme was meant to serve as a model for contemporary Frenchmen in the volatile political atmosphere of 1789.

In Janinet's series, modern righteousness takes after ancient examples, and prosperity is tied to scientific advancement and the trade in luxury goods.

Fig. 5
Jean-François Janinet (1752–1814), after Jean-Guillaume Moitte (1746–1810), *The Virtue of Lucretia*, 1789. Etching and roulette, sheet: 32 × 59.6 cm. Harvard Art Museums/ Fogg Museum, Acquisition Fund for Prints, 2015.123. (Detail on p. 229.)

Elizabeth M. Rudy and Tamar Mayer

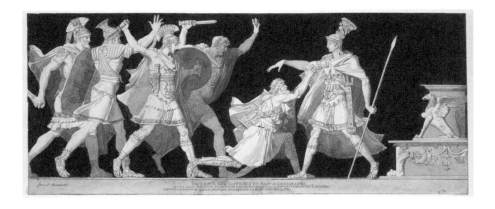

Celebrating classical authority, the artist produced in *The Virtue of Lucretia* an image that proclaims mastery of artistic progress. His neoclassical style, with utmost clarity and austere linearity, embodies the same values of morality and virtue represented in Lucretia's story. His *fond noir* (black background) engravings are also inspired by Etruscan vases and by the Fourth Style of Pompeian mural painting.[27] The predominant frieze-like structure of these works reflects the influence of another painting of a related subject, *The Lictors Returning to Brutus the Bodies of His Sons* (1789), by Moitte's friend and protector, Jacques-Louis David.[28]

The technique with which Janinet produced the striking contrasts between light and dark in this image was both innovative and complex. The print (like others by Janinet) has been described as containing passages made with aquatint,[29] yet recent analysis in Harvard's Straus Center for Conservation and Technical Studies shows that many of the areas that look like aquatint were actually created with extensive use of roulette.[30] Well-known for his inventive combination of various engraving techniques, here Janinet preferred the substantially more laborious, multilayered roulette approach, despite the fact that very few people would be able to discern the two techniques when looking at the finished print.[31] Roulette is a more physical practice; it involves greater contact with the plate and allows for better control of the overall process.[32] This desire for control, particularly in service of a result not immediately visible in the final product, is in line with the spirit of the era, which celebrated technical mastery, moral authority, and restraint (think, for example, of the values professed by David's *Oath of the Horatii*).

Responding to the demands of the art market, *The Virtue of Lucretia* bears a decorative printed frame that signals its status as a luxury object and invites its hanging on the wall. Much like Salon history painting at the time, the structure of the work anticipates its spectatorship 👁, thus enhancing its authority and public import. The print demonstrates how ancient examples, portrayed using unconventional techniques, were mobilized to promote the circulation of images within a shifting market, one in which luxury artworks were increasingly owned by greater publics. Its subject matter, taken from Roman history, together with its prominently neoclassical style, inventive engraving techniques, and decorative framing, constructs an important picture of what a desirable future looked like on the eve of the French Revolution.

PUBLIC

Fond noir continued to inspire artists after the Revolution, as seen in a drawing by Alexandre-Evariste Fragonard, son of painter Jean-Honoré Fragonard. The younger Fragonard's *Centurion Begging for Protection from Mark Antony during a Seditious Revolt* presents a different approach to the antique relief (Fig. 6).[33] The image depicts Mark Antony, the ancient Roman general who served under Julius Caesar, governing during an uprising. A talented officer, Antony is described by Plutarch as daring, sagacious, kind, highly respected, and admired by his soldiers.[34] He is likewise portrayed here as an exemplary figure, a powerful yet gracious leader. The work differs from other frieze-like compositions by Fragonard, where the artist replicated sculpted bas-reliefs by creating brighter backgrounds that resemble walls from which the figures project.[35] In the current drawing, the bright background was replaced with an extremely dark one, made with two layers of wash. The intense darkness forms a sense of depth, so that the figures moving across the frieze appear more pictorial than sculptural.[36] Fragonard's careful drawing in ink and wash, which may have been created in preparation for a print, results in a highly contrasted image of light and dark, with a dynamic flow of movement. Looking back at ancient models of heroism and virtue, Fragonard joins Janinet in drawing on Roman antiquity to reimagine modern French society.

For both Janinet and Fragonard, the opaque dark ground becomes the foundation upon which decorative, frieze-like representations of decisive moments from ancient history are presented. The grisaille non-color technique turns the past into metaphor for the present. It generalizes and universalizes the ancient story, making it timeless and therefore effective as inspiration for present-day France. In both of the works illustrated here, the source material is immortalized in the opposition of black and white and, at the same time, given life through the fluidity of moving figures. The result is yet another powerful view of the past activated to envision future promise.

In this essay, Elizabeth Rudy authored the sections on almanacs and millenarianism; Tamar Mayer authored the section on depictions of the ancient past. The authors are grateful to David Bindman, who read an earlier version of the essay and provided critical feedback on its arguments, to Kristel Smentek for her valuable comments, and to Eynat Koren and Daisy Matthewman for their help collecting reference materials.

1. "Le tems [*sic*] présent est gros de l'avenir." This Leibniz quote is inscribed on the title page of Louis-Sébastien Mercier's novel *L'An 2440: Rêve s'il en fût jamais* (Paris: 1771).

2. On the emergence of ideology at the dawn of the nineteenth century, see "Temps," in *Dictionnaire critique de l'utopie au temps des Lumières*, ed. Bronisław Baczko, Michel Porret, and François Rosset (Chêne-Bourg: Georg éditeur, 2006), 1304–6.

3. For a concise overview of almanacs from the fifteenth to the eighteenth century, see Marion Barber Stowell, *Early American Almanacs: The Colonial Weekday Bible* (New York: Burt Franklin & Co., 1977), 3–12.

4. Thomas A. Horrocks, *Popular Print and Popular Medicine: Almanacs and Health Advice in Early America* (Amherst: University of Massachusetts Press, 2008), 18–19.

5. Nathanael Low, "On Almanacks," in *An Astronomical Diary; or, Almanack for the Year of Christian Æra 1786* (Boston: T. & J. Fleet, 1785), n.p.; cited in Milton Drake, *Almanacs of the United States*, vol. 1 (New York: Scarecrow Press, 1962), viii.

6. The first almanac printed in colonial America was published by Harvard College in 1639. See Bruce Stanley Burdick, *Mathematical Works Printed in the Americas, 1554–1700* (Baltimore: Johns Hopkins University Press, 2009), 186–87; and Hugh Amory and David D. Hall, *A History of the Book in America* (Chapel Hill: University of North Carolina Press, 2009).

Elizabeth M. Rudy and Tamar Mayer

7. Maureen Perkins, *Visions of the Future: Almanacs, Time, and Cultural Change, 1775-1870* (Oxford: Clarendon Press, 1996), 13-14.

8. Horrocks, *Popular Print and Popular Medicine*, 5-6.

9. On *Taschenbücher*, see John Ittmann, ed., *The Enchanted World of German Romantic Prints, 1770-1850* (Philadelphia: Philadelphia Museum of Art, 2017), 198-207.

10. The print was one in a series of twelve parodies in Johann Christian Dietrich's *Göttinger Taschen-Calender vom Jahr 1783* (Göttingen: 1782).

11. See Robert Darnton, ed., *Revolution in Print: The Press in France, 1770-1800* (Berkeley: University of California Press, 1989), 203-22; and Jeremy D. Popkin, "A Colonial Media Revolution: The Press in Saint-Domingue, 1789-1793," *The Americas* 75 (1) (January 2018): 3-25.

12. On this moralizing turn in the genre, see Jochen Mecke, ed., *Medien der Literatur: Vom Almanach zur Hyperfiction* (Bielefeld: Transcript, 2011), 37; on Lichtenberg, see Anne-Marie Link, "The Social Practice of Taste in Late 18th-Century Germany: A Case Study," *Oxford Art Journal* 15 (2) (1992): 3-14.

13. *The Marriage of Frederick Duke of York and Princess Frederike of Prussia, The New Polish Constitution, The Peace between Austria and Turkey, The Children of France Threaten Their Mother, The Slave Revolt,* and *The Peace between Russia and Turkey.*

14. Georg Christoph Lichtenberg, "Kurze Erflärung der Monaths-kupfer," in *Goettinger Taschen Calender für das Jahr 1793*, by Johann Christian Dietrich (Göttingen: 1792), 197. Thanks to Gabriella Szalay for the translation.

15. For an analysis of the Polish print, see Ittmann, *The Enchanted World of German Romantic Prints*, 40-41. On the early phase of the revolution in Saint-Domingue and its perception abroad, see Jeremy D. Popkin, *A Concise History of the Haitian Revolution* (Malden, Mass.: Wiley-Blackwell, 2012), 35-61.

16. On European responses to the Haitian Revolution and the historiography of this period since the nineteenth century, see David Patrick Geggus, "Print Culture and the Haitian Revolution: The Written and the Spoken Word," *Proceedings of the American Antiquarian Society* 116 (2) (October 2006): 299-316; and David Patrick Geggus, *Haitian Revolutionary Studies* (Bloomington: Indiana University Press, 2002). The shift in European views of slavery in the last decades of the eighteenth century is critical to the responses to the early phase of the Haitian Revolution and to the reception of Chodowiecki's print: from the early hopes by some, such as Louis-Sébastien Mercier and the Abbé Raynal, for a Black Spartacus to lead avenging rebellions against colonial plantation owners, to the anxiety that abolition would precipitate a white European genocide. For an introduction to this shift, see Laure Marcel-lesi, "Louis-Sébastien Mercier: Prophet, Abolitionist, Colonial-ist," *Studies in Eighteenth-Century Culture* 40 (2011): 247-73.

17. Chodowiecki's depictions of these figures, identified in the text that accompanies the print in the pocket calendar, correlate with one of the most popular source books for iconography at the time, J. B. Boudard's *Iconologie*, 2 vols. (Vienna: Jean-Thomas de Trattnern, 1766). The attributes and appear-ance of Cruelty align closely with Boudard (see 1:138), as do the attributes of Despair, but not the sex of the latter (1:148).

18. J. G. Berenberg, *Genealogischer Kalender auf des 1780. Jahr* (Lauenburg: 1779).

19. "Eine Pariser Scene auf St. Domingo." Dietrich, *Göttinger Taschen-Calender vom Jahr 1783*, 200.

20. See Geggus, *Haitian Revolutionary Studies*, 9-14.

21. J. F. C. Harrison, *The Second Coming: Popular Millenarianism, 1780-1850* (New Brunswick, N.J.: Rutgers University Press, 1979), 6.

22. For an overview of Brothers's life and notoriety, see ibid., 57-85.

23. Richard Godfrey, *James Gillray: The Art of Caricature* (London: Tate Gallery Publishing, 2001), 140.

24. For a detailed explanation of the scene, see Mary Dorothy George, *Catalogue of Political and Personal Satires in the British Museum*, vol. 7 (London: British Museum, 1942), 179-80.

25. For the full list of prints, see Marcel Roux, *Inventaire du fonds français, graveurs du dix-huitième siècle*, vol. 12 (Paris: M. Le Garrec, 1930), nos. 150-57, pp. 63-66.

26. As paintings based on ancient history (by artists like Joseph-Benoît Suvée, Jean-François Pierre Peyron, François-André Vincent, and most prominently, Jacques-Louis David) were becoming more prevalent, Moitte chose an earlier scene, one that precedes Lucretia's more frequently depicted rape and suicide. See Richard J. Campbell, "Jean-Guillaume Moitte: The Sculpture and Graphic Art, 1785-1799," Ph.D. dissertation, Brown University, 1982, 205.

27. Victor I. Carlson and John W. Ittmann, *Regency to Empire: French Printmaking, 1715-1814* (Baltimore: Baltimore Museum of Art, 1984), 302-3. See also ibid., 200.

28. Carlson and Ittmann, *Regency to Empire*, 302-3. See also Gisela Gramaccini, *Jean-Guillaume Moitte (1746-1810): Leben und Werk*, vol. 1 (Berlin: Akademie Verlag, 1993), 70.

29. See the object records for editions in the Museum of Fine Arts, Boston, and the British Museum. See also Campbell, "Jean-Guillaume Moitte," 200. Aquatint—one of several print techniques developed around this time to replicate compositions rendered in chalk, wash, watercolor, or pastel—should be distinguished from the wash-manner prints made by professional printmakers in France, including Janinet, beginning in the 1770s. See Rena M. Hoisington, "Etching as a Vehicle for Innovation: Four Exceptional Painters-Graveurs," in *Artists and Amateurs: Etching in 18th-Century France*, ed. Perrin Stein (New York: Metropolitan Museum of Art, 2013), 82-84; and Rena M. Hoisington, *Aquatint: From Its Origins to Goya* (Washington, D.C.: National Gallery of Art, 2021).

30. This analysis was based on close study of the print as well as mock-ups re-creating Janinet's technique made by paper conservator Christina Taylor, in collaboration with Tamar Mayer. S. T. Prideaux describes Janinet's use of roulette as interfering with the transparency and charm of the aquatint, claiming that Philibert-Louis Debucourt outdid Janinet by maintaining the brilliance of aquatint without resorting to roulette. S. T. Prideaux, *Aquatint Engraving: A Chapter in the History of Book Illustration* (London: Duckworth & Co., 1909), 62. See also Emilia Francis Strong Dilke, *French Engravers and Draughtsmen of the XVIIIth Century* (London: G. Bell and Sons, 1902), 155. On the need to be cautious when applying Jean-Baptiste Le Prince's aquatint techniques to Janinet, see Carlson and Ittmann, *Regency to Empire*, 258n3. For more on the process of aquatint, see Claude Henri Watelet and Pierre Charles Levesque, *Encyclopédie méthodique: Beaux-Arts*, vol. 2 (Paris: Chez Panckoucke, 1788-91), 622-25; reprinted in Jules Hédou, *Jean Le Prince et son œuvre suivi de nombreux documents inédits* (Paris: J. Baur, 1879), 179-88.

31. Philippe de Carbonnières, *Les gravures historiques de Janinet: Collection du musée Carnavalet* (Paris: Paris musées, 2011), 11.

32. See Margaret Morgan Grasselli, with essays by Ivan E. Phillips, Kristel Smentek, and Judith C. Walsh, *Colorful Impressions: The Printmaking Revolution in Eighteenth-Century France* (Washington, D.C.: National Gallery of Art, 2003), 30-31.

33. Mark Brady, *Old Master Drawings* (New York: W. M. Brady & Co., 1999), no. 25.

34. Plutarch, *Lives*, vol. 9, trans. Bernadotte Perrin, Loeb Classical Library (Cambridge, Mass.: Harvard University Press, 1920), 145, 176-79, 238-39. See also Eleanor Goltz Huzar, *Mark Antony: A Biography* (London: Croom Helm, 1978).

35. See, for example, *Two Women and a Youth before a Seated Philosopher* and *The Infant Pyrrhus at the Feet of Glaucias*, both at the Louvre.

36. Stephen Ongpin, *Watteau to Gauguin: A Selection of 18th and 19th Century French Drawings* (London: Stephen Ongpin Fine Art, 2018), no. 40.

Elizabeth M. Rudy and Tamar Mayer

UTOPIA

Tamar Mayer

Utopian ideas flourished in the Enlightenment and were formative to revolutionary politics, undergirded by philosophical theories of equality, liberty, and morality developed by British authors (Locke, Shaftesbury) and their French counterparts (Montesquieu, Diderot, Rousseau).[1] These ideas proliferated in works on paper featuring ancient examples of autonomy, dreams of a return to nature, fascination with scientific progress, and other hallmarks of a free and flourishing society. With the actualization of successive revolutions on the continent and in the colonies, dystopian effects became part of such visualizations as well. Prints were particularly appropriate for this fast-changing political climate, reaching greater audiences in little time 👁.[2] They helped level criticism at monarchical powers, disseminate visions of an ideal future, and comment on the violence bound up in achieving such aims.

The word utopia does not mean "an ideal place" (the Greek *eu-topia*), but rather "no place" (*ou-topia*). According to Louis Ruprecht, the Greeks "appear to have understood a 'utopian' place to be a place that did not exist anywhere, save in the writer's or mythographer's mind."[3] In Jean-Jacques Rousseau's writing, utopia represents ideals both desirable and unreachable. "[I]t was just as impossible to re-acquire virtue," Franco Venturi explains, "as it was to return to the state of nature."[4] Each of the works considered in this essay draws attention to that gap between what is fervently desired and what is truly attainable. The prints address contemporary politics, referencing the American, French, and Haitian Revolutions while exploring novel models of liberty through the dialectic of light and dark, optimism and pessimism. Each contains the tension between reality and fiction, political struggle and utopian myth.[5]

James Barry's *The Phoenix; or, The Resurrection of Freedom* from 1776 is a direct attack on the British government, its corruption and oppression.[6] Barry's utopian image is not rooted in nostalgia for a lost past, but in the belief that the Golden Age is still to come. He saw the American Revolution as a providential plan for future Anglo-American cooperation.[7] The image has undergone many revisions; in addition to a preparatory drawing, five different states exist.[8] The one pictured here is the second state, where Barry's use of aquatint diversifies the tonal spectrum of the scene (Fig. 1).

The *Phoenix* is an allegory of the death of Liberty in Britannia, shown lying on a bier, and Liberty's new home in America, represented by the round temple in the middle of the composition (marked "Libert. Americ."). In the left foreground, Father Time is shown honoring classical Athens, republican Rome, and Renaissance Florence by casting flowers on their ruins. At right, writers and supporters of the Commonwealth Algernon Sydney, John Milton, and Andrew Marvell, together with John Locke and Barry himself, all mourn the death of Liberty in Britannia. A chained figure in the foreground possibly represents political thinker Edmund Burke, who was a friend of Barry.[9] Peeking out from the back of his coat is the Habeas Corpus Act, a safeguard against unlawful imprisonment, alluding to the government's violations at the time. The print is rich with texts and inscriptions—they appear on the bier at right, the headstone at left, a scroll of paper lying below, and a strip of added text across the bottom of the image.[10]

Fig. 1
James Barry (1741–1806), *The Phoenix;
or, The Resurrection of Freedom*, 1776.
Engraving and aquatint, published
state, plate: 43.2 × 61.3 cm. Yale
Center for British Art, New Haven,
Conn., Paul Mellon Collection,
B1977.14.11067.

The juxtaposition of dark pessimism in England and sunlit optimism in America turns the latter into a future paradise in which public art can thrive again.[11] These contrasts were intensified as Barry moved from preparatory drawing to print.[12] He used aquatint, an intaglio printmaking technique for creating tonal effects that had only recently been introduced in England. Yet Barry did not use it only in areas that needed shading; he reveled in the possibilities this new medium allowed.[13] He employed it in a freer and more ornate way, adding splashes of tone to the base of the print and over the area of writing, thus interweaving the added strip of text with the carefully designed image above.

In the early 1790s, Barry reworked the plate, eliminating aquatint in favor of more conventional modes of etching and engraving.[14] In his darker, more linear version of the scene, he sacrificed the painterly qualities of wash to achieve a gloomier mood—perhaps, as Michael Phillips suggests, a reflection of Barry's response to the deteriorating political situation in Britain.[15] The print is unsigned; in the political climate of the time, the very advantage of printmaking—the freer circulation of images at relatively low cost—became a threat to artists who preferred to approach public confrontation of the authorities more cautiously, and who therefore chose to remain anonymous.[16] It is in the turn toward increasing darkness—from drawing, to aquatint, to engraving—that Barry's utopia changes its moral tone. The present seems grimmer, as does Barry's earlier freedom of execution.

The Oracle, created by John Dixon in 1774, is a contemporaneous British response to the American Revolution. Father Time once again frames the composition, holding a magic lantern that projects onto the pictorial background. Dixon's print (like Barry's) stresses visualization by placing in the foreground figures who, with their backs to the viewer, look into the depth of the pictorial field toward a well-lit vision of the American Revolution, its triumphs as well as conflicts. Here, too,

variations made to the original version reveal changing perceptions of the political developments in colonial America.

Dixon's original mezzotint depicts a hopeful view of Great Britain: the triumph of Concord over Discord.[17] Britannia, armed with shield and spear, sits between Hibernia and Scotia. The figures are all dressed in classical draperies, Hibernia's harp is beside her, and the lantern sits atop a globe with a paper inscribed *Unite*. Across the way, in the dark, America sits on goods representing trade in the colonies. Within the projected image, Concord, with a crown, a bow, and a star on her breast, is chasing Discord away; alongside her are Plenty, Liberty, Truth, and Justice.[18] The scene presents an ideal portrait of a united Britain in the face of threatening disunity.

In a fascinating example of the reception and reappropriation of prints in the period, an unidentified artist chose to alter Dixon's print to convey a very different message (Fig. 2). Using gouache paint, the artist re-created the projection at back to represent Britain's destruction. Within this new vision, now titled *The Tea-Tax-Tempest (The Oracle)*, a violent struggle results in Britain lying defeated, her crown dropped to the ground. The menacing snake at lower right in the original was replaced with three fighting leopards, expressing anxiety about the outcome of the present conflict.

In 1778, four years after Dixon's original print and well into the American Revolution, German artist Carl Gottlieb Guttenberg created a satirical reversal of the original scene.[19] Instead of future unity, the magic lantern now projects an image of an exploding teapot, causing fright among British troops as the

Continental Army progresses. The caption below Guttenberg's engraving describes the explosion as a thunderstorm caused by the conditions imposed on tea in the colonies. In 1783, an anonymous artist further revised Guttenberg's image, adding text to explain the scene:

> There you see the little Hot Spit Fire Tea pot that has done all the Mischief—There you see the Old British Lion basking before the American Bon Fire whilst the French Cock is blowing up a storm about his Ears to Destroy him and his young Welpes—There you See Miss America grasping at the Cap of Liberty—There you see The British Forces be yok'd and be cramp'd flying before the Congress Men—There you see the thirteen Stripes and Rattle-Snake exalted—There you see the Stamp'd Paper help to make the Pot Boil—There you See &c &c &c.

Nine years separate Dixon's original print from the one published in London after the war in the colonies was lost, marking a shift in the conception of liberty within British political discourse. Similar to Barry's print, here it is no longer Britannia but America that possesses true freedom.[20]

European responses to the American Revolution were, however, extremely diverse. As Britain recognized U.S. independence in 1783 and the success of the American Revolution was assured, German painter and printmaker Daniel Chodowiecki created a series of twelve etchings bound in a historical-genealogical calendar of world events ◉. These etchings depict varying relationships between order, disorder, and violence. Instead of allegories of liberty, the miniature etchings focus on a number of significant historical moments: the signing of the Declaration of Independence, Benjamin Franklin at the French court, and in the print shown here (the third in the series), the first bloodshed in the name of American freedom (Fig. 3).

The image, made ten years after the event it represents, shows British soldiers firing on a disorderly group of Massachusetts militiamen, clouds of smoke rising between them.[21] Another decade later, Chodowiecki created the *Göttinger Taschen-Calender für das Jahr 1793* (Göttingen Pocket Calendar for the Year 1793), depicting events that took place during the Haitian Revolution the year prior.[22] The work illustrated in this volume (see p. 232) portrays the furious revolt of enslaved people against French colonial rule on the island of Saint-Domingue. Extremely small in scale, the scene is filled with smoke, fire, violence, and chaos. The view is far from sympathetic to the Haitian cause at this early stage of the insurrection. That same year, Chodowiecki criticized the French Revolution in a letter to Countess Solms, in which he expressed dismay that such atrocities and nonsense would come from an educated nation like France.[23] It is unsurprising, then, that his portrayal of the Haitian Revolution is dystopian in nature, emphasizing brutality and destruction as a means of pursuing political change.

Tamar Mayer

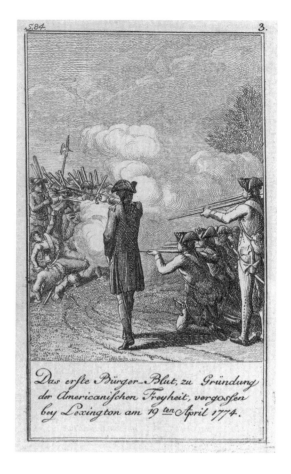

Another dark image of the Haitian Revolution is Jean-Baptiste Chapuy's ominous *Vue de l'incendie de la ville du Cap Français, arrivée le 21 juin 1793* (View of the Burning of the City of Cap Français on June 21, 1793) from 1794 (see p. 288). Chapuy created this colored engraving after a painting by J. L. Boquet of the destruction of Cap Français, set ablaze in the midst of massacre and looting. Clouds of thick smoke billow upward in the darkness of night. Reflections of fire shimmer on the black water and on the sailboats in the foreground of this important coastal town. Minuscule figures in the water cry for rescue as the world around them comes to an end. A volcanic fury of revolt permeates the image, representing a violent struggle for freedom. Emancipation, in this case, can seemingly be achieved only via complete destruction.

Indeed, in French thought, such as Louis-Sébastien Mercier's utopian writing, progress occurs through collapse. Mercier's 1771 novel *L'An 2440* (The Year 2440) is set in Paris in the far future. The protagonist falls asleep during the ancien régime and wakes up in the year 2440 to a society that has been transformed—and much improved—after its downfall. In this future version of a peaceful, secular, and egalitarian France, luxury has been banned, slavery abolished, and everyone is equal in the eyes of the law. The antithesis of the ancien régime, the social order of this idealized France reconciles personal happiness and collective well-being. The devastation

of Paris appears as a form of catharsis: "terrible but necessary to cleanse the metropolis of the excesses of both riches and poverty."[24]

Utopia in Revolutionary France meant, on the one hand, occupying a place that has never been seen before and, on the other, building on ancient precedents so that they might one day be surpassed.[25] While pastoral agrarian society was generally upheld as a Revolutionary ideal, dissonant French thinkers, including Mercier, conceived of utopia as an "endless, dynamic change in science and technology."[26] The vision of a "perfect" past helped foment dissatisfaction with the imperfect present of the French state, yet it was the example of the American Revolution, seen through the perspective of technological advancement and infinite progress, that gave hope for radical reform in the *present*.[27] Utopian imagination was related to the exploration and discovery of a new world. "'America,' as both an idea and in reality, was in alliance with the great hopeful forces of the age," Melvin Lasky writes. "[V]ery early on, some kind of American Revolution became part of the utopian dream."[28]

Richly diverse in their use of media (drawing, etching, engraving, aquatint, mezzotint, and more), the works discussed here reach across time and place to envision pathways to utopia and the constructive and destructive forces necessary to get there. The everlasting gap between ideal and reality, imagination and political practice, is captured in the many differences between those who envision and that which is being envisioned, between order and chaos, ruin and potential rehabilitation. Hopes raised by the American Revolution are viewed side by side with fears triggered by the French and Haitian Revolutions and by the changing politics of eighteenth-century Britain. Together, these ingenious revisions of light and dark articulate the various conceptualizations of utopia and dystopia in Enlightenment thought.

I wish to thank Elizabeth Rudy and Kristel Smentek for their valuable comments on this essay. I would also like to thank my current and former research assistants, Daisy Matthewman and Eynat Koren, for their help collecting reference materials.

1. For a comprehensive collection of essays on fifty-four main themes in utopian thought during the Enlightenment, see Bronisław Baczko, ed., *Dictionnaire critique de l'utopie au temps des Lumières* (Geneva: Georg Editeur, 2016). On the influence of British models of freedom on French thinkers, see Franco Venturi, *Utopia and Reform in the Enlightenment* (Cambridge: Cambridge University Press, 1971), ch. 3.

2. See Elizabeth M. Rudy, "On the Market: Selling Etchings in 18th-Century France," in *Artists and Amateurs: Etching in 18th-Century France*, ed. Perrin Stein (New York: Metropolitan Museum of Art, 2013), 40–67.

3. Louis A. Ruprecht, Jr., "Religion, Classical Utopias, and the French Revolution: The Strange Career of a Revolutionary Classicist in the Strange Course of a French Revolution," *Soundings* 97 (4) (2014): 407–8.

4. Venturi, *Utopia and Reform in the Enlightenment*, 77.

5. On the relationship between utopia and revolution, see Melvin Jonah Lasky, *Utopia & Revolution: On the Origins of a Metaphor* (New Brunswick, N.J.: Transaction Publishers, 1976), esp. 352. See also Pierre Serna, "Révolution," and Jean-Clément Martin, "Révolution Française," both in Baczko, *Dictionnaire critique de l'utopie au temps des Lumières*, 1093–1135.

6. See William L. Pressly, *The Life and Art of James Barry* (New Haven, Conn.: Published for the Paul Mellon Centre for Studies in British Art by Yale University Press, 1981), 77–78.

7. Daniel R. Guernsey, *The Artist and the State, 1777–1855* (Burlington, Vt.: Ashgate, 2007), 26.

Tamar Mayer

8. This is according to detailed research conducted by Nicholas Stogdon. I am grateful to him for sharing his observations with me.

9. The inscription *U & C fecit* (U and C made this) may refer to Ulysses (Burke) and Companion (Barry), as depicted in another painting by Barry. William L. Pressly, *James Barry: The Artist as Hero* (London: Tate Gallery, 1983), 75. See also Tom Dunne, "Painting and Patriotism," in *James Barry, 1741–1806: "The Great Historical Painter,"* ed. Tom Dunne (Kinsale: Gandon Editions for the Crawford Art Gallery, 2005), 121.

10. The inscription below the image reads: *O Liberty though Parent of whatever is truly amiable & Illustrious, associated with virtue, thou hastest the Luxurious & Intemperate & hast successively abandon'd thy lov'd residence of Greece, Italy & thy more favor'd England when they grew Currupt & Worthless, thou hast given them over to chains & despondency & taken thy flight to a new people of manners simple & untainted.* See Pressly, *James Barry*, 73.

11. See Guernsey, *The Artist and the State*, 46–48.

12. Victoria and Albert Museum, London, D.152-1890.

13. Barry used the "sugar-life" process developed by Paul Sandby a few years prior, which allowed the artist to draw directly with a brush onto copper, layering tone in a similar way to the use of wash. See Michael Phillips, "James Barry: Artist-Printmaker," in Dunne, *James Barry*, 143.

14. See *The Phoenix; or, The Resurrection of Freedom*, by James Barry, in the Snite Museum of Art at the University of Notre Dame (2015.002.001).

15. Phillips, "James Barry," 144.

16. The name that appears on the print is that of publisher John Almon, an active member of the political opposition. See Pressly, *James Barry*, 74.

17. See *The Oracle*, by John Dixon, in the Metropolitan Museum of Art, New York (67.797.45[b]).

18. M. Dorothy George, *Catalogue of Political and Personal Satires Preserved in the Department of Prints and Drawings in the British Museum*, vol. 5 (London: British Museum, 1935), no. 5225, p. 164.

19. See *The Tea-Tax Tempest, or the Anglo-American Revolution*, by Carl Gottfried Guttenberg, in the Philadelphia Museum of Art (1985-52-18861).

20. See *The Tea-Tax-Tempest, or Old Time with His Magick Lanthern*, in the Metropolitan Museum of Art, New York (83.2.2094). On the changing symbolism of liberty in British political prints portraying the American Revolution, see Amelia F. Rauser, "Death or Liberty: British Political Struggle for Symbols in the American Revolution," *Oxford Art Journal* 21 (2) (1988): 153–71.

21. See Donald H. Cresswell, with a foreword by Sinclair H. Hitchings, *The American Revolution in Drawings and Prints: A Checklist of 1765–1790 Graphics in the Library of Congress* (Washington, D.C.: Library of Congress, 1975), no. 251, pp. 81–83.

22. See Jeremy D. Popkin, *Facing Racial Revolution: Eyewitness Accounts of the Haitian Insurrection* (Chicago: University of Chicago Press, 2010).

23. See Peter Maerker, *Bürgerliches Leben im 18. Jahrhundert: Daniel Chodowiecki 1726–1801* (Frankfurt: Städel, 1978), 141–42.

24. Simon Schama, *Citizens: A Chronicle of the French Revolution* (New York: Knopf, 1989), 198; quoted in Riikka Forsström, *Possible Worlds: The Idea of Happiness in the Utopian Vision of Louis-Sébastien Mercier* (Helsinki: Suomalaisen Kirjallisuuden Seura, 2002), 257. (Forsström discusses pessimism and destruction in Mercier's writing more generally at 253–65.)

25. Ruprecht, "Religion, Classical Utopias, and the French Revolution," 414.

26. Fritzie Prigohzy Manuel and Frank Edward Manuel, *Utopian Thought in the Western World* (Cambridge, Mass.: Harvard University Press, 2009), 20.

27. America was admired by late eighteenth-century French philosophers as a "living utopia." See Forsström, *Possible Worlds*, 112; Louis-Sébastien Mercier, *Notions claires sur les gouvernemens*, vol. 2 (Amsterdam: 1787); and Harold T. Parker, *The Cult of Antiquity and the French Revolutionaries: A Study in the Development of the Revolutionary Spirit* (New York: Octagon Books, 1965), 70.

28. Lasky, *Utopia & Revolution*, 350. Utopian American reform was also imagined through ancient history. On resemblance and difference in conceptualizations of antiquity in the New World, see Marc André Bernier, "Amerique," in Baczko, *Dictionnaire critique de l'utopie au temps des Lumières*, 29–51.

John Russell
Lunar Planisphere, Hypothetical Oblique Light

London. Published by W^m Faden, Nov^r 26. 1806.

Plate N.º 2.

Like the Enlightenment itself, this impressively detailed engraving resists easy definition. It hovers somewhere between work of art, scientific document, religious expression, and personal passion. John Russell was both a portrait pastelist and an amateur astronomer. Spending over two decades studying the moon, he captured more accurate, detailed, and beautiful renderings of its surface than had previously existed. We may consider lunar study a secular, astronomical activity, but for this zealous Methodist artist, the moon was God's creation. Natural philosophy, a broad and somewhat fluid category that included scientific investigation, was often deeply connected to religious belief during this time.[1] Many scientists, including Isaac Newton, considered empiricism and religion not only harmonious but inextricably intertwined. Such reasoning persisted in and pervaded Russell's work.

Assisted by his second youngest daughter, Anne, Russell made nearly two hundred drawings of the moon that he kept for private use.[2] The drawings informed this engraving and its companion, *Lunar Planisphere, Flat Light*. The planispheres—maps of celestial bodies visible in whole or in part—were composites of the moon's surface, intimately studied via telescope. Though precisely measured, the engravings straddle truth and beauty, as their light and shadow were improved to maximize visual pleasure and legibility. In 1806, this print and *Lunar Planisphere, Flat Light* were published posthumously by Russell's brother-in-law, William Faden, but the artist's pastel portraits were far more commercially successful. Russell received no lasting scientific fame, in part because astronomers were interested in more remote celestial bodies and phenomena.

John Russell (1745–1806), *Lunar Planisphere, Hypothetical Oblique Light*, 1806. Stipple and line engraving, sheet (trimmed inside plate): 43.2 × 41.6 cm. Yale Center for British Art, New Haven, Conn., Paul Mellon Fund, B2016.39.2.

Thanks to George Cozens for his research assistance.

1. See Antje Matthews, "John Russell (1745–1806) and the Impact of Evangelicalism and Natural Theology on Artistic Practice," Ph.D. dissertation, University of Leicester, 2005.

2. Many are housed at the Museum of the History of Science in Oxford.

Heather N. Linton

VENUS

Kristel Smentek

In 1760, in the midst of the Seven Years' War (1756–63), French astronomer Joseph-Nicolas Delisle dispatched two hundred copies of a printed, hand-colored world map "of extraordinary precision" to colleagues across Europe (Fig. 1).[1] The map was an invitation to astronomers from friendly and enemy nations alike to transcend their differences and join together to record an exceptionally rare celestial occurrence: the transit of the planet Venus across the sun.

Delisle's map attests to the capacity of the printed image to bring together and consolidate facts gathered by scientists dispersed across Europe and its colonies.[2] The effort to track Venus's passage required coordinated international collaboration and travel on a scale previously unimagined. The expeditions that resulted generated several illustrated books for non-specialist audiences, exemplifying an Enlightenment ambition to make knowledge public ◉. These volumes, which brought little-known parts of the world into vivid view, show how surveying the heavens contributed to period understandings of human history and of societies here on earth.

Transits of Venus occur at intervals of more than a hundred years; when they do occur, as they did in 1761 and 1769, they happen in pairs, the second falling eight years after the first. For eighteenth-century astronomers, the opportunity to observe the transits was not to be missed. In 1716, Edmond Halley (for whom the comet is named) reasoned that if multiple observers at different points on Earth timed Venus's entry and exit from the solar disk, that information could be used to calculate the distance between our planet and the sun. With this calculation in hand, the dimensions of the solar system, "the 'final' problem of astronomy," could be resolved.[3] Delisle updated Halley's propositions, plotting on his map the ideal regions around the globe for observing each stage of the transit in 1761 as well as his calculations of the precise timing of the event at those sites. Colors applied by hand to the map further clarified the visibility of the transit. The complete passage could be viewed in regions marked red; in blue areas, only the entry of Venus could be observed; and in those colored yellow, only the exit. In uncolored regions, the passage would not

Fig. 1
Joseph-Nicolas Delisle (1688–1768), *Mappemonde on which are marked the correct hours and minutes of the entry and exit of Venus across the disk of the sun [...] on 6 June 1761*, c. 1761. Engraving with hand-coloring, 29 × 46.6 cm. Bibliothèque nationale de France, Département Arsenal, EST-1500 (19).

be seen at all.[4] There was urgency in Delisle's appeal; the next pair of transits would not occur until 1874 and 1882.

The aim to record the transits had far-reaching consequences not only for astronomy, but also for the colonial and commercial interests with which Enlightenment science was intertwined. Delisle's plan became a reality, in part, because of preexisting European trading posts and settlements located within the zones of visibility outlined on his world map; in turn, the project generated further European claims on distant territories. The 1769 transit was, famously, the official impetus for the first of James Cook's voyages to the South Pacific, the illustrated accounts of which indelibly shaped European imaginings of the region and its inhabitants and paved the way for its colonization ◉. Cook's more covert mission in 1769 was to seek out land and opportunities in the South Pacific, which he did with the guidance of Tupaia, the priest and star navigator from Ra'iātea who joined the captain's expedition in Tahiti.

Motivated by the desire to advance astronomical knowledge and enhance national prestige, European navigators and astronomers from across the continent and its colonies set out to record the transits of 1761 and 1769. Guided by Delisle's map, Harvard professor John Winthrop traveled to St. Johns, in British-controlled Newfoundland, to time Venus's exit in 1761.[5] French astronomer Jean-Baptiste Chappe d'Auteroche observed the first transit at Tobolsk, in Siberia, and the 1769 transit in Baja California. (He published a detailed illustrated account of his Siberian sojourn in 1768.[6]) Poor visibility and unexpected optical phenomena marred the viewing for some. In 1769, in Tahiti, the separate observations of Cook, botanist Daniel Solander, and astronomer Charles Green were complicated by the "black drop effect," a dark haze that obscured the edges of Venus and made their individual measurements of its passage inconsistent.[7] The hazards of war upended the plans of others. From England, Charles Mason and Jeremiah Dixon (who subsequently surveyed the Mason-Dixon line in colonial America) set sail in 1760 for Bencoolen, a British post in Sumatra, only to be attacked in the English Channel by a French warship. In the end, they witnessed the transit from the Cape of Good Hope, Bencoolen having fallen to the French. The least fortunate of the observers, however, was Guillaume Le Gentil de la Galaisière, an accomplished astronomer and member of the French Royal Academy of Sciences, who traveled to Pondicherry, a French trading post on the Coromandel Coast of India, for the 1761 transit, only to be turned away at the last minute because the settlement had been taken by the British. Le Gentil returned to Pondicherry (under French control again by 1763) well in advance of the 1769 transit, but on the day of Venus's passage, clouds obscured his view.

As the Cook publications demonstrate, the transit voyages generated knowledge well beyond the astronomical, occasioning books that combined scientific observations with the kinds of written descriptions and visual depictions of local customs and beliefs typical of early modern travelogues. Among the least familiar of these publications today is Le Gentil's illustrated *Voyage dans les mers de l'Inde* (Voyage to the Indian Ocean), published in Paris in two volumes, in 1779 and 1781, in which the astronomer recounts the eleven years he spent traveling between Madagascar,

Kristel Smentek

the Mascarenes, the Philippines, and India in the interim between the two transits. Le Gentil recorded astronomical, meteorological, and geographical information as well as reports of the practices and belief systems of the places he visited.[8] The first volume, discussed here, is dedicated to his twenty-three-month residency in Pondicherry before the second transit.

Le Gentil brought the rigor and precision of observational astronomy to his accounts of Pondicherry and its inhabitants. He wrote that "an accurate traveler should see everything for himself," and the illustrations produced for his book, as well as the claims he made about them, convey his ambition to represent himself as a trustworthy eyewitness.[9] Complementing his extended discussion of the history of Indian astronomy and his descriptions of architecture, festivals, processions, and clothing are thirteen printed images, including a detailed map of Pondicherry and its environs based on Le Gentil's own surveys, and two views of a gopura, or gate tower, at the nearby temple of Vilnour, which he and his assistants measured when it was temporarily abandoned.[10] The comet Le Gentil observed from Pondicherry in 1769 is also represented, as are twenty-four of the twenty-seven constellations of the Indian lunar zodiac—also called lunar mansions, or Nakshatras—whose configuration he was able to verify, their bright white stars emerging from an inky night sky of densely crisscrossing engraved lines (Fig. 2).

Le Gentil's sequence of plates opens with three prints of Hindu deities quite unlike any seen in European publications to date. The images, of Brahma (Fig. 3), Brahma and Sarasvati, and Viratapurusha, the last identified only as a "singular divinity of the heathens," were based on some of the thirty paintings on paper by Indian artists given and explained to Le Gentil by Tamil interpreters Maridas Pillai and Maleapa, the latter of whom Le Gentil referred to as "his teacher."[11] Le Gentil's printmaker, Pierre Claude de La Gardette, made no effort to adapt the South Indian images to European conventions of representation. He added no crosshatching or shading to impart volume. He did not "correct" postures or proportions, nor did he introduce landscape elements or other indicators of perspectival recession into depth. Instead, La Gardette carefully outlined forms and details of costume and expression in the same manner as the Indian artist whose work he copied, and he adhered to the highly codified aesthetics and iconography of Hindu imagery—with one probable exception.[12] Brahma is not usually depicted with his decapitated fifth head and toppled crown as he is in La Gardette's print, where they appear on the ground; the head is more commonly an attribute of the deity Shiva, who removed it. With its hooked nose, heavy-lidded drooping eye, and tonsure-like hair, La Gardette's severed head diverges from the aesthetic of the Indian models he otherwise followed, suggesting that Le Gentil requested its design from the printmaker to better illustrate the discussion of Brahma in his text.

The images that Le Gentil selected for reproduction visually confirm his most controversial claim: that India may well have been the cradle of human civilization, a nation to whom the ancient Egyptians, the Greeks, and possibly even the Chinese ANTIQUITIES were indebted ⊙. Part of his evidence was astronomical. What he was able to learn, via his Tamil interlocutors, of the computational skill and accuracy of Indian astronomers not only impressed Le Gentil but convinced him of the region's priority

Fig. 2

Pierre Claude de La Gardette (1743–1780), after an unidentified Indian artist, *The 27 Constellations or Placements of the Moon, Counted in the 12 Signs According to the Brahmins*, from *Voyage dans les mers de l'Inde* (Voyage to the Indian Ocean), by Guillaume Joseph Hyacinthe Jean Baptiste Le Gentil de la Galaisière, vol. I (Paris: 1779–81). Engraving, sheet: 27 × 20 cm. New York Public Library, General Research Division, 3-OPX (Legentil de La Galaisiere, G. J. H. J. B. Voyage dans les mers de l'Inde).

in astronomical knowledge: Indian astronomers were accurately calculating solar and lunar eclipses well before Europeans could. Le Gentil also speculated that India was the source of ancient Chinese astronomical learning.[13] His other evidence was visual. Conditioned to interpret the impressive gopura depicted in his book as a pyramid, which is how he refers to it, Le Gentil nevertheless reversed contemporary European understandings of the origins of the Egyptian structures: "Let us cease to admire the pyramids as much as we do or let us at least admire both the works of the Indians and those of the Egyptians. It seems to me that the Indians are the originators and that the Egyptians merely imitated them. If we in Europe have talked so much about the Egyptian pyramids, it is because Egypt is at our doorstep and India is so far away."[14] Basing his conjectures on the paintings of deities that he received, Le Gentil also boldly seconded English author John Zephaniah Holwell's claims that the ancient Greeks and Romans modeled their gods after those of India.[15]

If Le Gentil's images and text decentered European conventions, they simultaneously reinforced Eurocentric conceptions of scientific and aesthetic progress. His book thus exemplifies the deep ambivalence that subtended eighteenth-century Europe's expanding global consciousness. The gods depicted in Le Gentil's paintings were, he wrote, "very well drawn but in the Indian taste."[16] They were appreciated, but primarily as information, and reproduced by La Gardette to keep their documentary value intact. By implication, Indian artists were akin to the Indian astronomers whom Le Gentil described as operating by rote and unable (or unwilling) to fully explain their methods. This "forgetting" was a consequential charge, as rational method was the foundation of eighteenth-century European science.[17] Similarly, Le Gentil claimed that Indian artists and worshippers alike had long since forgotten the meanings of the allegories represented by their deities. Like the gopuras, the paintings he owned were, in his view, the product of an unchanging society, one whose practices had continued unbroken from "time

Kristel Smentek

Fig. 3

Fig. 3
Pierre Claude de La Gardette
(1743–1780), after an unidentified
Indian artist, *Brahma, First of the
Principal Gods of the Gentiles*, from
Voyage dans les mers de l'Inde (Voyage
to the Indian Ocean), by Guillaume
Joseph Hyacinthe Jean Baptiste Le
Gentil de la Galaisière, vol. 1 (Paris:
1779–81). Etching and engraving,
sheet: 27 × 20 cm. Bibliothèque
nationale de France, Département
Philosophie, histoire, sciences de
l'homme, 4-O2K-85 (1). (Detail
on p. 253.)

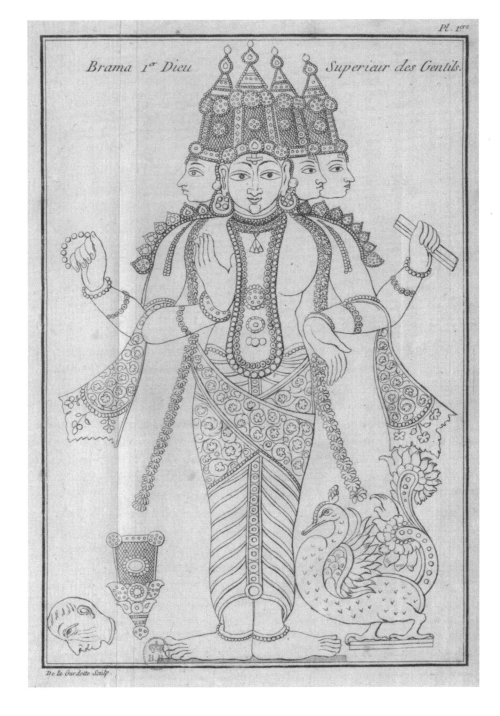

Brama 1ᵉʳ Dieu *Superieur des Gentils.*

immemorial."[18] There was, Le Gentil wrote, little progress in the arts of India; this belief made it possible for him to use contemporary South Indian images, astronomical knowledge, and architecture as reliable evidence of an immobile ancient India—and a dynamic modern Europe.

1. "Astronomie," *L'Avant Coureur* 19 (May 1760): 297. For Delisle's distribution list, see Harry Woolf, *The Transits of Venus: A Study of Eighteenth-Century Science* (Princeton, N.J.: Princeton University Press, 1959), 209–11. Delisle's map was also available for purchase by interested buyers.

2. Bruno Latour, "Drawing Things Together," in *Representation in Scientific Practice*, ed. Michael Lynch and Steve Woolgar (Cambridge, Mass.: MIT Press, 1990), 19–68.

3. Woolf, *The Transits of Venus*, vii. For a fast-paced account of the eighteenth-century transits, see Andrea Wulf, *Chasing Venus: The Race to Measure the Heavens* (New York: Alfred A. Knopf, 2012).

4. Delisle's successor, Jérôme de Lalande, distributed a similar map to the scientific community before the transit in 1769.

5. Sarah J. Schechner, "Transits of Venus," in *Tangible Things: Making History through Objects*, ed. Laurel Thatcher Ulrich et al. (Oxford: Oxford University Press, 2015), 179–86; and James E. McClellan, *Science Reorganized: Scientific Societies in the Eighteenth Century* (New York: Columbia University Press, 1985), 211.

6. Jean-Baptiste Chappe d'Auteroche, *Voyage en Sibérie fait par ordre du roi en 1761*, ed. Michel Mervaud, 2 vols. (Oxford: Voltaire Foundation, 2004).

7. Drawings of this effect were published in Charles Green and James Cook, "Observations Made, by Appointment of the Royal Society, at King George's Island in the South Sea," *Philosophical Transactions of the Royal Society* 61 (1771): 397–421.

8. Guillaume Joseph Hyacinthe Jean Baptiste Le Gentil de la Galaisière, *Voyage dans les mers de l'Inde*, 2 vols. (Paris: 1779–81). On Le Gentil's *Voyage* as a travelogue, see Dhruv Raina, "Le Gentil's *Voyage*: Addressing Disruptions in the Narrative of Scientific Progress," in *Variantology: On Deep Time Relations of Arts, Sciences, and Technologies*, Vol. 5: *Neapolitan Affairs*, ed. Siegfried Zielinski and Eckhard Fürlus (Cologne: Walter König, 2011), 385–97.

9. "Un voyageur exact doit tout voir par lui-même autant qu'il lui est possible." Le Gentil, *Voyage dans les mers de l'Inde*, 1:128.

10. Ibid., 1:573–78.

11. Ibid., 1:155–56, 204–5. Le Gentil variously refers to the images as illuminated prints or hand-colored drawings, but they were almost certainly paintings on paper.

12. My warmest thanks to Liza Oliver for discussing these images with me.

13. Le Gentil, *Voyage dans les mers de l'Inde*, 1:214.

14. "Cessons tant d'admirer les pyramides d'Égypte, ou du moins partageons notre admiration entre les ouvrages des Indiens & ceux des Égyptiens; les Indiens me paroissoient originaux, & je pense que les Égyptiens n'ont travaillé qu'à leur imitation. Si on a tant parlé de leurs ouvrages en Europe, c'est que l'Égypte est à notre porte, que l'Inde est trop loin." Ibid., 1:113–14, 195, pls. 8–9. See also Partha Mitter, *Much Maligned Monsters: A History of European Reactions to Indian Art* (Oxford: Clarendon Press, 1977), 113–15, 120; and Liza Oliver, *Art, Trade, and Imperialism in Early Modern French India* (Amsterdam: Amsterdam University Press, 2019), 196–97.

15. Le Gentil, *Voyage dans les mers de l'Inde*, 1:204–5.

16. Ibid., 1:155–56.

17. On the trope of forgetting, see Dhruv Raina, "The European Construction of 'Hindu' Astronomy," in *Handbook of Hinduism in Europe*, Vol. 1: *Pan-European Developments*, ed. Knut A. Jacobsen and Ferdinando Sardella (Leiden: Brill, 2020), 123–51.

18. Le Gentil, *Voyage dans les mers de l'Inde*, 1:205, 113.

WAGER Thea Goldring

Like the illusionistic sheets of *The Bubbler's Medley, or a Sketch of the Times: Being Europe's Memorial for the Year 1720*, published by London printmaker and printseller Thomas Bowles II (see Fig. 1 for a later edition), the eighteenth-century economy was awash in paper: bills of exchange, stock shares, paper credit, bank bills. Buying into these markets meant wagering on whether such paper instruments would maintain their worth, grow in value, or drop in price. Throughout the century, prints and drawings, themselves paper objects, were employed to explore these new forms of value, confront anxieties about their contingency, and entertain viewers with representations of those on the losing end of such bets.

In 1720, the implosion of John Law's Mississippi Company in France and the British South Sea Company—joint-stock ventures whose share prices rose on a wave of speculation before collapsing dramatically—swept across Europe. From the flotsam of wrecked fortunes emerged a new paper market of prints commemorating the first international stock market crash. In 1721, Bowles published a series of prints related to the financial calamities, known respectively as the Mississippi and South Sea Bubbles.[1] Some of the works repurposed Dutch prints that satirized the bubbles, while others, such as the pair of *Bubbler's Medleys*, developed new imagery to visualize the South Sea Company's demise.

The South Sea Company (SSC) initially held a monopoly on the supply of enslaved Africans to Spain's American colonies, but soon became a mechanism to refinance the British crown's debt.[2] In 1718, the SSC was given the right to purchase privately held government debt from individuals using company shares. The higher the shares' trading price, the fewer shares the company had to offer in exchange for the annuities and the more it could sell for a profit on the open market. To this end, the directors inflated the stock price by offering increasingly tempting subscriptions, allowing buyers to purchase stock on credit, and lending the company's money to investors. In the fervent cycle of speculation that ensued, investors bought and sold paper shares whose nominal worth derived from the purchased government debt, but whose market value was propped up by numerous layers of credit.

While medley prints had previously delivered couched political satire and visual almanacs of a year's events, *The Bubbler's Medley* shown here takes the London stock market—its documents, people, and mechanisms—as its subject.[3] Bowles's print invites viewers to replay the act of speculating, to wager on their ability to make sense of the paper instruments swirling around them in the eddies of the South Sea.[4] It is composed of various paper objects—engravings, playing cards, printed songs, a calling card—each with a distinct visual and typographical style. Even the speech bubbles of figures in the vignettes have been transmuted into written sheets. However, closer inspection reveals this wealth of paper to be a crafted fiction.

The trompe l'oeil form manifests eighteenth-century anxieties about the new immaterial forms of wealth and the fictitious nature of credit.[5] Indeed, both credit and medley prints were deemed a *deceptio visûs* (deception of sight), a traditionally nautical phrase for an optical illusion. Elements such as the anamorphic image of a riderless horse and the motto beneath the title, *Si Populus vult Decipi Decipiatur* (If the people wish to be deceived, let them be deceived)—which could apply to either the print or an investment in South Sea stock—suggest that in a world of illusory

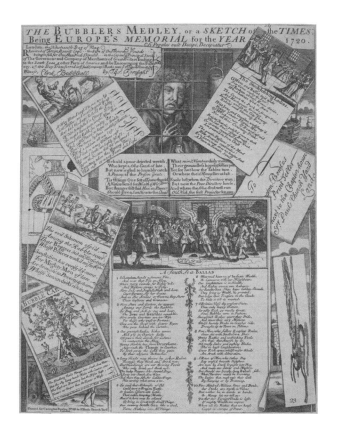

paper, those who do not look closely will be duped. But to perceptive viewers, these "scraps of paper," as the South Sea Ballad transcribed in the print's lower half might characterize them, reveal the truth about the market's rising tides: there is only more paper all the way down.

Just as it is possible to see through the print's illusion, so too could astute investors ride the wave of the South Sea Bubble and make off handsomely.[6] Indeed, the print documents a fictional act of successful speculation. In the upper left is a receipt dated May 19, 1720, notarized by "Clerk Bubbleall," which records that "Simon Nowitt Esq." purchased from "Thomas Foresight" a £100 SSC share for ten times that amount. As the seller's name suggests, Foresight sold the stock at a hefty profit before the market collapsed in August. Nowitt, on the other hand, did not see through the layers of paper inflating the bubble and bought in at the highest price; in a few months, his investment will be worthless.

The three signatures on the receipt point toward the importance of autographic gestures in the eighteenth-century paper economy. In this world, signatures were one of the main assurances of a document's value.[7] Amid the autographic marks that pervade *The Bubbler's Medley*, such as the calligraphic flourishes that tie off the lines of text, one script in particular stands out—the printer's calling card along the right edge. Thomas Bowles II's autograph, which his successor Carington Bowles replaced with his own in this later state, behaves both as an artist's signature, taking credit for the illusion, and as guarantor of the sheet for sale, certifying its worth in

Fig. 1
Published by Carington Bowles (1724–1793), after Thomas Bowles II (c. 1695–1767), *The Bubbler's Medley, or a Sketch of the Times: Being Europe's Memorial for the Year 1720*, c. 1762–84(?). Etching and engraving, image: 33.6 × 24.9 cm. The British Museum, London, 1867,0309.729.

Fig. 2
Roger Lorrain (active 18th century), *The Money Devil*, c. 1780. Ink and pen drawing on nine sheets of joined paper, 100 × 75 cm. Kress Collection of Business and Economics, Baker Library, Harvard Business School. (Detail on p. 261.)

the eighteenth-century print market. While the image invites viewers to wager on their ability to grasp the resonances between the medley and the speculative stock market, it also demonstrates that illusion—whether financial or visual—can still contain tangible value, in this case that of the print itself.

Calligraphic gestures take over the entire image of *The Money Devil*, forming the central figures from dense strokes, building up the ornamental frame, and doodling the outer vignettes (Fig. 2). Calligraphic drawings were made popular in France in the late 1770s by Jean-Joseph Bernard, also called Bernard de Paris, though the energetic messiness and subject of this drawing differ from Bernard's refined portraits and select caricatures.[8] The author of this drawing, Roger Lorrain—likely a pseudonym—remains largely a mystery.[9] The honorarium *maître écrivain*, or master scrivener, in the topmost vignette suggests that the artist was associated with the Bureau académique d'écriture, which grew out of the Parisian scrivener's guild and was restructured many times. In the eighteenth century, the corporation taught courses in grammar, penmanship, and financial accounting and, most importantly, held a monopoly on the identification and verification of handwriting in legal proceedings.[10] As more forms of commercial paper circulated in France, the bureau became increasingly critical to the economy as both producer of financial documents and arbiter of authenticity (and thus value).[11] As a scrivener, this drawing's author would have been intimately familiar with shifts and crises in this milieu.

Though the precise date of the drawing remains unknown, it is likely tied to the economic events of the 1780s.[12] While France's economy grew steadily throughout the eighteenth century thanks to the country's colonial outposts, mounting involvement in the slave trade, and participation in international commerce through the Compagnie des Indes, the French crown became increasingly mired in debt.[13] To assist with this crisis, Anne Robert Jacques Turgot, minister of finance, helped establish the Caisse d'escompte, or discount bank, in 1776—the first central bank since the financial institution John Law had erected atop the Mississippi Company collapsed in 1720.[14] Along with issuing stock and thereby raising capital, the Caisse offered bank bills payable to the bearer in exchange for private bills of exchange and government securities. Lending against its holdings, the bank infused the economy with new credit and liquidity. The Caisse grew steadily until the 1780s, when large loans to the French government in 1783 and 1787 and rampant speculation between 1785 and 1786 eroded confidence in the institution and its paper offerings.[15]

Faced with the rise of a new public bank, *The Money Devil* revives imagery from the 1720 crises to address the resurgence of paper financial instruments and associated anxieties. Much of this visual language came from *Het Groote Tafereel der Dwaasheid* (The Great Picture [or Scene] of Folly), a loose collection of Dutch prints, no two copies of which were identical, that circulated widely in Europe. This lineage may explain the drawing's Dutch character, evident in the central tumble of personages with exaggerated, nearly caricatural, features.[16] However, *The Money Devil* transforms and diverges from these models. The central figure sporting a large wig recalls earlier depictions of John Law; yet while Law and the Money Devil were formerly presented as accomplices, here Law stands upon him like a grotesque version of the archangel Michael. Part beast, part man, the financier has supplanted the

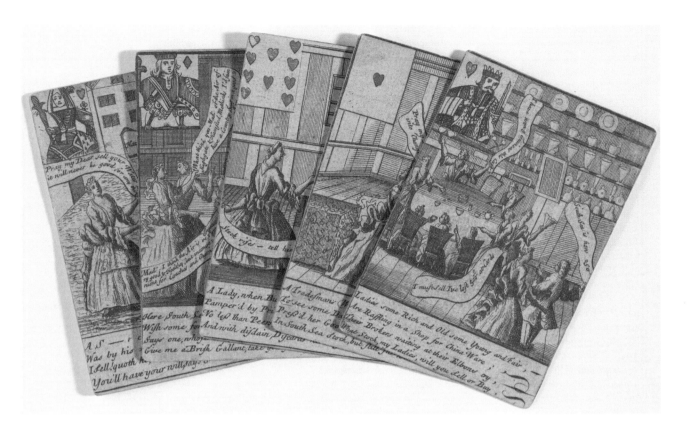

devil, taking his horn and his coin purse. Indeed, the establishment of the Caisse may have seemed like Law's triumphant resurrection. Furthermore, in contrast to the 1720 imagery that depicted stockjobbers as people of rank, this drawing returns to older versions of the Money Devil, which portray him corrupting tradespeople.[17] The largely working-class crowd is distracted by the falling coins and, like the beggar in the foreground, seems blind to the monster and the broader economic crisis awaiting them. Given that many master scriveners were later Revolutionaries, one might read the scene as a satirical critique of France's economic situation in the 1780s—the public, distracted by the market's liquidity, disregards for the moment the crown's dire financial straits. These troubles would soon spark the French Revolution, at which point the crowd assembled to retrieve not falling coins but falling heads ◉.

Like the autographic gestures that guarantee *The Bubbler's Medley* and constitute *The Money Devil*, the signatures on eighteenth-century financial instruments marked bets in speculative markets. When these wagers failed, certain signatories were scapegoated. The collapse of the South Sea Bubble, for example, was attributed to women's participation in the market and generated anti-Semitic rhetoric, both of which are on display in Bowles's *Bubble Cards*, a satirical deck of playing cards (Fig. 3).[18] At the same time, the actual individuals upon whom both the South Sea speculation and French economy were built are rarely, if ever, depicted. The slave trade is conspicuously absent from representations of these economic events, lying latent beneath the paper economy like the ships hidden beneath the layers of *The Bubbler's Medley*.[19]

Fig. 3
Published by Carington Bowles (1724–1793), after Thomas Bowles II (c. 1695–1767), *South Sea Bubble Playing Cards* (10, Q, K, A of hearts and J of diamonds), 1721. Engravings with hand-coloring, each: 9.5 × 6.3 cm. Kress Collection of Business and Economics, Baker Library, Harvard Business School, 06054.62-1.

TIME

Thea Goldring

1. Bowles advertised the series through the spring of 1721; it included two original pairs— *The Bubbler's Medleys* and *The Bubbler's Mirrours*—and two copies of Dutch prints, as well as the *Bubble Cards* and later print *Robin's Flight*. The medleys were reprinted by the post-1762 incarnation of Bowles's firm, under Carington Bowles. See M. Dorothy George, *Catalogue of Political and Personal Satires Preserved in the Department of Prints and Drawings in the British Museum*, vol. 2 (London: The British Museum, 1873), 412–20; Mark Hallett, *The Spectacle of Difference: Graphic Satire in the Age of Hogarth* (New Haven, Conn.: Paul Mellon Centre for British Art, 1999), 58–64; David McNeil, "Collage and Social Theories: An Examination of Bowles's 'Medley' Prints of the 1720 South Sea Bubble," *Word & Image* 20 (4) (2004): 283–98; Maggie Cao, "Trompe L'oeil and Financial Risk in the Age of Paper," *Grey Room* 78 (Winter 2020): 6–33; and Thea Goldring, "The Greater Fool: Paper, Illusion, and Time in Representations of the South Sea Bubble," *Eighteenth-Century Studies* 54 (1) (2020): 58–59.

2. For a bibliography on the South Sea Company and Bubble, see Goldring, "The Greater Fool."

3. Mark Hallett, "The Medley Print in Early Eighteenth-Century London," *Art History* 20 (2) (1997): 214–37; and Peter Fuhring et al., *A Kingdom of Images, French Prints in the Age of Louis XIV, 1660-1715* (Los Angeles: Getty Research Institute, 2015), 290.

4. For a more expansive version of this argument, see Goldring, "The Greater Fool," 53–75.

5. Mary Poovey, *Genres of the Credit Economy: Mediating Value in Eighteenth- and Nineteenth-Century Britain* (Chicago: University of Chicago Press, 2008), 36–56, 57–86. For a discussion of the relationship between print and new forms of paper credit, as well as the parallels between print collecting and participating in this paper economy, see Nina L. Dubin, Meredith Martin, and Madeleine C. Viljoen, *Meltdown! Picturing the World's First Bubble Economy* (Belgium: Harvey Miller Publishers, 2020), 15–16, 139–43.

6. Peter Temin and Hans-Joachim Voth, "Riding the South Sea Bubble," *American Economic Review* 94 (5) (2004): 1654–68.

7. Natasha Glaisyer, "Calculating Credibility: Print Culture, Trust and Economic Figures in Early Eighteenth-Century England," *Economic History Review* 60 (4) (2007): 708.

8. Lucien Biot, ed., *Bernard: Portraitiste en Trait de Plume* (Metz: Musée de Lunéville, 1966).

9. Bookseller Henry G. Bohn's catalogue lists thirteen drawings by Roger, Le Maître-Ecrivain devenu Dessinateur, describing them as "a Series of singular and very spirited Pen and Ink Drawings by a writing master" and dating them to 1780. Henry George Bohn, *A Catalog of Books* (London: AMS Press, 1841), 140.

10. The statutes of the Académie royale d'écriture were written in 1727; it opened in 1762. In 1779, Louis XVI converted the Académie into the Bureau académique d'écriture. See J. M. Wells, "The Bureau Académique d'Écriture: A Footnote to the History of French Calligraphy," *The Papers of the Bibliographical Society of America* 51 (3) (1957): 203–13; and Christine Métayer, "De L'école au Palais de Justice: L'Itinéraire Singulier des Maîtres Écrivains de Paris (XVIe–XVIIIe siècles)," *Annales ESC* 45 (5) (1990): 1217–38.

11. Amalia D. Kessler, *A Revolution in Commerce: The Parisian Merchant Court and the Rise of Commercial Society in Eighteenth-Century France* (New Haven, Conn.: Yale University Press, 2007), 219.

12. Technical analysis by Christopher Sokolowski at Harvard's Weissman Preservation Center found that the drawing is composed of nine sheets of paper, all of which contain the same watermark design, an armorial type with rampant lions on either side of a shield and sword, topped by a crown, the monogram "BL," or both. The "BL" countermark is typical of the Blum family of papermakers, who operated in Basel, Baden, and Alsace in the seventeenth and eighteenth centuries, though no exact paper mill has been identified and the herald does not match any known paper mill in Basel. The Blum family produced paper until around 1780.

13. Silvia Marzagalli, "Economic and Demographic Developments," in *The Oxford Handbook of the French Revolution*, ed. David Andress (Oxford: Oxford University Press, 2013), 9–16.

14. Lynn Hunt, "The Global Financial Origins of 1789," in *The French Revolution in Global Perspective*, ed. Suzanne Desan, Lynn Hunt, and William Max Nelson (Ithaca, N.Y.: Cornell University Press, 2013), 32–34.

15. Ibid., 39–42.

16. Frans De Bruyn, "Reading *Het groote tafereel der dwaasheid*: An Emblem Book of the Folly of Speculation in the Bubble Year 1720," *Eighteenth-Century Life* 24 (2) (2000): 1–42; and Dubin, Martin, and Viljoen, *Meltdown!*

17. Maurice de Meyer, "Le Diable d'Argent Evolution du Thème du XVIe au XIX siècle," *Arts et traditions populaires* 3 (4) (1967): 283–90.

18. Catherine Ingrassia, "The Pleasure of Business and the Business of Pleasure: Gender, Credit, and the South Sea Bubble," *Studies in Eighteenth-Century Culture* 24 (1995): 205–6; and Francesca Trivellato, *The Promise and Peril of Credit: What a Forgotten Legend about Jews and Finance Tells Us about the Making of European Commercial Society* (Princeton, N.J.: Princeton University Press, 2019).

19. For an account of the French slave trade and a bibliography on this subject, see Hunt, "The Global Financial Origins of 1789," 35–37.

Thea Goldring

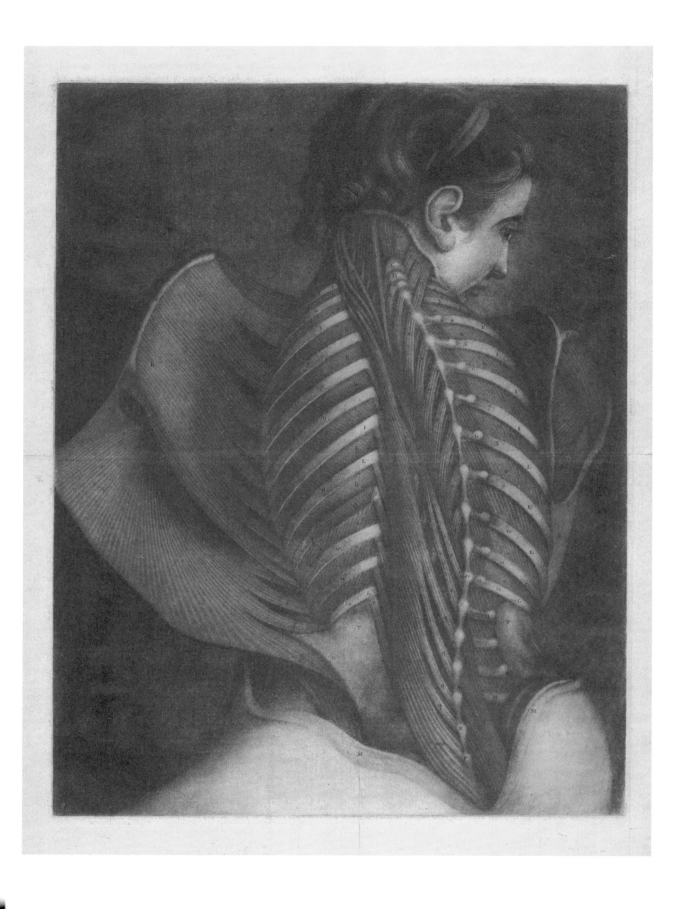

Fig. 1
Detail of impression in lower
left corner

Fig. 2
Ink fingerprints on verso

Jacques-Fabien Gautier d'Agoty
Muscles of the Back

To achieve the full color spectrum seen in *Muscles of the Back*, Jacques-Fabien Gautier d'Agoty printed four mezzotint plates in succession, each with a different color: first black (for the text), then blue, yellow, and red. The color mezzotint technique depends on the perfect alignment, or registration, of each plate, so that the final work reads as one continuous color image. Although Gautier claimed some of this process as his own invention, the techniques that he used were previously employed by artist Jacob Christoph Le Blon.[1] Early in his career, Gautier worked in Le Blon's studio, learning many of the older artist's methods. Indeed, a close study of *Muscles of the Back* reveals two clues that point to Le Blon's influence on Gautier.

The first is a small, round impression in the lower left corner of the image, a trace of the process with which Gautier prepared his plates (Fig. 1). To ensure precise alignment of the four copperplates, it is crucial that they are the same exact size. Le Blon achieved this by stacking the plates together, drilling a hole through each of the corners, and securing the stack in place with rivets. He then filed down the plates to equal size before preparing the image on each. The impression seen in *Muscles of the Back* is a result of the holes drilled in the lower left corners of the plates; this tells us that Gautier utilized Le Blon's specific plate preparation process.

The second clue is the fingerprints on the back of the print, where faint red ink was smudged and collected around the corner of the platemark (Fig. 2). To align the plates' printed images during production, Gautier would feel for the corners of the copperplate through the back of the paper, making sure that the position of the plate matched up with the impression left by the previous plate.[2] If his fingers were inky from printing, they would leave smudges on the back of the paper at the corners of the platemark. Instances of such fingerprints on earlier Le Blon prints indicate that this was another registration technique that Gautier learned from the older artist.

While these signs point to the influence of Le Blon, the perfect registration achieved in the final work attests to Gautier's own skill as a printer and artist. *Muscles of the Back* is an astonishing and disturbing example of Gautier's interest in producing full-color anatomical prints for medical illustrations. In this depiction of a woman calmly posing with her back flayed open, he employed artistic license to stunning effect, successfully blending scientific observation with pure imagination.

Jacques-Fabien Gautier d'Agoty (1710–1781), *Muscles of the Back*, Plate 14 from *Myologie complette en couleur et grandeur naturelle* (Complete Scientific Study of Muscles in Color and Life-Size), by Joseph Guichard Duverney (Paris: Gautier, 1746). Color mezzotint, sheet: 76 × 53 cm. Philadelphia Museum of Art, Purchased with the SmithKline Beckman Corporation Fund, 1968, 1968-25-79n.

I am grateful to Ad Stijnman, Laura Larkin, and Thomas Primeau for their contributions to this analysis.

1. Ad Stijnman, *Jacob Christoff Le Blon and Trichromatic Printing*, vol. 1 (Ouderkerk aan den Ijssel: Sound & Vision Publishers, 2020), lv.

2. Ibid., lxiv–lxv.

Christina Taylor

XXX

Ewa Lajer-Burcharth

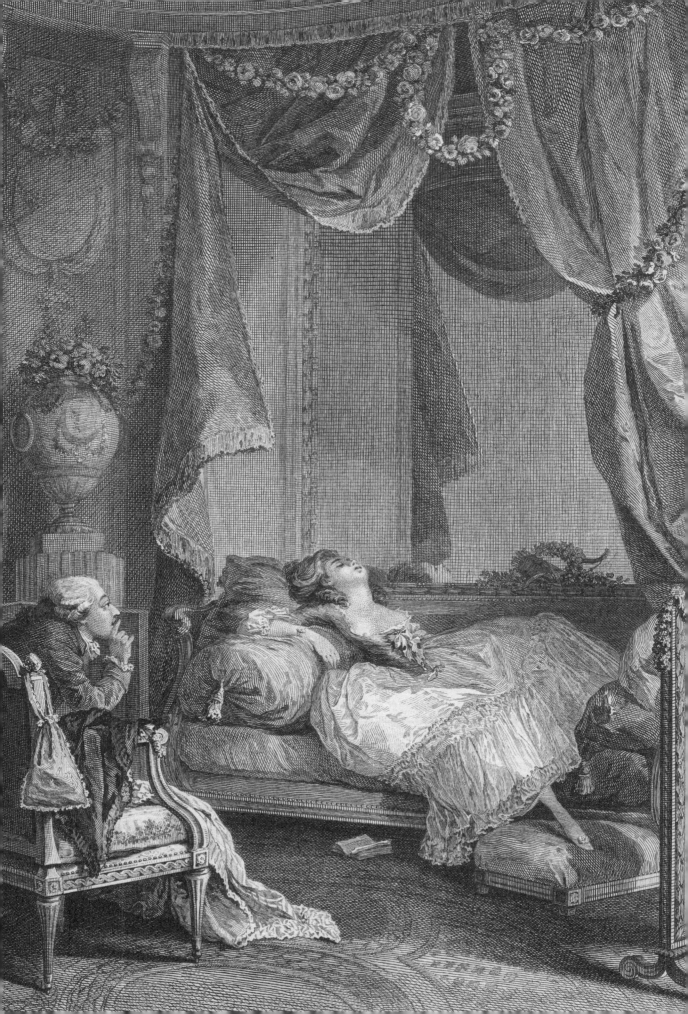

The Enlightenment inaugurated a modern understanding of sexuality by turning it into an object of knowledge and discourse.[1] Images played a fundamental role in this process, making visible what was previously invisible and revealing sex to be not only a basic human activity in need of reevaluation, but also a potential agent of change. Visual representations themselves could be transformative, helping to shake the prevailing system of physical, moral, and intellectual values and opening up new

possibilities to the imagination 👁. Whether and how they did so depended on their approach to the subject, their mode of dissemination, and their audience.

The circulation of and audience for erotic imagery were significantly expanded in France around the mid-eighteenth century. This was due to an outburst of illustrated publications that was fueled by, and in turn redefined, the cultural phenomenon of libertinism.[2] Originally designating an attitude of religious and political freethinking, the term *libertinage* acquired primarily sexual connotations in the eighteenth century, referring to a pursuit of pleasure unconstrained by religious, social, or moral conventions.[3] Sustained by the flourishing market for illustrated books, libertinism was transformed into a *visual* phenomenon, which contributed to its unprecedented cultural importance in this period.[4] Through ingeniously distributed publications—often combined with philosophical texts—libertine imagery helped spread Enlightenment ideas about sex in society at large.

Jean-Jacques Rousseau was among the first writers to recognize the importance of images as visual supplements to text and to exert authorial control over their use in his books. Even before completing his epistolary novel *Julie; ou, La nouvelle Héloïse* (Julie; or, The New Heloise), he started approaching potential illustrators for it.[5] "The plates alone will make the book successful," he explained to his publisher, penning short descriptions of what the illustrations should represent and how.[6] Engraver Hubert François Gravelot was ultimately charged with producing them.

Although Gravelot was an experienced illustrator, his plates for *Julie* did not entirely satisfy Rousseau.[7] The leadoff image may provide a hint as to why. *Love's First Kiss* portrays the first instance of intimate contact between the novel's heroine, Julie, and her tutor and lover-to-be, Saint-Preux (Fig. 1). The kiss is orchestrated by Julie's cousin, Claire, who invites Saint-Preux to give her a friendly smooch but swaps herself with the protagonist at the last moment. Taken by surprise, Saint-Preux is both elated and discombobulated: "Our burning lips breathed out fire with our sighs, and my heart was fainting under the weight of ecstasy," he writes to Julie afterward.[8]

Gravelot shows hardly any bodily contact, let alone a kiss. His competent but uninspired and even slightly awkward scene fails to convey the shattering physiological and emotional impact of the encounter on the lovers. Signaling his surprise with the conventional gesture of a raised hand, Saint-Preux bears no trace of the inner havoc he so vividly describes in the text. Julie, immobilized and statuesque, with only a hint of paleness on her face, seems similarly unaffected by what has just happened. Rousseau gave explicit instructions to depict her "in a state of languor, leaning, letting herself slip into her Cousin's arms . . . in an ecstasy," which Gravelot clearly

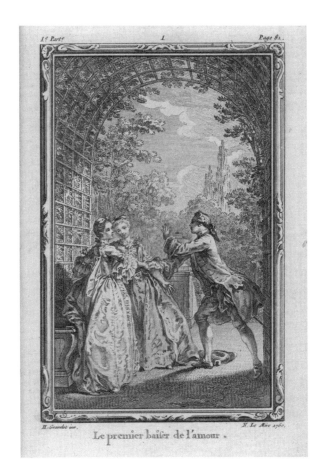

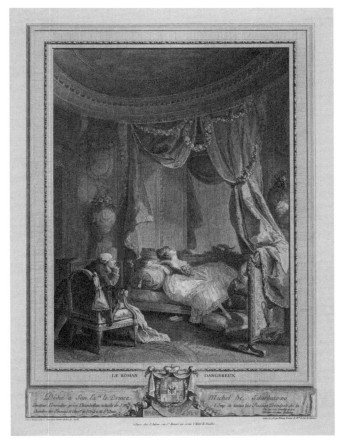

ignored. Instead, the artist presented a politely gallant scene—a social encounter, rather than the "sensuous intoxication" that will later lead to sexual intimacy.[9]

Gravelot's reluctance to convey Julie's emotions is all the more striking given that her amorous passion is the very subject of *La nouvelle Héloïse*. A story of female desire impeded by social codes and conventions, Rousseau's work was one of a growing number of French and British novels interested in women's affect and sexual experience at the time, most of them written by men.[10] The illustrator's toned-down interpretation of the text prompts us to ask: what was at stake in these new literary and visual representations of female desire?

*

The question pertains to Isidore-Stanislas Helman's print *The Dangerous Novel* (Fig. 2), which in contrast to Gravelot's image offers a far more direct representation of female eroticism. Etched and engraved after Nicolas Lavreince, a Swedish artist who built his career in France by specializing in gallant subjects, Helman's print features a woman in the throes of self-administered sexual pleasure. Spread languorously on a day bed—legs apart, hand slipped under her skirts, head thrown back with mouth half open—the woman's body conveys unambiguously the nature of her activity.

Fig. 1
Hubert François Gravelot (1699–1773), *Love's First Kiss*, from *Recueil d'estampes pour La nouvelle Héloïse* (Collection of Prints for *The New Heloise*), c. 1761–64. Graphite and ink, 28.1 × 20 cm. Houghton Library, Harvard University, Gift of Mr. and Mrs. John F. Fleming, 1959, F MS Typ 404.1, drawing #1.

Fig. 2
Isidore-Stanislas Helman (1743–1806), after Nicolas Lavreince (1737–1807), *The Dangerous Novel*, 1781. Engraving and etching, sheet: 44.1 × 32.6 cm. Harvard Art Museums/Fogg Museum, Gray Collection of Engravings Fund, 2017.243. (Detail on p. 273.)

Ewa Lajer-Burcharth

Amplifying the sexually charged atmosphere is the intimate setting of her elegantly appointed boudoir, replete with signs of sensory gratification (garlands of flowers) and eros (Cupid's bow and arrow). A book dropped on the floor beside her daybed represents the source of her arousal.

Produced in 1781, *The Dangerous Novel* inscribes itself in the by-then established iconography of female self-pleasure. Epitomized by the work of Pierre-Antoine Baudouin, this imagery drew on Gian Lorenzo Bernini's sculpture of *Saint Teresa in Ecstasy* (1647–52) to represent contemporary French women pursuing solitary gratification in their daily surroundings.[11] As explicit depictions of masturbation, these images were part of a broader cultural discourse concerned with solitary sex, particularly its medical consequences.[12] By focusing on women, however, they testify specifically to the intense Enlightenment preoccupation with female sexuality. On the one hand, they visualized a female sexual self-sufficiency, thus contributing to the cultural definition of the woman as a subject, rather than object, of desire. On the other hand, they signal the worry that accompanied this new development.

One hint of this concern is the motif of the abandoned book, which recurs throughout scenes like Helman's, echoing a broader discussion on the dangers of reading for women. As the title of the print suggests, novels were considered especially pernicious due to women's perceived erotic susceptibility and heightened lustfulness, attributed to a weak physical constitution and vivid imagination.[13] Libertine literature—most notoriously *Thérèse philosophe* (Therese the Philosopher; 1748), the story of a young woman's sexual formation[14]—featured female characters as a privileged locus of sexual exploits, both men's and their own. At the same time, the issue of feminine sexuality was caught up in cultural fears surrounding reproduction ⦿: since female orgasm was still widely believed to be necessary for conception, women's autonomous pursuit of pleasure outside of reproductive purposes—such as that of Helman's heroine—threatened to destabilize the social functions of woman as wife and mother. The book motif, then, may be seen as a sign of both recognition of and unease toward women's sexual autonomy. A scene of interrupted reading anxiously evoked the dangers of *lecture*, insofar as the activity provided a means of access to erotic self-knowledge and self-experience, facilitating women's sexual, subjective, and potentially social emancipation.

Complicating Helman's vision of feminine ardor is the presence of a man who, lurking from behind an armchair, secretly observes the woman. He stands in for the viewer, reminding us that while the woman is here the subject of her own pleasure, she has also been made the object of someone else's gaze. Pressing a finger to his lips, the man silences any onlookers, both assuming and enlisting their participation in the watching. Just as the novel has stirred the imagination of the woman, the picture seeks to inspire that of the viewer.[15] This is where the duplicity of Helman's image resides. Ostensibly, the iconography denounces the pleasures women derive from reading novels, yet it also caters to the desires of its male audience. Helman's dedication of the print to Count Michael Sherbatow, a Russian official at the court of Empress Catherine II, confirms the assumed masculinity of its viewers.

And yet, women were also recorded among the buyers of licentious images in this period.[16] By inserting a male figure into this spectacle of female sexual self-reliance, thus reclaiming the role of the voyeur for men, the artist points to yet another fear related to representations of female sexuality: the possibility that a *woman* would turn to images such as this for inspiration and education about the erotic possibilities of her own body.

<p style="text-align:center">* *</p>

The pursuit of anatomical knowledge is precisely what we witness in Jean-Honoré Fragonard's drawing *The Servant Girls' Dormitory* (Fig. 3). Standing in the middle of a bedroom illuminated by a candle, two young women playfully inspect each other's bodies. One lifts her diaphanous nightgown to let the other peek at her breasts, while their companions, spread out on their beds and on the floor in various degrees of undress, look on. A small dog resting on a pillow stares somewhat perplexed at the viewer.

A spirit of mischief and insouciance permeates this scene of carnal education, where the candle is both a source of light and a sign of enlightenment. Taking advantage of the freedom afforded by the privacy of their bedroom, the women pursue their intrafeminine pleasures in a markedly uninhibited way. At left, one figure lounges on her bed, her pulled-up chemise revealing her lower parts, while another crouches unceremoniously over a chamber pot. At right, the relaxed pose of a woman sitting on her bed "inadvertently" exposes her genitals to our view; next to her, a figure lying with her bottom exposed is being spanked with a garment by a scantily dressed friend.

Who are these women? Their description as servants in the title, which came later, cannot be trusted. (In a sales catalogue from 1779, the scene is described as a "dormitory in a pension for young women."[17]) Similar groups of female youths

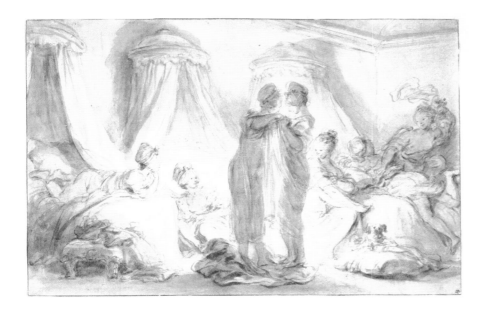

Fig. 3
Jean-Honoré Fragonard (1732–1806), *The Servant Girls' Dormitory*, c. 1770. Brown wash over graphite on off-white antique laid paper, 23.9 × 36.8 cm. Harvard Art Museums/ Fogg Museum, Gift of Charles E. Dunlap, 1954.106.

Ewa Lajer-Burcharth

engaged in parasexual activities appear in a series of drawings executed by Fragonard during the same period as the Fogg sheet, most likely intended for reproduction in print.[18] The stylish interior decor of these works, including the canopied beds, hardly corresponds to how servant quarters were furnished at the time. Yet it is difficult to situate the women socially with any precision.[19] Most likely, the Fogg "dormitory" was invented by Fragonard, notwithstanding the well observed poses of its inhabitants evidently drawn from the model.

What does this scene teach its viewers about sex, and who was the imagined addressee? The coyness of the figures, even those who perform indecorous acts, suggests that the image is less about how women behave and more about how men *imagine* they do in their absence. In this respect, the Fogg drawing joins a plethora of licentious imagery that circulated in France in the second half of the eighteenth century. An analogous later example is *Comparison* (1786), an etching and wash-manner print by Jean-François Janinet after Lavreince, in which two fashionable ladies competitively expose their breasts to an unseen, presumably male, judge (Fig. 4).[20] Fragonard, however, treats his subject with a visual and technical sophistication unmatched by later artists.[21] His passages of wash superimposed on softly drawn lines cast a literal and symbolic veil over the scene: like the bodies of the women that, seen *contre-jour*, are at once visible and concealed by their translucent shifts, the drawing itself both reveals and disguises its content from the viewer, complicating the epistemology of sex inherent in this scene.[22]

Does the simultaneous offer and withdrawal of sexual knowledge corroborate the presumed masculinity of the drawing's addressee? Or might it suggest other possibilities? Could the feminization of the medium have anything to do with the female *libertines* who consumed such risqué imagery?[23] More specifically, did the intrafeminine nature of the pleasures depicted by Fragonard entice a certain kind of female viewer: women involved in same-sex relations? As recent studies have revealed, relationships among women (and between women and gender nonconforming individuals) were more common in the eighteenth century than previously acknowledged.[24] Although this is speculative, it is possible that Fragonard's work was meant to appeal to this constituency.

* * *

Individuals attracted to members of the same sex were likely among the audiences targeted by a special edition of anacreontic poetry published in Glasgow in 1751 (Fig. 5). Named after the sixth-century poet Anacreon, the designation refers to the work of ancient Greek authors who specialized in love poems addressed to both men and women, at times in the space of one poem.[25] Besides Anacreon, the edition in question features the work of Sappho—who had a considerable following in eighteenth-century France (Fragonard, for one, owned a compendium of ancient poetry that included her work; he also painted her imagined portrait[26])—and the lesser-known Alcaeus. Sappho was closely associated with lesbianism, lending her name and the name of her native island of Lesbos to terms used to describe women

Fig. 4
Jean-François Janinet (1752–1814),
after Nicolas Lavreince (1737–1807),
The Comparison, 1786. Etching and
wash manner, printed in blue, red,
carmine, yellow, and black inks,
plate: 48.4 × 36 cm. National Gallery
of Art, Washington, D.C., Widener
Collection, 1942.9.2366.

LA COMPARAISON.

attracted to other women. An account of the practices of a lesbian sect known as La Loge de Lesbos was serialized in 1785 under the title *Confession de Sappho*.[27]

While it would be historically reductive to identify the love of both sexes celebrated in anacreontic poetry with homosexuality in the eighteenth century, it is reasonable to assume that the Glasgow volume was enjoyed by readers whose sexual desires differed from the accepted norm. Miniature in size, presumably for easy portability—one could slip it, say, inside a woman's corset—the book enabled inconspicuous, if not secret, consumption. Although unillustrated, its multicolored satin pages, with edges stitched elegantly for leafing through, offered a sensually rewarding experience that enhanced the book's erotic content. Combined with poems in the original Greek, the unusual format and extravagant materials of this particular edition suggest it was not intended for the mainstream consumer.

Ewa Lajer-Burcharth

The question of reception arises with particular urgency in regard to a series of works about which little else is known besides their author. Attributed to Claude-Louis Desrais, the *Suite of Sixty-Three Erotic Drawings* represents same-sex and heterosexual encounters with brutal explicitness. Set in finely decorated interiors, these raw, genitally specific acts openly violate the standard rules of decorum, making the paraerotic pranks of Fragonard's heroines look sweetly innocent by comparison. In one drawing (Fig. 6), two female voyeurs—likely chambermaids, judging from their dress—peek through a peephole at their mistress, who, propped up on a canopied bed, legs in the air, sex exposed, is masturbating vigorously. Licentious novel (or sexual manual) in hand, the woman is a cruder, more literal version of Helman's heroine. She, too, is staged as the object of someone else's pleasure in addition to her own—here, though, the second party is not a man, but the peeping women. The physical intimacy of the observers (note their embrace) suggests that the spectacle has encouraged their own pursuit of bodily gratification.

This pornographic, or in the terminology of the period, *obscène*, image is typical of the visual culture of *libertinage*.[28] Desrais, known mostly as a draftsman and illustrator, was an active contributor to this culture, as his work from the 1780s attests.[29] But this suite of erotic drawings appears to have been produced later. On the basis of fashion and interior decor, it may be dated to the early 1790s—closer to the work of the Marquis de Sade, whose version of libertine ideology involved expanding the very notion of sexuality through the depiction of unorthodox behaviors, including torture and violence.[30] Desrais's suite, however, distinguishes itself

Fig. 5
Hai tou Anakreontos Ōdai: Kai, Ta tes Sapphous; kai, Ta tou Alkaiou Leipsana (The Odes of Anacreon, with Fragments of Sappho and Alcaeus) (Glasgow: Excudebant R. & A. Foulis, 1751). Book printed on colored silk with overcast stitched edges, spine: 7.7 cm. MIT Libraries, Distinctive Collections, 1 PA3865. A1 1751.

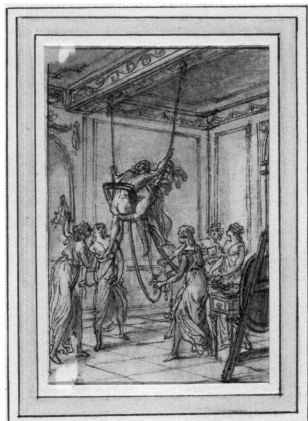

from Sade's erotic vision in that it consistently casts women as sexual protagonists and agents of violence.

Consider a drawing featuring a group of young women assisting a couple having intercourse on an improvised swing (Fig. 7). By pulling the ropes of the swing, they set the bodies of the pair in motion, thus mechanically facilitating—or coercing—their act. An element of sadomasochistic violence is signaled by the woman about to whip the man's exposed buttocks with a cat-o'-nine-tails.

While the executive role of the female figures in this image is evident, its implications remain unclear. The lack of text accompanying Desrais's drawings makes it difficult to gauge their intended meaning and audience. Does the central part played by women in this and other images in the suite imply an emancipatory sexual ethos, à la *Thérèse philosophe*, positing women as mistresses of their own desire? Or is it rather a critique of the depraved society under the ancien régime allegorized by the couple (note the outmoded plumed hat worn by the woman on the swing, in contrast with the *à l'antique* dresses of her young assistants), wherein the young maidens are merely providers of others' pleasure? The latter interpretation would align Desrais's drawings with imagery from the 1790s that used libertine tropes as a means of political critique during the French Revolution.

While uncertainty about the status and purpose of the suite impedes any definitive interpretation, this intriguing corpus of drawings nonetheless offers

Figs. 6–7
Claude-Louis Desrais (1746–1816), From the *Suite of Sixty-Three Erotic Drawings*. Black ink and brush with gray and brown wash, each: 8.9 × 5.8 cm. The Horvitz Collection, Wilmington, Del., DF-514.46, DF-514.36.

Ewa Lajer-Burcharth

important insight into the visual character of the libertine subculture and its Revolutionary afterlife. Taken together, the range of works discussed in this essay—from the image of an impassive ingenue to the portrayals of more assertive female figures taking their sexual satisfaction (literally) into their own hands—makes evident the scope of the erotic imagination of the Enlightenment and its relentless focus on the woman.

1. While this is the basic argument of Foucault's *History of Sexuality: An Introduction*, more recent accounts have added nuance. See, for example, Kim M. Phillips and Barry Reay, eds., *Sexualities in History: A Reader* (New York: Routledge, 2002); Katherine Crawford, *European Sexualities, 1400–1800* (Cambridge: Cambridge University Press, 2007); Alain Corbin, *L'Harmonie de Plaisirs: Les Manières de Jouir du Siècle des Lumières à l'Avènement de la Sexologie* (Paris: Perrin, 2008); and Faramerz Dabhoiwala, *The Origins of Sex: A History of the First Sexual Revolution* (Oxford: Oxford University Press, 2012).

2. Robert Darnton, *The Forbidden Best-Sellers of Pre-Revolutionary France* (New York: W. W. Norton, 1995), 90–91.

3. Michel Delon, *Le savoir-vivre libertin* (Paris: Hachette littératures, 2000), 9–30.

4. See Patrick Wald Lasowski, *La gravure libertine: Scènes du plaisir* (Paris: Éditions Cercle d'art, 2015), esp. 106–8; and Guillaume Faroult, *L'amour peintre: L'imagerie érotique en France au XVIIIe siècle* (Paris: Cohen & Cohen, 2020).

5. Claude Labrosse, "Les Estampes de la Nouvelle Héloïse, ou les Déceptions d'un Créateur," in *Voix et Mémoire: Lectures de Rousseau*, ed. Anne-Marie Mercier-Faive and Michael O'Dea (Lyon: Presses Universitaires de Lyon, 2020), 91.

6. "Les planches seules feraient les succès du livre." Ibid., 92. See also Jean-Jacques Rousseau, "Subjects of the Engravings," in *Julie; or, The New Heloise*, trans. and annotated by Philip Stewart and Jean Vaché (Hanover, N.H.: University Press of New England, 1997), 621–28.

7. Labrosse, "Les Estampes de la Nouvelle Héloïse, ou les Déceptions d'un Créateur." See also Nathalie Ferrand, "Translating and Illustrating the Eighteenth-Century Novel," *Word & Image* 30 (3) (2014): 181–93.

8. Letter XIV in Rousseau, *Julie*, 52.

9. Rousseau insisted that the "whole tableau must exude a sensual intoxication." Ibid., 622.

10. On this eighteenth-century literary concern, notably in Samuel Richardson's novels *Pamela* and *Clarissa*, see Dabhoiwala, *The Origins of Sex*, 169.

11. On this topic, see Philip Stewart, *Engraven Desire: Eros, Image and Text in the French Eighteenth Century* (Durham, N.C.: Duke University Press, 1992); Mary Sheriff, *Moved by Love: Inspired Artists and Deviant Women in Eighteenth-Century France* (Chicago: University of Chicago Press, 2004); and Faroult, *L'amour peintre*, esp. 289–306 (on Baudouin).

12. See Samuel-Auguste Tissot, *Onanism; or, A treatise upon the disorders produced by masturbation; or, The dangerous effects of secret and excessive venery* (London: [1760] 1766). See also Thomas Laqueur, *Solitary Sex: A Cultural History of Masturbation* (New York: Zone Books, 2003).

13. Sheriff, *Moved by Love*, 89; and Pierre Roussel, *Système physique et moral de la femme: Ou, Tableau philosophique de la constitution, de l'etat organique, du tempérament, des moeurs, & des fonctions propres au sexe* (Paris: Chez Vincent, 1775).

14. Darnton, *The Forbidden Best-Sellers of Pre-Revolutionary France*, 85–114.

15. Sheriff, *Moved by Love*, 104. Sheriff's reading contrasts with that of Philip Stewart, who assumes that the woman—her bodice loosened, thighs spread apart—is ready to be taken by the encroaching man. Stewart, *Engraven Desire*, 94–102.

16. On the eighteenth-century market for licentious prints, see Kristel Smentek, "Sex, Sentiment, and Speculation: The Market for Genre Prints on the Eve of the French Revolution," in *French Genre Painting in the Eighteenth Century*, ed. Philip Conisbee (Washington, D.C.: National Gallery of Art, 2007), 221–44.

17. Marie-Anne Dupuy-Vachey, entry in *Fragonard amoureux: Galant et libertin*, ed. Guillaume Faroult (Paris: Réunion des musées nationaux, 2015), cat. 47, p. 154.

18. On the drawings, dated 1763–65, see ibid., cats. 48–49, pp. 154–61; and Faroult, *L'Amour peintre*, 322–25.

19. An analogous scene by Lavreince has prompted the suggestion that Fragonard's women may be *ouvrières en modes*, or shop assistants in a fashion boutique, but the theory lacks consensus. See Dupuy-Vachey in Faroult, *Fragonard amoureux*.

20. On this image, see Smentek, "Sex, Sentiment, and Speculation," 232–33.

21. On Fragonard as a draftsman, see Eunice Williams, *Drawings by Fragonard in North American Collections* (Washington, D.C.: National Gallery of Art, 1978), 72–73 (on this drawing); and Perrin Stein, with contributions by Marie-Anne Dupuy-Vachey, Eunice Williams, and Kelsey Brosnan, *Fragonard: Drawing Triumphant* (New York: Metropolitan Museum of Art, 2016).

22. On the corporeal conception of the image in Fragonard, see Ewa Lajer-Burcharth, *The Painter's Touch: Boucher, Chardin, Fragonard* (Princeton, N.J.: Princeton University Press, 2018).

23. Lasowski, *La gravure libertine*, 158–61.

24. See, for example, Phillips and Reay, *Sexualities in History*; Crawford, *European Sexualities*; Kenneth Borris and George Rousseau, *The Sciences of Homosexuality in Early Modern Europe* (London: Routledge, 2008); and Jen Manion, *Female Husbands: A Trans History* (Cambridge: Cambridge University Press, 2020).

25. See René Schneider, "L'art anacréontique et alexandrin sous l'empire," *Revue des Études Napoléoniennes* 10 (1916); and Abigail Solomon-Godeau, *Male Trouble: A Crisis in Representation* (New York: Thames and Hudson, 1997), 103–14.

26. Faroult, *Fragonard amoureux*, cat. 64, p. 190.

27. Delon, *Le savoir-vivre libertin*, 296–97.

28. The term "pornographic" was used only in the context of prostitution. Darnton, *The Forbidden Best-Sellers of Pre-Revolutionary France*, 86; and Faroult, *L'Amour peintre*, 21.

29. Anne Leclair, "Durameau, De la Rue or Desrais: A Riddle Solved," *Burlington Magazine* 126 (March 1984): 152–58; and Angela Rene Nacol, "Visions of Disorder: Sex and the French Revolution in a Suite of Erotic Drawings by Claude-Louis Desrais," M.A. thesis, Texas Christian University, 2008.

30. In consultation with fashion historian Kimberly Chrisman-Campbell, Angela Rene Nacol suggests dating the *Suite of Sixty-Three Erotic Drawings* to 1791–93.

Ewa Lajer-Burcharth

YELLOW

Margaret Morgan Grasselli

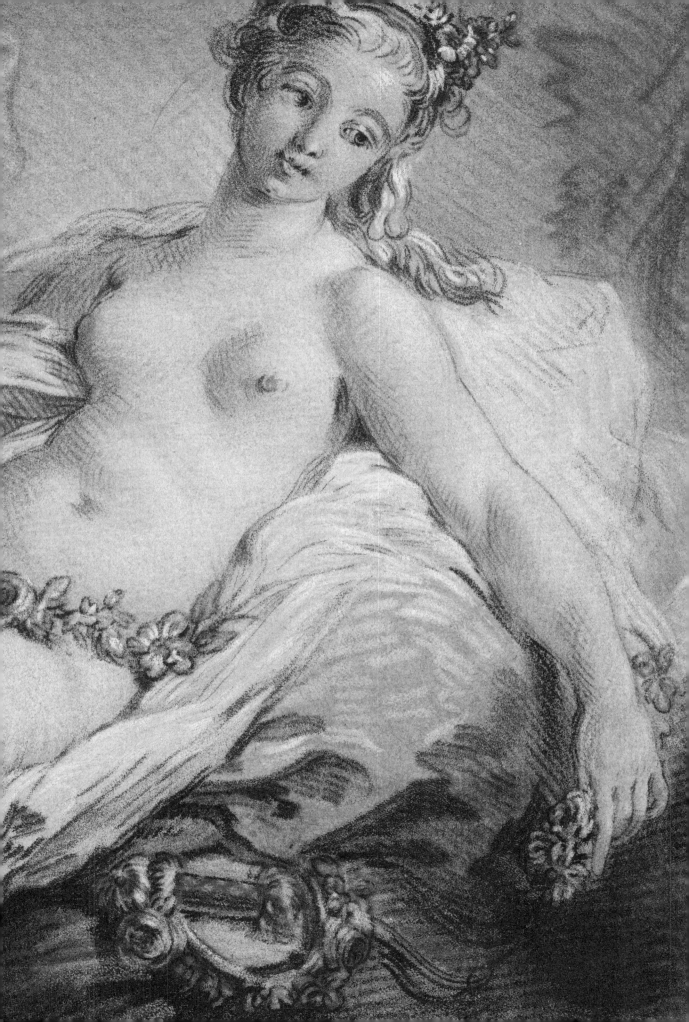

In Diderot's *Encyclopédie*, "yellow" is categorized under "Arts et métiers" (Arts and Crafts), beneath the subheading "Teinturier" (Dyer).[1] The discussion includes a quick mention of the color's reflective properties, but otherwise focuses on white substances that turn yellow over time; yellow substances that become white; dyes, such as weld (or gaude), turmeric, and savory; and various shades of yellow, including golden yellow, pansy yellow, isabella (a gray-yellow), nacarat (a red-yellow), and chamois. Aside from separate subentries on "jaune de Naples" (Naples yellow, a painting pigment), and "jaune de corroyeurs" (curriers' yellow, a dye used for leathers), as well as cross-references to "Color," "Light," "Gaude," "Whitening," and "Dyeing," this is the extent of the encyclopedia's treatment of the topic.

The entry could easily have been much longer, for the list of yellow pigments, dyes, and colorants available to eighteenth-century artists was more extensive than the volume suggests. Among the omissions were Indian yellow, orpiment, massicot, and yellow ocher.[2] Also left out were stil de grain and gamboge yellow, two organic pigments that, due to their particular qualities of translucency, played important roles in a new color printing process invented in the first quarter of the century by a little-known German painter and engraver, Jacob Christoph Le Blon.[3] Le Blon's idea sprang from the realization that an entire palette of colors could be produced from just three "primitive" colors, or what we now call the primary colors: red, blue, and yellow. He then applied this discovery to the production of full-color prints, using a different copperplate to print each color in succession, so that they combined to produce a full spectrum on the sheet. His new process posed several technical challenges: the inks had to have the right translucency, each plate had to be engraved with the correct parts of the design and in a manner that would convey the ink in precisely the right proportions, and each had to be properly aligned, or registered, on the paper during each pass through the press.[4]

Using the tonal intaglio technique of mezzotint, Le Blon produced a number of prints with this three-color process, but soon discovered that he had to add a fourth ink—black or dark brown—to help coalesce and add definition to the printed images. On occasion, he used more plates with additional inks, often variant tones of blue and red and sometimes a lead white that unfortunately quickly oxidized and turned gray or black.[5] It was specifically his work in four inks, however, that proved to be so important for modern color printing, giving rise to the four-color halftone process still in use today.

While Le Blon's original intention was to produce intaglio prints that would imitate oil paintings as closely as possible, his method was quickly adapted to medical and anatomical illustration, where the simultaneous production of image and color was especially valuable because it eliminated errors from hand-coloring.[6] One of the most striking anatomical prints ever produced is the rendering of *Muscles of the Back* by Jacques-Fabien Gautier d'Agoty, who had learned the color mezzotint technique from Le Blon and had quickly become his chief rival (see p. 271). Both shocking and strangely beautiful in its conception, the print is dominated by the color red. The light areas of the flesh and bones, however, were created through a carefully calculated combination of red, blue, and yellow inks, with yellow playing a particularly

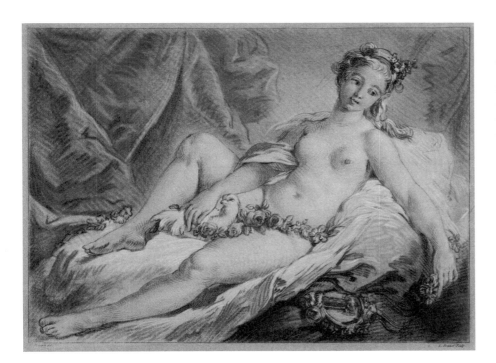

Fig. 1
Louis Marin Bonnet (1736–1793),
after François Boucher (1703–1770),
The Awakening of Venus, 1769. Pastel
manner engraving on blue paper,
sheet: 32.6 × 41.2 cm. Harvard
Art Museums/Fogg Museum,
Acquisition Fund for Prints, 2015.155.
(Detail on p. 285.)

important role. Yellow was also instrumental in creating the greenish tones of the dark background and the browns of the woman's hair.

Le Blon's multi-plate printing method was key to the development of other color printmaking techniques in the following years, such as chalk manner, invented in the 1750s to replicate the appearance of chalk drawings, and wash manner, from the 1770s, which imitated the look of watercolors.[7] Yellow ink did not play a role in the production of chalk-manner images that emulated drawings executed in red, black, and white chalks, singly or in two- or three-chalk combinations. It was, however, a regular component of the more complex pastel-manner version of that technique, which involved more inks and more plates. Pastel-manner prints were the unique province of the most ambitious of the chalk-manner printmakers, Louis Marin Bonnet, who had invented a white ink that did not discolor or turn black and had kept the recipe a secret so that no one else could use it. For his prints after pastels, the white provided the essential top layer of ink, which served to simulate the powdery appearance of colored chalks. He made a number of impressive works of this type, including *The Awakening of Venus* in 1769 (Fig. 1).[8] In the best impressions of the first state—such as the one illustrated here, printed on blue paper with crisp, fresh colors—the yellow is especially bright and pops amid the blues, reds, blacks, and whites that otherwise describe the majority of the composition. In this particular work, as is often the case with pastel-manner prints, the yellow was not intended to blend with any other color to create another, but instead was allowed to stand on its own, much like individual strokes of pastel often do.

The wash-manner technique was invented in the early 1770s by Bonnet's best pupil, Jean-François Janinet.[9] Like Le Blon, Janinet depended on the successive layering of translucent colors (yellow, red, blue, and black, in that order), printed

Margaret Morgan Grasselli

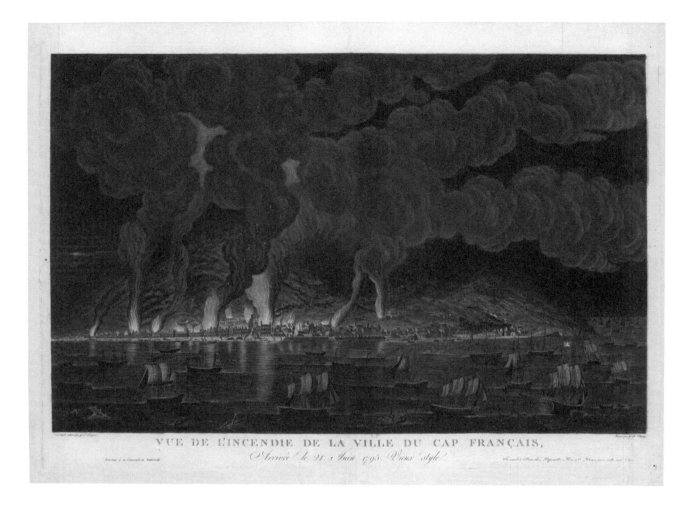

VUE DE L'INCENDIE DE LA VILLE DU CAP FRANÇAIS,
Arrivée le 21 Juin 1793. Vieux style.

Fig. 2
Jean-Baptiste Chapuy (c. 1760–1802), after J. L. Boquet, *Vue de l'incendie de la ville du Cap Français, arrivée le 21 juin 1793* (View of the Burning of the City of Cap Français on June 21, 1793), 1794. Etching printed in five colors, 52.5 × 73.5 cm. Bibliothèque nationale de France, Département des Estampes et de la Photographie, RESERVE QB-201 (171, 24)-FT 5.

one after the other in perfect alignment, to create full-color replicas of the water-colors that served as his models. Instead of mezzotint, however, he used a variety of tools—in a tonal technique literally called "tool work," since it is impossible to determine exactly what instruments were used for each print—to create the designs on the plates. The best practitioners of this new technique, including Janinet himself, Charles-Melchior Descourtis, Philibert-Louis Debucourt, and Gilles-Antoine Demarteau, among others, produced a number of extraordinary wash-manner prints before the end of the century.[10]

A particularly large and impressive example printed in five colors is the *Vue de l'incendie de la ville du Cap Français, arrivée le 21 juin 1793* (View of the Burning of the City of Cap Français on June 21, 1793), executed in 1794 by one of Janinet's followers and rivals, Jean-Baptiste Chapuy, after a painting by J. L. Boquet (Fig. 2). It depicts a dramatic and horrifying event that Boquet witnessed firsthand: the destruction of Cap Français, "the Paris of the Caribbean," during the rebellion in Saint-Domingue (now Haiti), one of the wealthiest French colonies ◉. The revolution lasted twelve years (1791–1803) and ultimately led to the establishment of Haiti as an independent nation. Chapuy priced his vivid nocturnal scene at 24 livres, apparently betting

TIME

that public fascination with such a historic disaster would motivate buyers to pay the large sum for his print. This was not the first time the artist had tapped into the market for images of infernal spectacles ; he previously produced two night views of volcanic eruptions—one of Mount Etna in 1766 and one of Mount Vesuvius in 1779—treating the fiery visual effects in a manner nearly identical to his handling of the decimation of the Saint-Dominguen port.[11]

In a technique that depends so heavily on the contributions of all four inks to achieve the correct coloristic effects, the fading of just one can alter the delicate balance; its complete disappearance is catastrophic. As it happens, the two organic yellows preferred by color printmakers—stil de grain and gamboge—are particularly fugitive, and gamboge has the added disadvantage of vanishing completely when washed with a solvent.[12] The loss of yellow is significant, for without it a print forfeits the whole range of oranges, greens, and browns, not to mention the yellow itself, and the palette is reduced to little more than pink, blue, and black. A case in point is the Harvard impression of *Spring* by Gilles Antoine Demarteau,

Fig. 3
Gilles Antoine Demarteau (1750–1802), after Jean-Baptiste Huet (1745–1811), *Spring*, 1785. Etching and aquatint with mezzotint and stipple, printed in four colors, plate: 29 × 36.4 cm. Harvard Art Museums/ Fogg Museum, Acquisition Fund for Prints, 2016.88.

Margaret Morgan Grasselli

executed in 1785 after a watercolor by Jean-Baptiste Huet (Fig. 3). The printing is clear, the plates are well registered, and the colors are bright; under ordinary circumstances, this would be considered a fine impression. However, all the foliage and the grassy areas, which ought to be green, are unequivocally blue, while the tree trunks are essentially gray or gray-blue instead of brown. The print should actually look more richly colorful, a critical deficiency made all the more apparent when one compares the work with wash-manner prints whose yellows are still present.[13] This is not to suggest that yellow plays a more essential role than the other colors in the four-color printing process—all are in fact equally indispensable. Rather, it is the particular vulnerabilities of the yellow inks used in the eighteenth century that make their presence or absence vital to the appearance of color prints produced at that time.

1. The entry can be consulted online at http://encyclopédie.eu/index.php/5349785-JAUNE.

2. See Patricia Railing, ed., "18th Century Colour Palettes," Painters' Palettes from Historical Writings, an Intermedia Website, accessed May 7, 2021, https://painterspalettes.net/18th-century-colour-palettes. Several of these pigments are mentioned in *An Atlas of Rare & Familiar Colour: The Harvard Art Museums' Forbes Pigment Collection* (Los Angeles: Atelier Éditions, 2019), 70–85.

3. On Le Blon and his color printing process, see Ad Stijnman, with a contribution by Helen Wyld, *J. C. Le Blon and Trichromatic Printing*, parts 1 and 2, ed. Simon Turner, The New Hollstein Dutch & Flemish Etchings, Engravings and Woodcuts, 1450-1700 (Ouderkerk aan den Ijssel: Sound & Vision Publishers, 2020).

4. Le Blon's methods are described in Antoine Gautier de Montdorge, *L'Art d'imprimer les tableaux* (Paris: Ches P. G. Le Mercier, Jean-Luc Nyon, Michel Lambert, 1756). See also the brief discussion by Judith C. Walsh, "Ink and Inspiration: The Craft of Color Printing," in *Colorful Impressions: The Printmaking Revolution in Eighteenth-Century France*, by Margaret Morgan Grasselli, with contributions by Ivan E. Phillips, Kristel Smentek, and Judith C. Walsh (Washington, D.C.: National Gallery of Art, 2003), 23–25, 175.

5. Le Blon's most elaborate print was his portrait of Louis XV after a painting by Nicholas Blakey, which he printed in six inks. See Walsh, "Ink and Inspiration," 24; and Grasselli, *Colorful Impressions*, cat. 1.

6. See Julia Nurse, "Colouring the Body: Printed Colour in Medical Treatises," in *Printing Colour, 1700-1830*, ed. Margaret Morgan Grasselli and Elizabeth Savage (forthcoming).

7. These techniques are discussed and illustrated at length in Grasselli, *Colorful Impressions*.

8. For his most ambitious pastel-manner print, *Tête de Flore* (Head of Flora), Bonnet used eight separate copperplates and eleven different inks, some printed more than once. See ibid., 68–71, cat. 19.

9. Janinet's method is demonstrated in a rare set of progress proofs of *Noce de village* (Village Wedding), by his pupil Charles-Melchior Descourtis, in the National Gallery of Art in Washington, D.C. (1958.8.77–86). See ibid., 108–11, cat. 55.

10. Many by these and other artists are reproduced and discussed in ibid.

11. Impressions of both prints
 by Chapuy after paintings by
 Alessandro d'Anna are in the
 Miriam and Ira D. Wallach
 Division of Art, Prints and
 Photographs at the New York
 Public Library. Images are avail-
 able at https://digitalcollections
 .nypl.org/items/5e66b3e8-76f8
 -d471-e040-e00a180654d7 and
 https://digitalcollections.nypl
 .org/items/5e66b3e8-8761-d471
 -e040-e00a180654d7.

12. About gamboge and its inher-
 ent vices, see John Winter,
 "Gamboge," in *Artists' Pigments:
 A Handbook of Their History
 and Characteristics*, vol. 3, ed.
 Elisabeth West FitzHugh
 (Washington, D.C.: National
 Gallery of Art; London:
 Archetype Publications,
 2012), 143–47.

13. For reproductions of several
 well-preserved impressions, see
 Grasselli, *Colorful Impressions*,
 cats. 44–45, 55j, 70–71, 75, 79–80.

Margaret Morgan Grasselli

ZEALOTRY

Joachim Homann

Enlightenment discourse around zealotry and tolerance was galvanized by a widely read essay published by Voltaire in 1763, a year after French Protestant Jean Calas became a casualty of the conflict between the Catholic majority and Protestant minority in Toulouse. For Voltaire, the unfair condemnation, public torture, and execution of Calas, whose body was broken on the wheel, had potential to become a turning point in European history. In *A Treatise on Religious Toleration*, the philosophe asked with great urgency how, in the future, religious fanaticism could be rooted out and tolerance could become a foundation of an enlightened society.[1] While attitudes toward public torture had already begun to shift at the time of his writing ⊙, and the breaking wheel has long since been abandoned as a method of execution, Voltaire's attempt to conceive of a pluralistic society has lost nothing of its pertinence.

CRUELTY

Calas's gruesome demise resulted from an alliance between a mob of religious zealots and a court blinded by prejudice—a union that, in Voltaire's view, posed a threat to everyone if the public failed to hold the responsible authorities accountable. On March 9, 1762, word spread in Toulouse that a well-established Protestant merchant had killed his own son, Marc-Antoine (Antony) Calas, after the young man announced his intention to adopt the Catholic faith. People swarmed to the scene of the tragedy, declaring the victim a martyr. Soon enough, members of the family and their household staff were arrested, while religious fanatics arranged for an honorary (Catholic) funeral for the deceased. Voltaire describes in great detail the events that followed. Members of a fraternity of penitents, disguised by their characteristic long hoods that covered all but the eyes, arranged for a procession in which they placed "on a magnificent bier" a "kind of moving skeleton, to represent Marc Antony Calas, holding in one hand a bough of the palm-tree, and in the other the pen with which he should have signed his abjuration."[2] Marc Antony was soon venerated by some as a saint. His family, however, was persecuted with a vengeance, the religious fervor stoked by the bicentennial of the 1562 massacre of four thousand Huguenots in Toulouse. The public execution of his father, Jean, became the centerpiece of the anniversary celebrations. Jean Calas maintained his innocence throughout the ordeal and was posthumously exonerated in 1765.

The reversal was the work of Voltaire, who set out to demonstrate in his essay that the unfortunate son had in fact died by suicide, likely due to economic misfortune and a psychological predisposition. But how, he asks in exasperation, could this truth remain hidden for so long, with such terrible consequences, "in times when philosophy hath made such considerable progress, and while so many academies are constantly employed in cultivating humanity and gentleness of manners!" He concludes: "It appears to me that fanaticism, enraged at the success of reason, vents its spleen with redoubled fury on itself."[3]

As news of the events in Toulouse spread, members of the European public became similarly concerned with the lack of justice and were relieved to learn that a review of the proceedings had absolved the surviving family members. Publicist and literary critic Friedrich Melchior, Baron von Grimm, a German expatriate who corresponded with European royalty and who was part of the top Parisian intellectual circles, conceived of a plan to illustrate the Calases' fate and sell a print to benefit the widow. The engraving, by Jean-Baptiste Delafosse after a drawing that Grimm commissioned from Louis Carrogis de Carmontelle, was published in 1765 (Fig. 1).[4]

Fig. 1
Jean-Baptiste Joseph Delafosse
(1721–1775), after Louis Carrogis
de Carmontelle (1717–1806), *The
Miserable Calas Family*, 1765. Etching
and engraving, sheet: 34.8 × 42.7 cm.
Harvard Art Museums/Fogg
Museum, Acquisition Fund for
Prints, 2019.258.

It illustrates a sentimental scene: the imprisoned Calas family gathered to read a letter, no doubt hoping to receive good news. Mother Calas, her two daughters, and a maidservant are huddled in their prison cell, listening as one of the surviving brothers (the other was sent into exile) relates what is transcribed. The elegant young man, the tallest and brightest figure in this gloomy dungeon, is joined by Lavaysse, a friend of the family who had also been implicated. Lavaysse now leans on his friend's shoulder as he eagerly seeks to read the message in the young man's hands. The women, dressed in mourning attire, project patience and poise, but their faces cannot hide their excitement for the letter's (unexplained) contents.

 Carmontelle and Delafosse used few props to support the narrative, indicating a simple wooden bench, the closed canopy of a bed, and a wooden table with writing utensils, perhaps suggesting that the prisoners had been able to send letters, to which the incoming message is in reply. The forbidding stone wall and floor, a grated window that lets in little light, and some steps define the scene. The stairs lead to the still-locked door, through which the group will soon find freedom. Viewers will undoubtedly sympathize with the protagonists, whose humanity and dignity in the face of adversity is the underlying theme of this work. The calamity of the human condition is addressed by the inscription, a quote from the second book of Lucretius's *On the Nature of Things*: "In what darkness of life, and in how great dangers, is this existence, of whatever duration it is, passed."[5]

 According to Grimm, the aim of the print was more than artistic excellence. He wrote in April 1765 that "[w]e don't offer the public a masterpiece of engraving, but we offer them the characteristics of virtue and innocence that were barbarically outraged and weakly revenged: This image is priceless, since it can serve sensitive

hearts as a pretext to fill themselves with feelings of charity."[6] Europe was ready for this cathartic experience, as the list of subscribers indicates; it ranges from Russian empress Catherine the Great to English writer and antiquarian Horace Walpole to musician and composer Leopold Mozart. As upsetting as the memory of the Calas trial was, the print seemed to suggest that justice was ultimately served, thanks to the intervention of the king and, one might add, Voltaire's public condemnation of the court of Toulouse. The latter was not well received by members of the French parliament, who ordered police to enforce a suspension of the sale of the print until the publisher agreed to refrain from publicly advertising the work. "Bad things are done in public while good deeds have to remain private," Grimm quipped.[7]

As it turned out, government interference did not much hamper the print's circulation. In Berlin, for example, it was popular within the sizable French Protestant community, which included Daniel Chodowiecki, an artist connected to that group through his own heritage and through marriage to a Huguenot.[8] In 1767, Chodowiecki painted a copy of the print and created a second painting of his own design as a pendant, envisioning the moment that Jean Calas bid farewell to his family before being led to his execution.[9] The success of this second painting inspired Chodowiecki to reproduce it in an etching (Fig. 2), which was likewise a commercial hit and the first notable achievement of his career as an artist and illustrator. The pictorial strategies of Chodowiecki's picture were derived from the sentimental family scenes by Jean-Baptiste Greuze (see p. 94) that moved visitors to tears when first exhibited in the annual Salons at the Louvre in the early 1760s.[10] Chodowiecki now directed viewers to sympathize with victims of zealotry.

He placed Jean Calas in the center of the image, seated on the edge of a bed. As a guard removes his shackles, his children caress their departing father one last

LES ADIEUX DE CALAS, A SA FAMILLE.
je crains Dieu............et n'ai point d'autre crainte

Fig. 2
Daniel Nikolaus Chodowiecki
(1726–1801), *Calas Bidding Farewell to His Family*, 1768. Etching, plate: 34.2 × 44.5 cm. Harvard Art Museums/ Fogg Museum, Acquisition Fund for Prints, 2019.259. (Detail on p. 293.)

time. Jean's two daughters affectionately embrace his shoulders and waist; his only remaining son kisses his father's right hand. With the other, Jean points to his wife, imploring his children to take care of their mother when he is gone. Lavaysse and a maidservant attend to the woman, who has passed out in agony on a nearby chair while reading the Bible. At left, a priest enters the cell with the approval of two armed guards. The glistening bayonet of one of these watchmen, standing at attention with his back to the viewer, appears right next to the priest's face, as if to illustrate the unholy and frightful alliance between church and state that led to Jean's undoing. A quote from *Athalie*, the final tragedy of dramatist Jean Racine, confirms that the patriarch is dying for his unwavering faith: "I fear God, and no one else I have to fear."[11] With this print, Chodowiecki not only used the fate of the Calas family to advance his audience's desire for tolerance, but also demonstrated his ability as an artist to contribute to a conversation that was taking place in both texts and images.

Indeed, some artists were as committed to promoting tolerance and chastising zealotry as Enlightenment era writers and thinkers. That art could serve public education was beyond doubt in this period: artists upheld values such as justice and tolerance and reminded viewers of their shared humanity, at times through captivating images much less complicated than the narrative described in illustrations of the Calas family tragedy. Consider, for example, an allegory of tolerance

Figs. 3–4
Francisco José de Goya y Lucientes (1746–1828), *Los Chinchillas* (The Chinchillas) (left) and *Que Pico de Oro* (What a Golden Beak) (right), from the series *Los Caprichos* (The Caprices), 1797–98. Etching and aquatint with burnishing, plates: 21.8 × 15.2 cm (left) and 21.7 × 15 cm (right). Harvard Art Museums/ Fogg Museum, Gift of Philip Hofer, M4350, M4353.

Joachim Homann

by Chodowiecki himself (see p. 36), or the satirical warning against zealotry by Spanish artist Francisco Goya (Figs. 3–4). The works exemplify competing strategies of image making. For an almanac published in 1792, Chodowiecki illustrated the glowing goddess Minerva, a personification of Tolerance, opening her arms to welcome representatives of the monotheistic religions, among them a Jew, a Muslim, a Catholic monk, and several prelates and Protestant pastors (all male) ◉. Minerva/Tolerance presents a lance, inviting these men to joust for the truth.[12] Goya, in the series *Los Caprichos* (The Caprices; 1797–98), presented a different model for how art can educate: by holding a satirical mirror to viewers' shortcomings. In one work, a blindfolded woman with donkey ears spoon-feeds two male figures whose uniforms resemble straightjackets (Fig. 3). While their mouths are open, eager to swallow what comes their way, their eyes are shut and—in an ingenious invention—their minds closed, barred from taking in any bit of information by the enormous locks covering their ears. Goya's condemnation of the uncritical consumption of what today might be called "fake news" is still effective.

It is only fitting, then, to give the last word in this essay—the final entry in a catalogue produced by a university art museum and devoted to the role of the graphic arts in the formation and dissemination of ideas—to Goya, whose satire could easily apply to Harvard or any other learned community. In another print from *Los Caprichos*, scholars gasp and wring their hands as they admire a talented speaker—a parrot with the golden beak that gives the print its title (Fig. 4). Goya reminded viewers that enlightenment depends on both idealism and critique. Each one of us is called to uphold its principles and, at the same time, to guard it from becoming yet another form of indoctrination.

<div style="margin-left:2em; text-indent:-2em; font-size:90%;">

1. Voltaire, *A Treatise on Religious Toleration. Occasioned by the execution of the unfortunate John Calas; unjustly condemned and broken upon the Wheel at Toulouse, for the supposed murder of his own son* (London: Printed for T. Becket and P. A. de Hondt, in the Strand, 1764).

2. Ibid., 8.

3. Ibid., 10.

4. The drawing is now in the Louvre; see the object record at https://collections.louvre.fr/en/ark:/53355/cl020230393.

5. Translation of the original Latin from Titus Lucretius Carus, *Lucretius: On the Nature of Things*, trans. John Mason Good and John Selby Watson (London: G. Bell and Sons, 1882), 54.

6. Marcel Roux, *Inventaire du fonds français, graveurs du dix-huitième siècle*, vol. 6 (Paris: M. Le Garrec, 1949), 207–8.

7. Ibid., 210.

8. Christina Florack-Kröll, Daniel Chodowiecki, and Ursula Mildner, *Daniel Chodowiecki, seine Kunst und seine Zeit: "Das Publikum wollte, dass ich Radierer sei,"* 1st ed. (Gelsenkirchen: Arachne, 2000).

9. Werner Busch, "Art in the Age of Enlightenment from a Pan-European Perspective," in *The Art of the Enlightenment*, ed. Lu Zhangshen (Beijing: National Museum of China; Berlin: Staatliche Museen zu Berlin; Dresden: Staatliche Kunstsammlungen Dresden; Munich: Bayerische Staatsgemäldesammlungen München, 2011), 31–37, esp. 36–37 (on Chodowiecki and Francisco Goya).

10. See, for instance, Greuze's 1763 painting *Filial Piety (The Paralytic)*, which Catherine the Great bought in 1766 through Denis Diderot, her agent in Paris. The work is now in the Hermitage Museum in St. Petersburg: https://www.hermitagemuseum.org/wps/portal/hermitage/digital-collection/01.+Paintings/37493.

11. Jean Racine, *Athaliah*, trans. J. Donkersley (Project Gutenberg), act 1, scene 1, https://www.gutenberg.org/files/21967/21967-h/21967-h.htm.

12. See Antony Griffiths and Frances Carey, *German Printmaking in the Age of Goethe* (London: British Museum, 1994), no. 26.

</div>

Pietro Antonio Novelli
Baptism

Pietro Antonio Novelli's *Baptism*, one in a set of finished drawings of the seven sacraments, is a vivid affirmation of the centrality of the rites to Catholicism and to the faith of the man who commissioned the works. According to an inscription on the backs of two of the sheets, Novelli executed the series, likely in 1769, for a Father Ghedini, a member of the Catholic Carmelite order probably living in Venice or Rome.[1] For Catholics, God's grace becomes manifest in the seven sacraments: baptism, confirmation, holy communion, confession, marriage, ordination, and extreme unction. Their number is an important point of doctrine and distinction between Catholicism and Protestantism, the latter stipulating just two: baptism and communion. Aspects of Novelli's drawings are suggestive of Ghedini's insistence on theological rigor in their representation, and more broadly, of a resistance to the Enlightenment's perceived undermining of traditional beliefs, which has been described as the counter-Enlightenment.[2]

Novelli's depictions are remarkable for how they merge figures in contemporary settings and fine eighteenth-century dress with visualizations of the significance of the sacraments that draw on much earlier iconographical traditions. In the drawing of baptism, God the Father (in the clouds), the Holy Spirit (represented by the dove directly above the baby's head), and Christ, whose sacrifice on the cross is the source of salvation, preside over the cleansing of original sin that the sacrament represents. Particularly striking is Novelli's contrast of Christ and his purifying blood, arcing unseen by the participants from the wound in his body to the head of the child, with a devil who lurks in the shadows at lower right—a figure who might embody the threat of heresy, indeed of the Enlightenment itself.

Pietro Antonio Novelli (1729–1804), *Baptism*, from the series *The Seven Sacraments*, 1769. Brush and gray wash with brown ink, sheet: 38.7 × 52.9 cm. Yale University Art Gallery, New Haven, Conn., Frederick M. Clapp, B.A. 1901, M.A. 1911, Fund, 2015.59.1.

1. The drawings have been little studied, but for a substantive introduction, see *Old Master and 19th-Century Drawings, 1540–1890* (New York: W. M. Brady & Co., 2015), cat. 21.

2. See, for example, Darrin M. McMahon, *Enemies of the Enlightenment: The French Counter-Enlightenment and the Making of Modernity* (Oxford: Oxford University Press, 2001).

Kristel Smentek

WORKS IN THE EXHIBITION

ARNOLD ARBORETUM LIBRARY, HARVARD UNIVERSITY

Mary Lawrance
English, 1776–1845
Passiflora serratifolia, Notch-leaved passion-flower
From *A Collection of Passion Flowers*, 1799–1802
Etching and engraving with transparent watercolor
Plate: 45.4 × 32.7 cm
GEN Fol. 4 L41 1799

Johann Michael Seligmann
German, 1720–1762
Die Nahrungs-Gefäse in den Blättern der Bäume: Nach ihrer unterschiedlichen (The Food Vessels in the Leaves of Trees) (Nuremberg: 1748)
Bound book
Spine: 46 cm
GEN Fol. 2 Se4 1748

Timothy Sheldrake
British, active 1740–1770
Botanicum medicinale: An herbal of medicinal plants on the College of Physicians list. Describing their medicinal virtues, names in nine languages (London: 1759)
Bound book
Spine: 45 cm
GEN Fol. 4 Sh4 1759

BAKER LIBRARY, HARVARD BUSINESS SCHOOL

Published by Carington Bowles
British, 1724–1793
The Bubbler's Medley, or a Sketch of the Times: Being Europe's Memorial for the Year 1720, 1720, printed 19th century
Engraving
48 × 30 cm
Kress Collection of Business and Economics, 124589

Published by Carington Bowles
British, 1724–1793
after
Thomas Bowles II
British, c. 1695–1767
South Sea Bubble Playing Cards (10, J, Q, K, A of hearts and of diamonds), 1721
Engravings with hand-coloring
Each: 9.5 × 6.3 cm
Kress Collection of Business and Economics, 06054.62-1

Roger Lorrain
French, active 18th century
The Money Devil, c. 1780
Ink and pen drawing on nine sheets of joined paper
100 × 75 cm
Kress Collection of Business and Economics

BIBLIOTHÈQUE NATIONALE DE FRANCE

Étienne-Louis Boullée
French, 1728–1799
Cénotaphe de Newton (Cenotaph to Newton), 1784
Black ink and gray wash with hues of brown
44 × 66 cm
Département des Estampes et de la Photographie, RESERVE HA-57-BOITE FT 4, plate 6

Jean-Baptiste Chapuy
French, c. 1760–1802
after
J. L. Boquet
Vue de l'incendie de la ville du Cap Français, arrivée le 21 juin 1793 (View of the Burning of the City of Cap Français on June 21, 1793), 1794
Etching printed in five colors
52.5 × 73.5 cm
Département des Estampes et de la Photographie, RESERVE QB-201 (171, 24)-FT 5

Louis-Jean Desprez
French, 1743–1804
La Chimère de Monsieur Desprez (Monsieur Desprez's Chimera), 1771
Etching
27.5 × 35.5 cm
Département des Estampes et de la Photographie, HA-52 FT-4

BOSTON ATHENAEUM

Manuel Salvador Carmona
Spanish, 1734–1820
Antigüedades arabes de España (Arab Antiquities of Spain), vol. 1 (Madrid: Real Academia de Bellas Artes de San Fernando, 1787)
Bound book
Spine: 60 cm
Gift of George W. Brimmer, 1838, Flat Folio UDHX //An8

BOSTON MEDICAL LIBRARY

Bernhard Siegfried Albinus
German, 1697–1770
Dissertatio secunda. De sede et caussa coloris Aethiopum et caeterorum hominum (Second Dissertation: On the Seat and Cause of the Color of Ethiopians and Other Human Beings) (Leiden: 1737)
Three-color mezzotints and letterpress (four sheets)
Each print: 12.6 × 16.8 cm (approx.)
R836.L12 c.1

CHÂTEAU DES DUCS DE BRETAGNE, MUSÉE D'HISTOIRE DE NANTES

René Lhermitte
French, active 18th century
Plan, profil et distribution du navire la Marie Séraphique de Nantes (Plan, Profile, and Layout of the Ship *La Marie-Séraphique* from Nantes, France), 1770
Ink and watercolor
74.6 × 53.4 cm
2005.3.1

COLLECTION OF HISTORICAL SCIENTIFIC INSTRUMENTS, HARVARD UNIVERSITY

Peter Dollond
British, 1730–1820
and
John Dollond
English, 1706–1761
Portable orrery, c. 1787
Brass, mahogany, and ivory, with paper face engraved with watercolor
Orrery: 12.2 × 25.6 × 23 cm; case: 15.6 × 26.5 × 25.3 cm
DW0701

Edward Nairne
English, 1726–1806
Manufactured by Eade & Wilton
English, active 1740–1765
Mariner's dry-card compass, 1765
Glass, oak, brass, and lead, with engraved card
16.8 × 31 × 29.4 cm
0094

COOPER HEWITT, SMITHSONIAN DESIGN MUSEUM, NEW YORK

Charles de Wailly
French, 1729–1798
View of the Pulpit, Saint Sulpice, Paris (Second Project), 1789
Black ink, brush and watercolor, and black chalk
57.8 × 47.3 cm
Purchased for the Museum by the Advisory Council, 1911-28-293

DISTINCTIVE COLLECTIONS, MIT LIBRARIES

Denis Diderot
French, 1713–1784
Encyclopédie, ou, Dictionnaire raisonné des sciences, des arts et des métiers (Encyclopedia; or, Analytical Dictionary of the Sciences, Arts, and Trades), vol. 23 (Paris: 1762–72)
Bound book
Spine: 40 cm
AE25.D555 1751 Plates

Hai tou Anakreontos Ōdai: Kai, Ta tes Sapphous; kai, Ta tou Alkaiou Leipsana (The Odes of Anacreon, with Fragments of Sappho and Alcaeus) (Glasgow: Excudebant R. & A. Foulis, 1751)
Book printed on colored silk with overcast stitched edges
Spine: 7.7 cm
1 PA3865.A1 1751

ERNST MAYR LIBRARY OF THE MUSEUM OF COMPARATIVE ZOOLOGY, HARVARD UNIVERSITY

Edmé-Louis Billardon de Sauvigny
French, 1736–1812
Histoire naturelle des dorades de la Chine (Natural History of Chinese Goldfish) (Paris: 1780)
Bound book
Spine: 36 cm
Special Collections (Martinet)

Robert Hooke
English, 1635–1703
and
Henry Baker
British, 1698–1774
Micrographia restaurata; or, The copper-plates of Dr. Hooke's wonderful discoveries by the microscope, reprinted and fully explained (London: John Bowles, 1745)
Bound book
Spine: 37 cm
F413

FINE ARTS LIBRARY, HARVARD UNIVERSITY

Johann Sebastian Müller
German, 1715–c. 1792
Herr Aaron (Pastor Aaron), c. 1741–44
Etching with watercolor and letterpress
27.9 × 21.6 cm
Edwin Binney 3rd Collection of Orientalist Prints circa 15th–19th century, Special Collections, AKP287.246

FLEET LIBRARY, RHODE ISLAND SCHOOL OF DESIGN

Claude-Nicolas Ledoux
French, 1736–1806
L'Architecture considérée sous le rapport de l'art, des mœurs et de la législation (Architecture Considered in Relation to Art, Mores, and the Law) (Paris: 1804)
Bound book
Spine: 57 cm
Special Collections, LF NA1053.L4 A5 1804

FRANCIS A. COUNTWAY LIBRARY OF MEDICINE, HARVARD MEDICAL SCHOOL

Jan L'Admiral
Dutch, 1699–1773
Arteries and Veins of the Intestine
From *Dissertatio de arteriis et venis intestinorum hominis. Adjecta icon coloribus distincta* (A Treatise on the Arteries and Veins of the Human Intestine: With the Addition of a Distinct Color Image), by Bernard Siegfried Albinus (Leiden: 1736)
Color mezzotint with etching
Print: 13 × 17.1 cm
R836.L12 c.2

William Smellie
British, 1697–1763
A sett of anatomical tables, with explanations and an abridgement, of the practice of midwifery, with a view to illustrate a treatise on that subject, and collection of cases (London: [1758] 1761)
Bound book
Spine: 58 cm
Rare Books ff, RG526 .S34 c.1

Jan Wandelaar
Dutch, 1690–1759
"Muscle-Manikin" and Clara, the
Rhinoceros
Plate IV from *Tabulae sceleti et muscu-
lorum corporis humani* (Tables of the
Skeleton and Muscles of the Human
Body), by Bernhard Siegfried Albinus
(Leiden: 1747)
Engraving and etching
72.7 × 52.7 cm
ff, QM25 .A148 copy 3

HARVARD ART MUSEUMS

S. Alkin
*Admission to see Mr. Wedgewood's copy
of "The Portland Vase,"* 1790
Engraving
6.3 × 8.9 cm
Harvard Art Museums Archives,
ARCH.0000.14

Francesco Bartolozzi
Italian, 1727–1815
after
Giovanni Battista Cipriani
Italian, 1727–1785
*Apollo and Daphne: A Billhead for the
Benefit of Mr. Giardini,* 1770
Engraving
12.5 × 13.4 cm
Fogg Museum, Gift of William Gray
from the collection of Francis Calley
Gray, G195

Francesco Bartolozzi
Italian, 1727–1815
after
Giovanni Battista Cipriani
Italian, 1727–1785
*The Ball at the Mansion House April
XVII, MDCCLXXV, The Right
Honorable John Wilkes, Lord Mayor,*
1775
Etching and engraving
Plate: 24.3 × 21.5 cm
Fogg Museum, Acquisition Fund for
Prints, 2022.4

Francesco Bartolozzi
Italian, 1727–1815
after
Giovanni Battista Cipriani
Italian, 1727–1785
*Muto, non Ciecho Sçavoir = Vivre
Masquerade* (Ticket to the Scavoir-
Vivre Masquerade), 1775
Etching and engraving
Sheet: 14.4 × 10.7 cm
Fogg Museum, Acquisition Fund for
Prints, 2022.5

Benigno Bossi
Italian, 1727–1792
after
Ennemond Alexandre Petitot
French, 1727–1801
Jeune Moine à la Grecque (Young Monk
in a Grecian Costume), 1771
Plate 9 from the series *Mascarade à la
Grecque* (Greek Masquerade)
Etching
Plate: 27 × 18.8 cm
Fogg Museum, Acquisition Fund for
Prints, 2017.180

Daniel Nikolaus Chodowiecki
German, 1726–1801
Calas Bidding Farewell to His Family,
1768
Etching
Plate: 34.2 × 44.5 cm
Fogg Museum, Acquisition Fund for
Prints, 2019.259

Charles-Nicolas Cochin le jeune
French, 1715–1790
Invitation to a Ball, February 24, 1745,
1745
Etching
11.4 × 15.7 cm
Fogg Museum, Acquisition Fund for
Prints, 2017.178

W. Cole
British, active 18th century
Thomas Ripley & Co.
Engraving
Sheet: 22.7 × 18.2 cm
Fogg Museum, Acquisition Fund for
Prints, 2021.642

Jean-Baptiste Joseph Delafosse
French, 1721–1775
after
Louis Carrogis de Carmontelle
French, 1717–1806
The Miserable Calas Family, 1765
Etching and engraving
Sheet: 34.8 × 42.7 cm
Fogg Museum, Acquisition Fund for
Prints, 2019.258

Alexandre-Evariste Fragonard
French, 1780–1850
*A Centurion Begging for Protection from
Mark Antony during a Seditious Revolt,*
c. 1800
Black ink and black and gray wash
over graphite(?) on off-white antique
laid paper
20.4 × 48 cm
Fogg Museum, Marian H. Phinney
Fund and William W. Robinson
Fund, 2018.210

Jean-Honoré Fragonard
French, 1732–1806
The Servant Girls' Dormitory, c. 1770
Brown wash over graphite on off-
white antique laid paper
23.9 × 36.8 cm
Fogg Museum, Gift of Charles E.
Dunlap, 1954.106

Henry Fuseli
Swiss, 1741–1825
*Agamemnon Pursuing a Trojan near the
Tomb of Ilos,* c. 1768–70
Brown ink, red gouache, and brown
and gray wash over graphite on off-
white laid paper
44 × 56 cm
Fogg Museum, Bequest of
Grenville L. Winthrop, 1943.706

Francisco José de Goya y Lucientes
Spanish, 1746–1828
Los Caprichos (The Caprices),
1797–98
Bound book
Spine: 31 cm
Fogg Museum, Gift of Philip Hofer,
M4301–80

Johann Jakob Hoch
German, 1750–1829
The Wizard's Spell, c. 1780
Black ink and gray wash on off-white
antique laid paper
45.9 × 59.7 cm
Fogg Museum, The Melvin R.
Seiden Fund, Louise Haskell Daly
Fund and Paul J. Sachs Memorial
Fund, 1985.68

William Hogarth
British, 1697–1764
The Four Stages of Cruelty, 1751
Etching and engraving
Each plate: 38.4 × 32 cm
Fogg Museum, Gray Collection of
Engravings Fund, G9032, G9033,
G9034, G9035

Johann Rudolph Holzhalb
Swiss, 1730–1805
The Tombs of the Jews, 1755
Etching and engraving with letter-
press and woodcut
Plate: 29.6 × 20.3 cm; folded sheet:
39.6 × 25.4 cm
Fogg Museum, Acquisition Fund for
Prints, 2016.99

François-Robert Ingouf
French, 1747–1812
after
Jean-Jacques-François Lebarbier
French, 1738–1826
*Canadians Weeping over the Tomb of
Their Child*, 1786
Engraving
Sheet: 54.5 × 40.2 cm
Fogg Museum, Gift of Belinda L.
Randall from the collection of John
Witt Randall, R7923

Jean-François Janinet
French, 1752–1814
*Gravures historiques des principaux
événemens depuis l'ouverture des Etats-
Généraux de 1789* (Historical Prints of
the Major Events Since the Opening
of the Estates General of 1789)
Bound with *The History of Jacobinism,
Its Crimes and Perfidies*, by William
Playfair (London: 1795)
Etching and aquatint
Spine: 21.2 cm
Fogg Museum, Gift of Patrice
Higonnet, M21315.1–33

Jean-François Janinet
French, 1752–1814
after
Jean-Guillaume Moitte
French, 1746–1810
The Virtue of Lucretia, 1789
Etching and roulette
Sheet: 32 × 59.6 cm
Fogg Museum, Acquisition Fund for
Prints, 2015.123

Giovanni Battista Piranesi
Italian, 1720–1778
Invenzioni capric di carceri (Capricious
Inventions of Prisons), 1749–50
Etching in book
59.5 × 45.5 cm
Fogg Museum, FINV2139

Giovanni Battista Piranesi
Italian, 1720–1778
Roman Architectural Fantasy, 18th
century
Red chalk, brown ink, and brown
and gray wash on white antique laid
paper
52.9 × 38.9 cm
Fogg Museum, Friends of Art,
Archaeology and Music at Harvard
Fund, 1945.10

Hubert Robert
French, 1733–1808
The See-Saw, c. 1786
Black ink, brown wash, and water-
color over traces of black chalk on
off-white antique laid paper
44.8 × 32.5 cm
Fogg Museum, Gift of Charles E.
Dunlap, 1956.250

Christian Bernhard Rode
German, 1725–1797
*Sculpted Masks from the Courtyard of
the Zeughaus, Berlin*
Etchings
Each sheet: 9.1 × 7.5 cm
Fogg Museum, Anonymous loan,
6.2017.1–3, 6.2017.5, 6.2017.7

Russian Woman
Englishman
Illustrated folios from manuscripts
of the *Zenanname* (Book of Women)
and *Hubanname* (Book of Beauties),
by Fazili Enderuni
Turkey, Istanbul, Ottoman period,
late 18th century
Ink, colors, and gold on paper
Russian Woman: 25.1 × 14.5 cm;
Englishman: 25 × 14.3 cm
Arthur M. Sackler Museum, The
Edwin Binney, 3rd Collection of
Turkish Art at the Harvard Art
Museums, 1985.254, 1985.255

Gabriel Jacques de Saint-Aubin
French, 1724–1780
*The Instructive and Appetizing
Meal: Voltaire and Three Dinner
Companions(?)*, 1778
Black and brown ink and gray wash
on off-white antique laid paper
18.5 × 15.2 cm
Fogg Museum, Gift of Charles E.
Dunlap, 1955.189

John Keyse Sherwin
British, 1751(?)–1790
*Henry Hastings, Nightman to His
Majesties Offices, & for the City &
Suburbs*, 1773
Engraving
Sheet: 24.5 × 17.3 cm
Fogg Museum, Acquisition Fund for
Prints, 2021.641

Giovanni Battista Tiepolo
Italian, 1696–1770
Death of Saint Onophrius(?), 18th
century
Brown ink and brown wash over
black chalk on off-white antique laid
paper
43 × 29.4 cm
Fogg Museum, Gift of Mr. and Mrs.
Edward M.M. Warburg, 1961.171

Adrian Zingg
Swiss, 1734–1816
View of Dresden, c. 1788
Black ink and gray wash over graph-
ite on off-white antique laid paper
48.9 × 64.5 cm
Fogg Museum, Gift of Belinda L.
Randall from the collection of John
Witt Randall, 1898.115

Unidentified artist
American, active 18th century
Lottery Ticket: The Endless Knot,
c. 1785–95
Woodcut
Sheet: 17.2 × 14.3 cm
Fogg Museum, Gift of Walter S.
Poor, Class of 1905, M20297

Unidentified artist
British, active 17th–18th century
S. Gibbons Stationers in ye Temple
Engraving on album page
Mount: 16.7 × 9.5 cm
Fogg Museum, Acquisition Fund for
Prints, 2021.647

Unidentified artist
British, active 18th century
Animal Comedians, 1753
From *Universal Magazine*, February
1753
Engraving and letterpress
Mount: 19 × 24.3 cm
Fogg Museum, Acquisition Fund for
Prints, 2021.645

Unidentified artist
British, active 18th century
*A Representation of the Surprising
Performances of Mr. Price*
From *Universal Museum & Complete
Magazine of Knowledge and Pleasure*
Engraving
Plate: 20 × 22.4 cm
Fogg Museum, Acquisition Fund for
Prints, 2021.646

Unidentified artist
British, active 18th century
Walking Temple Gates
Engraving and letterpress
Sheet: 8 × 10 cm
Fogg Museum, Acquisition Fund for
Prints, 2021.643

Unidentified artist
French(?), active 18th century
Trademark, c. 1790
Engraving
Sheet: 9.4 × 16.5 cm
Fogg Museum, Acquisition Fund for
Prints, 2022.3

HARVARD LAW SCHOOL LIBRARY

Printed by André-Charles Cailleau
French, 1731–1798
*Vie privée et criminelle d'Antoine-
François Desrues* (The Private and
Criminal Life of Antoine-François
Desrues) (Paris: 1777)
Bound pamphlet with illustrations
Spine: 17 cm
Historical & Special Collections,
Rare Foreign Treatises V

HARVARD MAP COLLECTION

Engelbert Kaempfer
German, 1651–1716
*Het Koninkryk Japan: Verdeelt in acht
en zestig Provintien* (The Kingdom
of Japan: Divided into Sixty-Eight
Provinces), 1733(?)
Etching and engraving with water-
color
41 × 51 cm
Christophe Daniel Ebeling Collection,
Gift of Israel Thorndike, 1818,
MAP-LC G7961.F7 1733 .K3

Matthaeus Seutter
German, 1678–1756
*Stockholm die vortreffliche Haupt
und Residenz Statt deß König Reichs
Schweden, in einem accuraten Grund Riß
u. Prospecten vorgestellt* (Stockholm,
the Splendid Capital and Residence
of the King of Sweden, Represented
in an Accurate Ground Plan and in
Prospects), 1735
Etching and engraving with water-
color
Sheet: 56 × 62 cm
Christophe Daniel Ebeling Collection,
Gift of Israel Thorndike, 1818,
MAP-LC G6954.S7 1735 .S4

THE HORVITZ COLLECTION

Marie-Gabrielle Capet
French, 1761–1818
Self-Portrait, c. 1790
Black, red, and white chalk
34 × 29.4 cm
D-F-429

Louis-François Cassas
French, 1756–1827
*Two Temples and a Palace in Spalato,
Dalmatia*
Black ink with brush and gray wash,
heightened with white gouache
28.5 × 40.1 cm
D-F-541

Charles-Nicolas Cochin le jeune
French, 1715–1790
Cartographic Scale with Putti, c. 1775
Red chalk over graphite
32.8 × 46.4 cm
D-F-1229

Claude-Louis Desrais
French, 1746–1816
Two drawings from the *Suite of Sixty-
Three Erotic Drawings*
Black ink and brush with gray and
brown wash
Each: 8.9 × 5.8 cm
D-F-514.36, D-F-514.46

Jean Démosthène Dugourc
French, 1749–1825
*Vue du Champ de Mars à l'instant du
Serment (fête de la fédération)* (View of
the Champ de Mars at the Moment
of the Oath during the Festival of
the Federation), 1790
Black ink and brush with gray wash
over black chalk on cream wove
paper
63 × 94.5 cm
D-F-1515

Nicolas Maréchal
French, 1753–1803
Ursus maritimus (Polar bear)
Black chalk, extensively stumped
24.8 × 33.4 cm
D-F-1456

Jean-Michel Moreau, called Moreau
le jeune
French, 1741–1814
The Cutler's Workshop
Black ink and brush with gray wash
over traces of black chalk
10.3 × 20.5 cm
D-F-1090

Benoît-Louis Prévost
French, 1735–1804
after
Jean-Michel Moreau, called Moreau
le jeune
French, 1741–1814
The Cutler's Workshop
Engraving
Plate: 35.2 × 22.3 cm
C-F-41a

HOUGHTON LIBRARY, HARVARD UNIVERSITY

Daniel Nikolaus Chodowiecki
German, 1726–1801
A Slave Revolt
From *Begebenheiten der neueren
Zeitgeschichte, in Göttinger Taschen-
Calender für das Jahr 1793* (Events
of Contemporary History, in
Göttingen Pocket Calendar for the
Year 1793) (Göttingen: 1792)
Bound book
Closed: 10.4 × 6.3 × 1.8 cm
Gift of Philip Hofer, GEN Typ
720.93.432

Johann Bernhard Fischer von Erlach
Austrian, 1656–1723
*Entwurff einer historischen Architectur
in Abbildung: Unterschiedener berühm-
ten Gebäude, des Alterthums, und
fremder Völcker, umb aus den Geschicht-
büchern, Gedächtnüss-müntzen, Ruinen
und eingeholten wahrhafften Abrissen,
vor Augen zu stellen* (Plan of a History
of Architecture in Illustrations:
Various famous buildings, of
antiquity and foreign peoples to
bring before the eyes true represen-
tations drawn from history books,
commemorative medals and ruins)
(Vienna: 1721)
Bound book
Spine: 42 cm
Gift of Philip Hofer, 1939, pf (horz)
Typ 722.21.394

Hubert François Gravelot
French, 1699–1773
Le Premier baiser de l'amour (Love's
First Kiss)
From *Recueil d'estampes pour La nou-
velle Héloïse* (Collection of Prints for
The New Heloise), c. 1761–64
Graphite and ink
28.1 × 20 cm
Gift of Mr. and Mrs. John F.
Fleming, 1959, F MS Typ 404.1,
drawing #1

Sir William Hamilton
English, 1730–1803
*Campi Phlegraei: Observations on the
Volcanoes of the Two Sicilies* (Naples:
1776)
Bound book
Spine: 46.8 cm
Gift of Philip Hofer, pf Typ
725.76.447

Ilantai
Manchu, active at the Qing court
c. 1749–1793
Haiyantang Dongmian (Calm Seas
Palace)
From the series *Changchun yuan
shuifa tu* (Pictures of the European
Palaces and Waterworks), 1781–87
Copperplate engraving with silk
border
64.9 × 98.3 cm
Philip Hofer Charitable Trust and
Amy Lowell Bequest, GEN Typ
778.83.274 Plate 12

Ilantai
Manchu, active at the Qing court
c. 1749–1793
Huayuan Zhengmian (Labyrinth)
From the series *Changchun yuan
shuifa tu* (Pictures of the European
Palaces and Waterworks), 1781–87
Copperplate engraving with silk
border
64.9 × 98.3 cm
Philip Hofer Charitable Trust and
Amy Lowell Bequest, GEN Typ
778.83.274 Plate 5

Pavel L'vov
Russian, 1770–1825
*Rossiiskaia Pamela, ili Istoriia Marii,
dobrodetel'noi poselianki. Chast' vtoroia*
(Russian Pamela, or the Story of
Maria, the Virtuous Countrywoman)
(Moscow: 1794)
Bound book
Spine: 21 cm
Charles Minot Fund, GEN *RC7.
L9791.789rb 2 v. in 1

Printed by James Phillips
British, 1745–1799
Description of a Slave Ship, 1789
Engraving
Sheet: 62.6 × 48.5 cm
Gift of O. Peck, 1845, p EB75 A100
789pb

Nicolas Edme Restif de la Bretonne
French, 1734–1806
*La découverte australe par un homme
volant* (The Discovery of the Austral
Lands by a Flying Man) (Paris:
Leïpsick, 1781)
Bound book
Spine: 18.5 cm
Gift of Francis Greenwood Peabody,
1952, GEN *FC7.R3135.781d (A)

Jacob Christian Schäffer
German, 1718–1790
*Neue Versuche und Muster das
Pflanzenreich zum Papiermachen und
andern Sachen wirthschaftsnützlich zu
gebrauchen* (New Experiments and
Samples of Paper Made without
Rags or at Least a Small Addition of
Those Materials), 5 vols. and encl.
(Regensburg: 1765–67)
Bound books
Each spine: 19 cm
Bequest of Philip Hofer, 1984, GEN
Typ 720.65.773

J. PAUL GETTY MUSEUM, LOS ANGELES

Louis Carrogis de Carmontelle
French, 1717–1806
Figures Walking in a Parkland,
1783–1800
Watercolor and gouache with traces
of black chalk underdrawing on
translucent Whatman paper
47.3 × 377 cm
96.GC.20

Jean-Baptiste Greuze
French, 1725–1805
The Father's Curse: The Ungrateful Son,
c. 1778
Brush and gray wash, squared in
pencil
50.2 × 64 cm
83.GG.231

Augustin Pajou
French, 1730–1809
Monument to Buffon, c. 1776
Fabricated red chalk
37.4 × 23.9 cm
Purchased in part with funds pro-
vided by the Disegno Group, 2015.16

**THE METROPOLITAN
MUSEUM OF ART, NEW YORK**

Louis-François Cassas
French, 1756–1827
View of Messina Harbor, 1783
Black and brown ink and brush and
brown and gray wash over traces of
black chalk underdrawing, framing
lines in pen and black ink
61 × 97 cm
Harry G. Sperling Fund, 2013,
2013.519

John Dixon
Irish, c. 1740–1811
The Oracle, 1774
Mezzotint
Sheet (trimmed to image): 51 ×
59.5 cm
The Elisha Whittelsey Collection,
The Elisha Whittelsey Fund, 1967,
67.797.45(b)

Unidentified artist
after
John Dixon
Irish, c. 1740–1811
The Tea-Tax-Tempest (The Oracle),
1774
Mezzotint with gouache; scratched
proof
Sheet: 52.1 × 59.4 cm
Gift of William H. Huntington,
1883, 83.2.2083

MIDDENDORF COLLECTION

Paul Revere, Jr.
American, 1734–1818
after
Henry Pelham
American, 1749–1806
*The Bloody Massacre Perpetrated in King
Street, Boston,* c. 1770
Hand-colored engraving
Framed: 35.6 × 32.4 × 3.8 cm

**THE MORGAN LIBRARY &
MUSEUM, NEW YORK**

Charles-Michel-Ange Challes
French, 1718–1778
Architectural Fantasy, 1747
Pen and brown ink with gray-black
wash on laid paper
40.2 × 67 cm
Gift of Mrs. W. Murray Crane,
1952.31

Attributed to Joseph Ducreux
French, 1735–1802
Portrait of a Gentleman, c. 1800
Black, brown, red, and white chalk
on gray-blue laid paper
52.1 × 41.3 cm
Estate of Mrs. Vincent Astor, 2012.23

William Hogarth
British, 1697–1764
*Third Stage of Cruelty (Cruelty in
Perfection),* 1750
Red chalk, with graphite, on paper;
incised with stylus and squared for
transfer in graphite; verso rubbed
with red chalk for transfer
36 × 30.2 cm
Purchased by Pierpont Morgan
(1837–1913) in 1909, III, 32d

Louis-Nicolas de Lespinasse
French, 1734–1808
*The Reception of an Ambassador by the
Grand Vizier at the Sublime Porte,* 1790
Graphite, brown ink, watercolor,
and gouache, heightened with white
25.1 × 39.1 cm
Purchased on the Sunny Crawford
von Bülow Fund 1978, 2006.3

MUSÉE DU LOUVRE

Louis-Jean Desprez
French, 1743–1804
La Prise d'Agrigente par les Carthaginois
(The Capture of Agrigento by the
Carthaginians), 18th century
Conté, gray ink, gray wash, and
watercolor, heightened with white
59 × 99 cm
Département des Arts graphiques,
RF 54234

Jean-Étienne Liotard
French, 1702–1789
*Portrait de l'archéologue et théolo-
gien Richard Pococke* (Portrait of
Archaeologist and Theologian
Richard Pococke), 1740
Red and black chalk
21 × 13 cm
Département des Arts graphiques,
RF 1379

Augustin Pajou
French, 1730–1809
*Diomède assailli par les Troyens, son
écuyer tué à côté de lui* (Diomedes
Assaulted by the Trojans, His
Horseman Killed at His Side), 1756
Black ink, gray wash, black chalk,
and red wash
59.3 × 84.8 cm
Département des Arts graphiques,
RF 40437

**MUSEUM OF FINE ARTS,
BOSTON**

Louis-François Cassas
French, 1756–1827
Plate 54
From *Voyage pittoresque de la Syrie,
de la Phoenicie, de la Palaestine et de la
Basse Aegypte: Ouvrage divisé en trois
volumes contenant environ trois cent
trente planches* (Picturesque Journey
to Syria, Phoenicia, Palestine and
Lower Egypt: A Work Divided into
Three Volumes and Containing
around 330 Illustrations), vol. 1
(Paris: 1799)
Etching and engraving
Plate: 29.5 × 46.3 cm
2016.62.13

Daniel Nikolaus Chodowiecki
German, 1726–1801
First Shot of the American Revolution at Lexington
From *Historisch-genealogischer Calender, oder Jahrbuch der merkwürdigsten neuen Welt-Begebenheiten für 1784* (Historical-Genealogical Calendar, or Yearbook of the Most Noteworthy World Events for 1784) (Leipzig: Haude und Spener, 1783)
Etching and engraving
Sheet: 11 × 7 cm
William A. Sargent Fund, 44.827

Thomas Frye
British, 1710–1762
Young Man in a Turban with Book, 1760
Mezzotint
Plate: 50.8 × 35.2 cm
Gift of Benjamin A. and Julia M. Trustman, 1985.429

Francisco José de Goya y Lucientes
Spanish, 1746–1828
Los Chinchillas (The Chinchillas)
From the series *Los Caprichos* (The Caprices), 1797–98
Etching, burnished aquatint, and burin; first edition
Plate: 20.7 × 15.1 cm
Gift of Miss Katherine Eliot Bullard, 14.1782

Francisco José de Goya y Lucientes
Spanish, 1746–1828
Que Pico de Oro (What a Golden Beak)
From the series *Los Caprichos* (The Caprices), 1797–98
Etching, burnished aquatint, and burin; first edition, with ms. annotations in brown ink
Plate: 21.8 × 15.2 cm
Gift of Miss Katherine Eliot Bullard, 14.1783

Franz Anton Maulbertsch
Austrian, 1724–1796
The Quacksalver, 1785
Etching and drypoint; first state
Sheet: 33.3 × 41.3 cm
Katherine E. Bullard Fund in memory of Francis Bullard, 2000.997

Gabriel Jacques de Saint-Aubin
French, 1724–1780
Expulsion of the Jesuits, 1761
Etching, trial proof with hand additions in brush and gray wash
Plate: 18 × 20.8 cm
Katherine E. Bullard Fund in memory of Francis Bullard, 62.604

Reinier Vinkeles
Dutch, 1741–1816
after
Jacques Kuyper
Dutch, 1761–1808
and
Pieter Barbiers
Dutch, 1749–1842
Salle de Physique (Physics Theater), 1794–1802
Etching and engraving
Plate: 37.5 × 51.2 cm
Katherine E. Bullard Fund in memory of Francis Bullard, 2016.242.4

Unidentified artist
English, active 18th century
Mask fan, 1740s
Paper leaf patched with skin, etched, engraved, and painted in watercolor; pierced, partially painted, varnished, and gilded ivory sticks; mother-of-pearl; brass guard
Guard: 26.3 cm; open (max.): 48.5 cm
Oldham Collection, 1976.179

NATIONAL GALLERY OF ART, WASHINGTON, D.C.

Daniel Nikolaus Chodowiecki
German, 1726–1801
Affairs of State, 1780–1790, 1791
Uncut sheet of six etchings
Plate: 22.8 × 20.2 cm
Gift of Dr. Dieter Erich Meyer, 1976, 1976.52.2

Barbara Regina Dietzsch
German, 1706–1783
A Branch of Gooseberries with a Dragonfly, an Orange-Tip Butterfly, and a Caterpillar, 1725–83
Gouache over graphite
28.7 × 20.4 cm
Ailsa Mellon Bruce Fund, 2008, 2008.53.2

Claude-Mathieu Fessard
French, active 1765–1805
after
Jean-Honoré Fragonard
French, 1732–1806
Fragonard and Bergeret with Jeanne Vignier and Marie-Anne Fragonard Visiting a Tomb in Pompeii, 1781
Etching
Plate: 18.4 × 24.6 cm
Gift of Ivan E. and Winifred Phillips in memory of Neil Phillips, 1999, 1999.141.1

Johann Esaias Nilson
German, 1721–1788
Two Actors Peeking through a Theater Curtain while Others Prepare the Footlights, 1746–47
Gray ink with gray wash
25.9 × 36.9 cm
Ailsa Mellon Bruce Fund, 2004, 2004.157.1

William Pether
British, 1731–c. 1795
after
Joseph Wright of Derby
British, 1734–1797
A Philosopher Giving a Lecture on the Orrery, 1768
Mezzotint
Plate: 44.6 × 58.1 cm
Paul Mellon Fund, 2001, 2001.96.12

Unidentified artist
after
Jean Huber
Swiss, 1721–1786
The Philosophers' Meal, after 1772
Etching with gray wash on blue wove paper
Sheet: 21.2 × 31.7 cm
Rosenwald Collection, 1980, 1980.45.846

NEW YORK PUBLIC LIBRARY

Guillaume Joseph Hyacinthe Jean
Baptiste Le Gentil de la Galaisière
French, 1725–1792
Voyage dans les mers de l'Inde (Voyage
to the Indian Ocean) (Paris: 1779–81)
Spine: 27.3 cm
3-OPX (Legentil de La Galaisière,
G. J. H. J. B. Voyage dans les mers de
l'Inde) v. 1

Frederik Ludvig Norden
Danish, 1708–1742
Voyage d'Egypte et de Nubie (Travels
in Egypt and Nubia) (Copenhagen:
1755)
Bound book
Spine: 47 cm
Spencer Coll. Danish 1755++

Francesco Piranesi
Italian, 1750–1810
and
Louis-Jean Desprez
French, 1743–1804
The Fireworks above Castel Sant'Angelo,
1781 or 1783
Etching with watercolor and
gouache
Sheet: 78.4 × 57.5 cm
Miriam and Ira D. Wallach Fund,
105853b

PEABODY MUSEUM OF ARCHAEOLOGY & ETHNOLOGY, HARVARD UNIVERSITY

John Webber
British, 1750–1793
*Interior of Habitation at Nuu-chah-nulth
Sound*, April 1778
Black ink, watercolor, and white
gouache
25.4 × 48.5 cm
Gift of the Estate of Belle J. Bushnell,
1941, 41-72-10/499

John Webber
British, 1750–1793
*Interior of Habitation at Nuu-chah-nulth
Sound*, April 1778
Black ink and gray wash over black
chalk
18.3 × 43.9 cm
Gift of the Estate of Belle J. Bushnell,
1941, 41-72-10/500

PHILADELPHIA MUSEUM OF ART

Antonio Cattani
Italian, active 1770–1780s
after
Ercole Lelli
Italian, 1702–1766
Male Écorché Seen from the Rear, 1781
Etching
Overall: 201.9 × 61 cm
Purchased with SmithKline
Beckman (later SmithKline
Beecham) Funds for the Ars Medica
Collection, 1995, 1995-9-2

Jacques-Fabien Gautier d'Agoty
French, 1710–1781
Muscles of the Back
Plate 14 from *Myologie complette
en couleur et grandeur naturelle*
(Complete Scientific Study of
Muscles in Color and Life-Size), by
Joseph Guichard Duverney (Paris:
Gautier, 1746)
Color mezzotint
Sheet: 76 × 53 cm
Purchased with the SmithKline
Beckman Corporation Fund, 1968,
1968-25-79n

Marguerite Gérard
French, 1761–1837
after
Jean-Honoré Fragonard
French, 1732–1806
To the Genius of Franklin, 1778
Etching
Sheet: 55.1 × 41 cm
Gift of Mrs. John D. Rockefeller Jr.,
1946, 1946-51-249

Johann Esaias Nilson
German, 1721–1788
after
Daniel Nikolaus Chodowiecki
German, 1726–1801
Neues Caffehaus (The New
Coffeehouse), c. 1755
Etching and engraving
Plate: 18.6 × 28.5 cm
Purchased with the Katharine Levin
Farrell Fund, 1958, 1958-105-72

William Woollett
British, 1735–1785
after
William Hodges
British, 1744–1797
Monuments in Easter Island
From *A Voyage Towards the South Pole
and Round the World. Performed in
His Majesty's Ships the Resolution and
Adventure, in the Years 1772, 1773, 1774,
and 1775*, by James Cook (London:
1777)
Etching and engraving
Sheet: 28.3 × 45 cm
The Muriel and Philip Berman Gift,
acquired from the John S. Phillips
bequest of 1876 to the Pennsylvania
Academy of the Fine Arts, with
funds contributed by Muriel and
Philip Berman, gifts (by exchange)
of Lisa Norris Elkins, Bryant W.
Langston, Samuel S. White 3rd
and Vera White, with additional
funds contributed by John Howard
McFadden, Jr., Thomas Skelton
Harrison, and the Philip H. and
A.S.W. Rosenbach Foundation, 1985,
1985-52-38306

WIDENER LIBRARY, HARVARD UNIVERSITY

Bernard Picart
French, 1673–1733
*Cérémonies et coutumes religieuses de
tous les peuples du monde* (Religious
Ceremonies and Customs of All
the Peoples of the World), vol. 1
(Amsterdam: 1739)
Bound book
Spine: 41 cm
Judaica Collection

YALE CENTER FOR BRITISH ART

James Barry
Irish, 1741–1806
*The Phoenix; or, The Resurrection of
Freedom*, 1776
Engraving and aquatint; published
state
Plate: 43.2 × 61.3 cm
Paul Mellon Collection,
B1977.14.11067

Giovanni Battista Borra
Italian, 1713–1770
Stromboli and Vesuvius, 1750
Black ink with gray wash over
graphite
Sheet: 54.3 × 37.9 cm
Paul Mellon Collection, B1977.14.1015

John Flaxman
British, 1755–1826
Italian Sketchbook, 1787
Graphite, pen and black ink, and
gray wash in bound sketchbook
Spine: 22.9 cm
Paul Mellon Collection, B1975.3.468

James Gillray
British, 1757–1815
Published by Hannah Humphrey
British, c. 1745–1818
Presages of the Millennium, 1795
Etching and aquatint, hand-colored
Sheet: 33 × 37.6 cm
Paul Mellon Collection, B1981.25.916

John Russell
British, 1745–1806
*A Drawing of a Part for the Map of the
Moon*, 1794
Graphite
Sheet: 20.3 × 15.6 cm
Paul Mellon Collection, B1975.4.920

John Russell
British, 1745–1806
*Lunar Planisphere, Hypothetical Oblique
Light*, 1806
Stipple and line engraving
Sheet (trimmed inside plate): 43.2 ×
41.6 cm
Paul Mellon Collection, B2016.39.2

Paul Sandby
British, 1725–1809
*The Meteor of August 18, 1783, as Seen
from the East Angle of the North Terrace,
Windsor Castle*, 1783
Watercolor
Sheet: 31.8 × 48.3 cm
Paul Mellon Collection, B1993.30.115

George Stubbs
British, 1724–1806
*Fowl Skeleton, Lateral View (Finished
Study for Table V)*, c. 1795–1806
Graphite
54.6 × 40.6 cm
Paul Mellon Collection, B1980.1.5

George Stubbs
British, 1724–1806
*Human Skeleton, Lateral View (Close to
the Final Study for Table III but Differs
in Detail)*, c. 1795–1806
Graphite
54.6 × 40.6 cm
Paul Mellon Collection, B1980.1.50

YALE UNIVERSITY ART GALLERY

Mancest
French, active late 18th century
La rentrée du char triomphant (The
Return of the Triumphant Balloon)
Etching
Sheet: 21.5 × 28 cm
Purchased with a gift from Allan
Appel and Suzanne Boorsch in mem-
ory of Georges May, 2003.148.2

Filippo Morghen
Italian, 1730–after 1807
Zucca che serve per barca da Pescare
(A Pumpkin Used as a Fishing Boat),
1766–67
From the series *Raccolta delle cose
più notabili vedute dal Cavaliere Wild
Scull, e dal Sigr. de la Hire nel lor famoso
viaggio dalla Terra alla Luna* (Suite of
the most notable things seen by Cav.
Wild Scull and Sig. de la Hire on
their famous voyage from the Earth
to the Moon)
Etching
Plate: 28 × 38.8 cm
Everett V. Meeks, B.A. 1901, Fund,
2012.19.1.7

Pietro Antonio Novelli
Italian, 1729–1804
Baptism, 1769
From the series *The Seven Sacraments*
Brush and gray wash with brown ink
Sheet: 38.7 × 52.9 cm
Frederick M. Clapp, B.A. 1901, M.A.
1911, Fund, 2015.59.1

Pietro Antonio Novelli
Italian, 1729–1804
Confession (or Penance), 1769
From the series *The Seven Sacraments*
Brush and gray wash with brown ink
Sheet: 38.9 × 52.8 cm
Frederick M. Clapp, B.A. 1901, M.A.
1911, Fund, 2015.59.4

ANONYMOUS LENDER

Unidentified artist
Assignat de Cinq Livres (French cur-
rency), *Series 4211*, November 11, 1793
Engraving with letterpress and blind
stamp
6.5 × 10 cm

Unidentified artist
Assignat de Quinze Sols (French cur-
rency), *Series 1509*, May 23, 1793
Engraving with letterpress and two
blind stamps
7.6 × 8.6 cm

Anderson, R. G. W., ed. *Enlightening the British: Knowledge, Discovery, and the Museum in the Eighteenth Century*. London: British Museum Press, 2003.

Baczko, Bronisław, Michel Porret, and François Rosset, eds. *Dictionnaire critique de l'utopie au temps des Lumières*. Chêne-Bourg: Georg éditeur, 2016.

Beck, Herbert, Peter C. Bol, and Maraike Bückling, eds. *Mehr Licht. Europa um 1770. Die bildende Kunst der Aufklärung*. Munich: Klinkhardt & Biermann, 1999.

Bensaude-Vincent, Bernadette, and Christine Blondel, eds. *Science and Spectacle in the European Enlightenment*. Burlington, Vt.: Ashgate, 2008.

Bindman, David. *Ape to Apollo: Aesthetics and the Idea of Race in the 18th Century*. Ithaca, N.Y.: Cornell University Press, 2002.

Bleichmar, Daniela. *Visible Empire: Botanical Expeditions & Visual Culture in the Hispanic Enlightenment*. Chicago: University of Chicago Press, 2012.

Brewer, John. *The Pleasures of the Imagination: English Culture in the Eighteenth Century*. London: Routledge, 2013.

Buisseret, David. *Monarchs, Ministers, and Maps: The Emergence of Cartography as a Tool of Government in Early Modern Europe*. Chicago: University of Chicago Press, 1992.

Carlson, Victor I., and John W. Ittmann, eds. *Regency to Empire: French Printmaking, 1715–1814*. Baltimore: Baltimore Museum of Art, 1984.

Changeux, Jean-Pierre, ed. *La Lumière au siècle des Lumières & aujourd'hui: Art et science*. Paris: Odile Jacob, 2005.

Cook, Alexander, Ned Curthoys, and Shino Konishi, eds. *Representing Humanity in the Age of Enlightenment*. London: Pickering & Chatto, 2013.

Couturier, Sonia. *Drawn to Art: French Artists and Art Lovers in 18th-Century Rome*. Milan: Silvana, 2011.

Curran, Andrew S. *The Anatomy of Blackness: Science and Slavery in an Age of Enlightenment*. Baltimore: Johns Hopkins University Press, 2011.

Curry, Helen Anne, Nicholas Jardine, James A. Secord, and Emma Spary, eds. *Worlds of Natural History*. Cambridge: Cambridge University Press, 2018.

Daston, Lorraine, and Elizabeth Lunbeck, eds. *Histories of Scientific Observation*. Chicago: Chicago University Press, 2011.

Daston, Lorraine, and Peter Galison. *Objectivity*. New York: Zone, 2010.

Delon, Michel, ed. *Dictionnaire européen des Lumières*. Rev. ed. Paris: Quadrige/PUF, 2007.

Dobie, Madeleine. *Trading Places: Colonization and Slavery in Eighteenth-Century French Culture*. Ithaca, N.Y.: Cornell University Press, 2010.

Edelstein, Dan. *The Enlightenment: A Genealogy*. Chicago: University of Chicago Press, 2010.

——, ed. *The Super-Enlightenment: Daring to Know Too Much*. Liverpool: Liverpool University Press, 2010.

Fauchois, Yann, Thierry Grillet, and Tzvetan Todorov. *Lumières! Un héritage pour demain*. Paris: Bibliothèque nationale de France, 2006.

Fend, Mechthild. *Fleshing Out Surfaces: Skin in French Art and Medicine, 1650–1850*. Manchester: Manchester University Press, 2017.

Ferrone, Vincenzo. *The Enlightenment: History of an Idea*. Trans. Elisabetta Tarantino. Princeton, N.J.: Princeton University Press, 2015.

Ferrone, Vincenzo, and Daniel Roche, eds. *Le monde des Lumières*. Paris: Librairie Arthème Fayard, 1999.

Festa, Lynn M. *Sentimental Figures of Empire in Eighteenth-Century Britain and France*. Baltimore: Johns Hopkins University Press, 2006.

Friedland, Paul. *Seeing Justice Done: The Age of Spectacular Capital Punishment in France*. Oxford: Oxford University Press, 2012.

Gordon, Daniel, ed. *Postmodernism and the Enlightenment: New Perspectives in Eighteenth-Century French Intellectual History*. New York: Routledge, 2001.

Griffiths, Antony. *The Print before Photography: An Introduction to European Printmaking, 1550–1820*. London: British Museum, 2016.

Griffiths, Antony, and Frances Carey. *German Printmaking in the Age of Goethe*. London: British Museum, 1994.

Hoisington, Rena M. *Aquatint: From Its Origins to Goya*. Washington, D.C.: National Gallery of Art, 2021.

Horkheimer, Max, and Theodor W. Adorno. *Dialectic of Enlightenment: Philosophical Fragments*. Ed. Gunzelin Schmid Noerr. Trans. Edmund Jephcott. Stanford, Calif.: Stanford University Press, 2002.

Hunt, Lynn, Margaret C. Jacob, and Wijnand Mijnhardt, eds. *Bernard Picart and the First Global Vision of Religion*. Los Angeles: Getty Research Institute, 2010.

———. *The Book That Changed Europe: Picart and Bernard's Religious Ceremonies of the World*. Cambridge, Mass.: Harvard University Press, 2010.

Hyland, Paul, Olga Gomez, and Francesca Greensides, eds. *The Enlightenment: A Sourcebook and Reader*. London: Routledge, 2003.

Ittmann, John, ed. *The Enchanted World of German Romantic Prints, 1770–1850*. Philadelphia: Philadelphia Museum of Art, 2017.

Lafont, Anne, ed. *1740, un abrégé du monde: Savoirs et collections autour de Dezallier d'Argenville*. Lyon: Fage, 2012.

———. *L'art et la race: l'Africain (tout) contre l'oeil des Lumières*. Dijon: Les presses du réel, 2019.

Lilti, Antoine. *L'héritage des Lumières. Ambivalences de la modernité*. Seuil: Gallimard, 2019.

Lyon, John, and Philip R. Sloan, eds. and trans. *From Natural History to the History of Nature: Readings from Buffon and His Critics*. Notre Dame, Ind.: University of Notre Dame Press, 1981.

McAleer, John, and Nigel Rigby. *Captain Cook and the Pacific: Art, Exploration & Empire*. New Haven, Conn.: Yale University Press, 2017.

McGrath, Elizabeth, and Jean Michel Massing, eds. *The Slave in European Art: From Renaissance Trophy to Abolitionist Emblem*. London: Warburg Institute, 2012.

Outram, Dorinda. *The Enlightenment*. 4th ed. Cambridge: Cambridge University Press, 2019.

———. *Panorama of the Enlightenment*. Los Angeles: J. Paul Getty Museum, 2006.

Safier, Neil. *Measuring the New World: Enlightenment Science and South America*. Chicago: University of Chicago Press, 2012.

Schmidt, James, ed. *What Is Enlightenment? Eighteenth-Century Answers and Twentieth-Century Questions*. Berkeley: University of California Press, 1996.

Siskin, Clifford, and William Warner, eds. *This Is Enlightenment*. Chicago: University of Chicago Press, 2010.

Sloan, Kim, ed. *Enlightenment: Discovering the World in the Eighteenth Century*. London: British Museum Press, 2004.

Stafford, Barbara Maria. *Body Criticism: Imaging the Unseen in Enlightenment Art and Medicine*. Cambridge, Mass.: MIT Press, 1996.

Stewart, Susan. *The Ruins Lesson: Meaning and Material in Western Culture*. Chicago: University of Chicago Press, 2020.

Stijnman, Ad. *Engraving and Etching, 1400–2000: A History of the Development of Manual Intaglio Printmaking Processes*. Houten: Archetype Publications Ltd., 2012.

Stroumsa, Guy G. *A New Science: The Discovery of Religion in the Age of Reason*. Cambridge, Mass.: Harvard University Press, 2010.

Thomas, Keith. *Man and the Natural World: Changing Attitudes in England, 1500–1800*. New York: Oxford University Press, 1996.

Thomas, Sarah. *Witnessing Slavery: Art and Travel in the Age of Abolition*. New Haven, Conn.: Yale University Press, 2019.

Vila, Anne C., ed. *A Cultural History of the Senses in the Age of Enlightenment*. London: Bloomsbury Academic, 2014.

Wheeler, Roxann. *The Complexion of Race: Categories of Difference in Eighteenth-Century British Culture*. Philadelphia: University of Pennsylvania Press, 2000.

Zhangshen, Lu, ed. *The Art of the Enlightenment*. Beijing: National Museum of China; Berlin: Staatliche Museen zu Berlin; Dresden: Staatliche Kunstsammlungen Dresden; Munich: Bayerische Staatsgemäldesammlungen München, 2011.

IMAGE CREDITS

All photographs were supplied by the owners of the works of art, who hold the copyright thereto, and are reproduced with permission.

All images of objects from Harvard collections and archives © 2022 President and Fellows of Harvard College. Unless otherwise indicated, photographs of works in the Harvard Art Museums are by the Department of Digital Imaging and Visual Resources. Unless otherwise indicated, photographs of works in other Harvard University collections are by Digital Imaging and Photography Services.

ADDITIONAL CREDITS

Introduction
Fig. 1: Courtesy of the National Gallery of Art, Washington, D.C.; Fig. 2: Courtesy of the Philadelphia Museum of Art

Antiquities
Fig. 1: Yale Center for British Art; Fig. 2: © Musée du Louvre, Dist. RMN-Grand Palais/Martine Beck-Coppola/Art Resource, NY; Fig. 3: Courtesy of the National Gallery of Art, Washington, D.C.; Fig. 4: © RMN-Grand Palais/Art Resource, NY; Fig. 5: The Horvitz Collection, Wilmington, Del.; Fig. 6: Photo: Christina Taylor

Believe
Fig. 1: Widener Library, Harvard University; Fig. 2: Fine Arts Library, Harvard University; Fig. 3: Franckesche Stiftungen; Fig. 7: Courtesy of the National Gallery of Art, Washington, D.C.

Cruelty
Fig. 1: The Morgan Library & Museum, New York; Fig. 2: Bibliothèque nationale de France; Fig. 3: Houghton Library, Harvard University

Drawing
Fig. 1: bpk Bildagentur/Kupferstich-kabinett, Staatliche Museen, Berlin/Volker-H. Schneider/Art Resource, NY; Fig. 2: Photo © Smithsonian Institution; Fig. 3: © Musée du Louvre, Dist. RMN-Grand Palais/Harry Bréjat/Art Resource, NY; Fig. 4: Digital image courtesy of the Getty's Open Content Program

Expedition
Fig. 1: © The Trustees of the British Museum; Fig. 2: Houghton Library, Harvard University; Fig. 3: John G. Wolbach Library, Harvard University; Figs. 4–5: Courtesy of the Philadelphia Museum of Art

Flight
Figs. 1, 3–4: Yale University Art Gallery; Fig. 2: Yale Center for British Art; Fig. 5: Houghton Library, Harvard University

Geography
Fig. 2: Yale Center for British Art; Fig. 3: Harvard Map Collection; Fig. 4: The British Library, Creative Commons; Fig. 5: Digital image courtesy of the Getty's Open Content Program

Human
Fig. 1: The Morgan Library & Museum, New York; Fig. 2: © Musée d'art et d'histoire, Ville de Genève, Photo: Yves Siza; Fig. 4: Digital image courtesy of the Getty's Open Content Program; Figs. 5–6: Francis A. Countway Library of Medicine, Harvard Medical School

Imagination
Fig. 4: The Morgan Library & Museum, New York; Fig. 6: Bibliothèque nationale de France

Jest
Fig. 1: © The Trustees of the British Museum; Fig. 2: Photograph © 2022 Museum of Fine Arts, Boston; Fig. 3: © Photographic Archive Museo Nacional del Prado

Knowledge
Figs. 1–2: The Horvitz Collection, Wilmington, Del.; Fig. 3: Grace Johnson-DeBaufre, MIT Libraries, Distinctive Collections; Fig. 4: Photograph © 2022 Museum of Fine Arts, Boston; Fig. 5: Courtesy of the Philadelphia Museum of Art

Lava
Figs. 1, 3: Houghton Library, Harvard University; Fig. 2: The New York Public Library; Fig. 4: Yale Center for British Art; Fig. 5: Special Collections, Senate House Library, London

Microscope
Fig. 1: Photo: Christina Taylor; Fig. 2: Courtesy of the Linda Hall Library of Science, Engineering & Technology; Fig. 3: Courtesy of the National Gallery of Art, Washington, D.C.; Figs. 4–5: Courtesy of the Collection of Historical Scientific Instruments, Harvard University

Nature
Fig. 1: Wellcome Collection, Creative Commons; Fig. 2: Digital image courtesy of the Getty's Open Content Program; Figs. 3–4: Yale Center for British Art; Fig. 5: Dumbarton Oaks Research Library and Collection, Trustees for Harvard University, Washington, D.C.; Fig. 6: Courtesy of the National Gallery of Art, Washington, D.C.

Oculus
Fig. 1: National Archives and Records Administration, Washington, D.C.; Fig. 2: Photograph © 2022 Museum of Fine Arts, Boston; Fig. 3: Courtesy of the Fleet Library at Rhode Island School of Design, Special Collections; Fig. 4: Houghton Library, Harvard University; Fig. 5: © RMN-Grand Palais/Art Resource, NY

Public
Fig. 3: Digital image courtesy of the Getty's Open Content Program; Fig. 4: © RMN-Grand Palais/Art Resource, NY

Quack
Fig. 3: Photograph © 2022 Museum of Fine Arts, Boston

Reproduction
Fig. 1: The Metropolitan Museum of Art, New York; Fig. 2: Houghton Library, Harvard University; Fig. 3: Courtesy of the Philadelphia Museum of Art; Fig. 4: Courtesy of University of Glasgow Archives & Special Collections, Hepburn 7

Skin
Fig. 1: Francis A. Countway Library of Medicine, Harvard Medical School; Fig. 2: Digital Imaging and Photography Services, Harvard University, and Boston Medical Library; Fig. 3: Photograph © 2022 Museum of Fine Arts, Boston

Time
Fig. 1: Photo: akg-images; Fig. 2: Courtesy of the Philadelphia Museum of Art; Fig. 3: Photo © Smithsonian Institution; Fig. 4: Yale Center for British Art

Utopia
Fig. 1: Yale Center for British Art; Fig. 2: The Metropolitan Museum of Art, New York; Fig. 3: Houghton Library, Harvard University

Venus
Figs. 1, 3: Bibliothèque nationale de France; Fig. 2: The New York Public Library

Wager
Fig. 1: © The Trustees of the British Museum; Figs. 2–3: Baker Library, Harvard Business School

XXX
Fig. 1: Houghton Library, Harvard University; Fig. 4: Courtesy of the National Gallery of Art, Washington, D.C.; Fig. 5: Grace Johnson-DeBaufre, MIT Libraries, Distinctive Collections; Figs. 6–7: The Horvitz Collection, Wilmington, Del.

Yellow
Fig. 2: Bibliothèque nationale de France

SPOTLIGHTS

1. Jacob Christian Schäffer, *Second Sample, First Trial with Pine Cones*: Houghton Library, Harvard University

3. Marie-Gabrielle Capet, *Self-Portrait*: The Horvitz Collection, Wilmington, Del.

4. René Lhermitte, *Plan, Profile, and Layout of the Ship* La Marie-Séraphique *from Nantes, France*: © Chateau des ducs de Bretagne—Musée d'histoire de Nantes

5. Susanna Drury, *A View of the Giant's Causeway: East Prospect*: MIT Libraries, Distinctive Collections

6. François Nicolas Martinet and Aaron Martinet, Plate 10, from *Natural History of Chinese Goldfish*: All images courtesy of Catherine Badot-Costello

8. Étienne-Louis Boullée, *Cenotaph to Newton*: Bibliothèque nationale de France

9. John Russell, *Lunar Planisphere, Hypothetical Oblique Light*: Yale Center for British Art

10. Jacques-Fabien Gautier d'Agoty, *Muscles of the Back*: Courtesy of the Philadelphia Museum of Art; Photo: Joseph Hu; Fig. 1: Photo: Thomas Primeau, Conservator of Works of Art on Paper at the Philadelphia Museum of Art, 2021; Fig. 2: Photo: Jason Wierzbicki, Conservation Photographer at the Philadelphia Museum of Art, 2021

11. Pietro Antonio Novelli, *Baptism*: Yale University Art Gallery

This book accompanies the exhibition *Dare to Know: Prints and Drawings in the Age of Enlightenment*, on view at the Harvard Art Museums, Cambridge, Massachusetts, from September 16, 2022 through January 15, 2023.

Published by
Harvard Art Museums
32 Quincy Street
Cambridge, MA 02138-3847
harvardartmuseums.org

Distributed by
Yale University Press
302 Temple Street
PO Box 209040
New Haven, CT 06520-9040
yalebooks.com/art

Managing Editor: Micah Buis
Editors: Sarah Kuschner, Cheryl Pappas
Design Manager: Zak Jensen
Designers: Angela Lorenzo, Adam Sherkanowski

Typeset in Portrait Text by Matt Mayerchak
Printed on Munken Lynx
Printed in Belgium by die Keure

Note on the type: This book is set in Portrait Text, designed by Berton Hasebe. Upon its release in 2013, the foundry Commercial Type described Portrait Text as both "beautiful and brutal." It is a contemporary interpretation of an Old Style typeface with classical proportions.

ISBN: 978-0-300-26672-6
Library of Congress Control Number: 2022932812

Cover image: Jacques-Fabien Gautier d'Agoty, *Muscles of the Back* (detail). See p. 271 for full information. Photo: Joseph Hu.

This project is supported in part by an award from the National Endowment for the Arts. Additional support provided by the Gladys Krieble Delmas Foundation.